251

SEPARATE SPHERES

SEPARATE SPHERES

Women's Worlds in the 19th-Century Maritimes

Edited by
JANET GUILDFORD & SUZANNE MORTON

ACADIENSIS PRESS
Fredericton
New Brunswick
1994

Acadiensis Press is pleased to acknowledge the support of the Department of History, Dean of Arts and the Vice-President (Academic), University of New Brunswick.

The chapters by Gail Campbell, Judith Fingard, Janet Guildford and Suzanne Morton were published previously in *Acadiensis: Journal of the History of the Atlantic Region*.

Cover photograph: Elizabeth "Betsey" Seamond (1852-1901), Kirkpatrick Collection, Queens County Museum, Liverpool, Nova Scotia.
Book design: Julie Scriver for Goose Lane Editions.
Editorial production: Charles Stuart and Beckey Daniel.

The paper used in this publication is acid-free.

Canadian Cataloguing in Publication Data

Main entry under title:
Separate Spheres

Includes bibliographical references.

ISBN 0-919107-41-9

1. Women — Maritime Provinces — History — 19th century.
I. Guildford, Janet Vey. II. Morton, Suzanne Ruth.

HQ1453.S46 1994 305.4'09715 C94-950077-1

Acadiensis Press
Campus House
University of New Brunswick
Fredericton, N.B.
Canada E3B 5A3

CONTENTS

ACKNOWLEDGEMENTS

Our first thanks must go to our collaborators, the authors of the chapters in this collection. These authors and their essays have played a central role not only through their essays, but also by influencing our thinking. Margaret Conrad and Linda Kealey, both of them long-time and valued contributors to women's history in Atlantic Canada and beyond, read all the essays and offered insightful criticisms which have substantially improved the finished work. Numerous discussions — ranging from the supportive and challenging atmosphere of the Halifax Women's History Reading Group and the Toronto Gender History Group to relaxing afternoons at the beach — have enriched the content of the book and our approach to it.

Elizabeth "Betsey" Seamond (1852-1901) is the subject of the photograph on the cover of this volume. Seamond was an unmarried woman and member of a German-Nova Scotian family from Milton, Queens County, Nova Scotia. While the census simply described her as a labourer, according to local tradition she earned her living by pushing a hand-cart through the village. Proud and defiantly pipe-smoking, she represents the strength, courage and independence of Maritime women. She also provides a wonderful example of the diversity of the female experience, for she stands as a contrast to Milton's most famous daughter, the writer Margaret Marshall Saunders, who is discussed in Gwen Davies' chapter in this book. Although there are similar photographs from virtually everywhere in the Maritimes, we chose a Queens County woman because of the special role of Beach Meadows in this project. Seamond's photograph is a part of the Kirkpatrick Collection at the Queens County Museum in Liverpool, Nova Scotia, and we are grateful to Lt.Col. Robert Kirkpatrick for sharing his knowledge of Betsey's life with us. Linda Rafuse, Acting Curator of the Queens County Museum, and Valerie Inness, Museum Assistant, have been especially generous and helpful both in arranging for us to use the photograph and in helping us uncover the details of Betsey Seamond's life. We would also like to thank Betsey Seamond's great-niece, Mrs. Rita Koller, who has shared family stories about her with us.

INTRODUCTION

JANET GUILDFORD & SUZANNE MORTON

The women you meet in these pages will, we hope, spark your historical curiosity and challenge some of the prevailing stereotypes about 19th-century Maritime women. You will certainly be struck by the variety of women represented here. African-Nova Scotian women, laden with baskets of produce and handicrafts, offered their wares in the Halifax market. Recently arrived Scottish fish "lassies" skilfully wielded knives in a Dartmouth fish plant. In Prince Edward Island farm women aggressively, sometimes even violently, defended their family homes. Women in Saint John and Halifax joined parades and processions to commemorate civic events. Other women defended their rights in police stations and courthouses or took up the pen to articulate a woman's viewpoint in regional literature. Female itinerant preachers drew large, enthusiastic crowds in St. Stephen, New Brunswick. And in local schoolhouses all over the Maritimes, women taught children the three R's.

The women in these essays moved freely between the so-called public sphere of the market, religion and politics and the private sphere of the home, despite expectations that women in their society would fulfill domestic roles. Yet most of them led lives that would have seemed entirely comprehensible to their contemporaries. Few of these women, in fact, conform to the narrow and lifeless stereotypes we have inherited about 19th-century — "Victorian" — women, and their remarkably varied experiences pose interesting and important questions. Making sense of the gap between experience and ideology is the central problem we address in this book.

This collection of essays is the result of seven years of conversation, collaboration and friendship. When we first began to talk about such an endeavour as graduate students, it offered us a way of thinking and talking about women's history in the region. It also served as an escapist fantasy that took us to a time beyond the completion of our theses. It was fun, and it was one aspect of how we became feminist historians. Our original two-woman collaboration has since expanded to include scholars now living throughout the country, a number of whom have contributed essays to the collection. In an important way, history is always a collaborative process as we continually build upon or revise existing interpretations of evidence. But collaboration in the sense of working collectively toward a common goal is an important

tenet of feminist scholarship, and we believe that it has offered us a creative and fruitful approach to the history of 19th-century Maritime women.

Collaboration on this project began in earnest when the time came to choose a theme for the collection. This proved to be more difficult than we had anticipated; engaging in a collective or collaborative project highlighted our differences both as historians and as individuals. As historians we had examined quite different groups and time periods, and as individuals we had very different personal histories.

We did, however, share an interest in the impact of gender ideology on women's lives. In particular, we were interested in the ideology of separate spheres, which asserted the naturalness of assigning to women nurturing and submissive roles within the household and assigning to men active and dominant roles in the economy and politics. This seemed to offer potential as a unifying theme. But before we could agree that the separate spheres theme was a useful one, we first had to agree on just what separate spheres meant to the lives of 19th-century Maritime women and what it means to us as historians and as feminists in the 1990s. We have been able to agree that it was a powerful prescriptive ideology, elevated to the level of common sense during the industrial and bourgeois revolutions of the 19th century. It continues to have considerable power and resonance in women's and men's lives today.

But the ideology of separate spheres was neither a blueprint for the daily reality of 19th-century Maritime women nor the basis for a uniform women's culture or a universal sisterhood. Instead, it has had a powerful negative and constraining impact on women's lives. Women's use of the ideology has been a classic example of people trying to shape their own lives in conditions not of their own choosing. Until very recently the ideology of separate spheres was enshrined in law. It continues to have a powerful negative impact on women's economic opportunities, and its role in shaping ideas about female sexual respectability still influences social policy in the areas of welfare and violence against women. Statistics on what happens to Canadian women after divorce and on the poverty rates for Canadian children in female-headed households all owe a major debt to separate spheres. Historians obviously want to free themselves of the dichotomy between male and female, yet this division has been one of the central organizing concepts of western capitalist society. Indeed separate spheres ideology is more than an old intellectual debate because of the power it had and continues to have in shaping, defining and imposing order on real people's lives.

Rooted in the transformations of the bourgeois and industrial revolutions in 18th and 19th-century Europe and North America, separate spheres ideology has been closely associated with the formation of the middle class. Leonore Davidoff and Catherine Hall in *Family Fortunes*, their

influential interpretation of the formation of the middle class, argue that the middle class moved production out of the household without dissolving the household or family economy.[1] The division of labour asserted by separate spheres ideology was appropriate to middle-class families in the emerging industrial capitalist economy. Separate spheres has been a powerful cultural tool of middle-class hegemony, and the contribution of middle-class women to the acceptance and elaboration of the ideology has been an important part of garnering middle-class power and credibility. As such, it has also been used to discredit the experience and demands of the great majority of women who did not conform to the Euro-American, middle-class, heterosexual ideal.

But neither 19th-century England nor the Maritimes was characterized by uniform industrial development. The economy of the Maritime Provinces remained complex, varied, often struggling, but it was increasingly integrated into global trading patterns and influenced by the ideas which accompanied them. The relationship between conditions that foster the development of ideology, and the adoption of the same ideology in locations with differing conditions, is difficult to chart and well beyond the scope of this discussion. Still, it is clear that the way in which ideas travelled meant that gender ideology often acquired a cultural force of its own in women's lives under diverse conditions.

In the last 20 years feminist historians have tackled separate spheres from a variety of viewpoints, and in the midst of these debates we sometimes lose sight of the fact that it was not historians who invented the idea of separate spheres.[2] Initially viewed as constraining, separate spheres ideology was held

1 Leonore Davidoff and Catherine Hall, *Family Fortunes: Men and Women of the Middle Class* (London 1990).

2 Hewitt's article has been misinterpreted as a rejection of separate spheres ideology. We believe she urges caution and the acknowledgement of separate spheres as an ideology rather than its abandonment. Nancy Hewitt, "Beyond the Search for Sisterhood: American Women's History in the 1980s", *Social History*, 10, 3 (October 1985), pp. 299-322; Joy Parr, "Nature and Hierarchy: Reflections on Writing the History of Women and Children", *Atlantis*, 11, 1 (Fall 1985), pp. 39-44; Linda Kerber, "Separate Spheres, Female Worlds, Woman's Place: The Rhetoric of Women's History", *Journal of American History*, 75, 1 (June 1988), pp. 9-39; Mary P. Ryan, *Women in Public: Between Banners and Ballots, 1825-1880* (Baltimore, 1989); Alice Kessler-Harris, "Gender Ideology in Historical Reconstruction: A Case Study from the 1930s", *Gender and History*, 1, 1 (Spring 1989), pp. 31-49; Margaret Hobbs, "Rethinking Antifeminism in the 1930s: Gender Crisis or Workplace Justice? A Response to Alice Kessler-Harris", *Gender and History*, 5, 1 (Spring 1993) pp. 4-15; Alice Kessler-Harris, "Reply to Hobbs", *Gender and History*, 5,1 (Spring 1993), pp. 16-19; Susan M. Reverby and Dorothy O. Helly, "Introduction: Converging on History", in Reverby

accountable for limiting female participation in the mainstream of social and political life. This approach offered important insights into many power relationships, yet it obscured the ways in which some women used separate spheres ideology to claim moral and spiritual authority within the household and in the public domain. In response, revisionists argued that the separation of women in the domestic sphere nurtured a distinct women's culture that provided the basis for empowerment. Exaggerated claims were made that women's culture promoted a universal sense of sisterhood. This interpretation was based on the centrality of sexual difference and ignored women's class and race loyalties. A sense of sisterhood was, in fact, limited to very specific groups of women who were bound together by factors in addition to sex. Both interpretations were inadequate, however, as separate spheres ideology could be both empowering and constraining, bonding and fragmenting at the same time. Furthermore, separate spheres ideology not only described but also distorted the complexity of men's and women's relations.

Canadian women's historians, perhaps because of the influence of European scholarship and the insights of labour history, were less inclined to embrace separate spheres as the basis for a universal sisterhood than were their counterparts in the United States.[3] An awareness of a class-based gender experience preserved us from some of the excesses of the American identification of a singular or unified women's culture. As a result, we also have been less likely to reject it overtly. Certainly, separate spheres ideology continues most strongly in the work of Canadian historians of the middle class such as Wendy Mitchinson.[4] To some extent, however, its fall from fashion in the U.S. literature has been met with silence from Canadian counterparts. In a recent collection of essays edited by Franca Iacovetta and Mariana Valverde, for example, gender ideologies form a central theme in the introduction, yet there is rather conspicuously no mention of separate spheres.[5] In our view, to ignore separate spheres ideology because it is contradictory, frustrating or unsatisfactory means to avoid grappling with the agenda as set by the men and women of that time.

The historiography of Maritime women reflects many of the Canadian

and Helly, eds., *Gendered Domains: Rethinking Public and Private in Women's History: Essays from the Seventh Berkshire Conference on the History of Women* (Ithaca, N.Y., 1993).

3 Our thanks to Joan Sangster for this point.

4 Ramsay Cook and Wendy Mitchinson, eds., *The Proper Sphere: Women's Place in Canadian Society* (Toronto, 1976) and Wendy Mitchinson, *The Nature of their Bodies: Women and their Doctors in Victorian Canada* (Toronto, 1991).

5 Franca Iacovetta and Mariana Valverde, eds., *Gender Conflicts: New Essays in Women's History* (Toronto, 1992).

and international trends, but it also has its own unique features. The publication of this collection of essays reflects the exciting explosion of work in the region. An increasing number of historians are exploring new terrain and enlarging our understanding of the female past. In September 1992 the first scholarly conference on women in Atlantic Canada was held at Acadia University under the broad umbrella of the Thomas H. Raddall Symposium. Collectively, the papers presented to the symposium significantly increased our understanding of women's history and of women's role in creating regional culture.

Maritime women's history is solidly located in the renaissance of regional history that began in the 1970s. *Acadiensis*, the journal of the rebirth of scholarly research in the region, has kept a watchful eye on developments in the field.[6] In three review essays, *Acadiensis* provided a valuable resource in tracing the development of women's history in the region and the scholars who have nurtured and advanced it. The first, by Ruth Pierson, was published in 1977, and while it outlines a project barely begun it also reminds us of the valuable contribution of historians of women who were only temporary residents of the region. Historians such as Wendy Mitchinson, Tamara Hareven, Christina Simmons, Sylvia Van Kirk and Ruth Roach Pierson herself left their marks on regional history before out-migration.[7] Others such as Linda Kealey at Memorial University, Judith Fingard at Dalhousie and Margaret Conrad at Acadia have remained, and their influence has been felt through teaching and research.[8]

Margaret Conrad was the author of the second review, which appeared in 1983. It was appropriate that Conrad reported on the significant growth in the field of regional women's history, since she herself combined pioneering scholarship with missionary enthusiasm. Margaret Conrad has been a contributor to the development of feminist theory through her explorations of the role of time and place in women's history and has raised the profile of

6 Ruth Pierson, "Women's History: The State of the Art in Atlantic Canada", *Acadiensis*, VII, 1 (Autumn 1977), pp. 121-31; Margaret Conrad, "The Re-Birth of Canada's Past: a Decade of Women's History", *Acadiensis* XII, 2 (Spring 1983), pp. 140-62; Gail G. Campbell, "Canadian Women's History: A View from Atlantic Canada", *Acadiensis*, XX, 1 (Autumn 1990), pp. 184-99.

7 We would like to thank Judith Fingard for reminding us of the important contribution these historians made to the development of women's history in the Maritimes.

8 See Linda Kealey, ed., *Pursuing Equality: Historical Perspectives on Women in Newfoundland and Labrador* (St. John's, 1993); Judith Fingard, *The Dark Side of Life in Victorian Halifax* (Porter's Lake, N.S., 1989) and Margaret Conrad, Donna Smyth, Toni Laidlaw, eds., *No Place Like Home: The Diaries and Letters of Nova Scotia Women* (Halifax, 1988).

Maritime women's history nationally.[9] The publication of *No Place Like Home: The Diaries and Letters of Nova Scotia Women*, which she co-edited with Donna Smyth and Toni Laidlaw, was a major milestone in regional women's history.[10] The latest review essay, published in 1990, was written by Gail Campbell, whose important essay on women petitioners in New Brunswick is included in this volume. Her review helps us to understand why Veronica Strong-Boag and Anita Clair Fellman recently remarked on the relative ease of selecting "good readable material" on women in the Maritimes.[11] To an extent unprecedented in other regions of the country, a number of our male colleagues have been caught up in the energy and excitement of women's history and have begun to acknowledge the role of women and the importance of gender as a category of analysis in their own work.[12]

In the earliest stages of the renaissance in regional history, there was an emphasis on gender-blind political economy, which examined the roles of men in resource industries, industrial development and formal electoral politics. At a time when women's history was fighting for a place on the historical agenda in other parts of Canada, most progressive historians in the Maritimes were preoccupied with the question of underdevelopment. This approach adopted ways of seeing the region and its history in which gender did not

9 The inclusion of Margaret Conrad's work in Alison Prentice and Susan Mann Trofimenkoff, eds., *The Neglected Majority: Essays in Canadian Women's History, Vol. Two* (Toronto, 1985) and Veronica Strong-Boag and Anita Clair Fellman, eds., *Rethinking Canada: The Promise of Women's History* (Toronto, 1986) drew national attention to regional work.

10 Conrad *et al.*, eds., *No Place Like Home*.

11 Strong-Boag and Fellman, eds., *Rethinking Canada*, p. 5. This edition included Gail G. Campbell, "Disfranchised But Not Quiescent: Women Petitioners in New Brunswick in the mid-19th Century", pp. 81-96; Margaret Conrad, "'Sundays Always Make Me Think of Home': Time and Place in Canadian Women's History", pp. 97-112; and Christina Simmons, "'Helping the Poorer Sisters': The Women of the Jost Mission, Halifax, 1905-1945", pp. 286-307.

12 E.R. Forbes played a particularly important role in countering the then accepted interpretation of Maritime women as conservative. See Ernest Forbes, "Battles in Another War: Edith Archibald and the Halifax Feminist Movement" and "The Ideas of Carol Bacchi and the Suffragists of Halifax", in *Challenging the Regional Stereotype: Essays on the 20th Century Maritimes* (Fredericton, 1989); David Frank, "The Miner's Financier: Women in the Cape Breton Coal Towns, 1917", *Atlantis*, 8, 2 (Spring 1983); Colin Howell and Michael Smith, "Orthodox Medicine and the Health Reform Movement in the Maritimes, 1850-1885", *Acadiensis*, XVIII, 2 (Spring 1989), pp. 55-72; D.A. Muise, "The Industrial Context of Inequality: Female Participation in Nova Scotia's Paid Labour Force, 1871-1921", *Acadiensis*, XX, 2 (Spring 1991), pp. 3-31; John Reid, "The Education of Women at Mount Allison, 1854-1914", *Acadiensis*, XII, 2 (Spring 1983), pp. 3-33.

play a central role. Because women in the 19th century were denied full political citizenship, they seldom came into view in the debates surrounding Confederation. Women were not coal miners and were seldom participants in formal labour politics, and therefore economic and labour historians rarely treated them as direct actors in the great class upheavals in resource industries. This emphasis on the behaviour and activities of men compromised our understanding of the process of regional development as we accepted the male experience as normal and continued to define politics in the most narrow of terms. This trend is changing in response to the compelling work of scholars such as Martha MacDonald and Patricia Connelly, who have demonstrated that even so apparently masculine a bastion as the fishery cannot be understood until we address the important question of the role of gender.[13] We await reassessments of the Confederation debates, industrialization and Maritime Rights that take full cognizance of all the people involved, men and women alike.

Much remains to be done, and our knowledge of women's history in the Maritimes remains limited and spotty. As has been the case in other areas, late-19th and early-20th-century Anglo-Celtic, urban, heterosexual women have received attention that exaggerates their place in a predominantly rural and small-town society. The consequence of this bias in the literature has been that the important diversity of experience is obscured and complexity lost. We are happy that some of the essays in this collection not only expand our knowledge but also open up new areas of investigation. At the same time we regret that we have not included work dealing with the Acadian or native historical female experience, and it is our hope that work in these areas will continue.[14]

13 Patricia Connelly and Martha MacDonald, "Women's Work: Domestic and Wage Labour in a Nova Scotia Community", *Studies in Political Economy*, 10 (Winter 1983), pp. 45-72; Martha MacDonald, "Studying Maritime Women's Work: Underpaid, Unpaid, Invisible, Invaluable" in Phillip Buckner, ed., *Teaching Maritime Studies* (Fredericton, 1986), pp. 119-29; MacDonald and Connelly, "Class and Gender in Fishing Communities in Nova Scotia", *Studies in Political Economy*, 30 (August 1989), pp. 61-85; Nanciellen Sealey Davis, "Women's Work and Worth in an Acadian Maritime Village", in Naomi Black and Ann Baker Cottreel, eds., *Women and World Change: Equity Issues in Development* (Beverly Hills, 1981); Davis, "Acadian Women: Economic Development, Ethnicity and Status of Women" in Jean Elliot, ed., *Two Nations, Many Cultures in Canada* (Scarborough, 1979), pp. 123-135 and Joan McFarland, "Changing Modes of Social Control in a New Brunswick Fish Packing Town", *Studies in Political Economy*, 4 (Autumn 1980), pp. 99-113.

14 Work which acknowledges the diversity includes Ginette Lafleur, "L'industrialisation et le travail rémunéré des femmes, Moncton, 1881-91" in *Feminist Research: Prospect and Retrospect/Recherche Feministe: Bilan et Perspectives d'Avenir* (Kingston, for the

These essays reflect themes and approaches currently being addressed by historians inside and outside Canada, while remaining firmly anchored in the lives of Maritime women. The experiences of Maritimers, perhaps like the women we study here, have too often been treated as exceptional and outside the Canadian historical mainstream. This collection builds on a literature that continues to "challenge the regional stereotype".[15]

As feminist historians working in the field of Maritime history, we have been concerned with the exclusion of the region from national debates, and we feel that it is important to help our readers understand the context of Maritime women's history. The 19th century was a time of change, and change was an important theme in the experience of all Maritimers. But it was a period of change without continuous growth. The Maritime economy in the 19th century was influenced by international trends. The dismantling of tariff protection for British colonies in the 1830s and 1840s caused serious dislocation. In response, a continental orientation was pursued through free trade with the United States between 1854 and 1866, and then with Confederation and the National Policy. The Maritimes were wracked by international depressions in the 1830s and the 1870s and by frequent more localized recessions. In spite of the new continental orientation, the Maritimes continued to rely on the production and export of staples, the carrying trade and imperial spending. As a result, two overlapping economies emerged within the region. One economy was based on export-oriented staples production, the other on industrial production for the domestic market. Both economies were linked by railway-building and the development of Nova Scotia and New Brunswick coal resources.

The political landscape of the Maritimes underwent great change in the period from 1830 to the mid-1860s as the expansion of both colonial self-government and the male franchise limited female access to the emerging formal political arena. The creation of a national polity with the Confederation of Nova Scotia and New Brunswick with the Canadas in 1867, and Prince Edward Island in 1873, further altered the axis of power within Ma-

Canadian Research Institute for the Advancement of Women, 1988), pp. 127-40; Isabel Knockwood, *Out of the Depths: The Experience of the Mi'kmaw Children at the Indian Residential School at Shubenacadie, Nova Scotia* (Lockeport, N.S., 1992); Johanna Brand, *The Life and Death of Anna Mae Aquash* (Toronto, 1993).

15 Forbes, *Challenging the Regional Stereotype*; see also E.R. Forbes and D.A. Muise, eds., *The Atlantic Provinces in Confederation* (Toronto/Fredericton, 1993); P.A. Buckner and John G. Reid, eds., *The Atlantic Region to Confederation: A History* (Toronto/Fredericton, 1994).

ritime society. The political framework was complemented by the National Policy of 1879, which consolidated the foundation of an integrated national and industrial economy. Political questions remained unresolved as many Maritime men continued to express ambivalence towards political change through participation in "better terms" and repeal agitations.

The building of railways in Nova Scotia and New Brunswick, and later in Prince Edward Island, also reflected state formation. Economic infrastructure was accompanied by other state institutions. By Confederation, all three colonies had created systems of tax-supported, government-administered public schools. While schools and prisons were the sole jurisdiction of the state, other specialized institutions, such as orphanages, hospitals, asylums and reformatories, were co-founded and co-operated by government and voluntary charitable organizations.

Social organization was shaped not only by political and economic changes within the region, but also by a distinct pattern of European settlement. One legacy of 17th-century colonization was the Acadian people, who returned to the region after their expulsion. Large-scale European settlement occurred in the late 18th and early 19th centuries, with immigration primarily from the British Isles and the United States. Men and women of African descent composed one important component of the American immigrants, and their numbers were augmented by West Indian newcomers. Regional settlement came to a virtual stop by the middle of the 19th century, resulting in the entrenchment of distinct ethnic and religious enclaves. Economic struggle and hardship, rural and ethnic inequality and poverty, combined with the limited ability of regional cities to absorb the rural poor, produced very high rates of out-migration in the second half of the century.

Inequality within Maritime society was also evident in class formation. On the one hand there was the development of an increasingly militant working class, most often associated with the large work force of the mines. On the other hand there was the Protestant and Roman Catholic middle class, which emulated middle-class social patterns in Great Britain and the northeast United States. Although this was especially noticeable in the cities, the rural middle class also consolidated influence and wealth, thereby exacerbating rural inequality.

The final dimension of social organization was gender ideology, particularly around separate spheres, which returns us to the central theme of this collection. Maternal feminism — an important, and perhaps the best-known, expression of this gender ideology — led groups of women in the region to demand the prohibition of alcohol, access to higher education and professional employment, and the right to vote for municipal, provincial and

federal governments.[16] The arguments of the maternal feminists help us to understand the ways in which people can change and adapt gender ideology to suit new needs and new purposes.

The essays in this collection are arranged chronologically rather than thematically. Determining the organization was a difficult process, in part because so many of the essays share important areas of overlap in both theme and subject. The investigation of women's involvement in paid work unites more than half of the essays, and the role of family relationships in women's lives is important to all of them. While the essays do not provide a sustained or complete narrative of the history of Maritime women over the course of the 19th century, they do introduce the reader to many of the key elements of their history, and the chronological organization assists the reader in developing a sense of the changes over time.[17] All of the essays look at dimensions of separate spheres ideology in the region.

In Rusty Bittermann's path-breaking treatment of Prince Edward Island women in the Escheat movement in the 1830s, we see how the active involvement of rural women in informal politics was followed by their exclusion from the formal arena of electoral politics. With the expansion of the male franchise, electoral politics played a more and more important role in the political culture of Prince Edward Island, the region and the country.

Gail Campbell's essay about New Brunswick women who petitioned their provincial government in the 1840s and 1850s is important in its own right and is an excellent companion to Bittermann's. Campbell persuasively argues that disfranchisement and a gender ideology which denied women a role in electoral politics were not able to eliminate the participation of women in the political culture of their society. Women petitioned for personal economic compensation, for improvements in local infrastructure and for legislation designed to promote social improvement, all subjects theoretically the preserve of men.

Law and religion have served as two of the most important pillars of patriarchy in our culture. Philip Girard and Rebecca Veinott's essay on the

16 Valuable studies of maternal feminism are available. See Linda Kealey, ed., *A Not Unreasonable Claim: Women and Reform in Canada, 1880s-1920s* (Toronto, 1979); Rebecca Veinott, "A Call to Mother: The Halifax Local Council of Women, 1910-1921", Honours essay, Dalhousie University, 1985; Simmons, "Helping the Poorer Sisters"; Forbes, "Battles in Another War"; Mary Ellen Clarke, "The Saint John Women's Enfranchisement Association, 1894-1919", M.A. thesis, University of New Brunswick, 1980.

17 For a narrative account of Canadian women's history which includes some material on women in the Maritimes, see Alison Prentice *et al.*, *Canadian Women: A History* (Toronto, 1988).

changes in married women's property law in Nova Scotia explores the codification of the separate spheres ideology. It demonstrates a concrete instance of the impact of the ideology on women, the centrality of the institution of marriage and the leadership of the father in the family. Separate spheres ideology only has meaning and use in a society that institutionalizes the heterosexual family as the norm.

In her study of Methodist women in St. Stephen, New Brunswick, Hannah Lane reveals that while women played crucial roles in church development and built their identities around their piety, church involvement also provided opportunities for leadership and female preaching. Religion was women's proper sphere, and therefore provided opportunity and a rationale for transcending and extending the accepted roles of women. Despite the centrality of Christianity in shaping the world view of so many 19th-century Maritimers, we still have much to learn about the relationship between women and religion.

Janet Guildford exposes ambiguities in separate spheres ideology in her examination of Nova Scotia women teachers and their struggle with and against their male colleagues and supervisors to improve their conditions of work and their professional status. To justify their presence in a public role, these women resorted to linking the character of public school teaching to the duties they had performed in the home. They then had no basis for collective cause with men in demanding improved wages and working conditions. In response, female teachers employed the rhetoric of separate spheres to demand improvements.

Bonnie Huskins' original paper on the role of women in public celebrations in Saint John, New Brunswick adds to the complexity of our understanding of separate spheres ideology and allows us to examine change over time. Huskins reminds us that part of the effort to exclude women from a public role was connected to the desire to regulate female sexuality. Her essay also demonstrates the value of exploring the ways in which women were publicly represented in the parades and celebrations which symbolized the social order as a way of understanding how 19th-century Maritimers understood and represented gender ideology.

Like Guildford, Sharon Myers emphasizes that although women were supposedly protected from the paid labour force by separate spheres ideology, many women did work for wages. Although female paid labour frequently took place outside the home, even when it was factory work this labour was often an extension of the productive activities women had performed in the home, such as the preparation of food or the making of clothing. Working class women were important participants in the often unsettling economic and social changes associated with industrialization. Myers also exposes the

class divisions among women through an examination of the relationship between middle class reformers and working class women.

Separate spheres ideology does not provide a description of the lives of African-Nova Scotian women in Halifax County or the women who used the services of the Society for the Prevention of Cruelty (SPC), yet the rhetoric was certainly employed when it was perceived to be of use to these women. In the case of African-Nova Scotian women, Suzanne Morton argues that separate spheres ideology supported the constraints and oppression of racism to limit economic opportunities and rewards for women of African descent, while at the same time it offered an ideological basis for demands of justice and protection. In Judith Fingard's article on domestic abuse and the Halifax SPC, women were more likely to seek redress and outside support when men violated their breadwinner role than when they were physically abusive. Like teachers and African-Nova Scotian women, these women couched their claims for redress in terms of the protection patriarchal society apparently promised to women under the terms of the separate spheres ideology.

In the final essay in the collection, Gwendolyn Davies directs our attention to the literary women who explicitly challenged and renegotiated the meanings of the separate spheres ideology through their writing. Building on a tradition of subverting the confines of the domestic sphere by the act of writing, the literary "New Women" of the Maritimes in the 1880s and 1890s used fiction, poetry and articles in the local press to give voice to their concerns about social justice and the limiting expectations of women's proper sphere. Although their voices became more muted with the turn to maternal feminism in the 1890s, their efforts to expand the social, economic and intellectual opportunities for women provide a stimulating conclusion to our exploration of the impact of the separate spheres gender ideology on Maritime women.

The paradoxes within separate spheres ideology and the tensions generated by its use as a prescriptive ideal, a hegemonic doctrine and an historiographic debate can only be understood by looking at the lives of actual women. Its lack of descriptive consistency did not undermine its potency as an ideology that assigned women to the private sphere and constrained and oppressed all women across class, race and age. Simultaneously, however, middle-class and working-class women selectively used separate spheres ideology to negotiate power in the home and to make claims in public based on a respectability rooted in domesticity. The pervasiveness and tenacity of the separate spheres ideology is explained by the fact that it had something to offer nearly everyone and by the ways in which the gender division of labour served capitalism. Although the ideology is based on the centrality of sexual difference,

it could not provide the basis for a generalized sex-consciousness or sense of sisterhood as it failed to recognize differences within the category of woman. Maritime women had strong loyalties and identities other than those based on sex, and separate spheres ideology did not provide the strategies needed to transcend the realities of class, age, residency, religion, sexual orientation and race.

WOMEN AND THE ESCHEAT MOVEMENT
The Politics of Everyday Life on Prince Edward Island

RUSTY BITTERMANN

In September of 1833, Constable Donald McVarish, acting on behalf of Flora Townshend, the resident owner of an estate in eastern Prince Edward Island, made his way to her property with a bundle of papers in hand. These were warrants of distress, legal documents which permitted Townshend to seize the goods of her tenants for back rents which she claimed were due. It was not to be a pleasant day for McVarish. Rents were going unpaid, as always, because tenants found it difficult to meet these costs, but growing militant resistance to the entire structure of landlordism made rent resistance a political act, too. In the wake of political initiatives begun earlier in the decade, the dream of an escheat was the talk of the countryside. Members of the House of Assembly and the rural population alike were discussing the legitimacy of proprietorial claims to the colony's land and arguing that because landlords had never fulfilled the settlement obligations of the original grants of 1767 they did not in fact have valid deeds; their grants had reverted to the Crown by default. Establishment of a court of escheat, it was contended, would expose the fraudulence of landlords' claims on the Island's tenantry and permit them to gain title to the farms they had made productive. McVarish, acting for the landlords, could no longer count on deference to law officers in the rural regions in the fall of 1833. Believing that the existing land system was fundamentally flawed because the titles that supported it were invalid, rural residents balked at complying with the laws pertaining to rents.

McVarish's mission to the Naufrage region of northern Kings County took him into a region that was known for the strength of its anti-landlord sentiments — arguably, the heartland of agrarian radicalism on the Island. William Cooper, the leading advocate of the idea of an escheat, had propounded his ideas on the flaws of proprietorial title and the rights of tenants in Kings County during the general election of 1830 and then again in a by-election in 1831. The support he received ultimately permitted him to promote these ideas from the House of Assembly. The enthusiastic response from country people in Kings County and elsewhere, expressed in public meetings, petitions and rent resistance, marked the beginning of what came to be known as the Escheat movement. The loaded pistol that McVarish had tucked in his pocket before leaving home probably reflected his understanding of rural sentiments in the region, as did his attempts to hide his mission

from those he met and his decision to sometimes travel through fields rather than on the road. McVarish's precautions notwithstanding, he was seen and confronted by a cluster of the tenants for whom his warrants were intended. Hard words were spoken and McVarish drew his pistol. He was, nonetheless, knocked to the ground, disarmed and conveyed to the main road. Having promised he would never return, he was released and helped on his way with a blow from a board.[1]

The person wielding the board was Isabella MacDonald, then well advanced in a pregnancy. Judging from testimony from a subsequent trial, Isabella was the most vociferous party in the altercation. McVarish claimed that the three male and two female tenants who confronted him "were all alike active and threatening", but when he pulled his pistol he aimed it at Isabella. It would seem that he perceived her as the most violent of the group. This move allowed men who were not receiving McVarish's primary attention to pull him down from behind and disarm him, in turn exposing him to Isabella's wrath. Her blow with the board was the only gratuitous violence McVarish received. Perhaps she was settling scores for his aiming his pistol at her, perhaps fulfilling the promise of violence which had prompted McVarish's move in the first place.

McVarish's discomfiture at the hands of Isabella and her companions was not an isolated incident. It cannot be explained simply as the act of a particularly forceful female tenant, a matter of personality. Again and again over the course of the Escheat movement, women assumed prominent roles in physically resisting the enforcement of landlords' claims in the countryside. This paper examines these women's behaviour and argues that the modes of resistance they employed had roots in, and were extensions of, the conditions of their daily lives. To discern this, however, it is necessary to move away from the image of rural women most commonly found in North American literature on the pre-industrial countryside. The conception of the rural woman's sphere that dominates this literature draws too heavily from middle-class experiences and sentiments and does not provide an appropriate starting place for understanding the actions of women such as Isabella MacDonald. Attentiveness to the early-19th-century perceptions that gave birth to these pervasive images may, however, help us to better understand the roles rural women assumed in violent confrontations. Upper-class beliefs

1 Minutes of Naufrage Trial, Colonial Office Records [CO] 226, vol. 52, pp. 91-4, Public Record Office, Great Britain [microfilm copies in Harriet Irving Library, University of New Brunswick]. I would like to gratefully acknowledge the assistance of the Social Sciences and Humanities Research Council of Canada, whose financial support aided this research. Many thanks are due as well to Margaret McCallum for her comments on an earlier version of this paper.

concerning women's sphere shaped the context in which Escheat activism unfolded. Being perceived as the weaker sex and the guardians of domesticity may have permitted women more latitude than men in their use of violence.

While it is important to recognize the significant part that women played in direct action, their participation in this form of popular politics needs to be set in the broader context of the Escheat struggle of the 1830s and early 1840s and the political changes which were occurring during this period. Direct action was not Escheat's main focus. The Escheat challenge was primarily grounded in the development of a new mass politics in the formal political arena. Formal politics, unlike community-level direct action, excluded women. To examine the role of women in the Escheat movement is to be reminded that the changes associated with the rise of bourgeois democracy included the decline of an older popular politics which once afforded women a substantial place.

Direct resistance to the claims of landlords, the area of Escheat activism in which women were most prominent, occurred in two forms. There were household-level defences, such as that Isabella MacDonald engaged in, and there was larger community-organized resistance. Women were active at both levels. In the first, the members of a single household, or perhaps adjoining households, responded defensively to the arrival of law officers. When officials attempted to serve legal papers, remove possessions or arrest members of the household, those directly involved resisted. Women took part in such protective actions on their own and in the company of men. Catherine Renahau and her husband John acted together to resist the enforcement of their landlord's claims against their premises in southern Kings County in the spring of 1834. In this case, the wife and the husband were both indicted and found guilty of assaulting and wounding the constable who had arrived at their door.[2] The actions of Mrs. McLeod and her husband Hugh fit the same pattern. When a constable and a sheriff's bailiff came to seize their cattle in the summer of 1839, Mrs. MacLeod took up a pike and Hugh an axe. Together they rebuffed the law officers. When a posse was subsequently sent to arrest the two, the entire family took a hand in attempting to prevent the high sheriff and his deputies from invading their house.[3] Charges laid against Mary and Margaret Campbell for assaulting constable William Duncan in 1834 provide some evidence that women also acted without men in farm-level defences.[4]

2 *Royal Gazette* (Charlottetown), 24 June 1834, p. 3; Supreme Court Minutes, 25 June 1834; Indictments, 1834, RG 6, Public Archives of Prince Edward Island [PAPEI].
3 *Royal Gazette*, 23 July 1839, p. 3.
4 *Royal Gazette*, 16 December 1834, p. 3

In addition to these sorts of spontaneous farm-level defences, tenants were involved in more broadly organized actions aimed at securing entire communities or regions from the enforcement of landlords' claims. Women figured prominently in many of these actions. Attempts to arrest the five tenants charged with repelling McVarish provoked two major community-level confrontations. In the spring of 1834, a posse was dispatched from Charlottetown to Naufrage to arrest the miscreants. They were turned back at the Naufrage bridge by a crowd, said to include "a large number of women", which had assembled in anticipation of their arrival.[5] Armed with muskets, pikes and pitchforks, the assembly informed the deputy sheriff that they were prepared to fight and die before they would permit him to arrest the five tenants he sought. When yet another posse led by the sheriff himself attempted a similar mission the following year, women were said to make up more than one-third of the armed crowd that waited for the posse in the pre-dawn darkness and again blocked the sheriff.[6]

Women were active as well in a series of major community-level confrontations in the fall and winter of 1837-38 that, with the mass meetings being held in support of Escheat, prompted some observers to believe that the Island, like the Canadas, was on the verge of civil war. The first of these confrontations concerning land title was on Thomas Sorell's estate in northern Kings County. In September 1837, when the sheriff and his deputies attempted to enforce court orders Sorell had obtained against John Robertson, a long-time resident on the estate, they were repulsed by a crowd wielding sticks and throwing stones. As well, one ear was removed from each of the law officers' horses, which had been left at a distance from the farm.[7] Women were part of the crowd that blocked the sheriff, and they were reputed to be the primary actors in the violence.[8] Later that winter, women made up part of an armed party which assembled near Wood Islands to repel people whom they believed to be law officers initiating rent actions in that district. In a case of mistaken identity, shots were fired over the head of the rector of Charlottetown and his elite friends, who were on a baptismal mission on behalf of a spiritual lord rather than a rental mission on behalf of a secular one.[9] While the actions of the tenant group were misdirected, they

5 *Royal Gazette*, 17 June 1834, p. 3.
6 *Royal Gazette*, 6 January 1835, p. 3; "Council Minutes", 7 January 1835, CO 226, vol. 52, pp. 330-2.
7 Executive Council Minutes, 5 September 1837, RG 5, PAPEI; *Royal Gazette*, 5 September 1837, p. 3.
8 Hodgson to Owen, 30 September 1837, MS 3744, vol. 26, PAPEI.
9 George R. Young, *A Statement of the "Escheat Question" in the Island of Prince Edward: Together with the Causes of the Late Agitation and the Remedies Proposed*

nonetheless served notice that those who might attempt to enforce rent collection in the region were not welcome. On the Selkirk estate the following month, women again were active in co-ordinated crowd actions which blocked the enforcement of rental claims. In several locales, bailiffs attempting to seize farm goods were confronted by tenants armed with pitchforks and sticks. Men and women alike took a hand in resisting the seizure of goods and driving law officers from the communities they had attempted to enter.[10] The cumulative effect of these actions was, for a time, to bring the enforcement of rental payments to a halt across much of the Island and to force the government to consider whether it was willing to hazard deploying troops — then in short supply due to the demands made by the risings in the Canadas — in order to uphold the claims of the Island's landlords.

That rural women would be active in household defences and collective action of this sort would come as no surprise to the student of Old World popular protest. In locations on the eastern side of the Atlantic, a rich array of research has pointed to the importance of women in protest actions and has suggested ways of understanding this activity in terms of their everyday lives.[11] The evidence of female involvement in the popular resistance associ-

(London 1838) p. 2; "One of the Party" to the editor, *Colonial Herald* (Charlotte-town), 27 June 1838, p. 3; "O.P.Q." to the editor, *Colonial Herald*, 23 January 1841, p. 3; "Plain Common Sense" to the editor, *Colonial Herald*, 6 February 1841, pp. 2-3; John Myrie Hall to the editor, *Colonial Herald*, 20 February 1841, p. 2; "The only clergyman resident within the bounds of the district" to the editor, *Colonial Herald*, 20 March 1841, p. 3; Charles Stewart and W.P. Grossard to the editor, *Colonial Herald*, 27 March 1841, p. 3.

10 Statement of Angus McPhee, George Farmer and Robert Bell, 27 February 1838, CO 226, vol. 55, pp. 176-80.

11 John Bohstedt, "Gender, Household and Community Politics: Women in English Riots, 1790-1810", *Past and Present*, 120 (August 1988), pp. 88-122; Rudolf Dekker, "Women in Revolt: Collective Protest and its Social Setting in Holland in the Seventeenth and Eighteenth Centuries", *Theory and Society*, 16 (1987), pp. 337-62; E.P. Thompson, "The Moral Economy of the English Crowd in the Eighteenth Century", *Past and Present*, 50 (1971), pp. 76-136; George Rudé, *The Crowd in the French Revolution* (Oxford, 1959); George Rudé, *The Crowd in History: A Study of Popular Disturbances in France and England, 1730-1848* (London, 1964); Olwen Hufton, "Women in Revolution", *Past and Present*, 53 (1971), pp. 90-108; John Stevenson and Roland Quinault, eds., "Food Riots in England, 1792-1818", in *Popular Protest and Public Order: Six Studies in British History, 1790-1920* (London, 1974), pp. 33-74; Natalie Zemon Davis, *Society and Culture in Early Modern France* (Stanford, 1975), pp. 124-87; Kenneth J. Logue, *Popular Disturbances in Scotland, 1780-1815* (Edinburgh, 1979); Malcolm I. Thomas and Jennifer Grimmet, *Women in Protest 1800-1850* (London, 1982). A useful Canadian extension of this rich literature is Terence Crowley, "'Thunder Gusts': Popular Disturbances in Early French Canada", in Michael Cross and Gregory Kealey, eds. *Readings in Canadian Social History*, vol. 1, *Economy and*

ated with the Escheat movement fits less easily within North American historiography and its portrayal of rural women. To be sure, the literature is broad and varied and blanket descriptions are misleading. Nonetheless, what emerges again and again in North American descriptions of women in northern pre-industrial rural settings is the image of the farm woman as nurturing caretaker of the domestic sphere. Though her work was tiring and she was often incessantly busy, hers was an existence bounded by walls and sheltered from the coarser aspects of life. Women looked after the household and, perhaps, the adjacent garden and barns, while the men tended to rough work and public affairs.

In his late-19th-century reminiscences on rural life in Ontario in the first half of the century, Canniff Haight drew the common distinctions: "The farmer was a strong, hardy man, the wife a ruddy cheerful body, careful of the comforts of her household".[12] Male muscularity was applied to the exterior world, female gentleness and diligence to the interior: "While the work was being pushed outside with vigour, it did not stand still inside. The thrifty housewife was always busy".[13] "The work" was of course male. The division is clear as well in Robert Leslie Jones' characterization of farm life on the Upper Canadian frontier. While the man of the house "split rails, built worm fences, and erected his log cabin", his wife attended to "various household industries, ranging from spinning and sometimes weaving, to the preservation of fruits by drying, and the making of butter and cheese".[14] Or in a recent version of the theme as played out in Lower Canada: Féllicité tended to "feeding, washing, and cleaning the family, its clothes, and its house" as well as "milking the cows, making butter, and feeding the fowls". Théophile ploughed, "erected fences around the fields", and saw to "repairs to house, barn and equipment".[15] "Women's work", Christopher Clark has argued in the case of pre-industrial rural New England, "remained separate, functionally distinct from men's". "In addition to cooking, cleaning, and looking after children, women undertook the myriad tasks associated with preserving food, making and mending clothing, and keeping up their houses".[16] Or, as a

Society During the French Regime (Toronto, 1983), pp. 122-51.

12 Canniff Haight, *Country Life in Canada Fifty Years Ago: Personal Recollections and Reminiscences of a Sexagenarian* (1885; rpt. Belleville, Ont., 1971), p. 86.
13 Haight, *Country Life in Canada*, p. 46.
14 Robert Leslie Jones, *History of Agriculture in Ontario, 1613-1880* (1946; rpt. Toronto, 1977), pp. 20-1.
15 Graeme Wynn, "On the Margins of Empire", in Craig Brown, ed., *The Illustrated History of Canada* (Toronto, 1987), p. 247.
16 Christopher Clark, *The Roots of Rural Capitalism: Western Massachusetts, 1780-1860* (Ithaca, N.Y., 1990), p. 274.

recent textbook of Canadian women's history has it, farm women "scrubbed clothes on scrub boards (if they were lucky enough to have one), hauled water from the creek or the well, cooked on wood stoves, and made most of the family clothes. In addition they grew vegetables, gathered fruit, preserved and baked, and looked after their children".[17]

No doubt many "ruddy" farm women did spend their days tending to berries, butter, bread and babies in 18th- and 19th-century North America and, no doubt, there were many households where prosperity and culture blended to create the domestic feminine sphere that is described in so much of the literature.[18] The scholarship that has given rise to this image is not incorrect. But in the absence of more nuanced studies of the experiences of women in rural settings, it has sustained misleading impressions. A vision of country life rooted in the experiences of relatively prosperous, well-established households and heavily grounded in mid-19th- century circumstances has, often enough, come to stand as a general portrait of the pre-industrial rural world. Thus, our view of the rural past tends to be too uniform and too rosy.[19] One might profitably explore the reasons for the dominance of this image and its significance to broader myths concerning rural life and North American exceptionalism. For comprehending the actions of women within the Escheat movement, the immediate problem is finding a more appropriate starting place for explaining how Mrs. MacLeod came to pick up a pike, Isabella MacDonald a board and other country women to join in the armed

17 Alison Prentice *et al.*, *Canadian Women: A History* (Toronto, 1988), p. 116. See also pp. 76, 79, 83.

18 Hal Barron's call for the study of the extent, and timing, of the spread of the bourgeois ideals of the cult of domesticity among "the less affluent and less 'enlightened' strata of rural society" usefully indicates a single facet of a broader challenge, that of disaggregating and more closely examining rural experiences and rural change. John Faragher's critique of stereotypes in the writing of rural women's history, and call for moving beyond these, is to the point as well. Hal Barron, "Listening to the Silent Majority: Change and Continuity in the Nineteenth-Century Rural North", in Lou Ferleger, ed., *Agriculture and National Development: Views on the Nineteenth Century* (Ames, Ia., 1990), p. 16; John Mack Faragher, "History From the Inside-out: Writing the History of Women in Rural America", *American Quarterly*, 33 (1981), pp. 537-57.

19 There are, of course, exceptions to this characterization. Marjorie Griffin Cohen, for instance, notes that farm women in early-19th-century Ontario frequently performed "men's work", though she tends to treat this as a temporary frontier phenomenon. *Women's Work, Markets, and Economic Development in Nineteenth Century Ontario* (Toronto, 1988), pp. 69-71. As well, it is not unusual for contradictory evidence to be integrated with a more idyllic picture of the countrywoman's sphere. See, for instance, The Clio Collective, Roger Gannon and Rosalind Gill, trans., *Quebec Women: A History* (Toronto, 1987), p. 89.

groups organized to repulse law officers in Naufrage, Wood Islands and else-
where about Prince Edward Island in the 1830s. While some of these women
no doubt tended to the domestic duties that have been assigned to the fe-
minine sphere of rural life, there is much that these sorts of descriptions leave
out, matters that go a long way toward helping us to understand how women
came to participate as they did in the Escheat movement.

For most country women in Prince Edward Island in the early 19th cen-
tury, life was much rougher and the bounds of work much broader than the
prevailing images suggest. Indeed, for the rural poor, of whom there were
many, the notion of a distinct feminine sphere could not have had much
meaning. While there was work that was exclusively female, even in poorer
households — having babies, early child care and so on — it is less clear that
there was much work about the farm that women could avoid because it was
securely outside their domain. In many rural households, particularly the
poorer ones, the men were away for extensive periods earning wages in the
woods, shipyards and other sites where farm income might be supplemented.[20]
Of necessity, then, women's work expanded beyond the women's sphere that
is described in much of the literature. In such households, women often as-
sumed the dominant role in maintaining the farm.[21] In farm households
where life was lived on the margin, even when men were present, women
often participated in heavy tasks such as clearing, planting and harvesting. In
his early-19th-century observations on life in Prince Edward Island, Walter
Johnstone spoke disparagingly of rural women from comfortable back-
grounds who were "unable and unwilling to take the hoe, and assist their
husbands in planting the seed, and raising the crop".[22] To make a go of it in
the New World, immigrant women needed to apply themselves to the hard
outdoor tasks of farm-making. Land-clearing work, which Johnstone de-
scribed as being "the most dirty and disagreeable" and "tiresome as any I
have seen in America", was shared by the entire family, women and men
alike.[23] Similar observations of women's roles in the hard task of farm-mak-
ing are found in the works of John MacGregor and George Patterson, who

20 Rusty Bittermann, "Farm Households and Wage Labour in the Northeastern Ma-
 ritimes in the Early 19th Century", *Labour/Le Travail*, 31 (Spring 1993), pp. 13-45.
21 When a Cape Breton farmer noted in the coal boom of 1871 that "farmers and their
 sons by hundreds, nay, thousands, [were] leaving their farms to the women, and seek-
 ing employment at the collieries and railways", he was describing the efflorescence of
 an older pattern. *Journal of Agriculture for Nova Scotia*, July 1871, p. 652.
22 Walter Johnstone, *A Series of Letters, Descriptive of Prince Edward Island* (1822) re-
 printed in D.C. Harvey, ed., *Journeys to the Island of St. John* (Toronto, 1955), p. 143.
23 Johnstone, *A Series of Letters*, p. 108.

commented as well on women's part in the subsequent tasks of planting and harvesting.[24] Women, MacGregor observed, "assist in the labours of the farm during seed-time, hay-making, and harvest".[25] Getting the crops in, Johnstone noted, was the work of the entire household — "man, wife, children, and all that can handle a hoe, must work, as the season is short" — and disaster loomed for the poor if the crops were not successful.[26] It is not surprising then that Island evidence from the 1832 murder trial of Martin Doyle indicates that Martin and his wife were working side by side among the charred stumps of their field on the day that Martin was said to have shot his brother.[27] From the scattered evidence that is available concerning women's work, such was a common pattern of rural life.

The dominant image of the daily lives of rural women is inadequate not only because women's work could be much broader than it depicts, but also because the domestic sphere of work was often much narrower, too. Again and again the existing literature emphasizes the long hours that women spent cleaning house, washing clothes, preparing meals and spinning and weaving. No doubt long hours were spent in this work by those who possessed frame houses and ample wardrobes, ate a varied diet, kept sheep and had spinning wheels and looms. We need to recognize, though, that many did not. In the Maritimes of the early 19th century, this picture of the woman's sphere pertains to the rural middle class and does not reflect the circumstances of the whole of the rural population. Indeed, for many, the physical requirements for the woman's separate sphere — multi-roomed house, kitchen and pantry, area for textile manufacture, adjoining dairy and poultry shelters — quite simply did not exist. It did not take long to clean a one-room dwelling, assuming that this was even an objective, nor did cooking and washing absorb a day's labour when household members ate boiled potatoes and oatmeal and possessed little clothing beyond what they were wearing. We need not paint the picture this starkly, however, no matter how real it was for many, to point out that much of the existing view of the rural woman's sphere assumes material circumstances that were far more comfortable than those of much of the rural population.

As well, we must re-examine the notions of domesticity and of lives sheltered from the rough and tumble of the public world, which are commonly associated with characterizations of the pre-industrial North American farm

24 John MacGregor, *British America* (Edinburgh, 1832), p. 329; George Patterson, *A History of the County of Pictou Nova Scotia* (1877; rpt. Belleville, Ont., 1972), p. 223.
25 MacGregor, *British America*, p. 346.
26 Walter Johnstone, *A Series of Letters*, p. 109.
27 *Royal Gazette*, 28 February 1832, p. 1.

woman, if we are to understand the behaviour of the women who were in-
volved in direct action during the Escheat movement. In part because many
Island women did engage in outdoor farm labour, they, like men, became in-
volved in physical disputes over resources and household relations. Margaret
Taylor and Jane Maclachlan fought it out with fence pickets and fists in the
spring of 1830 when they differed over ownership of a piece of ground.[28] A
similar physical dispute over land and fencing brought Catherine McCor-
mack and Alexander Macdonald before a court later that year.[29] The same
court session that heard the Taylor/Maclachlan case also heard the case of
Elizabeth Cahill and Margaret Shea, whose personal differences had moved
to the level of heaving stones.[30] As with women's work, evidence bearing on
women's use of violence, or the threat of violence, in the public realm is fugi-
tive.[31]

Certainly what emerges in the court record is but a fraction of a broader
phenomenon. What percentage of the disputes where women picked up a
stick or a stone or brandished their fists ultimately ended up before a judge
or a justice of the peace? And what percentage of these disputes is preserved
in the incomplete legal record?

In addition to engaging in direct violence, Island women were also re-
peatedly cited for resorting to maiming animals.[32] In this traditional form of
rural retribution, livestock received the violence directed toward their
owners. Vengeance was taken, or a threat communicated, by hamstringing,
slashing or otherwise mutilating the animals of an enemy.[33] There was noth-
ing unusual in the methods used against the horses of law officers who came
to Robertson's farm in the fall of 1837; they were employed against the
mounts of law officers on many other occasions. Animal-maiming, by women
and men, was not uncommon in intra-household disputes.

Women's participation in violent actions was not an unusual feature of
the Escheat movement, nor was the targeting of law officers. Consider, for
instance, the 1836 rescue of Rose Hughes from a constable's custody. Ar-
rested near Fort Augustus in the late fall of 1836 for obtaining goods under
false pretences, she was forcibly released when the arresting constable, Angus

28 *Prince Edward Island Register* (Charlottetown), 15 June 1830, p. 3.
29 *Royal Gazette*, 13 July 1830, p. 3.
30 *Prince Edward Island Register*, 15 June 1830, p. 3.
31 See also the case of Mary Prendergast v. Ellen Prendergast, *Royal Gazette*, 3 January
 1837, p. 3; and Isabella Stewart v. Edward Wilson, *Royal Gazette*, 13 July 1830, p. 3.
32 *Royal Gazette*, 21 January 1834, p. 3; 22 September 1835, p. 3; 7 July 1840, p. 3.
33 For a good discussion of the tactic see John E. Archer, "'A Fiendish Outrage'?: A
 Study of Animal Maiming in East Anglia: 1830-1870", *Agricultural History Review*,
 33, 2 (1985), pp. 147-57.

MacPhee, was attacked by a group who had pursued him beyond the community. Though there were four men present in the rescue party, they remained in the background. The assault itself was said to be the work of nine women.[34]

We need, then, to broaden our notion of female lives and experiences, if we are to make sense of women's participation in direct action during the Escheat movement. Isabella, used to hard physical labour, is unlikely to have thought it peculiar, or inappropriate, for women to use physical means to uphold their interests. When we examine the role of women in the Escheat movement, we see in part an extension of the normal patterns of work and life to meet the challenges thrown up by the land war of the 1830s. Women familiar with the rough and tumble of outdoor rural life dealt with the law officers who came to their farms as they would any other threat to their household. Accustomed to the heft of an axe and the swing of a fence picket, they applied their strength, skills and inclinations to the problems at hand.

Those like McVarish who were on the receiving end of these responses were caught in an unenviable dilemma. On the one hand they were, often enough, dealing with women who possessed strength, endurance, physical tenacity and the urge to cause considerable physical harm. McVarish's choice of targets when he levelled his pistol probably showed his appreciation of women's abilities. On the other hand, he and the other law officers on the front lines of the land war were, in one fashion or another, linked to a culture which saw women differently. According to increasingly dominant middle-class and upper-class views, women were revered as submissive nurturers of the domestic sphere.[35] Historians studying women's roles in collective action in other 19th-century contexts have suggested that plebeian protesters may have sought to exploit such perceptions when they challenged the status quo. Women, the argument goes, enjoyed some degree of immunity in violent confrontations, or at least believed that they did, and scattered evidence does suggest they were less likely than men to suffer harm or be prosecuted for their actions. This fact may help explain their prominence in illegal protest.[36] Might this have been the case with women's participation in the direct action associated with the Escheat movement?

34 *Royal Gazette*, 20 December 1836, p. 3.

35 Barbara Leslie Epstein, *The Politics of Domesticity: Women, Evangelism, and Temperance in Nineteenth-Century America* (Middletown, Conn,, 1981), pp. 67-87; Nancy F. Cott, *The Bonds of Womanhood: "Women's Sphere" in New England, 1780-1835* (New Haven, 1977).

36 Malcolm I. Thomas and Jennifer Grimmet, *Women in Protest 1800-1850* (London, 1982), p. 54; Logue, *Popular Disturbances in Scotland*, pp. 199-203.

The evidence bearing on this question is limited, but it supports an affirmative answer. Interestingly, despite the prominent role played by women in resisting the enforcement of landlords' claims in Kings and Queens counties in the tense fall and winter of 1837-38, none were named in the law officers' reports nor were any indicted for their actions. Only men were tried. Such preliminary screening raises questions concerning how adequately indictments and court cases document women's participation in direct action or, indeed, in other sorts of activities of this type. Were law officers uncomfortable with admitting that their lumps and bruises were the work of women or that they had been chased or intimidated by women? And, other things being equal, did law enforcement take place in a cultural context where charges against males were preferable, if an example was to be made of a few members of a larger riotous assembly? Women, it would appear, were more likely to be indicted in household-level confrontations where the numbers involved were quite small. Even when charged, however, they sometimes fared better than men. Although two women were indicted for the assault on Donald McVarish, neither served a prison term or paid a fine. The charges were dropped against Nancy MacDonald, and Isabella MacDonald, though found guilty, was pardoned by the Island's governor, Aretas Young, on account of her "being far advanced in pregnancy and having six young children".[37] All three men involved were committed to prison.

The ways in which contemporaries referred to gender when assigning meaning to incidents of Escheat-related collective action provide another window on these issues. In the wake of the resistance to the sheriff at Robertson's farm in the fall of 1836, pressure was brought on the new governor, Charles FitzRoy, to send troops into the region to sustain the civil forces in their enforcement of landlords' claims. FitzRoy sent Charlottetown's mayor, Ambrose Lane, to the region as his personal emissary to enquire into the current state of the countryside and to conspicuously make arrangements for billeting soldiers. Seeking to downplay the seriousness of the incidents that had brought Lane to the region, Robertson and his family told him that the sheriff and his assistants had never been in any real danger as "all the violence offered was by women and boys". The law officers who had beat a hasty retreat from the mob assembled at the farm had been "unnecessarily alarmed"[38]. Similarly, a dispute over the significance of the Wood Islands incident of January 1838 came, in part, to revolve around the composition of the crowd which had assembled and fired shots over the heads of the rector's party. Those seeking to downplay the confrontation insisted that it had, in large

37 Young to Hay, 20 March 1835, CO 226, vol. 52, p. 89.
38 Hodgson to Owen, 30 September 1837, MS 3744, vol. 26, PAPEI.

part, been staged by women and boys. Those intent on seeing it as an indica-
tion of a broader spirit of rebellion threatening the status quo on the Island
were equally insistent that the crowd had been "composed chiefly of able-
bodied men".[39] What the disputants in these battles of words shared, or
claimed to share, was the notion that females could not figure as real threats
in violent confrontations. It is not clear whether exploitation of these per-
ceptions of women figured into the strategic planning of household and
community-level rent resistance prior to confrontations or whether they
were invoked only after the violence. Cases such as the rescue of Rose
Hughes, where men were present but remained at a distance while women
assaulted the constable, or the resistance at Robertson's farm, in which,
according to reports, men were present but not active in the physical con-
frontation with law officers, suggest a conscious gendered strategy that made
use of upper-class assumptions concerning women's behaviour.

The similarity between the roles women assumed in some of these cases
of direct action and the patterns that emerged in the land war in the Scottish
Highlands is striking. In the Highlands during the era of the clearances,
women played a central role in physical confrontations with law officers. As
Eric Richards has noted, "women and boys" were "invariably" in "the front
line" of crowd actions.[40] They were the ones who engaged in violent resist-
ance. Men remained in the rear. The description of events at Robertson's
farm or the release of Rose Hughes might easily be integrated into the re-
ports of resistance to law officers in the Highlands without attracting notice;
the patterns are virtually identical. The regions in Prince Edward Island pro-
viding much of the evidence concerning women and direct action were areas
of extensive Highland settlement, and many of the names that figure in the
incidents, male and female alike, are Highland names — MacDonald, Mac-
Leod, McCormick, MacInnis, MacPhee. Is part of the explanation for
women's roles in the Escheat struggle a transfer of Old World patterns of re-
sistance to a New World setting? Given the scale of emigration from the
Highlands in the aftermath of the Napoleonic Wars, the extent to which
other aspects of Gaelic culture re-emerged in the region and, as Ian Robert-
son has noted, the similarity between the challenges that Highland tenants
faced on the Island and those they had left in Scotland, might not such cir-
cumstances have fostered a transfer of traditional patterns of response?[41]

39 "One of the Party" to the editor, *Colonial Herald*, 27 June 1838, p. 3.
40 Eric Richards, "How Tame were the Highlanders during the Clearances?" *Scottish
 Studies*, 17 (1973), p. 39.
41 Charles Dunn, *Highland Settler: A Portrait of the Scottish Gael in Nova Scotia* (1953;
 Toronto, 1980); D. Campbell and R.A. MacLean, *Beyond the Atlantic Roar: A Study
 of Nova Scotia Scots* (Toronto, 1974); I.R. Robertson, "Highlanders, Irishmen and the

While such an explanation seems plausible, there are grounds for caution in claiming too close a connection between the patterns of protest in the Highlands and those that emerged in Prince Edward Island. We have to ask why we would see the re-emergence of aspects of one culture's traditions of rural resistance, Highland in this case, and not another, such as Whiteboyism among the Island's Irish population. And even if we focus exclusively on the Scottish background of a segment of the Island's tenantry, the issue of timing raises serious questions concerning the extent to which women's roles in direct action on Prince Edward Island, even in Highland communities, are likely to have been transfers of Old World patterns of protest.[42] Much of the Highland resistance in which women assumed prominent roles occurred after the Escheat movement, and most occurred well after many of the Highlanders present on the Island had left their native home.[43] As well, the primary zones of early resistance in the Highlands — Easter Ross and Sutherland — do not seem to have been dominant source areas for Island Scots. The resistance in the Highlands that emerged in the regions where most of the immigrants originated and that seems most comparable to women's direct action on the Island occurred between 1825 and 1875, as communities in the Hebrides and on the adjacent mainland became the sites of sharp confrontations. If there is a connection between women's resistance in the Highlands and on the Island, it probably exists less with the transfer of specific tactics than with the persistence of deeper cultural patterns that, given comparable challenges, gave rise to similarly gendered responses.

Whatever the case for direct linkages between the patterns of rural protest in the British Isles and those in Prince Edward Island, there is, without a doubt, a generic relationship between the types of direct action associated with the Escheat movement and the modes of community-level resistance that emerged in Scotland and elsewhere. Drawing attention to the essentially defensive nature of collective action such as the Highland resistance to clearance — or comparable confrontations on Prince Edward Island — or land protests, food riots, tax protests and conscription riots in a host of other

Land Question in Nineteenth-Century Prince Edward Island", in L.M. Cullen and T.C. Smout, eds., *Comparative Aspects of Scottish and Irish Economic and Social History, 1600-1900* (Edinburgh, 1977), pp. 227-40.

42 I have attempted to make some sense of these patterns of cultural transfer. Rusty Bittermann, "Agrarian Protest and Cultural Transfer: Irish Emigrants and the Escheat Movement on Prince Edward Island", in Tom Power, ed., *The Irish in Atlantic Canada* (Fredericton, 1991), pp. 96-106.

43 See Logue, *Popular Disturbances in Scotland*, pp. 54-74; Eric Richards, "Patterns of Highland Discontent, 1790-1860", in Quinault and Stevenson, *Popular Protest and the Public Order*, pp. 75-114.

locales, Charles Tilly has argued that they fit within a broader category of "reactive" collective action, locally focused efforts to protect existing rights or to uphold popular notions of justice.[44] John Bohstedt's term "common people's politics" aptly captures another facet of this type of collective action. In contexts where ordinary people were excluded from participation in formal politics, direct action provided a means for articulating plebeian sentiments; it permitted them to act as "proto-citizens".[45] As Bohstedt and others have noted, women often participated extensively in this sort of political action. "Common people's politics" tended to be an extension of plebeian life, and in locales where women "worked shoulder to shoulder with men" they also "marched shoulder to shoulder with men" in defence of their households and communities.[46] Such was the case with women's participation in the direct action associated with the Escheat movement. Local-level politics of this type was a matter for women and men alike.

This was not the case in the formal political arena. There the rules and norms that governed participation were extensions of elite and middle-class ways of life. In these circles, other notions of womanhood held sway. This would be of no small significance for the majority of women when, beginning in the late 18th century and extending across the 19th century and beyond, ordinary people about the Atlantic rim increasingly pushed themselves into, or were incorporated within, the field of formal politics. Lower-class entry into the sphere of political life was gained by compromise and by the acceptance of many of the modes of procedure that had been established by the upper classes. On the Island one thinks even of simple matters such as dress. When the Escheat leader John LeLecheur went off to Quebec to discuss the land question with Lord Durham, a fund-raising campaign was necessary in order to buy him a new set of clothes. Such props were unnecessary for engaging in political debate in Murray Harbour, but they were a part of the basic entry requirements for being taken seriously in the Governor General's circles.[47] Certainly, involvement in formal politics did lead to fundamental changes in the nature of plebeian politics. As historians have noted in other contexts, one of the many prices popular forces

44 Charles Tilly, *From Mobilization to Revolution* (Reading, Mass., 1978), pp. 143-71.

45 John Bohstedt, "The Myth of the Feminine Food Riot: Women as Proto-Citizens in English Community Politics, 1790-1810", in Harriet B. Applewhite and Darline G. Levy, eds., *Women and Politics in the Age of the Democratic Revolution* (Ann Arbor, 1990), pp. 21-60.

46 John Bohstedt, "The Myth of the Feminine Food Riot", p. 21. See also Thomas and Grimmet, *Women in Protest*, pp. 54-5.

47 Rusty Bittermann, "Escheat!: Rural Protest on Prince Edward Island, 1832-1842", Ph.D. dissertation, University of New Brunswick, 1992, pp. 321-8.

paid for entrance into the formal political arena in the 19th century was the relegation of women to a sphere outside direct participation in political life. A new mass politics was emerging at the time of the Escheat movement, but as it embraced larger numbers of previously excluded lower-class elements, it also denied political expression to women.[48] On the Island, women were legally disenfranchised on the eve of Escheat's electoral victory of 1838.[49]

The involvement of women in the local politics of direct action needs to be set in this larger context. While recognizing women's participation in the "common people's politics" of the 1830s, it is important to note the transitional nature of the period and the immediate and long-term significance of the zone of political life in which women had a prominent place. Rural protest in Prince Edward Island had by the 1830s largely shifted away from direct action. A relatively broad franchise allowed many male tenants to vote; some even possessed sufficient wealth to meet the property requirements necessary for assuming a seat in the House of Assembly. The energy of the Escheat movement was directed toward exploiting the political possibilities these openings permitted. Escheat leaders sought to make agrarian voices heard in the formulation of state policy by achieving power in the legislature. This pursuit drew rural protest into an exclusively masculine sphere. The activities in which women had a substantial presence were not at the forefront of the Escheat movement, nor would they be central to the new politics that developed in the years which followed.

48 Useful views of the process are provided in Wayne Ph. te Brake, Rudolf M. Dekker, and Lotte C. van de Pol, "Women and Political Culture in the Dutch Revolutions", in Applewhite and Levy, *Women and Politics in the Age of Democratic Revolution*, pp. 109-46; Joan B. Landes, *Women and the Public Sphere in the Age of the French Revolution* (Ithaca, N.Y., 1988); Allan Greer, "La république des hommes: les patriotes de 1837 face aux femmes", *Revue d'histoire de l'Amérique française*, 44, 4 (Spring 1991), pp. 507-28; Bohstedt, "The Myth of the Feminine Food Riot".
49 They were disenfranchised by statute in 1836. John Garner, *The Franchise and Politics in British North America, 1755-1867* (Toronto, 1969), p. 155.

DISFRANCHISED BUT NOT QUIESCENT
Women Petitioners in New Brunswick in the Mid-19th Century

GAIL G. CAMPBELL

Canadian women's participation in the political life of their society is usually dated from their struggle for and achievement of the vote. Yet denial of the franchise had not prevented women from being actively involved in the political life of their communities. Indeed, from the earliest times, women had found ways to influence their government.[1] In the period prior to the introduction of manhood suffrage — a period characterized by deferential politics — distinctions between men's and women's political behaviour were often blurred. Women, as well as men, regularly participated in politics by petitioning legislatures to achieve specific political goals.[2] Women, like men, were involved in creating the political culture of their society.

Political culture, which involves much more than participation in the formal political system, is shaped by those values and attitudes that are so widely accepted they are taken for granted. Such values provide the underpinnings for the development of formal political institutions and structures.[3]

1 For example, following a long-established European tradition, the women of New France took to the streets during the late 1750s to protest food shortages. Terence Crowley, "Thunder Gusts: Popular Disturbances in Early French Canada", *Communications historiques/Historical Papers* (1979), pp. 19-20. And evidence from the pre-history period strongly suggests that Iroquois women, at least, had enormous political influence in their society. See especially Judith K. Brown, "Economic Organization and the Position of Women Among the Iroquois", *Ethnohistory*, 17 (1970), pp. 153-6. This paper builds on a data base that was created while I was a post-doctoral fellow at the University of New Brunswick. This particular study is part of a much broader project dealing with political culture in mid-19th-century New Brunswick.

2 In an article discussing the role of women in American political society, Paula Baker has made this argument very effectively. Of course, the political transition which separated male and female politics occurred much earlier in the United States where the introduction of manhood suffrage (demonstrating definitively to women that their disfranchisement was based solely on sex) and the rise of mass political parties dated from the early 19th century. Paula Baker, "The Domestication of Politics: Women and American Political Society, 1780-1920", *American Historical Review*, 89 (1984), pp. 620-47. For a review of the literature concerning the role of deference in male political behaviour during the antebellum period, see Ronald P. Formisano, "Deferential-Participant Politics: The Early Republic's Political Culture", *American Political Science Review*, 68 (1974), pp. 473-87.

3 For similar definitions of political culture, see Robert R. Alford, *Party and Society:*

The role of women both in maintaining and in shaping societal values re-quires further investigation. While women undoubtedly had a significant indirect impact on government and politics through their influence within their own families and as members of voluntary groups and organizations within their communities, this paper will focus on women's direct political participation by analysing the nature and extent of political lobbying by women from three New Brunswick counties, as measured by the number and content of their petitions to the Legislative Assembly during the mid-19th century. In political terms, the decade selected for analysis — 1846 through 1857 — was a highly significant one. Political parties emerged dur-ing this period. Those great moral questions, temperance, and then prohibition, became, for a time at least, the major political issues. And it was on the moral issues that women began to petition the legislature in numbers during the decade.

While petitions do not represent a new source for the historian, resear-chers have not normally attempted to identify petition signatories unless they happen to be active members of a specific organization. Often resear-chers have been satisfied to count the number of petitions, identify the specific sponsoring group and note the number of signatories.[4] In the past, then, petitions have been used only as supplementary evidence. Yet for those who wish to analyse the nature and significance of women's political role in the 19th century, petitions provide the key. Only through the medium of pe-tition could a woman gain official access to her government or express her views about policy to the legislators. Thus, the petition provides a useful measure of the signatory's knowledge of the way government worked, her degree of interest in the issues of the day, and her attitudes concerning those issues.

Petitions and petitioners can be divided into two discrete categories. The first category includes petitioners seeking to use the law in some way: to apply for a government subsidy to which they were legally entitled, to red-

The Anglo-American Democracies (Chicago, 1963), pp. 2-6; Gabriel A. Almond and G. Bingham Powell, Jr., *Comparative Politics: System, Process, and Policy*, 2nd ed. (Boston, 1978), pp. 25-30; Ronald P. Formisano, *The Transformation of Political Cul-ture: Massachusetts Parties, 1790s-1840s* (New York, 1983), p. 4.

4 See, for example, Carol Lee Bacchi, *Liberation Deferred? The Ideas of the English-Canadian Suffragists, 1877-1918* (Toronto, 1982), pp. 34, 38, 75, 82, 143; Catherine Cleverdon, *The Woman Suffrage Movement in Canada* (Toronto, 1970), pp. 23-110, 160-220; Wendy Mitchinson, "The WCTU: 'For God, Home and Native Land': A Study in Nineteenth Century Feminism", in Linda Kealey, ed., *A Not Unreasonable Claim: Women and Reform in Canada, 1880-1920s* (Toronto, 1979), pp. 155-6.

ress a grievance, to appeal for aid at a time of personal distress, or to request a grant from public monies to carry out a worthy public project. Individual petitioners normally fall into this first category, and while such petitions do not reveal the petitioner's opinions on the issues of the day, they do suggest the extent to which she both understood the system and was able to use it to her advantage. The second category includes petitioners seeking to change the law in some way. Through the medium of the petition, they sought to influence their government, to persuade the legislators to accept their view. Occasionally such people petitioned as individuals, but usually they petitioned in concert with others. Legislators would, after all, be more inclined to take a petition seriously if they could be persuaded that a majority of their constituents supported it. Regardless of the success or failure of the petition, such documents can provide important insights concerning societal attitudes. Whether the signatories were members of an organized group with a specific platform and goals, or a group of unorganized individuals who coalesced around a specific issue, an analysis of the demographic characteristics of the supporters of the issue can enhance our understanding of political attitudes and political culture.

The petition process was a popular political strategy used by men as well as women. During the ten-year period from 1846 through 1857, between 400 and 500 petitions to the New Brunswick legislature were received annually. On average, between 25 per cent and 30 per cent of these were rejected and approximately 50 per cent were granted, while the remainder were tabled or sent to committee. However, if they persisted in their petitions, even those who had initially been rejected could eventually achieve their goals. Moreover, legislators did not prove more responsive to petitions from men whose votes they might risk losing at the next election.[5] Although a minority among petitioners, women demonstrated their ability to use the strategy effectively.

5 Although these figures represent the average yearly percentages, the success rate varied significantly from year to year, with legislators proving decidedly more sympathetic some years than others. But in no case did male petitioners prove more successful than their female counterparts. Even election years did not necessarily bring a greater likelihood of success than other years. Petitions to the New Brunswick Legislature are located in Record Group 4, Record Series 24, 1846-57/Petitions [RG 4, RS 24, 1846-57/Pe], Provincial Archives of New Brunswick [PANB]. It is also possible that the success rate of certain types of petitions varied over time. In her analysis of the Woman's Christian Temperance Union and its impact, for example, Wendy Mitchinson has suggested that the petition campaign was not a particularly effective strategy and that women were naïve in their belief that they could achieve legislative change through the medium of petition. Mitchinson, "The WCTU", p. 156. If women were naïve in this belief, however, they were certainly not alone, for the majority of petitioners were men.

This study is concerned with the women petitioners of the counties of Charlotte, Sunbury and Albert in the mid-19th century. All three counties are in the southern half of the province. Charlotte is a large, economically diverse county in the south-west corner. Sunbury is an agricultural county in the central region, just east of Fredericton; and Albert is in the south-east region between Saint John and Moncton, on the Bay of Fundy. Although originally selected because of the richness of their sources for the study of political history, Albert, Charlotte and Sunbury proved typical in many ways. Thus, while these three counties cannot be considered a microcosm of the province as a whole, they did encompass a broad spectrum of 19th-century anglophone New Brunswick society, including areas of pre-Loyalist, Loyalist and post-Loyalist settlement and encompassing rural communities, villages and even large towns. Moreover, one-fifth of New Brunswick's petitioners came from one of these three counties.[6]

Together the three counties included over 30,000 people at mid-century, nearly half of them female. A large majority of those people (over 80 per cent) lived in nuclear families, although a small minority of such families (perhaps as many as ten per cent) included one or more single or widowed relations, apprentices, boarders or servants. Over 80 per cent of the inhabitants had been born in New Brunswick of American or British stock. Of the immigrant population, nearly 70 per cent had been born in Ireland. Although the three counties included substantial numbers of Episcopalians, Baptists, Presbyterians, Roman Catholics and Methodists as well as a few Universalists and Congregationalists, among others, in both Albert and Sunbury the Baptists were stronger by far than any other denomination, comprising almost 62 per cent of Albert's population and one-half of Sunbury's population in 1861.[7]

In both Albert and Sunbury counties, the farm sector accounted for more than half the workers. Even in Charlotte County, which contained very little good agricultural land, more than one-third of the population were engaged in agriculture, providing for the needs of the fishery and the lumbering industry. Fifteen per cent of Charlotte's families were employed in the fishery

6 Of the 5,081 petitions considered, 1,029 originated in one of the three counties. This suggests that the people of Albert, Charlotte and Sunbury were slightly over-represented among the colony's petitioners, comprising 20.25 per cent of petitioners as compared to 16.3 per cent of the total population of the province. (The discrepancy is not statistically significant, however, as differences of plus or minus five per cent could occur entirely by chance.)

7 Information on denominational affiliation is not available for 1851 and therefore the 1861 census was used in this case. See *The Census of the Province of New Brunswick, 1861* (St. John, 1862).

while one-quarter of that county's population depended on the lumbering industry for their livelihood. In each of the three counties 17 per cent of those whose occupation was listed were skilled artisans; a further 15 per cent listed their occupation merely as labourer; and approximately four per cent of all families were headed by merchants and professional men.[8] While the men were occupied in the farming, fishing and lumbering industries, or as skilled artisans or professionals, the women were scarcely idle. Approximately one in every four women of child-bearing age actually bore a child in 1851 and, aside from running their households and caring for the needs of their 14,600 children, the 6,289 women of the three counties churned 689,363 pounds of butter and wove 94,019 yards of cloth on their hand looms.[9] Yet, despite the demands of their busy and productive lives, hundreds of women in the three counties found the time to petition their government.

A wide variety of motives persuaded these women to put their names to petitions. Many of the women in the first category of petitioners — those who sought to use the law in some way — were widows seeking financial compensation or support which they knew was their due. A cursory examination of their petitions would seem to give credence to the common notion that women were "forever dependent" on men, and that women who lost their husbands were left destitute, dependent on their sons, family or the charity of the public for support.[10] A more careful reading of the individual petitions

8 Unless otherwise noted, all information contained in the demographic profiles provided for the three counties under study is drawn from *The Census of the Province of New Brunswick, 1851* (St. John, 1852).

9 The 6,289 figure refers only to women over the age of 20. For a discussion of women's role in the dairying industry in British North America during this period, see Marjorie Griffin Cohen, "The Decline of Women in Canadian Dairying", in Alison Prentice and Susan Mann Trofimenkoff, eds., *The Neglected Majority: Essays in Canadian Women's History, Volume 2* (Toronto, 1985), pp. 61-70, and *Women's Work, Markets, and Economic Development in Nineteenth-Century Ontario* (Toronto, 1988), pp. 59-117. While the 1851 census does not specify who the weavers are, the manuscript census of manufacturing for 1861 indicates that virtually all of the hand loom weavers engaged in this cottage industry were women. The manuscript census of manufacturing for 1871 also supports this assumption. See Manuscript Census for Charlotte County, 1861 and 1871, PANB.

10 This view of women as forever dependent on men is argued by Rosemary Ball, "'A Perfect Farmer's Wife': Women in 19th Century Rural Ontario", *Canada: An Historical Magazine* (December 1975), pp. 2-21. And even historians like David Gagan, who recognize that "the fact of subordination was partially, if not wholly, mitigated by environment which cast women in a central role in the farm family's struggle to improve, and endure" often conclude that "for those women who outlived their partners, widowhood . . . was a calamity the consequence of which clearly troubled even the stoutest hearts". David Gagan, *Hopeful Travellers: Families, Land, and Social Change in Mid-*

leads to quite a different interpretation. Unless their husbands had been soldiers, widows did not generally petition the legislature for support, and those rare women who did appeal to their government for aid at a time of personal distress were not begging for charity or long-term support. In fact, most such petitioners were following an accepted and established formula used by men as well as women, to request compensation for the sacrifices they had made for their country and their community.

In 1848, for example, Margaret Baldwin, widow of the late Thomas Baldwin, of St. Andrews Parish in Charlotte County, petitioned the Legislative Assembly for help. Her husband had been employed in the early part of the previous summer by the medical attendant at Hospital Island to help with the care of sick and destitute "emigrants". He proved so satisfactory in the discharge of his duties that when a second group of "emigrants" arrived later in the year he was employed a second time. This time, however, he contracted typhus fever and died, leaving his wife destitute with no means of support for either herself or their two children.[11] Margaret Tufts faced a similar situation. Her husband, Benjamin, had also been employed on Hospital Island. He had been contracted to erect the pest house and repair the public buildings. While he was so employed, a large number of sick "emigrants" were landed on the island and Benjamin "devoted all his spare time in administering to the wants of the sick". While so engaged, he was himself taken ill with typhus fever of which, in a few days, he died, leaving his wife destitute, with "a large and helpless family" to support. In petitioning her government for help, Mrs. Tufts pointed out that she had, since her husband's death, subsisted on the meagre sum of £10, the balance owing to him at that time. At the time when she filed her petition, she had no visible way of making a living and feared that she must, for the coming winter at least, be dependent on the sympathy of the public.[12]

Both Margaret Baldwin and Margaret Tufts received grants from a sympathetic legislature. On the surface, these two petitions, which were the only petitions of this general nature to be submitted during the entire decade, appear to be the kind one might expect from women. However, although these petitions do point out these women's potentially destitute condition, that is not the focal point of their arguments. Margaret Baldwin and Margaret Tufts were not asking their government for charity: they were demanding, in very proper and formulaic terms, money they believed to be their just due in consideration of the services their husbands had rendered to their community.

Victorian Peel County, Canada West (Toronto, 1981), pp. 89-90.

11 RG 4, RS 24, 1848/Pe 4, PANB.

12 RG 4, RS 24, 1848/Pe 5, PANB.

Having received their grants, neither woman saw fit to petition for money a second time. Margaret Baldwin and her family soon left the parish, while Margaret Tufts managed by sharing a house with another family and taking in a lodger.[13]

A more unusual widow's petition came from Mary Ann Storr. Mrs. Storr and her family had made their entry into the province in April 1854, by way of Partridge Island. Her husband had died there, a victim of the cholera epidemic. In 1855, Mary Ann and her children were living in St. Andrews Parish in Charlotte County. In that year Mrs. Storr petitioned for, and was granted, compensation for the clothing and bedding of herself and her children which had been destroyed by direction of the authorities at the Quarantine Station in an effort to prevent the spread of cholera. Mrs. Storr was not asking for charity, only for just compensation.[14]

The majority of widows who petitioned the legislature were the widows of "old soldiers", men who had fought in the American Revolution. The "Act for the Relief of Old Soldiers of the Revolutionary War and their Widows", passed on 28 March 1839, entitled widows of veterans to an annual pension of £10. Despite the formulaic nature of their petitions, it would seem that the women themselves initiated their petitions, and continued to press their claims against apparently deaf officials until they were satisfied. Many such petitions referred to the women as indigent, if not destitute, and assured the legislature that the petitioner had insufficient property to support herself and had not divested herself of any property in order to be eligible for a pension under the terms of the act. Most of the women who applied for the widow's pension reported that their husbands had, in the past, been recipients of the pension.[15] An analysis of the content of their petitions indicates that these were not desperate and destitute women begging for charity, but, rather, capable and competent women claiming and, if necessary, persisting in claiming pensions as their right. And they needed to be persistent. Although

13 New Brunswick Manuscript Census, 1851, PANB. Not only were women less likely to petition their government for charity than were men, the Overseers of the Poor in each parish, in requesting reimbursement for monies expended on poor relief, more often listed men than women as recipients of that relief. On the rare occasions when individual men and women did petition their government for help in times of distress, they pressed their claims in very similar ways.

14 RG 4, RS 24, 1855/Pe 162, PANB.

15 See *Acts of the General Assembly of Her Majesty's Province of New Brunswick* (Fredericton, 1839-45), 2 Victoria, c. 27; amended 4 Victoria, c. 16 and 6 Victoria, c. 36. Under the terms of the act widows were eligible for the same annual pensions their husbands had received. Moreover, the eligibility clauses in the oath drew no distinction between veterans and their widows: the formulaic wording for initial applications, as set out in the 1839 Act, was the same for both.

widows' pensions were routinely granted by the legislature, some such petitions were rejected. Seven of the women who applied for the pension received at least one rejection by the legislature. Jerusha Black, who was living in Pennfield Parish, Charlotte County, at the time of her husband's death in 1846, left that parish after his death and her first petition was filed from St. George Parish in 1848. She was granted her pension that year, but the following year, when she applied from St. David Parish, she was denied support. Back in St. George in 1850, she received her pension once more. The following year, at age 79, she returned to her childhood home, Campobello Island, where she and John Black had married in 1793. There is no record of her application in that year, but in the following year, 1852, she was receiving her pension in Campobello.[16]

Of the 23 women who petitioned the legislature for pensions as the widows of "old soldiers", only six were able to sign their own names. But, illiterate or not, these women were apparently responsible for initiating their own petitions. Thus, in 1852, Nancy Leonard, of West Isles in Charlotte County, requested that she be granted her pension for the previous year as well. She noted that "on account of ill health and great infirmity your petitioner neglected to furnish the usual petition as she had previously done for these nine years".[17] Ruth McFarlane, of St. Patrick Parish in the same county, had been receiving the allowance of £10 by annual application since her husband's death in 1841. However, as she explained in her petition of 1849, in 1848 she had been told by county officials that there was no need to petition each year. As a result of this misinformation, she had not petitioned and she had not received her pension for 1848. Mrs. McFarlane, at 82, may have been "infirm and poor", but she knew her rights; she requested, and was granted, £20.[18] Martha Pendleton, of West Isles, was equally annoyed with the apparent incompetency of local officials. Her husband, who had regularly received a pension as an "old soldier", died in 1845, leaving her with no property or other means of support. According to her petition of 1849, she had filed petitions each year following his death but had received no pension. Upon inquiry, she was informed that her petitions had been mislaid.[19] By the winter of 1849-50, she had reason to believe that her persistence had finally been rewarded, for the legislature awarded her £30 for the three years she had been without support. She was informed that her application had been granted

16 RG 4, RS 24, 1848/Pe 152; 1849/Pe 13; 1850/Pe 56; 1852/Pe 67, PANB.
17 RG 4, RS 24, 1852/Pe 68, PANB.
18 RG 4, RS 24, 1849/Pe 39, PANB.
19 Nor has any earlier petition from Martha Pendleton been found among the petitions to the legislature.

and that payment would be made through the Clerk of the Peace. Mrs. Pendleton's triumph proved short lived, for, as she reported in her petition of 1850, the clerk had only agreed to certify her petition for £10, thereby depriving her of the retroactive award.[20] Petitioners, even elderly and infirm ones, could not count on local officials to look after their interests, since the officials were not always co-operative or even very well informed.

That women were aware of their rights, and counted on their government to uphold and protect those rights is nowhere more evident than in the case of the large group of young single women who fall within the first category of petitioners. Teachers, regardless of their sex, were required to petition the legislature in order to receive the provincial school allowance. The licensing procedure was the same for both men and women, and only licensed teachers were eligible to receive the provincial subsidy. Although the criteria changed somewhat during the decade, as the Normal School was established and became generally accepted, the change was gradual and the basic requirements remained consistent until 1853, when the requirement that teachers petition the legislature directly was dropped. Women remained at a disadvantage throughout the period. The School Act of 1837, which eliminated the previous distinction between a grant issued to a female teacher and one issued to a male, also stipulated that not more than three women teachers per parish were eligible for certification by the trustees in their semi-annual reports. Moreover, the School Act of 1852 restored the distinction between grants issued to male and female teachers. Women teachers holding a third-class certificate were to receive £4 less than their male counterparts, while grants to women who had attained a first-class certificate were a full £10 lower than those received by men who held first-class certificates. The community also had a significant responsibility in the process, for the school proprietors were required to provide a building and to match the amount paid by the province and teachers' petitions had to be certified by the local trustees.[21]

For Alice Thomson of Charlotte County, the fact that only three female teachers per parish could apply for the provincial allowance meant that although she had taught in St. Andrews for 18 months, she received the provincial allowance for only the first six. In her petition of 1847, she informed the legislators that the trustees had refused to report her for the last 12 months "by reason of the too great number of female schools in the parish

20 RG 4, RS 24, 1850/Pe 42, PANB.

21 Katherine F.C. MacNaughton, *The Development of the Theory and Practice of Education in New Brunswick, 1784-1900* (Fredericton, 1946), pp. 89, 149.

at that time".[22] This was a not infrequent occurrence in St. Andrews, which
was a large parish. In 1849, both Lydia Thomson and Mary O'Neill reported
that, although they had been certified by the trustees, their petitions of the
previous year could not be returned to the legislature "as the number of fe-
male schools allowed by law had already passed".[23] Nor was the problem
confined to large and populous parishes. Susannah Rogers of Coverdale, the
smallest parish in Albert County, reported in 1850 that she could not be cer-
tified in the usual way for 1849 because the parish had exceeded its allotment
of female school teachers.[24] These four young women, faced with an obstacle
their male counterparts did not have to deal with, persisted in pressing their
claims and all four eventually received their allowances, delayed by a full
year in each case.

 Nonetheless, the legal restriction did have the desired effect: significantly
fewer women than men applied for the provincial subsidy each year. In Sun-
bury County only two of the 15 petitions from teachers were from women,
and one of those was requesting remuneration not for her services, but rather
for the services of her late husband. In Albert four of the 28 petitioning tea-
chers were women. But in Charlotte County 45 of the 96 teachers who
petitioned the legislature for remuneration were women, and, although one
of the female petitions was from a woman requesting the school allowance
due her late husband, one of the male petitioners was requesting payment for
the services of his late wife, while another was claiming the school allowance
of his late daughter.

 In some cases teachers counted on the good will of their employers when
accepting teaching positions. When they responded to "emergency" situ-
ations, teachers recognized that they were taking a risk which would make
them vulnerable to rejection. This is clearly evidenced by the cogent argu-
ments such teachers developed in their efforts to convince legislators to grant
them an allowance to which they were not legally entitled. Women were
more likely than men to respond to "emergency" situations, and occasionally
they suffered as a result. Isabella Fogg of St. Patrick, a licensed teacher of the
third class, agreed to step into the breach while the man who had been teach-
ing in her district went off to attend the Training School in Fredericton.
When he returned she was obliged to close her school. Six months of con-
tinuous teaching were required in order to be eligible for the provincial
subsidy and Isabella's school had been open for only three months. She ar-
gued her case so effectively, however, that the legislators granted her petition

22 RG 4, RS 24, 1847/Pe 471, PANB.
23 RG 4, RS 24, 1849/Pe 91; 1849/Pe 209, PANB.
24 RG 4, RS 24, 1850/Pe 21, PANB.

to be paid for those three months.[25] Other women were not so lucky. Sophia Flagg of Campobello lived in a district which had been unable to attract a licensed teacher. When approached by the local trustees, she agreed to help out in the hope that, allowing for the circumstances, she might be granted the usual subsidy. She taught for six months but her petition for the provincial school allowance met with rejection.[26] Mary Hitchings of St. Stephen taught in a remote district of that parish for nine months in 1845. She did not apply for a licence because she "did not contemplate pursuing the business of teaching but was induced to teach as long as she did from the solicitation of a number of inhabitants in the district and from its destitute condition as to the means of education". Her application for the provincial allowance was rejected because she did not have a licence.[27] Rebecca Pratt of St. George agreed to teach on Pleasant Ridge in St. Patrick Parish despite the fact that the few poor inhabitants could not afford to remunerate a teacher. She taught for six months in the hope of receiving the provincial allowance, but her petition was denied.[28] Male teachers rarely put themselves in such vulnerable situations.[29]

In some cases the trustees themselves proved peculiarly lax, often at the expense of female teachers. In St. David Parish in Charlotte County, women teachers frequently found themselves at the mercy of seemingly incompetent trustees. In 1845, Mary Jane Perkins, a native of the parish, completed her education and applied for her teaching licence. She filled out all the necessary papers and paid the 30s fee. Then she accepted a job teaching school in the parish. However, when it came time to certify her for the provincial allowance, she was told her papers had been lost.[30] Susan Rogers was also teaching in the parish in 1846. She had passed her licensing examination in 1839 and had been duly certified as qualified to teach spelling, reading, writing, arithmetic and English grammar. When her licence was cancelled, she had immediately applied for a new one but had been told that renewal was unnecessary. Since then the trustees had apparently changed their minds, for they refused to certify her petition in the usual manner because her licence had not been renewed.[31] Just two years later Rachel Hawes faced a similar problem. An 18-year-old native of the parish, Rachel had been employed to

25 RG 4, RS 24, 1851/Pe 35, PANB.
26 RG 4, RS 24, 1849/Pe 95, PANB.
27 RG 4, RS 24, 1848/Pe 158, PANB.
28 RG 4, RS 24, 1848/Pe 131, PANB.
29 Two per cent of male teachers as compared to ten per cent of female teachers fall into this category.
30 RG 4, RS 24, 1846/Pe 60, PANB.
31 RG 4, RS 24, 1846/Pe 261, PANB.

teach for a six-month period. Yet she was discouraged from applying for her teacher's licence. She was told not to go to the expense because "licences would soon be cancelled and issued only from the Training School".[32] In order to grant the petitions of these three young women, the legislators were required to exhibit extraordinary flexibility in their interpretation of the law. The women had understood the provisions of the law and had attempted to comply with them, yet had been prevented from doing so by the trustees, the men who should have understood the School Act better than anyone else, since they were responsible for its enforcement. In the end, not one of the women involved was denied her allowance. Yet it is perhaps significant that no male teacher in any parish reported having been told by the trustees not to bother applying for a licence.

Some of the reasons for rejection were, of course, common to both men and women. Young single teachers of both sexes proved very mobile. One of the most common problems encountered by both men and women involved their failure to transfer their licences when moving from parish to parish. Fortunately the legislators proved flexible concerning this rule, often allowing teachers to renew their licences "after the fact". Yet whether the problems they faced were shared by both sexes or clearly gender related, women teachers demonstrated their superior skill in the petitioning process. Three of Sunbury's 15 teachers received rejections from the legislators: all three were male. Rejection was rare for Albert County petitioners, with only two of the 28 petitions being turned down by the legislature, both of them from men. In Charlotte County, 18 male petitioners and seven female petitioners were rejected. In general, it appears that women were not more likely to be rejected than were their male counterparts.[33] Moreover, as in the case of soldiers' widows, it was the women themselves who pressed their claims and ultimately, sometimes through sheer doggedness, gained their allowance.

Married women did not typically petition the legislature as individuals.[34] Nor did they sign petitions calling for the building of roads, wharfs, bridges and other public works. They did not petition for the incorporation of either the Roman Catholic bishop or the Loyal Orange Order. Nor did they join in requests for the division of parishes or the creation of free ports. Their hus-

32 RG 4, RS 24, 1848/Pe 162, PANB.
33 RG 4, RS 24, 1846/Pe; 1847/Pe; 1848/Pe; 1849/Pe; 1850/Pe; 1851/Pe; 1852/Pe, PANB.
34 There were four exceptions to this general rule in the three counties during the 12-year period under study. They include a woman who had been named executrix of her father's estate and three married teachers. One of the latter had continued to teach after her marriage while the remaining two were applying for allowances earned prior to marriage. See RG 4, RS 24, 1851/Pe 239; 1852/Pe 25; 1849/Pe 84; 1850/Pe 49, PANB.

bands, in contrast, did all these things. The failure of women to become involved in such lobbying campaigns can cause historians to draw misleading conclusions about women and their role within the broader society. Because 19th-century women were denied the vote and because they did not lobby their legislature as part of an organized group, it has been assumed that women were not knowledgable about political issues and that they were not active politically. Politics has been regarded as an activity outside the 19th-century woman's "proper sphere", as defined for her by a patriarchal society, and women's political involvement is usually dated from the rise of provincial and national women's organizations in the late 19th century. The political awareness evinced by the women who joined such organizations is viewed as a new departure which saw women becoming active outside the domestic sphere for the first time.[35] Yet there was a far greater degree of continuity than such interpretations would lead one to expect. At least some married women in mid-19th-century New Brunswick understood the system and quickly learned to use it effectively. These women had stepped beyond the domestic sphere long before the advent of national, or even provincial, women's organizations.

Take the case of John and Alice Wilson of St. Andrews Parish in Charlotte County. John was a highly successful merchant. In 1851 he was 64 years old. Alice, his American-born wife, was 58. According to the census of that year, their household also included a hired man, two female servants, and an errand boy. John and Alice had sundry relatives living in the parish including their married son Thomas, a lawyer, and John's two younger brothers, who

35 For a discussion of women's lack of power within the family, see Margaret Conrad, "'Sundays Always Make Me Think of Home': Time and Place in Canadian Women's History", in Veronica Strong-Boag and Anita Clair Fellman, eds., *Rethinking Canada: The Promise of Women's History* (Toronto, 1986), pp. 69, 75-7. For examples of the view that the rise of provincial and national women's organizations signalled a 'new day' for women in terms of political activity, see Deborah Gorham, "Flora MacDonald Denison: Canadian Feminist", in Kealey, ed., *A Not Unreasonable Claim*, pp. 48, 58-64; Wendy Mitchinson, "The WCTU", pp. 152-4, 166-7; and Veronica Strong-Boag, "'Setting the Stage': National Organization and the Women's Movement in the Late 19th Century", in Susan Mann Trofimenkoff and Alison Prentice, eds., *The Neglected Majority: Essays in Canadian Women's History* (Toronto, 1977), pp. 87-103. Historians have not altogether ignored women's political activity during this period, but in general women's participation in the petitioning process has been characterized as exceptional rather than normal. For the best discussion of women's political activity during this period, see Alison Prentice, Paula Borne, Gail Cuthbert Brandt, Beth Light, Wendy Mitchinson and Naomi Black, *Canadian Women: A History* (Toronto, 1988), pp. 105, 174-5 (for references to petitions and petitioners, pp. 70, 81, 102, 105).

were also merchants. Between 1846 and his death in 1855, John Wilson petitioned the legislature no fewer than 21 times. Some of the petitions he initiated involved lobbying for parish improvements, while others were more personal in nature. In 1847, for example, he petitioned for and received a grant of money to improve Dark Harbour, Grand Manan. In 1849 he asked to be reimbursed for the money he had expended in the care and maintenance of "emigrants" from Ireland brought over to work for the St. Andrews and Quebec Railroad Company, of which he was president. His petition was rejected. In 1851 he requested a further grant to deepen the channel at Dark Harbour, which was, he argued, the only safe harbour in the area in the event of a storm. Once more the legislature granted his request. In 1855 he requested yet another grant for the purpose of further improvements at Dark Harbour.[36]

During that entire decade, Alice Wilson did not sign a single petition to the legislature. But there is every reason to assume that she understood precisely what her husband had been doing. In his will, John named his "dear wife Alice" his sole executrix, leaving her all his "real estate viz. land, buildings, mills, wharfs, stores" as well as all his "personal estate of every description consisting of household furniture, all my books, debts, notes of hand, bonds, bank stock, bridge and steamboat stock, money, vessels and of all description property termed personal estate".[37] John's obvious faith in the abilities of his "dear wife Alice" proved fully justified. Less than a year after his death, Alice petitioned the legislature for the first time. She asked to be reimbursed the amount expended by her late husband in opening and improving Dark Harbour, Grand Manan. The following year she petitioned for the appointment of a person to look into the expenses incurred by her late husband in constructing a breakwater at Dark Harbour. That same year she requested that the government suspend the issue of debentures to the New Brunswick and Canada Railroad and Land Company until reparation had been made her for the claims of her late husband. When that request was tabled, she followed it up with a second petition.[38] Clearly Alice Wilson was a force to be reckoned with. Indeed, her immediate facility with the petition process makes one wonder if perhaps Alice had not always been the "petitioner" in the family. Whatever her role may have been in the process while her husband was alive, after his death she quickly proved herself fully capable of handling his affairs.

36 RG 4, RS 24, 1846/Pe 285; 1847/Pe 67, 116, 154, 313, 402; 1848/Pe 365, 389; 1849/Pe 7, 89, 355; 1851/Pe 333, 334; 1852/Pe 320, 321; 1853/Pe 260; 1854/Pe 37, 105, 354; 1855/Pe 291, 292, PANB.
37 Charlotte County Probate Court Records, RG 7, RS 63B3, 1852, PANB.
38 RG 4, RS 24, 1856/Pe 5; 1857-58/Pe 7, 9, 164, PANB.

While Alice Wilson is undoubtedly the best example of a widow who used petitions to promote her business interests after the death of her husband, she was by no means the only example.[39]

Custom — and perhaps some husbands — prevented married women from signing more petitions dealing with individual and family affairs, but one should not assume either a lack of knowledge about or a lack of interest in the political system and the way it worked, on the part of such women. Moreover, starting in 1853, married women began to sign petitions in numbers. The petitions they signed were qualitatively different from the petitions women had signed up to that time. Such women fell into the second category of petitioners: those who sought to change the law. The issue that finally mobilized them to take up their pens was, not surprisingly, a reform issue. By the final decades of the century it would be an issue closely associated with the organized women's movement. The issue was temperance.

The temperance movement was well entrenched in New Brunswick by 1853, the first formal temperance organization having been established in 1830. Drawing inspiration and encouragement from both Great Britain and the United States, the New Brunswick movement had gained ground steadily throughout the 1830s and 1840s.[40] Temperance societies were established in Fredericton, Saint John, Dorchester, Chatham, St. Stephen and St. Andrews and temperance soirées and teas were very popular.[41] During the early years, the goal had been to encourage moderation and sobriety, but by the mid-1840s many temperance activists were advocating total abstinence.[42] As the

39 For examples of other widows who were involved in the economic life of their communities see RG 4, RS 24, 1846/Pe 216; 1849/Pe 195; 1852/Pe 17, 202; 1854/Pe 215, 225, PANB.

40 For evidence of British and American influences see J.K. Chapman, "The Mid-Nineteenth Century Temperance Movement in New Brunswick and Maine", *Canadian Historical Review*, 35 (1954), pp. 43, 48-50; and T.W. Acheson, *Saint John: The Making of a Colonial Urban Community* (Toronto, 1985), pp. 140-50. Analysts of the 19th-century temperance movements in Great Britain and the United States tend to characterize the movement as an Anglo-American crusade. The American and British campaigns began at the same time and nourished each other. See, for example, Brian Harrison, *Drink and the Victorians: The Temperance Question in England, 1815-1872* (Pittsburgh, 1971), pp. 99-103; W.R. Lambert, *Drink and Sobriety in Victorian Wales, c. 1820-c. 1895* (Cardiff, 1983), pp. 59-61; and Ian R. Tyrell, *Sobering Up: From Temperance to Prohibition in Antebellum America, 1800-1860* (Westport, Conn., 1979), pp. 135, 299.

41 Chapman, "The Mid-Nineteenth Century Temperance Movement", p. 48.

42 Acheson, *Saint John*, p. 138. The British and American movements had made this shift somewhat earlier. Teetotalism had gained popularity in Britain by the late 1830s while the "Washingtonians" popularized teetotalism in the United States after their inception in 1840. Lambert, *Drink and Sobriety*, p. 59; Tyrrell, *Sobering Up*, pp. 135-90.

depression of the late 1840s began, temperance advocates, in their search for explanations, increasingly associated drinking with the broad social problems of crime and poverty.[43] In 1847, the Sons of Temperance, the most successful of the American total-abstinence organizations, established its first division in British North America at St. Stephen, New Brunswick. The Sons of Temperance and its affiliates, the Daughters of Temperance and the Cadets of Temperance, had widespread appeal. Teas, picnics and steamer excursions provided family diversions and attracted many to the great crusade.[44] By 1850 there were branches all over the southern part of the province.[45]

For many years temperance advocates sought to achieve their goals by moral suasion, but by the late 1840s some had become convinced that moral suasion alone was not enough. For a time, they focused their efforts on gaining control of liquor consumption within their own communities through attempts to secure limitations on the number of tavern licences issued by county and city councils.[46] But such efforts proved unsuccessful. In Maine, temperance crusaders facing a similar failure had appealed to a higher authority. By 1851 they had gained enough support in the legislature there to achieve an effective prohibition law. The "Maine Law", which was the first prohibitory liquor law in North America, had a significant effect on the New Brunswick temperance movement. In 1852, a so-called "monster petition" calling for the prohibition of the importation of alcoholic beverages was presented to the House of Assembly.[47] The 9,000 signatures on the petition so impressed the province's legislators that they were persuaded to pass "An Act to Prevent the Traffic in Intoxicating Liquors". This act "forbade the

43　While the prohibition advocates of a later period would focus on the effects of drinking on individual families, the women petitioners of this early period, like their male counterparts, regarded drinking as a community rather than a family problem. The petitions that went beyond a formulaic request for the enactment of "a Law to prevent the importation, manufacture and sale of all intoxicating Liquors within this Province", generally decried intemperance as "a great public evil". As the authors of one 1851 petition succinctly put it, "your petitioners are convinced that crime, pauperism and lunacy in nine cases out of ten are the direct result of drinking habits". See RG 4, RS 24, 1846/Pe 45; 1848/Pe 270; 1849/Pe 87; 1849/Pe 151; 1849/Pe 363; 1851/Pe 228; 1854/Pe 220; 1854/Pe 394; 1854/Pe 395; 1854/Pe 404; 1854/Pe 465, PANB.

44　Acheson, *Saint John*, p. 149; Chapman, "The Mid-Nineteenth Century Temperance Movement", p. 50.

45　W.S. MacNutt, *New Brunswick, A History: 1784-1867* (Toronto, 1963), p. 350.

46　Acheson, *Saint John*, p. 141. Similar attempts were made in New England to control licensing at the local level. Tyrrell, *Sobering Up*, pp. 91, 242-3.

47　RG 4, RS 24, 1852/Pe 406, PANB. The Maine Law also had a significant impact in England and within the United States. See Harrison, *Drink and the Victorians*, p. 196; Tyrrell, *Sobering Up*, p. 260.

manufacture within New Brunswick of any alcoholic or intoxicating liquors except for religious, medicinal or chemical purposes. Beer, ale, porter and cider were excepted".[48]

Women had, of course, been involved in the temperance cause from the time of its first appearance in New Brunswick in 1830. But men had always outnumbered women in temperance organizations, and until 1853 the vast majority of temperance petitions were submitted by and signed by men.[49] Urban women were the first to take up their pens in the temperance cause: the "Ladies' Total Abstinence Society for the City and County of Saint John" submitted the first recorded petition from women on the issue to the legislature in 1847. Three years later Woodstock's Victoria Union No. 4 of the Daughters of Temperance submitted a petition opposing the granting of tavern licences. The following year the "Ladies of Woodstock" went even further, calling for "an act to prevent the sale of spiritous liquors". In 1852, the Daughters of Temperance from Woodstock were joined in the campaign by women from Fredericton and the surrounding area.[50] Rural women, including the subjects of this article, in contrast, did not sign temperance petitions to the legislature before 1853. Yet this cannot be taken as an indication of either a lack of knowledge or a lack of interest. Some, like the women of Albert County, had, for several years, regularly signed petitions addressed to their local county councils opposing the issuance of tavern licences.[51] Many such women signed petitions not as members of any organized temperance group, but rather as members of their local community; and this pattern was to continue when they turned their attention to the Legislative

48 Chapman, "The Mid-Nineteenth Century Temperance Movement", p. 53.

49 New Brunswick women were by no means atypical in this regard. Barbara Epstein argues, for example, that during this period American women in the temperance movement were generally relegated to subsidiary roles — influencing sons and husbands. Barbara Leslie Epstein, *The Politics of Domesticity: Women, Evangelism, and Temperance in Nineteenth-Century America* (Middletown, Conn., 1981), p. 91.

50 See RG 4, RS 24, 1847/Pe 465; 1850/Pe 445; 1851/Pe 431; 1852/Pe 348; 1852/Pe 402; 1852/Pe 407, PANB. The early involvement of urban women is not surprising. Harrison argues that the temperance movement in England owed much to industrialization. Led by pioneers among whom doctors, coffee traders, evangelicals and industrialists figured prominently, the movement spread out from the towns. Harrison, *Drink and the Victorians*, pp. 92-8. Similarly, Tyrrell argues that temperance "flourished in a society in transition from a rural to an urban industrial order", receiving its strongest support from the promoters of that change. Tyrrell, *Sobering Up*, pp. 7, 209, 241, 252. A comprehensive study of the New Brunswick temperance movement during this period remains to be done, but the pattern of petitioning is suggestive of the need for a careful comparative analysis.

51 RG 18, RS 146, B9 (1851), PANB.

Assembly in 1853. Rural women had not participated in the legislative lob-
bying campaign that had culminated in the drafting of the Liquor Bill. Yet
they were very much in the mainstream of the temperance movement as it
gathered force, attempting first to achieve sobriety through moral suasion,
then seeking local solutions through no licensing campaigns. And they
would soon have the opportunity to demonstrate their support for the new
legislation.

The new law was to come into force on 1 June 1853. In fact, it never came
into effect. No sooner had it passed into law than the lobby against it began.
Petitions calling for the repeal of the new law flooded in from nearly every
county in the province. And the legislators were disposed to listen. Perhaps
they had, after all, been just a little too hasty. The Legislative Assembly
depended mainly on customs duties for its disposable revenue and duties on
rum alone represented over one third of that revenue.[52] It was at this stage
that the women of New Brunswick mobilized for action. Women who had
never before signed a petition took up their pens. They begged their legisla-
tors not to repeal the new law. Men had achieved the law; the women were
determined to keep it.[53]

After the election of 1854, temperance advocates, many of them women,
redoubled their efforts. Through the medium of petitions, they urged their
newly elected assembly to enact yet another law "to prevent the importation,
manufacture and sale of all intoxicating liquors within this province". Sun-
bury prohibitionists, for example, addressed three separate petitions to their
legislators in 1854. Those petitions contained no less than 915 signatures, and
488 of those names were female.[54] Three hundred and seventy-five (77 per
cent) of these women were living in the county when the census was taken in
1851.[55] They represented well over 30 per cent of the county's 846 families.
One hundred and fifty-five of these women (just over 40 per cent) were mar-
ried and the majority of them (95) petitioned with their husbands and
children. Thus, fathers and sons signed the petition from "the male inhabi-

52 Chapman, "The Mid-Nineteenth Century Temperance Movement", p. 44.
53 Women from both Charlotte and Sunbury participated in the 1853 campaign against
 the repeal of the act. See the index of the *Journal of the New Brunswick House of As-
 sembly*, 1853, which refers to: Petition 366, Lucinda Garcelon, Clara A. McAllister,
 Margaret Robinson and 300 others, female inhabitants of Charlotte, and Petition 386,
 Israel Smith, Thomas H. Smith, Esq. and 996 others of Sunbury and York. Other pe-
 titions for Charlotte which might well have numbered women among their signatories
 include: Petition 318 from Charlotte County, Petition 354 from St. Andrews and Pe-
 tition 355 from St. George. None of the above has survived in the PANB.
54 RG 4, RS 24, 1854/Pe 394, 1854/Pe 395, 1854/Pe 404, PANB.
55 Manuscript Census for Sunbury County, N.B., 1851, PANB.

tants of Sunbury County" while mothers and daughters were signing the pe-
tition from "the female inhabitants of Sunbury County". Often fathers
signed on behalf of their sons, and mothers on behalf of their daughters. Oc-
casionally parents included the names of very young children on the petition:
16 of the daughters listed were under ten years of age in 1854 (see Table One). In
very rare cases, one parent signed both petitions on behalf of the entire fam-
ily, but these amounted to less than five per cent of the total signatures.

Typical of those who signed as families were the Carrs of Burton Parish.
Free Will Baptists, they were prepared to take a stand on the prohibition
issue. Mary Ann Carr, who was 44 in 1854, signed the petition on behalf of
herself and her daughter Louisa, who was 17; Huldah, at 24, signed on her
own behalf. Mary Ann's husband, William, 11 years her senior, a farm owner
and operator, also signed the petition, as did their 21-year-old son, Alexan-
der. Sarah and Andrew Smith also supported the call for a new prohibitory
liquor law. Sarah was 42 in 1854, while Andrew was 49. Like the Carrs, they
were Free Will Baptists and farm owners. Their three oldest children, Fran-
ces, 23, George, 19, and Abigail, 17, joined their parents in supporting the
petition. Similarly, Margaret Nason, a 34-year-old weaver, her farmer hus-
band, and her two sons, aged 14 and 15, all signed. Residents of Lincoln, they
were, like the Carrs and the Smiths, Free Will Baptists. Augusta Perley's fam-
ily was less typical. Her husband, George, a 47-year-old Maugerville farmer,
had signed a petition urging temperance legislation in 1852. In 1854, Augus-
ta, then 38, joined him in his fight for the cause, as did their daughters, Mary
Frances, 19, and Charlotte, 17, and their eldest son, Walter, 15. The Perleys,
however, were one of only 23 Episcopalian families to sign the petition.

Although 60 married women signed the petition even though their hus-
bands had not, the majority of these women did not sign alone. For example,
Gertrude Harris, the wife of a Blissville farmer, signed the petition without
her husband, but her three eldest children, Thomas, 17, Mary, 14, and Han-
nah, 12, signed with her. Like the majority of Sunbury signatories, the
Harrises were Free Will Baptists. Mary Glasier, the Irish-born wife of a Lin-
coln lumberman, signed the petition on behalf of her 13-year-old daughter,
Melissa, as well as herself; her mother, Catherine O'Brien, also signed. The
Glasiers were Methodists, a group that provided close to 20 per cent of Sun-
bury's petitioners. Some married women signed alone, independent of their
families as well as of their husbands. Among them was Ann Tosh, the 26-
year-old wife of an Irish labourer in Sheffield. Such women were, however,
usually strengthened by religious as well as moral conviction. Ann Tosh, for
example, like so many other signatories, was a Free Will Baptist.

Almost 60 per cent of the female signatories were not married. Eight
were widows, while the remaining 212 were single. Of the single women, 68

per cent signed with one or both of their parents. While the majority of married women who signed were between 30 and 39 years of age, the single women signatories were somewhat younger on average. Typical of the young single women who signed were Alice and Mary Ann Patterson, aged 31 and 27 respectively. Both were dressmakers, living with their parents, a dressmaker and a tenant farmer, and their three younger brothers. All the members of this family signed. Margaret Barker, 24, and her sister Mary, a 21-year-old schoolmistress in Sheffield Parish, signed the petition along with their widowed mother and elder brother. A farm family, they were Congregationalists. The five daughters of William Smith, Phebe, aged 30, Mary, 27, Hepzedah, 23, Adeline, 21, and Sarah, 20, all signed, as did their brother Steven, aged 26. Not surprisingly, they were Free Will Baptists. Yet their older brother and their father did not sign.

Denominational affiliation could be determined for only 71 per cent of the 303 Sunbury families.[56] Baptists, Methodists and Congregationalists were slightly over-represented among signatories, while Roman Catholics were significantly under-represented. Thus, women who belonged to Protestant evangelical sects were more likely to sign temperance petitions than were women of other denominations. However, in Sunbury County, where over 50 per cent of the families were Baptist and the numbers of other denominations were small, patterns among the other denominational groups prove difficult to discern with any degree of precision.

The wives and daughters of labourers were under-represented among petition signatories from Sunbury, but so, too, were the wives and daughters of artisans. In contrast, farm families were significantly over-represented. Thus, while 56 per cent of the work force classified themselves as farmers in 1851, 71 per cent of the female petitioners were the wives or daughters of farmers. The occupations of some of the women signatories were also listed in the census. These included five weavers, three dressmakers, four schoolmistresses, a trader and four servants.

On the whole, then, the women who signed the Sunbury petitions of 1854 were very ordinary women, unremarkable within their community. The average signatory was relatively young, between 20 and 29 years of age, and was likely to sign with some other member of her family. Like the majority of her contemporaries, she was probably part of a farm family and attended

56 These included 61.7 per cent of Sunbury's 488 women petitioners. Information concerning religious denomination was drawn from the Manuscript Census for 1861, PANB. Thus, almost 40 per cent of all female signatories had removed from their parish of residence by 1861, suggesting that women petitioners were not likely to be more geographically stable than were their contemporaries.

either a Baptist or Methodist Church. Although she had never before signed a petition to the legislature, she was prepared to stand up and be counted in support of her beliefs or those of her parents or friends. She may not have been either sophisticated or worldly, yet her interests and knowledge extended beyond the domestic sphere. The action she took was a decidedly political one and it would be difficult to argue, at least in the case of any of the 109 women over the age of 20 who signed the petition independent of any husband or parent, that she did not understand the principle behind that action. And, for one brief moment, her action had the desired effect, for in 1855, the legislature did pass yet another prohibitory liquor act.

Of course, the women of Sunbury did not achieve their goal single-handed. In 1854, at about the same time as the people of Sunbury were presenting their petitions, a second "monster petition" was presented to the House of Assembly. It was far longer than the petition that had so impressed the legislators back in 1852; this petition included over 20,000 signatures. Moreover, it suggested more broadly based support. Whereas the signatories of the earlier "monster petition" had been drawn largely from Saint John City and County, this time they came from at least half of the 14 counties of New Brunswick, although not from Sunbury. Well over half of the 20,000 signatories were women, including 143 women from Hillsborough in Albert County, and 198 women from Charlotte County, 93 from St. Stephen Parish and 105 from the parish of St. Andrews.[57]

The patterns that emerged in Sunbury were repeated in Hillsborough. Eighty per cent of Hillsborough's women signatories were living in the parish when the census was taken in 1851.[58] They included representatives of more than one-quarter of the parish's families. Forty-eight were married women, while a further six were widows (see Table Two). The husbands of 28 of these women could be identified as having signed temperance petitions in the past. Elizabeth Steeves was typical of the married women who signed. Her husband George, a Baptist farmer descended from the Pennsylvania Germans who had settled the parish in the previous century, had signed temperance petitions to both his local county council and the provincial legislature in the past. Now his wife, joined by her two daughters and her daughter-in-law (aged 28, 26 and 26 respectively), signed the "monster petition" of 1854. Margaret Duffy was the wife of the Baptist minister. Although her husband was an Irish immigrant, she was of German descent and had been born and raised in the parish. She and her daughters, Jane, 22, Theora, 12, and Margaret, 10, added their names to the petition. Mary Gross also

57 RG 4, RS 24, 1854/Pe 465, PANB.
58 Manuscript Census for Albert County, N.B., 1851, PANB.

traced her roots to the original German settlers. She, too, was a Baptist. In the past, her husband Robert had signed temperance petitions and now she and her daughters, Ruth, 18, Hannah, 14, and Anne, 12, took up their pens. Dillah Steeves and her husband shared a common background, but he was not, apparently, as interested in the temperance cause as his wife. While her farmer husband never signed a temperance petition, Dillah, at age 48, signed her first. Her daughters, Elizabeth, 23, and Jane, 17, signed with her.

Of the 61 single women who signed, 48 were the daughters of temperance advocates. Isaac Milton, a Baptist farmer, had signed a petition calling for prohibition in 1851. In 1854, his daughters, Ruth, 21, and Mary, 20, joined the campaign. Elizabeth Steeves, 25, and her sister Permelia, 22, the daughters of a widowed farmer who had, in the past, been a temperance advocate, also added their names. They, too, were Baptists. Occasionally women signed independent of parents or siblings. Twenty-one year old Jane Boyd signed the petition despite the fact that no one else in her large family signed with her, but Jane was exceptional. Only 13 of the 61 single women signatories identified could claim to have taken a stance independent of their parents. As was the case in Sunbury, the wives and daughters of the farmers of Hillsborough were over-represented among the signatories: although only 59 per cent of the parish's families were headed by farmers, 72 per cent of the women signatories came from farm families. The Baptists were again significantly over-represented.[59] While Baptists comprised 76 per cent of the parish population, fully 92 per cent of the Hillsborough women who signed the "monster petition" of 1854 were Baptists. Many were descendants of the original German settlers who had begun immigrating to the parish from Pennsylvania as early as 1765. On the whole, then, the Hillsborough women were a more cohesive group than the Sunbury women, although their demographic profile is very similar.[60]

The Charlotte County signatories, drawn mainly from the two major towns in the county, were a more diverse group of women. They were also

59 Religious affiliation was drawn from the 1861 Manuscript Census for Albert County, PANB. Fully 72 per cent of Hillsborough's female signatories were located in the 1861 census. In this case, marriage records were used to trace those women who may have removed to another parish within the county. This, coupled with the tendency to greater geographical stability within Albert County as a whole, accounts for the high rate of record linkage for Hillsborough.

60 It should be noted, however, that the Hillsborough Baptists were quite different from the Sunbury Baptists. While the Hillsborough Baptists traced their roots back to the religious traditions carried as part of their cultural baggage by the original Pennsylvania German immigrants, Sunbury Baptists had been strongly influenced by the New Light movement of the late 18th century.

more mobile. Of the 260 women who signed either the "monster petition" or another petition calling for prohibition in 1854, only 63 per cent had been living in the county when the census taker called in 1851.[61] The women were older on average than the women in either Hillsborough or Sunbury. Forty-eight per cent of the signatories were married, while a further six per cent were widows. The majority of the married women ranged in age between 30 and 50, while the majority of single women who signed were in their twenties (see Table Three). In Charlotte County, the temperance movement was clearly a middle-class movement, attracting supporters from the families of professional men, merchants and skilled artisans as well as from the most prosperous farm families.

In St. Stephen, many of the most prosperous members of society belonged to the Congregational Church and a high proportion of these were temperance advocates. Mary and Frances Porter, daughters of George M. Porter, one of the wealthiest lumber merchants in the county, signed the "monster petition". Mary Ann Murchie also signed: her husband, James, listed himself merely as a farmer in the census, but he was much more than that, controlling nearly 20,000 acres of land. Charlotte Hitchings, another signatory, was the wife of a lawyer. Her daughter Frances, then 17, also signed, as did Mary and Louisa Todd, the daughters of a local merchant. All these women were Congregationalists.

In St. Andrews, the picture proved somewhat more varied. Ann Berry, a Scottish-born Presbyterian, was the wife of a house carpenter. Her husband, Thomas, had signed a temperance petition as early as 1848. In 1854, she and her daughters, Helen, 23, and Isabella, 13, followed his example. Jane McCracken was an Irish-born Presbyterian. A 43-year-old widow, she made her living as a dressmaker. Her sister Susan, also a widow, and her niece lived with her: they, too, were dressmakers. Elizabeth Clark, 35, and her daughter Jane, 17, were Methodists, a denomination often associated with the temperance cause; yet there is no record of Obadiah, the 40-year-old mariner who was husband to Elizabeth and father to Jane, ever having signed a temperance petition. Perhaps he was too much away at sea to find time for such things. Like the Clarks, Christiana Stevenson, an American-born immigrant, was a Methodist. But her husband, Robert, a tanner and currier, and his brother, Hugh, had both signed temperance petitions to the legislature in 1848. Elizabeth Harvey, the wife of a ship's carpenter, was an Episcopalian who supported the great crusade; she was 33 in 1854. Just 22 in 1854, Mary Stickney, the young wife of a watchmaker, was, like Elizabeth Harvey, an

61 RS 24, 1854/Pe 220 and 1854/Pe 465, PANB; Manuscript Census for Charlotte County, N.B., 1851, PANB.

Episcopalian who rallied to the temperance cause. None of these women was unusual among St. Andrews' petitioners, who were drawn largely from among Presbyterians, Methodists and Episcopalians, and represented many of the families of the skilled craftsmen of the parish. Women like Ann Chesty, the 26-year-old daughter of an Irish-born Roman Catholic labourer, were rare indeed among the signatories.

The Charlotte County experience raises questions about the role of religion in determining which women would prove most likely to support the movement. The representation of a particular religious denomination among the Charlotte County petitioners seems to have depended on organization. In St. Stephen, Congregational Church women proved the most likely to sign although Congregationalists comprised only five per cent of the total population of the parish. In St. Andrews, Presbyterian and Methodist and, surprisingly, Episcopalian women predominated. The tiny contingent of signatories from St. Patrick were almost exclusively Baptist (nine of 12 families). Were petitions passed around at church meetings? If so, the denominational affiliation of the majority of signatories in any single parish may well be accidental. Nonetheless, in comparing the denominational affiliation of the women who signed petitions calling for prohibitory liquor legislation with the denominational affiliation of the men who signed petitions calling for the repeal of such legislation, clear trends do emerge. Roman Catholics and Episcopalians were over-represented among the repeal petitioners. And while Episcopalians were only slightly under-represented among the women petitioners, Roman Catholic signatories were rare indeed.[62]

The typical Charlotte County woman signatory was married or widowed and was between 30 and 50 years of age. She lived in one of the two major towns in the county and was solidly middle-class, the wife of a relatively prosperous merchant or artisan. Her daughters were likely to sign with her. She might be a Congregationalist, a Presbyterian, a Methodist or possibly an Episcopalian, but whatever her religious faith, she would be joined in the temperance crusade by other members of her local congregation.

As significant and impressive as the petition campaign was, the petitioners did not comprise a majority of the adult population of the province. And the 1853 act had not proved popular. Thus, it is scarcely surprising that the newly elected government proved reluctant to act. Early in November, how-

62 Information concerning the religious affiliation of petitioners was drawn from the Manuscript Census for Charlotte County, 1861, PANB. Denominational affiliation was determined for 81 of the 115 families identified. These included 113 women in all, just 43.5 per cent of the county's 260 female petitioners. Charlotte County was characterized by a high degree of geographic mobility during this period and female temperance petitioners were not atypical in this regard.

ever, a vote in the House of Assembly went against the government and the government of the day resigned. The lieutenant-governor called upon the Liberal opposition to form a government; and among the leaders of this new government was Samuel Leonard Tilley, a man who had recently been chosen Most Worthy Patriarch of the Sons of Temperance in North America.[63] Shortly thereafter, in the parliamentary session of 1855, Tilley put forward, as a private member, a new prohibitory liquor bill, which passed narrowly in the House of Assembly and in the Legislative Council. Despite personal reservations, the lieutenant-governor, John Manners-Sutton gave his assent on the advice of his Executive Council and the act was scheduled to become law on 1 January 1856.

For a brief moment it seemed as if the fight had been won. But, as was the case in 1853, agitation for repeal began almost immediately. Petitions opposing the new law poured in. No women were among the signatories of these petitions.[64] After a brief, ineffectual attempt to enforce the act, the legislators gave up. Yet they did not repeal the act. The lieutenant-governor demanded that they either repeal it or enforce it and the entire issue became so controversial that the lieutenant-governor forced a dissolution of the house and yet another election was called. Shortly after that election, which was held in 1856, the act was repealed. The temperance fight, for the moment at least, was over.

Even though the fight was ultimately lost, the role women played in it is highly significant. The very fact that two prohibitory liquor acts were passed demonstrates the power of the petition as a political tool in mid-19th- century New Brunswick. Petitions and petitioners were taken seriously. Nor was it suggested that women had less right than men to petition their legislature. There is no evidence to suggest that women's signatures carried any less weight than men's.[65] By analysing the women signatories, we can gain new

63 Chapman, "The Mid-Nineteenth Century Temperance Movement", p. 53.

64 This is not so surprising as it might appear. Women were not involved in repeal campaigns in the United States, either. In general, 19th-century women saw drinking as a male vice and sought to reform men. Epstein, *The Politics of Domesticity*, pp. 1, 110; Tyrrell, *Sobering Up*, p. 181.

65 In discussing women signatories of the "monster petition" of 1852, Mr. Hatheway, the representative for York County, argued that women's signatures on petitions were "a sufficient reason" for passing the Liquor Bill then before the house. He believed a politician needed "the good opinion of the fair portion of the community" and declared that he "would always rather have one lady canvasser than a dozen men". *Reports of the Debates and Proceedings of the House of Assembly of the Province of New Brunswick* (Fredericton, 1852), p. 101. In the 1854 debates, while some members questioned the signatures of "children in schools", the right of women to sign was generally accepted. Indeed, the majority of those who rose in the house to comment on the 1854

insights concerning 19th-century politics and political culture. It is true that wives and daughters of men who signed repeal petitions are rarely to be found among the signatories calling for prohibition. At the same time, almost half of the married women who signed petitions were not joined by their husbands in their fight for the cause. Moreover, there is some indication that mothers were more influential than fathers, for sons proved twice as likely to follow their mothers in signing temperance petitions as they were to follow their fathers in signing repeal petitions. But daughters were even more likely to follow their mothers' lead than were sons. More important than any of these considerations, the women's decisions to take up their pens in the cause of temperance when they did, demonstrates that women had followed the political progress of the temperance legislation and were prepared to take a public political stand on an issue they believed to be important. And in many cases their stand was quite independent from that of their husbands.

Of those inhabitants who petitioned the Legislative Assembly during the 12 years covered by this study, women represented only a very small minority. Thus, while female petitioners from each of the three counties numbered in the hundreds, male petitioners numbered in the thousands. Nonetheless, in Sunbury, the county for which the most complete records are available, women from over 30 per cent of the families listed in the 1851 census signed at least one petition to their legislature during the period. Petition signatories included women of all ages, all classes, all ethnic and religious groups. But no matter what their age, ethnicity, religious denomination or economic status, the very fact that significant numbers of women signed petitions is historically important. Women did not have the right to vote in the mid-19th century. Yet, in New Brunswick, at least, women were not passive and they were not silent. Many understood the law and were determined to make it work for them. They petitioned for pensions and subsidies to which they were legally entitled and, from time to time, they petitioned for redress of personal grievances. Most were successful in achieving their ends. Many more women became politically active during the decade, seeking, through the medium of petitions, to influence their government to change the law. Working in concert with others of like mind, they effectively demonstrated their power to persuade, although ultimately they failed to achieve their goal.

bill argued that 30,000 signatures in favour of the bill, as opposed to 4,000 against, was strong evidence of the public feeling. *Reports of the Debates and Proceedings* (1854), pp. 70-3. Similarly, American and British legislators attacked the validity of children's signatures on temperance petitions but did not question the signatures of non-voting women for, as the women themselves argued, "although they did not themselves vote, their husbands did, and their husbands would be heeding the advice of their spouses". Harrison, *Drink and the Victorians*, p. 229; Tyrrell, *Sobering Up*, pp. 279-80.

Whether they petitioned as individuals or in association with others, whether they were seeking to change the law or merely to use it, whether they succeeded or failed, these 19th-century New Brunswick women had stepped outside the domestic sphere and into the world of politics. Their lives had a political dimension and, by exercising their rights as subjects under the Crown, they helped to shape the political culture of their province.

TABLE ONE
Sunbury County: Women Temperance Petitioners by Signing Category and Age Group

AGE	Wives whose husbands signed	Wives whose husbands did not sign	Widows	Daughters signing with one or both parents	Daughters whose parents did not sign	Other women signatories	Totals	% of women petitioners
0-9	–	–	–	16	–	–	16	4
10-14	–	–	–	37	11	–	48	13
15-19	–	–	–	45	13	2	60	16
20-29	14	12	–	38	20	11	95	25
30-39	28	20	1	8	4	5	66	18
40-49	21	14	1	1	–	–	37	10
50-59	20	10	1	–	–	–	31	8
60-69	9	3	3	–	–	–	15	4
70-89	3	1	2	–	–	1	7	2
TOTALS	95	60	8	145	48	19	*375	100
% of women petitioners	25	16	2	39	13	5	–	100

*Women identified in the 1851 census (77 per cent of all women signatories)

TABLE TWO
Albert County: Women Temperance Petitioners by Signing Category and Age Group

AGE	Wives whose husbands had been temperance advocates	Wives whose husbands had not been temperance advocates	Widows	Daughters whose parents were temperance advocates	Daughters whose parents had not been temperance advocates	Other women signatories	Totals	% of women petitioners
0-9	–	–	–	5	3	–	8	7
10-14	–	–	–	12	1	–	13	11
15-19	–	–	–	15	3	–	18	16
20-29	8	6	–	16	3	2	35	30
30-39	7	3	–	–	1	–	11	10
40-49	8	7	1	–	–	–	16	14
50-59	3	3	–	–	–	–	6	5
60-69	1	1	2	–	–	–	4	3.5
70-89	1	–	3	–	–	–	4	3.5
TOTALS	28	20	6	48	11	2	*115	–
% of women petitioners	24.5	17.5	5	41.5	10	1.5	–	100

*Women identified in the 1851 census (80 per cent of all women signatories)

TABLE THREE
Charlotte County: Women Temperance Petitioners by Signing Category and Age Group

AGE	Wives whose husbands had been temperance advocates	Wives whose husbands had not been temperance advocates	Widows	Daughters whose parents were temperance advocates	Daughters whose parents had not been temperance advocates	Other women signatories	Totals	% of women petitioners
10-14	–	–	–	5	1	–	6	4
15-19	–	–	–	16	11	2	29	18
20-29	3	5	–	19	12	3	42	26
30-39	10	15	2	2	3	–	32	19
40-49	16	15	3	–	–	–	34	21
50-59	6	4	4	–	–	–	14	8
60-69	2	3	2	–	–	–	7	4
TOTALS	37	42	11	42	27	5	*164	–
% of women petitioners	22	26	7	26	16	3	–	100

*Women identified in the 1851 census (63 per cent of all women signatories)

MARRIED WOMEN'S PROPERTY LAW
IN NOVA SCOTIA, 1850-1910

PHILIP GIRARD & REBECCA VEINOTT

At first glance, 19th-century changes in married women's property law in the English-speaking world appear to reflect the demise of separate spheres ideology and the triumph of sexual egalitarianism within the marital economy. The common law's construction of the husband as "public" administrator of all marital assets and the wife as their "private" and passive beneficiary gave way to the legislative regime of separate property, which viewed husband and wife as independently and equally capacitated to acquire, administer and dispose of their own property. Appearances can be deceiving, however, as this essay will argue with reference to the adoption of separate property for married women in Nova Scotia.

The Nova Scotia experience is worthy of study because of the extent to which reform was propelled for much of the 19th century by conservative rather than liberal conceptions of the family. That this development occurred with the apparent support of Nova Scotia women sits uneasily with much of the existing literature, which tends to assume that a "harsh" common law was distrusted by women yearning for the adoption of separate property. The Nova Scotia experience makes us aware that in some jurisdictions at least, the application of liberal economic principles to family life possessed little appeal for much of the 19th century. Simultaneously, it reveals a perception by contemporaries that the conservative idea of the family, based on familial responsibility rather than individual independence, was capable of being transformed to serve the interests of women and children. Finally, it urges us to reconsider whether an explanatory paradigm based upon a movement from separate spheres to sexual equality adequately captures the dynamic of law reform in this instance.[1]

Most recent histories of married women's property legislation, informed by an explicitly feminist approach to the question, begin their analysis with a

1 We regard this effort as a modest assault on what Judith Allen has called the Anglo-American hegemony in the field of feminist history: "Contextualising Late Nineteenth-Century Feminism: Problems and Comparisons", *Journal of the Canadian Historical Association* (1990), pp. 17-36. We acknowledge with thanks the comments of Margaret McCallum, which helped improve this study.

lengthy catalogue of the defects of the common law.[2] This approach, in our opinion, may be misleading in at least two ways. Firstly, it suggests that these defects were as "obvious" to contemporaries as they are to modern-day historians, and thus that the chosen route to reform — adoption of the liberal concept of separate property — was inexorable and "correct". Secondly, by focusing only on the potential for abuse within the common law regime, this approach totally ignores those cases in which the common law achieved its goals — wise management of family assets to ensure societal reproduction — in an uncontroversial manner. Finally, there is a methodological problem in highlighting notorious "problem cases", which generate a definite paper trail, at the risk of overlooking the views of a possible "silent majority". A failure to address these issues will cause particular difficulty in the Maritime context, where full separate property was not implemented until later than in most jurisdictions. Unless we are content to adopt the thought-stopping explanation of "Maritime conservatism" for this development, we need to understand what appealed to contemporaries — men and women alike — about the common law regime. Thus we begin with an analysis of what was "right" about the common law of matrimonial property before proceeding to consider what, eventually, was deemed to be wrong with it.

The common law doctrine of marital unity — that the husband and wife constituted but one person in the eyes of the law — led to the vesting of sole control over all the wife's property in the husband during his lifetime. This legal rule was usually justified by appeals to an ideology of separate spheres, according to which the man, "by his education and manner of life, has [usually] acquired more experience, more aptitude for business, and a greater depth of judgment than the woman".[3] Yet this formally patriarchal rule was tempered by colonial attitudes which viewed the family as a community. The family was considered as an economic unit, and recognition of separate interests for the husband and wife was considered undesirable as a potential threat

2 Constance Backhouse, "Married Women's Property Law in Nineteenth-Century Canada", *Law and History Review*, 6 (Fall 1988), pp. 211-57; Peggy A. Rabkin, *Fathers to Daughters: The Legal Foundations of Female Emancipation* (Westport, Conn., 1980); Linda E. Speth, "The Married Women's Property Acts, 1839-1865: Reform, Reaction or Revolution?", in D. Kelly Weisberg, ed., *Women and the Law, A Social Historical Perspective, Vol. II: Property, Family and the Legal Profession* (Cambridge, 1982); Norma Basch, *In the Eyes of The Law: Woman, Marriage and Property in Nineteenth Century New York* (Ithaca, 1982); Lee Holcombe, *Wives and Property: Reform of the Married Women's Property Law in Nineteenth Century England* (Toronto, 1983).

3 Peregrine Bingham, *The Law of Infancy and Coverture* (London, 1816), p. 162. See also Susan Staves, *Married Women's Separate Property in England, 1660-1833* (Cambridge, 1990), p. 25.

to the common familial interest and a possible encouragement to defraud creditors. The Nova Scotia jurist Beamish Murdoch resolved these tensions by regarding the husband as a sort of trustee for the family's income and assets. He wrote in 1832 that the general principle of the English law was to treat the spouses'

> joint earnings and acquisitions, and the rents and profits of their real estates [as] *a united fund for the benefit of them and their family*, nominally the husband's property, and actually under his direct control, and liable for all the debts of the husband, for all those of the wife before coverture and for the necessary support and that of their children, during the coverture.[4]

This focus on the husband's responsibility rather than his rights suggests that the common law position was not as "harsh" as is often thought.

The fact that the husband was the sole legal point of contact with the outside world does not mean that all economic decisions were necessarily made pursuant to his fiat. He had the power to be a despot, and many men clearly were, but the extent to which marital practice in general reflected this power must remain an open question in the absence of further research. Evidence of such attitudes is difficult to find precisely because they were so fundamental, but a glimpse of the community basis of marital property can be gleaned from Mary Ambuman's 1799 divorce petition. Although Nova Scotia's divorce law provided only for alimony, Mary asked that a "certain portion of the Real and Personal Estate of [her husband] equivalent to her fortune which he had with her . . . be set apart for [her] sole and separate use", revealing her own perceptions, as well as those of her counsel, R.J. Uniacke, about her entitlement.[5]

We must not forget the considerable influence of wide networks of kinship, community and religion in encouraging socially responsible behaviour. Twentieth-century conceptions of the family as a primary zone of privacy must be set aside when we turn to the largely rural society of 19th-century Nova Scotia. Nor must we forget the extent to which rural Maritime women in particular were key contributors to the family economy. Rural women wove cloth, while women in towns and urban centres took in boarders, sometimes in astonishing numbers, to supplement family income.[6] A long

4 Beamish Murdoch, *Epitome of the Laws of Nova Scotia* (4 vols. Halifax, 1832-33), vol. II, p. 28. Emphasis added.

5 RG 39, series "D", vol. 1A, no. 10, Public Archives of Nova Scotia [PANS]. As with many of the early petitions for divorce, the outcome is unknown.

6 Janine Grant and Kris Inwood, "Gender and Organization in the Canadian Cloth Industry, 1870", in Peter Baskerville, ed., *Canadian Papers in Business History*, vol. I

tradition of occupational pluralism in the Maritimes, which by no means died out with industrialization, reinforced the role of women in contributing whatever they could to the family economy.[7] It is no doubt true that market-oriented factors of production tended increasingly to be dominated by men.[8] An observer of the domestic economy in mid-century rural Ontario has reminded us, however, that while women were certainly subordinated, factually and legally, "the fact of subordination was partially, if not wholly, mitigated by [an] environment which cast women in a central role in the farm family's struggle to improve, and endure".[9]

In agricultural societies not fully participating in a wage economy, the theory and practice relating to matrimonial property probably coincided tolerably well. The family farm could not normally be sold without the wife's consent, but wages were a different story.[10] An increasing reliance on cash, wages and consumer goods led to enhanced possibilities for abuse by husbands. The problem was not the basic assumption that the income of all family members should be spent for family purposes. Rather, the fault lay with the vesting of exclusive and unfettered economic authority in the husband. The law assumed good faith on the part of husbands and provided no recourse for wives (or children for that matter) to ensure that the income

(Victoria, 1989). Sheva Medjuck, "Family and household composition in the 19th century: the case of Moncton, N.B. 1851 to 1871", *Canadian Journal of Sociology*, 4, 3 (1979), pp. 275-86, found that as many as 35 per cent of all Moncton households had boarders in 1851, although this figure fluctuated dramatically according to the number of immigrants.

7 L.D. McCann, "'Living the Double Life': Town and Country in the Industrialization of the Maritimes", in Douglas Day, ed., *Geographical Perspectives on the Maritime Provinces* (Halifax, 1988). See also the examples given by Margaret Conrad, "'Sundays always make me think of home': Time and Place in Canadian Women's History", in Veronica Strong-Boag and Anita Clair Fellman, eds., *Rethinking Canada: The Promise of Women's History* (n.p., 1986).

8 Marjorie Griffin Cohen, *Women's Work, Markets and Economic Development in Nineteenth-Century Ontario* (Toronto, 1988).

9 David Gagan, *Hopeful Travellers: Families, Law and Social Change in Mid-Victorian Peel County, Canada West* (Toronto, 1981), p. 90.

10 Even if the husband had sole title to the farm, the law recognized the wife as having an eventual dower interest should she survive her husband. She thus had to "bar her dower" by signing any conveyance by the husband to a third party, and statute law provided that she be separately examined by a magistrate to ensure that her consent was genuine: *Revised Statutes of Nova Scotia* [RSNS] (1851), c. 111. This statute was carried forward in subsequent revisions until its repeal in 1884, when its provisions were incorporated into the Married Women's Property Act of that year. Dower is defined in the text following note 12.

from the couple's joint work or assets was actually applied for the benefit of the family. Beamish Murdoch's notion that the husband might be considered a trustee of the wife's and children's assets remained a theoretical insight which never attracted the sanction of legal enforceability. The reasons for this gap between the ideal and the actual are not hard to discern. Allowing the wife to question formally the husband's administration of their assets would not only interfere with his freedom of disposition, but would also encourage a clash of spousal wills which traditional legal and marital theory said had to be settled by the husband in any case.

If the modernization of the Nova Scotia economy led to enhanced possibilities for "active" economic abuse, it also led to a similar increase in "passive" economic abuse: desertion. Increasingly after 1850, out-migration left many female-headed households to fend for themselves. Whether the husband departed against the family's wishes or with their encouragement, the woman left behind was in a sort of legal limbo as far as the family's assets were concerned. As in a number of other jurisdictions, it was the problem of the deserted wife which first impelled Nova Scotia to re-examine the traditional common law precepts regarding matrimonial property.[11]

These precepts were succinctly contained in the Blackstonian adage that "in law husband and wife are one person, and the husband is that person". In legal theory, married women lost the capacity to contract and were deprived of all control over any real property for the duration of the marriage. The husband could not, however, dispose of the wife's realty. If the wife survived her husband the land reverted to her control; if she predeceased him it passed to her heirs at law, subject to her husband's curtesy.[12] If he predeceased her, she would be allotted her dower, a life interest in one-third of all freehold property which the husband had ever possessed during the marriage.[13] Movable property became her husband's absolutely on marriage, the sole exception being the wife's paraphernalia — clothing, jewellery and other personal ornaments.

In addition to the loss of economic power, a married woman also lost her legal status and personal autonomy upon marriage. Her husband became her legal representative in virtually all actions and remained responsible for all her antenuptial debts, contracts or torts, as well as being responsible for her actions during marriage. A married woman was also required to take her hus-

11 See below, text accompanying note 24.

12 Curtesy was a life interest accorded to the husband in all realty which his late wife possessed at her death, provided issue of the marriage had been born alive.

13 Murdoch, *Epitome*, vol. II, pp. 97-104. See also "Of the Writ of Dower", *RSNS* (1851), c. 138.

band's domicile. Thus if a man chose to move from Nova Scotia to New Brunswick and his wife refused to accompany him, her action constituted legal desertion. Furthermore, her husband was legally permitted to use "reasonable" means to ensure her wifely obedience. These measures included the right to verbally chastise her and to confine her against her will.[14]

There is evidence that some married women in Nova Scotia did chafe at the restrictions of coverture. As early as 1757, Elizabeth McManus, who had been deserted by her husband, pointed out in her complaint to the Executive Council the disadvantages which married women encountered:

> Your complainant while under coverture is in a much worse condition than any single person such being at liberty to pursue any lawful means for a living and can compel such as are indebted to them in payment. Your complainant at present cannot.[15]

Hannah Cupples, a widow who had inherited some property from her father and her first husband, fought constantly with her second husband over money matters. In her divorce petition, filed in 1838, she alleged that he had withdrawn £200 paid to her account with agents in Dartmouth and collected rents from a house she owned, all without consulting her. A constant pattern of physical and economic abuse finally drove her to the divorce court.[16]

Cupples was illiterate and had not sought to protect herself prior to her second marriage by establishing a marriage settlement. Other women did use equitable doctrines by which property could be settled upon a married woman to her separate use. It has often been assumed that marriage settlements were initially unknown in Canada,[17] but our research has revealed a number of instances where the device was used. A sample of 21 marriage settlements which came before the Nova Scotia Supreme Court in Halifax

14 Holcombe, *Wives and Property*, p. 30. Holcombe notes that until the late 17th century the law permitted husbands to beat wives for failing to fulfil their duties. For a discussion of the Nova Scotia Court of Divorce and Matrimonial Causes' attitude to wife-beating see Kimberley Smith Maynard, "Divorce in Nova Scotia, 1750-1890", in Philip Girard and Jim Phillips, *Essays in the History of Canadian Law: Vol. III, Nova Scotia* (Toronto, 1990); and James Snell, "Marital Cruelty: Women and the Nova Scotia Divorce Court, 1900-1939", *Acadiensis*, XVIII, 1 (Autumn 1988), pp. 3-32. For a personal account see Lorna Hutchinson, "'God Help Me for No One Else Can': The Diary of Annie Waltham, 1869-1881", *Acadiensis*, XXI, 2 (Spring 1992), pp. 72-89.

15 Executive Council Minutes, 2 February 1757, RG 1, vol. 210, p. 278, PANS.

16 Hannah Elizabeth Cupples v. Samuel Cupples (1830), William Young Papers, MG 2, vol. 765, PANS.

17 Peter Ward, *Courtship, Love and Marriage in Nineteenth-Century English Canada* (Montreal and Kingston, 1990).

County between 1866 and 1893 reveals a wide variation in the types and value of property held on trust and also in the circumstances leading to the creation of the settlement. The trusts contain land alone, money or financial instruments alone, and mixed funds. The total value of the property ranges from a single city lot worth $500 to a fund of $20,000, and the occupations of the husbands and fathers of the women involved cover the whole social spectrum. Although merchants and men of the professional classes predominate, a plasterer, a truckman and a bookkeeper also appear among the husbands.[18]

This overview suggests that the use of marriage settlements in Nova Scotia may have conformed more closely to the more "democratic" pattern of the United States than to English usage, where settlements were restricted to the well-to-do. Despite their apparent availability, however, settlements could hardly be considered an adequate remedy for the potentially detrimental economic consequences of marriage for women at common law. It did not aid women, such as Hannah Cupples, who lacked the legal knowledge or means to effect a settlement. Furthermore, since the terms of settlement were in the discretion of the parties, women could be left with no control over the property. As illustrated by one case in our sample, in such circumstances the woman might be forced to rely, like other married women, on the generosity of her relatives and friends and the good will of creditors.[19]

Early attempts to pass married women's property legislation in Nova Scotia prior to the first act of 1866 have been discussed by one of us elsewhere.[20] In brief, the pattern was similar to that described by Backhouse in Ontario, where a number of early bills — some implementing full separation

18 The data base used for this sample is not comprehensive. It consists only of a subset of Supreme Court cases (RG 39, series "C", PANS) involving non-contentious trust and family matters (appointment of new trustees, guardians, etc.). Marriage settlements may also have come before the courts when disputes arose between husbands and wives or in disputes involving third parties, but the absence of a subject index for the Supreme Court records made such research impossible. A more comprehensive data base is available in the records of the Registry of Deeds and also in probate records, but these records were too vast to use in this study. Although the sample presented here is admittedly small, it is believed that it is representative, as marriage settlements were probably not widely utilized in the province. The only contemporary comment available with respect to the frequency of marriage settlements is provided by Justice Meagher, who stated that marriage settlements were rare in Nova Scotia. See Archibald v. Archibald (1903), 40 *Nova Scotia Reports [NSR]* 406, p. 409. For fuller analysis of these settlements see Rebecca Veinott, "The Changing Legal Status of Women in Nova Scotia 1850-1910", M.A. thesis, Dalhousie University, 1989, pp. 10-21.

19 *In Re* Eliza Alice Weir (1890), RG 39, series "C", vol. 392, no. 2546, PANS.

20 Philip Girard, "Married Women's Property, Chancery Abolition and Insolvency Law Reform in Nova Scotia, 1820-1867", in Girard and Phillips, *Nova Scotia Essays*, pp. 83-92.

of property — failed before a more circumscribed reform bill succeeded. In Nova Scotia, the boldest bill was the earliest: an 1855 attempt to copy New York's separate property reform of 1848. This bill would have secured to married women complete title and control over all their real and personal property and would have allowed women not supported by their husbands to carry on business in their own names after giving public notice. Further bills followed, in 1857, 1858, 1862 and 1865, but all failed and all retreated in some way from the initial effort of 1855.

It is perhaps a portion of the bill of 1857, passed by the Legislative Council[21] but not the Assembly, which best expresses the dominant strand of opinion on the married women's property question from the 1850s through the 1870s. It is apparently a homedrawn bill, not copied from a wealthier, worldlier jurisdiction, and its language is simple and direct. Section 3 allowed a woman who had to support herself and her family because of her husband's "drunkenness, worthlessness or other cause" to control and dispose of any property acquired during such a period.[22] This is the language of morality and family responsibility, not the language of independent and equal spouses pursuing their individual goals. It was this language which spoke most directly to Nova Scotians, legislators and citizens alike. Protecting the wife's assets from her husband's creditors was an idea with a certain attractiveness for the mercantile classes. For most of the population it reeked of fraud on creditors and did not accord with the common perception of marriage as a community.[23] The desire to reform the law by stripping it of "feudal" trappings also motivated some legislators, as revealed by their adoption of the international feminist rhetoric comparing marriage to slavery.[24] Such views were not widespread, however, and it is not clear that the women's groups which were beginning to coalesce in the province ever supported this vision of feminism during the 19th century.

Economic fluctuations may have been a factor in the adoption of the earliest legislation on married women's property, but it was more likely the increasing tide of out-migration and deserted wives which played a key role, rather than concern over debtor and creditor relief as such. Nor can one discount the possibility of a desire to encourage deserted wives to keep their families off poor relief.

It was against this backdrop that the Act for the Protection of Married Women was passed in 1866. It did not reproduce the provisions of the earlier

21 Nova Scotia had a bicameral legislature until 1928.
22 RG 5, series "U", vol. 25, PANS.
23 See below, note 37 and text following note 40.
24 See the examples given in Girard, "Law Reform in Nova Scotia", p. 91.

bills that would have given women complete ownership of their property. In their place was a law which would protect only the property of deserted wives from their husbands and the husbands' creditors. Furthermore, such protection could be secured only after the Supreme Court had determined to its satisfaction that the woman was deserted and that "the same was without reasonable cause".[25] In addition, the legislators provided a mechanism whereby the husband or his creditors could apply to have the protection order removed. Those who had relied upon the order were protected, for the discharge was not retroactive.

The fact that the 1866 legislation obliged a deserted woman to obtain a court order meant that it would probably affect only a small number of women. Indeed, records have been found for only six women who applied for a protection order between 1866 and 1884.[26] Although the data base is not large, the files are reasonably complete and thus provide an accurate picture of the circumstances in which women applied for and received protection orders.[27] The circumstances of the women who sought protection orders highlight their vulnerability under the common law and underscore the importance of the 1866 legislation. Women who married unscrupulous or financially irresponsible men encountered severe economic hardships. In the absence of a protection order, they faced financial ruin.

All of the women who sought protection orders were members of the working or middle class. Table One gives the occupational breakdown of the women and their husbands. The husbands for whom occupational information is available were small business owners or skilled workers, but none was

25 *Statutes of Nova Scotia [SNS]* (1866), c. 33, s.2.

26 This figure is based on an examination of the surviving Supreme Court records for all the counties in Nova Scotia for which indices exist and which are housed at PANS. As such, it is undoubtedly under-representative. All of the applications for protection orders which were discovered came from Halifax County.

27 The cases in which women sought protection orders are: *In Re* Application for Protection Sarah Healey (1869), Halifax Supreme Court Records, RG 39, series "C", vol. 245, no. 9642, PANS. Hereafter records will be referred to by name, volume and number only as all records are contained in the Halifax Supreme Court Records. For the protection order see Halifax County Registry of Deeds, 8 January 1869, reel 968, PANS. *In Re* Martha DeChevery (1871), vol. 258, no. 11610, PANS. It is unknown whether she received a protection order. *In Re* Emily Wakefield (1874), vol. 282, no. 29091/2a. The protection order is contained in Sinclair v. Wakefield *et. al.* (1880), 13 *NSR* 468. *In Re* Property of Louisa Tracy (1874), vol. 287, no. 4000a. It is unknown whether she received an order. In the Matter of Maria Breslow (1874), vol. 288, no. 4377a. The protection order is contained in the case file. *In Re* Ellen Gertrude Greening (1881), vol. 336, no. 11645a. The protection order is contained in the case file.

financially successful. All had financial problems and left their wives with few resources at the time of desertion.

Table One underscores how difficult it was for these women to obtain a livelihood after their desertion. Apart from a lack of job skills or work experience, family demands may have played some role in these employment decisions. Four of the women had children, making it difficult for them to work outside the home.[28] The limited resources of the women can be seen most clearly in the description of the property which they sought to protect from their husbands' creditors (see Table One).

TABLE ONE
Occupation of Husband and Wife / Nature of Property Subject to Protection

*Year	Name	Occupation		Property
		Husband	Wife	
1869	Healey	?	keeps house of entertainment	leasehold property and premises, furniture, cash and other unspecified property
1871	DeChevery	dentist	none	$1,000 in bank account and other unspecified property
1874	Tracy	?	keeps boarding house	$600 of unspecified personal property
1874	Wakefield	former auctioneer commission merchant	runs boarding house and day school for girls	household and school furniture
1874	Breslow	wage labour (episodic)	keeps boarding house and shop	$3,300 comprising the remainder of the estate of her first husband
1881	Greening	former master mariner, in prison	keeps boarding house	personal property and the property necessary to run her business

*Indicates the year in which the protection order was sought.

Most of the women were successful in obtaining their protection orders. In the four cases for which the outcome is known, the protection order was granted. It is not known whether Louisa Tracy or Martha DeChevery received an order. The procedure was very expeditious, once a woman had received a court hearing. Sarah Healey, Emily Wakefield and Ellen Greening each received her order within three days of applying to the court. Maria Breslow, however, had to wait six months for her order because her husband contested the application — the only husband to do so in the sample.[29]

28 Maria Breslow, Sarah Healey, Louisa Tracy and Emily Wakefield.
29 For further discussion of these cases see Veinott, "Changing Legal Status", pp. 27-38. Backhouse discusses Sinclair v. Wakefield in "Married Women's Property Law in Nineteenth Century Canada", pp. 219-21.

The 1866 act was based on an explicit protectionist rationale which involved the holding out of a state agent — a Supreme Court judge — as a person who would defend virtuous, deserted women from exploitative creditors and husbands. Nonetheless, the idea that the state had a right and a duty to intervene to protect the economic interests of the weaker party within the family sphere represented a significant break with traditional notions of male authority. Under the common law regime, the court's power was limited to supporting marital authority within the family. The act of 1866 began to redefine the state's role as active intervener in the spousal relationship, rather than passive conservator of marital right.

This new appreciation of the state's role in spousal and family relations also appears in the context of temperance agitation. Fear of the economic irresponsibility of alcoholic husbands eventually led to demands for legal reforms which parallelled shifts in married women's property law. Aside from purely religious organizations, temperance groups were probably the earliest and most important forms of female collective action in the province. Although the Woman's Christian Temperance Union was only formed in the 1870s, petitions submitted by earlier all-female temperance groups survive from at least 1840.[30] Their language reveals a female population which accepted prevailing notions of women's separate sphere but used that very ideology to justify their intervention and bolster their arguments. These petitioners argued that women's competence in domestic management could entitle them to authority over the entire domestic economy (including the husband's assets) in appropriate cases.

Thus in 1847 the women of the Guysborough and Manchester Temperance Society declared that on any ordinary topic of legislation, "it would be their duty to abstain from any interference, but viewing the subject . . . as of vital importance to the moral, social and religious interest of the Community, and as deeply affecting even the female portion thereof", it was their duty to speak out.[31] A decade later the women of Lower Londonderry also apologized for speaking out, reassuring the legislature that they felt "no dissatisfaction with the peculiar sphere in society allotted to their Sex". Rather, they acted out of a sense of "cruel injustice all the more intolerable

30 RG 5, series "P", no. 13, PANS contains an 1840 petition from 82 women from Cumberland County who "would consider their happiness in this world consummate if the Monster alcohol was banished [from] our land".

31 RG 5, series "P", vol. 9, no. 108, PANS. On the world view of female petitioners, see Gail Campbell, "Disfranchised but not Quiescent: Women Petitioners in New Brunswick in the Mid-19th Century", in this volume.

because perpetrated in the name of Law and clothed with the high authority of the Legislature". They also urged that the property of the confirmed drunkard "should be under legal charge and protected for the benefit of creditors and relatives in the same manner as the property of those who are of unsound mind".[32] By the 1860s, petitions for an inebriates' home became frequent, and in 1875 an Act to provide for the Guardianship and Cure of Drunkards attempted to meet both sets of demands.[33] The government licensed the Grove Inebriate Asylum in Dartmouth[34] and provided a procedure for the interdiction of "habitual drunkards" under which their wives or sons (only males were to be admitted) could be appointed guardians of their estate. In a striking departure from the doctrine of marital unity, section V of the act specifically provided that the wife of an interdicted man was to have all the statutory powers of a guardian of the estate of a lunatic. This reform was more radical than the 1866 statute, since it allowed a married woman to manage not just her own property but also that of her husband.

This brief digression into the temperance movement illustrates the nature of the reforms in the family economy demanded by an important section of 19th-century Nova Scotia women. It is surely significant that we find no petitions from women demanding the adoption of separate property while we find many advocating prohibition, including specific measures designed to curb the economic irresponsibility of alcoholic husbands. It is also significant that these petitions came almost exclusively from rural and outport women, not from metropolitan women.[35] For these women petitioners, the *abuse* of the husband's economic authority was the problem which needed to be addressed. The *fact* of it was not a major concern during a healthy marriage, presumably because of a shared belief that marriage was a community rather than an association of two individuals. Thus the demand for separate estates for all married women was not a vocal, or even perceptible one, prior to the 1880s.

No further initiative on the issue of married women's property was taken again until 1884 when the Hon. Mr. William Pipes introduced a bill to amend

32 RG 5, series "P", vol. 11, no. 136, PANS.

33 *SNS* (1875), c. 24.

34 Judith Fingard, *The Dark Side of Life in Victorian Halifax* (Porters Lake, N.S., 1989), pp. 122-4. The Grove Asylum apparently did not last beyond 1879. Curiously, spouses were forbidden from acting as guardians for each other after the passage of the first Married Women's Property Act, *SNS* (1884), c. 94, s. 86. The English legislation did not contain any such prohibition.

35 Few womens' historians in Canada have ventured beyond the urban context, a tendency criticized by Margaret Conrad, "The Re-Birth of Canada's Past: A Decade of Womens' History", *Acadiensis*, XII, 2 (Spring 1983), pp. 140-62, p. 149.

and consolidate the law relating to the separate property and the rights of property of married women. The bill passed with only minor amendments and became law on 19 April 1884. The measure was an extremely lengthy one at 100 sections, making it possible to discuss only the most important provisions of the bill. It reflects a compromise between conservative and liberal conceptions of the family and confusion over the appropriate role of the state in intra-familial disputes. The act emulated in many respects the liberal thrust of the separate property reforms which had been consummated in the English act of 1882. Thus, it gave a woman who had married prior to the act the right to

> have, hold and enjoy all her real estate not on or before such date taken possession of by her husband, by himself or his tenants, and all her personal property, not on or before such date reduced into the possession of her husband; whether such real estate or personal property shall have belonged to her before marriage, or shall have been in any way acquired by her after marriage, otherwise than from her husband, free from his debts and obligations contracted after such date, and from his control of disposition without her consent, in as full and ample a manner as if she were sole and unmarried.[36]

Women who married after the act came into force had similar rights, excluding the initial proviso in favour of the husband. Women were made liable for their ante-nuptial contracts and torts; husbands continued to be liable for them only to the extent that they benefited from the receipt of property from their wives upon marriage. Women were also given the right to hold separate bank accounts and to will their property.

The bill eliminated many of the disabilities which women experienced under coverture, but it attempted to strike a fine balance between giving women greater rights and protecting husbands and creditors. Many provisions thus upheld a more conservative view of the family. For example, a woman could hold and enjoy her earnings and carry on her own business only where her husband gave his consent in writing, which was to be filed with the registry of deeds. For those women establishing separate businesses, such consent also had to be filed with the clerk of the municipality or district in which she carried on her business. This elaborate consent procedure greatly reduced the impact of the act for working-class women while protecting husbands and creditors.[37] Most working-class women possessed very little if any real

36 *SNS* (1884), c. 12, s. 3.
37 A crucial question is whether working-class couples were generally aware of the

property, and their personal property consisted predominantly of household belongings and necessary clothing and personal articles. Their wages represented their main form of property, and property purchased with those wages might not have been considered separate under the act unless the husband's consent had been filed. Finally, the fact that the husband remained responsible for his wife's post-nuptial contracts and torts, to the extent that they could not be satisfied by her separate property, continued the common law tradition of marital unity.

Although many of the act's provisions were paternalist in nature, in one case the conservative conception of the family was used to enhance the position of married women. The mechanism of protection orders was expanded to give deserted wives the right to receive the income of their minor children, free from the claims of absent or incompetent husbands. Schooling was only compulsory for children under the age of 12, and the wages of adolescents may well have kept female-headed households from disaster in some cases.[38]

What was the impetus for the enactment of this legislation? Certainly the leadership of other jurisdictions played some role. The English act of 1882, which instituted full separation of property, served as a catalyst to reform in much of the common law world. Yet, the Nova Scotia legislation was modelled on an 1859 Ontario act and on the English act of 1870 rather than more recent, and more liberal, legislation in those jurisdictions.[39] It did not simply reproduce the provisions of either piece of legislation; instead, Nova Scotia legislators adapted these initiatives to the local context. The fact that Nova Scotia chose to adapt the earlier, more circumscribed married women's property acts of those jurisdictions indicates the province's continuing defence of the conservative conception of the family, but it does not negate the influence of the English example in creating a climate favourable to reform.

Economic factors may also have played a role in the province's adoption of a married women's property act at this time, as the National Policy changed the face of the Nova Scotia economy. The textile industry was a major growth area during the late 1870s and the 1880s, and the high concentration of female workers in that industry may have prompted concern that women have some protection for their wages. The value of this explanation is undermined, however, by the fact that few married women worked for wages

changes in the law, and the extent to which they utilized the provisions relating to the wife's wages and separate business. A sample of these consents is analysed in Veinott, "Changing Legal Status of Women", pp. 45-8. Newspaper research revealed editorial concern about the high numbers of consents registered in 1892, allegedly as a means of avoiding creditors. *Acadian Recorder* (Halifax), 3 May 1892, 19 November 1892.

38 *RSNS* (1884), c. 29, ss. 75-87.
39 *Statutes of Ontario* (1859), c. 34; 33 & 34 Vict. (1870), c. 93 (U.K.).

outside the home even by 1890, and that those who did were required to file their husbands' consent before their wages were protected.[40] The significance of the rapid industrialization of the province in the 1880s lies in a more general result of that phenomenon which in turn had an impact on married women's property: the transformation in attitudes towards debt.

Nova Scotia legislators clung with some tenacity to the practice of imprisonment for debt, reflecting societal attitudes towards indebtedness which prevailed in the province prior to Confederation.[41] Where the family unit was concerned, the perception was deeply ingrained that household debts, although contracted by the husband alone, were incurred on the credit of both spouses' assets, as well as any income of the children. This practice reflected not so much the power of an oppressive clique of creditors, as a widespread belief that family debts should be exigible on family assets. Where New Brunswick had completely shielded the wife's assets from the husband's creditors as early as 1851, and Ontario had provided a partial shield in 1859, Nova Scotia would not protect the assets of non-deserted wives until 1884; even this protection was partial and would not be complete until 1898. Insofar as separate property for all married women (not just deserted wives) involved some departure from traditional notions of family responsibility, reform had to await a more general evolution in attitudes toward debt and debtors. The reconceptualizing of debt as involving social responsibility as well as individual ineptitude or moral failing had in turn to await the transformation of the Nova Scotia economy after the adoption of the National Policy.

It is thus no coincidence that the 1880s — the decade when the stimulus of the National Policy was most strongly felt in the provincial economy — saw the adoption of three pieces of "debtor relief" legislation: the Married Women's Property Act of 1884, the Joint Stock Companies Act of 1883, which made limited liability available as of right to corporations, and the final abolition of imprisonment for debt in 1890. The latter move in particular had been debated and rejected for nearly seven decades, while automatic limited liability for corporations had been fended off for nearly 40 years.[42]

40 D.A. Muise, "The Industrial Context of Inequality: Female Participation in Nova Scotia's Paid Labour Force, 1871-1921" *Acadiensis*, XX, 2 (Spring 1991), pp. 3-31.
41 Girard, "Law Reform in Nova Scotia", pp. 92-105.
42 Peter Baskerville has argued that the creditors' lobby was an important factor in the adoption of married women's property legislation in B.C.: "'She has already hinted at board': Enterprising Urban Women in British Columbia, 1863-1896", Paper delivered at the Atlantic Studies/BC Studies Conference, St. John's, Newfoundland, 21 May 1992. Similar links may exist in Nova Scotia, but they have not been discovered by us. It is possible that the effect of the 1880 decision in Sinclair v. Wakefield alarmed credi-

The relaxation of attitudes toward debt provided a necessary but not a sufficient condition for further reform. Changing attitudes respecting the role of women in society undoubtedly gave another important boost to the enactment of a married women's property law in 1884, but they were refracted through a rather different lens in Nova Scotia. Elsewhere in Canada, in England and in the United States feminists lobbied fiercely for married women's property legislation during the mid-19th century.[43] It has not been possible, however, to tie the Nova Scotia legislation to any similar lobbying efforts within the province. No petitions on the subject were presented to the legislature. One cannot be conclusive on this point because of the absence of records for the Woman's Christian Temperance Union before 1890. However, it would not be surprising if the group was unenthusiastic about separate property; as the major maternal feminist organization in the province, its philosophy favoured a maternal/protectionist rather than a liberal approach to married women's property.

The real feminist subtext to the 1884 act was the nascent female suffrage movement in the province.[44] The act owed its passage to a rather odd alliance of pro-suffrage legislators, who favoured the liberal solution to the married women's property issue advocated by the international anglophone feminist movement, and the large anti-suffrage group within the assembly. The emergence of a pro-suffrage group became clear during the 1884 session when the House of Assembly also had to consider a Bill to Allow Unmarried Women and Widows to vote at Municipal Elections and Elections for School Trustees. When that bill was debated a number of members spoke out in its favour. One member, the Hon. Mr. John McNeil, even argued that the bill did not go far enough and suggested that the provincial and federal franchises should be extended to women because "he believed that so long as [women] paid taxes and exercised the other rights of citizens, they should enjoy all the

tors and made them feel that a reform more fundamental than that of the 1866 act was necessary. In the case of Sinclair a creditor was left exposed when the Nova Scotia Supreme Court decided that an existing protection order was discharged automatically by renewed cohabitation with the husband which was known to the creditor.

43 See Holcombe, *Wives and Property*; Backhouse, "Married Women's Property Law", pp. 223-4; and Speth, "Reform, Reaction or Revolution?".

44 See the two essays by E.R. Forbes in his recent collection *Challenging the Regional Stereotype: Essays on the 20th Century Maritimes* (Fredericton, 1989): "Battles in Another War: Edith Archibald and the Halifax Feminist Movement" and "The Ideas of Carol Bacchi and the Suffragists of Halifax". Both are excellent, but neither examines the rural debate over suffrage. For a corrective see Rebecca Veinott, "Women as Citizens" (unpublished manuscript, 1989, on file with the authors).

rights and privileges of citizenship".[45] These sentiments were echoed in subsequent debates of the 1880s on the issue of women's suffrage in both the council and the assembly. A growing number of members of the government shared the view of the Hon. Mr. Henry Goudge that women should no longer be denied rights purely on the basis of sex.[46]

Despite the presence of small groups of supporters of women's rights in the legislature, the majority of legislators had not yet embraced feminism. However, even the most vehement anti-feminists agreed that women deserved protection within marriage, despite the fact that affording them such protection entailed weakening the common law doctrine of marital unity. Hence, the progress of the married women's property bill through the legislature provides a striking contrast with the bills of the 1850s and 1860s. Whereas the earlier bills had met with serious opposition, the 1884 bill had the whole-hearted support of the legislature in principle and received little substantive debate.[47]

The debates which were conducted underscored the theoretical differences between those who advocated the legislation in order to promote women's equality and those who supported the legislation in order to protect women. During the bill's third reading, the Hon. Mr. J.W. Longley (a stalwart defender of separate spheres for men and women and the foremost opponent of women's suffrage during the 1890s) objected to a clause which would have required women having separate property to support their pauper husbands. The Hon. Mr. Alexander Campbell supported Longley, arguing that the clause "was not in accordance with the general object of the bill, which was designed for the protection of married women and their property".[48] The offending clause was accordingly struck out. A similar situation arose with respect to another clause which required women having separate property to maintain their children. This clause, however, remained intact as it was considered reasonable that a woman should be required to

45 These arguments paralleled those made on behalf of blacks who were seeking equal access to public education in Halifax in the 1880s. See Judith Fingard, "Race and Respectability in Victorian Halifax", *Journal of Imperial and Commonwealth History*, 20, 2 (May 1992), pp. 169-95.

46 *Debates of the Legislative Council of Nova Scotia* [*DLC*] (1886), p. 43.

47 There was very little debate in the House of Assembly, and none whatsoever in the Legislative Council. The bill also does not appear to have excited the interest of journalists. An examination of the *Morning Chronicle* (Halifax), the *Acadian Recorder* and the *Novascotian* for the months of February and March 1884 failed to turn up any editorial comment. The only mention of the bill occurred in the papers' verbatim coverage of the debates of the House of Assembly.

48 *Debates of the House of Assembly of Nova Scotia* [*DHA*] (1884), p. 78.

bear such responsibility, provided that her "husband was not relieved from the same duty".[49] In addition, a disagreement arose when it was proposed that women should no longer be exempt from imprisonment for debt. The Hon. Mr. Jason Mack stated that "it was hard, when the House was moving in the direction of the protection of the female sex, that the House should take away one of the protections which they had hitherto enjoyed".[50] Although some members argued against continuing women's special status in this area, claiming that it was purely "a matter of business" that women should face the same penalties as men, Mack prevailed and women remained exempt from imprisonment for debt.[51]

The incongruities of the 1884 legislation undoubtedly owed much to compromises between those who espoused liberal views with respect to women's rights and those who held more conservative views about the family and women's role within it. The liberal conception of the family upon which the English act was based, which emphasized the autonomy and economic independence of husband and wife, probably had few supporters in Nova Scotia. The conservative conception of the family, which stressed the subordination of wives and the responsibility of husbands, was more widespread. Nova Scotia legislators kept the English act's core "liberal" feature of separate property during marriage, but persisted in seeing this as providing protection for the wife rather than autonomy. Indeed, in the 1884 act they carefully provided for some continuing marital authority in the case of wage-earning and entrepreneurial wives, and grafted on other provisions which blunted the more radical liberal features of the English legislation.

Judicial interpretation of the 1884 act was uneven. The fundamental alteration of the common law which it represented, coupled with its hybrid character, made it difficult for judges to interpret and apply. As it was not merely a copy of legislation from another jurisdiction, there were no ready-made precedents which could be easily followed. In addition, the attitudes of judges respecting married women's property law had been formed over years of study, practice and judicial decision-making under the common law doctrine. The Nova Scotia Supreme Court's decisions respecting the act were, for the most part, quite technical and were framed by a literal interpretation of the act. As a result, the decisions tended to favour husbands and creditors.

The main impediment to a progressive approach in the interpretation of the legislation came in the form of a Supreme Court of Canada decision in

49 *DHA* (1884), p. 79.
50 *DHA* (1884), p. 104.
51 *DHA* (1884).

the case of Crowe v. Adams.[52] The case was an appeal from the majority decision of the Nova Scotia Supreme Court in which it was held that where property was seized by a sheriff from a married woman carrying on business in her own name to satisfy her husband's judgement creditor, the sheriff must prove the judgement in order to defend against an action by the married woman. Judge Townshend in a dissent held that it was unnecessary for the sheriff to prove the judgement. "It was for the plaintiff to clearly prove, in making out her case, that she acquired the property otherwise than from her husband".[53] The Supreme Court of Canada agreed with Townshend. As Judge Strong stated,

> Prima facie goods in the actual possession of the wife of an execution-debtor are the goods of the latter. It lies on the wife to show if she can that they are her separate property, that is her property under the statute law or under the doctrines of courts of equity as to the separate property of married women.[54]

This decision was subsequently followed by the Nova Scotia Supreme Court,[55] and it imposed a heavy onus on women seeking the protection of the act.

The most important Nova Scotia Supreme Court decision under the 1884 legislation came in 1895 in Foster v. Hartlen, for it eventually led to an amendment to the act which greatly extended the powers of married women over their property. The action was brought against a husband and wife by a workman who sought to recover payment for work done upon a house which the wife held as separate property. The workman held a promissory note made by the husband and endorsed by the wife, and he sued on the note. The court held that the creditor could not succeed against the wife. In reaching this conclusion the court relied heavily upon the decision of the Supreme Court of Canada in a similar case under the Ontario statute of 1859.[56] The court held that because the separate property of women (other than that established by marriage settlement) was the product of statute, a woman could only charge it to the extent provided for by statute. Since the statute did not give married women a general power to enter into contracts, the wife had no power to endorse the note.[57]

52 Crowe v. Adams (1892), 21 *Supreme Court Reports* [SCR] 342.
53 Adams v. Crowe (1892), 26 *NSR* 510.
54 Crowe v. Adams, pp. 344-5.
55 Cormier *et al.* v. Mattinson (1895), 27 *NSR* 354.
56 Moore v. Jackson (1893), 22 *SCR* 210.
57 Foster v. Hartlen (1895), 27 *NSR* 357, pp. 361-2.

As a result of the case, the Hon. Angus McGillivray introduced a bill modelled on the English act, to consolidate and amend the acts relating to the property of married women in 1897. He argued that Nova Scotia should adopt legislation similar to the English act of 1882, as Nova Scotia's act was considered unworkable by the courts. He emphasized that the English act had been in place for many years and that the court had decided many issues with respect to the provisions and application of the law. Thus, he concluded that "the house would be safe in following the provisions of that act".[58] Although the bill passed the house, it was given the three-month hoist by the council. Rather than leave further action to a future session, McGillivray introduced an amendment to the 1884 act which would enable a married woman to enter into contracts with respect to her separate property and to sue or be sued in contract or tort without her husband being joined in the suit. The amendment passed both the house and the council.

McGillivray succeeded in his object of bringing the English legislation to Nova Scotia in 1898. The Married Women's Property Act of 1898 was virtually identical to the English act of 1882. It gave a married woman the right to acquire, hold and dispose of both her real and personal property as if unmarried and incorporated the 1897 provision enabling a woman to enter into contracts with respect to her separate property and to sue and be sued in both contract and tort. The two major provisions of the act remedied some major shortcomings of the 1884 legislation. Women were no longer required to have the consent of their husbands in order to be entitled to their wages and earnings, though consent was still required if they proposed to carry on a separate business. This was a major advance for working-class women whose earnings comprised their major form of property. In addition, the provision preventing women who had committed adultery from enjoying the benefits of the 1884 legislation was not incorporated into this act. Thus women's rights in their property were no longer tied to moral purity.[59]

There does not appear to have been any feminist activity relating to the Married Women's Property Act of 1898, despite the fact that there were strong feminist organizations in place in the province at that time. The Woman's Christian Temperance Union does not appear to have undertaken any activity in this regard, nor did the Halifax Local Council of Women.[60] Both organiz-

58 *DHA* (1897), p. 102.
59 See Nolan v. McAdam (1906), 39 *NSR* 380, where a bigamous wife was able to claim dower from her first (true) husband upon his death.
60 A women's enfranchisement society was in operation in the province, but no records of the society survive. See the *Morning Chronicle*, 26 March 1895, p. 4.

ations were politically active, and both lobbied for legislation on behalf of women. This lack of activity is consistent with our earlier observations regarding the ambivalence of provincial feminists with regard to separate property. A further explanation, with respect to the Woman's Christian Temperance Union, might be that the members wished to focus their attention on women's suffrage. During the 1890s the organization was engaged in extensive lobbying campaigns in an effort to have the vote extended to women. It is possible that this was given priority with the view that other women's rights issues could be pursued after the vote was won. This conjecture is supported to some extent by the fact that at the second annual convention of the Nova Scotia Woman's Christian Temperance Union, held in October 1897, it was announced that the married woman's property bill had failed to pass. Members were called upon to pursue the vote even more diligently.[61]

The most interesting aspect of the enactment of the 1898 legislation was the general consensus within the legislature. On the issue of women's property there was no longer a gulf of opinion between feminists and conservatives. Indeed, the Hon. Mr. McGillivray, who introduced both the 1897 and 1898 legislation, was an opponent of women's suffrage. Yet his support for a married women's property act did not seem to him at all incongruous. As he stated:

> In voting against the bill for enfranchisement of women . . . he did not deny them any rights; he merely preserved them from those responsibilities which must be accepted as a condition of the right to exercise the franchise. While he was unwilling to impose these responsibilities upon women, he was prepared to support a measure which secured to them all the rights they should enjoy in connection with their property.[62]

This consensus emerged out of extensive debate on the rights of women, which centred predominantly on suffrage. Those who argued against a broader role for women could not deny that they were legally afforded an inferior status even within their "proper" sphere — at home.

61 Nova Scotia Woman's Christian Temperance Union, Second Annual report, October 1897, MG 20, vol. 356, PANS. Erna Reiss has noted that in England feminist efforts focused mainly on the vote at the end of the 19th century and left other issues to be dealt with after suffrage had been attained. See Erna Reiss, *The Rights and Duties of English Women: A Study in Law and Public Opinion* (London, 1939), p. 100.

62 *DHA* (1898), p. 103. Clearly he did not consider the right to have property represented at the electoral polls to be important.

As women sought access to political power, it is perhaps not surprising that both feminist and conservative legislators paid closer attention to the law respecting women's rights in other areas. The dramatic improvement, effected in 1893, to the rights of women to custody of their children, can also be traced to this consensus among both feminist and conservative legislators on the need to provide married women with a "bill of rights".[63] Faced with an increasing clamour that male legislators could not or did not represent women's interests, even conservative members of the assembly had to take action to preserve their legitimacy. J.W. Longley, the bête noire of women's suffrage, pointed to the enactment of the married women's property legislation of 1884 as proof that women's exclusion from the franchise was not to their disadvantage, for the legislature was actively protecting their interests.[64]

Increasing public support for feminist goals may have played some role in this regard. During the 1890s the legislature was bombarded by petitions in support of women's suffrage which included the signatures of many prominent men and women including members of the medical profession, university professors, lawyers, clergymen and merchants from various counties.[65] Furthermore, public debates were being held on the subject. In one such debate, students from Acadia College met students from King's College. The pro-suffrage Acadia team argued, among other things, that women's increasing role in the economy required that the franchise be extended to them — and prevailed in the debate.[66]

The judicial response to the 1898 act was favourable. Indeed, in some instances the Supreme Court adopted a purposive approach to the legislation. This is illustrated by the decision *In Re* Ruth Woolner White. The case involved an appeal from a decision in which Marion J. White, a married woman, was appointed the guardian of Ruth Woolner White, "a person of unsound mind".[67] The appointment was challenged on the grounds that a married woman could not act as guardian. The court found that married women could always act as trustees, though it was generally not considered advisable. In delivering the judgement of the court, Justice Drysdale stated:

Since the *Married Women's Property Act*, cap. 112 R.S., I am inclined to think that many of the objections formerly urged against the appointment of a married woman as a trustee have been swept away. A

63 Rebecca Veinott, "Child Custody and Divorce: A Nova Scotia Study, 1866-1910", in Girard and Phillips, *Nova Scotia Essays*.

64 *DHA* (1898), p. 203.

65 *DHA* (1893), p. 202.

66 *Morning Chronicle*, 18 March 1895, p. 5.

67 *In Re* Ruth Woolner White (1907), 42 *NSR* 248, p. 250.

married woman may now expressly accept a trust by virtue of her power to contract as a *femme sole*.[68]

The court was willing to consider the implications of the Married Women's Property Act in other areas of law relating to women's rights and capacities and to adopt a liberal approach to the legislation in its deliberations.

The triumph of liberal principles in the 1898 act also represented a new force for change in late Victorian Nova Scotia: the enhanced power and status of a more professional — and more anglophile — bar. Lawyers had always played a special, and sometimes resented, role in law reform, but their new professional orientation late in the century led to a change in that role. The new professional standards were reflected in what has been called the renaissance of the Nova Scotia bar after 1875.[69] Nothing is known about the actual drafting of the 1884 statute, but one need only compare its text with that of the act of 1866 and the unpassed bills of the 1850s and 1860s to observe that a major change has occurred. Relatively brief texts expressed for the most part in easily comprehensible, occasionally homespun, language were superseded by a mammoth statute replete with difficult technical terms. It is not surprising that there was little debate on the substance of the 1884 or 1898 bills, as non-lawyers (whether men or women) would have had difficulty seeing the forest for the trees. The social policy issues which had been so hotly debated at mid-century were now obscured by the screen of professional jargon.

Part of this enhanced professionalism involved a return in some (but not all) areas of law to imperial models, the English bar and judiciary being much admired by North American lawyers in the late Victorian period. In Canada, this meant that the easiest way to ensure assent to a piece of legislation was to suggest that it was modelled so closely on the relevant English act that any difficulties in its interpretation could be eased by reference to the English cases decided under it — a ploy used with great success in the passing of the Criminal Code in 1892.[70] The bar was not, of course, the sole repository of anglophilia during this heyday of British imperialism, and the lay public often followed willingly where the lawyers led.

This study has tried to approach its topic from a rather different perspective than that found in the existing literature. Rather than assume that the

68 *In Re* Ruth Woolner White (1907), 42 *NSR* 248, p. 252.
69 Philip Girard, "The Roots of a Professional Renaissance: Lawyers in Nova Scotia, 1850-1910", in Dale Gibson and W. Wesley Pue, eds., *Glimpses of Canadian Legal History* (Winnipeg, 1991).
70 D.H. Brown, *The Genesis of the Canadian Criminal Code of 1892* (Toronto, 1989), pp. 126-35.

common law of matrimonial property was uniformly harsh and archaic, or that the reform strategy which eventually prevailed was the only viable one, we have tried to discern whether, and why, the unreformed law might have inspired some allegiance among both men and women. The Nova Scotia experience, with its long insistence on the conservative or protectionist approach to reform, demanded that such questions be asked.

Such an inquiry presents particular problems, as people tend not to leave much direct evidence explaining precisely why they are happy with a given state of affairs. When they are unhappy, mountains of data (legal and otherwise) accumulate — thus the problem of a biased sample. The common law definition of matrimonial property was doubtless accepted by many without much thought as a customary part of married life. That acceptance was based largely on the prevailing view of marriage as a shared commitment involving more responsibilities than rights. Husbands who abused their economic rights were seen to represent individual moral failings rather than any deficiency in legal principle. Thus the essential demand of women in the temperance movement was for better husbands, not better laws. Laws regarding guardianship of incompetent husbands or protecting the earnings of deserted women were only required when the more general efforts at moral reform failed.

It is worth stressing that from at least the 1840s on, Nova Scotia women saw it as the state's responsibility to assist them in protecting themselves and their families from the economic and physical abuse of alcoholic husbands. Judith Fingard's study of the clients of the Nova Scotia Society for the Prevention of Cruelty has found this attitude still prevalent in the early 20th century.[71] Initially, provincial legislators were sympathetic to these demands (as in the 1866 and 1875 legislation), but increasingly they came under the sway of liberal elements in professional elites, aided and abetted by the strongly liberal ideals of the English feminist movement. In the end, demands of provincial women for more state intervention in the family economy were finessed by the shift to a new legal conception of the family, one which firmly removed the family from the public sphere and shunted it to the private. With the exception of the husband's duty to maintain his wife and the wife's continued claim to dower, the economic affairs of spouses remained essentially unregulated. The husband's formal monopoly over the family economy had been broken, but in substance it still remained because of his superior opportunities for education, income generation and wealth accumulation.

71 Fingard, *Dark Side of Life*, pp. 171-86, and see "The Prevention of Cruelty, Marriage Breakdown and the Rights of Wives in Nova Scotia, 1880-1900" in this volume.

The claims of Nova Scotia women to more control over the family economy, not just their own property, were ultimately stymied as the principle of formal economic equality between spouses became entrenched in provincial law.

"WIFE, MOTHER, SISTER, FRIEND"
Methodist Women in St. Stephen, New Brunswick, 1861-1881

HANNAH M. LANE

English immigrant Sarah Robinson was the wife of an Irish-born house-painter and the mother of a large family. Her death in 1861 inspired a lengthy obituary in the *Provincial Wesleyan*, which only briefly noted that she had faithfully discharged the typical roles of a 19th-century woman: "wife, mother, sister, friend". Her sister-in-law, Rebecca Robinson Cleland, died 15 years later and was also memorialized at length, with brief references to her domestic virtues. In both obituaries, the secular sphere of life was secondary to these women's spiritual pilgrimages as Methodist converts. Despite many "afflictions", Sarah Robinson had built "a superstructure of personal and social, experimental and practical piety". Rebecca Cleland's "spiritual history" closed with "her declarations of trust in the atonement of Christ, of peace with God, and hope of entering into rest, together with words of affectionate counsel to those around her death bed".[1]

The transformation of church history into the social and cultural history of religion has focused more attention on the experience of lay women.[2] Once largely male and clerical, the historical image of trans-Atlantic Methodism now includes the denomination's female founders, preachers and church workers.[3] But the nature of lay Methodism in a local setting has re-

1 *Provincial Wesleyan*, 13 February 1861, p. 2; 28 November 1874, p. 1. For their help with this paper, I would like to thank Nancy Burnham whom I consulted about Statistical Analysis Systems (SAS) programmes, T.W. Acheson, Gail Campbell and D.G. Thompson of the History Department at the University of New Brunswick. An early version of this paper was presented to the Atlantic Canada Workshop at Carleton University in Ottawa in August 1991.

2 See Ruth Compton Brouwer, "Transcending the 'unacknowledged quarantine': Putting Religion into English-Canadian Women's History", *Journal of Canadian Studies*, 27, 3 (Fall 1992), for a summary of recent scholarship.

3 See, for example, the essays in vols. 6 (1987), 7 (1989) and 8 (1988 and 1990) of *Papers*, Canadian Methodist Historical Society; John D. Thomas, "Servants of the Church: Canadian Methodist Deaconess Work, 1890-1926", *Canadian Historical Review*, 65 (1984), pp. 371-95; and Elizabeth Gillan Muir, *Petticoats in the Pulpit: The Story of Early Nineteenth-Century Methodist Women Preachers in Upper Canada* (Toronto, 1991).

ceived less attention. In inspiring relatively detailed obituaries in their de-nomination's newspaper, Sarah Robinson and Rebecca Robinson Cleland were exceptional among lay Methodist women. Most bequeathed no diaries to historians, nor were their religious lives much noted by contemporaries. For those whose lives can be glimpsed only through church and census rec-ords, their religious expression was social, not literary. Like their male counterparts, Methodist women occupied demographic roles in families and communities, while forming or unforming denominational ties. Part of a larger study of Methodist growth in St. Stephen, New Brunswick, during the third quarter of the 19th century, this paper explores the idealized and actual relationship between these roles and denominational affiliation.[4]

At first glance, the tribute to Sarah Robinson's "sacred and important duties" in the roles of wife, mother, sister and friend seems to reflect the "cult of domesticity" promoted in 19th-century Anglo-American print culture, a reformulation of long-standing ideology denoting "separate spheres" of in-fluence for men and women.[5] A shifting emphasis in Protestant clerical writings from woman as temptress to woman as redemptress had begun as early as the 17th century, and the belief that women were by nature or nur-ture more religious than men was easily accommodated by this reformula-tion.[6] The greater importance accorded in some denominations to "Christian nurture" over adult conversion further accented the spiritual role of mothers. Yet historians of women and economic life have contrasted separate spheres ideology with the more complex and shared social reality of women such as Sarah Robinson, who lived most of her life in a small farming and lumbering settlement.[7] So too must historians of religion reconsider ideology and beha-viour.

4 The themes of this paper are developed and documented more fully in Hannah Lane, "Re-Numbering Souls: Lay Methodism and Church Growth in St. Stephen, New Brunswick, 1861-1881", M.A. thesis, University of New Brunswick, 1993.

5 See Leonore Davidoff and Catherine Hall, *Family Fortunes: Men and Women of the English Middle Class* (Chicago, 1987), and several studies of New England Protestant-ism: Barbara Welter, "The Feminization of American Religion", in Mary Hartman and Lois Banner, eds., *Clio's Consciousness Raised*, (New York, 1973), pp. 137-55; Nancy F. Cott, *The Bonds of Womanhood: "Woman's Sphere" in New England, 1780-1835* (New Haven and London, 1977); Ann Douglas, *The Feminization of American Cul-ture* (New York, 1977); and Mary P. Ryan, *Cradle of the Middle Class: The Family in Oneida County, New York* (Cambridge, 1981).

6 Rosemary Ruether and Eleanor Mclaughlin, *Women of Spirit: Female Leadership in the Jewish and Christian Traditions* (New York, 1979), pp. 16-28.

7 Joy Parr, "Nature and Hierarchy: Reflections on Writing the History of Women and Children", *Atlantis*, 11, 1 (Fall 1985), pp. 40-2; Gail Cuthbert Brandt, "Postmodern

Relating the experience of St. Stephen's Methodist women to separate spheres ideology is not just evidentially challenging, but further complicated by the ambivalence concerning gender roles within Methodism itself. During the 1860s and 1870s, the Methodist weekly that memorialized Sarah Robinson and her sister-in-law often copied American articles reflecting separate spheres ideology. It also memorialized male Methodists such as Stephen Hill, who belonged to the same church as Sarah Robinson. His obituary ignored his career as a lumberman, but noted that he was "an affectionate husband, a tender parent, and . . . a kind and hospitable friend".[8] Just as domestic life was a footnote to evangelical piety in these obituaries, the view of gender as difference was only a subordinate theme in regional Methodism's own print culture, and one at odds with the prescriptive ideal of comprehensive evangelism and family religion. Confronted with the reality of women's greater church involvement, however, Methodist clergy sought this ideal by promoting "muscular Christianity", while validating the reality with the Methodist version of "evangelical womanhood". In this sense then, Methodist women's "seeming affinity for religion" was "socially constructed".[9]

But patterns of church membership among lay Methodists in St. Stephen show that church involvement was also self-constructed and that male and female relationships were "interactive". Church membership was not a socially timed rite of passage, but the experience of a minority. Male members were more likely to join the church while married and to join with or follow their female relations. Women — the majority of members — demonstrated greater independence than men in timing their memberships at any stage of life, either in association with or apart from their families. Although Methodism's appeal to women can be explained by cross-cultural theories of religion and by Methodist ideology, this appeal was ultimately associational, and thus dependent on lay church involvement. Methodism both expanded and sheltered women's sphere, holding public prayer meetings led by women and private all-female class meetings, providing unique opportunities for community and voice. In local church life, this "sphere was constructed both for and by women".[10]

Patchwork: Some Recent Trends in the Writing of Women's History in Canada", *Canadian Historical Review*, 72 (1991), pp. 445-58.

8 *Provincial Wesleyan*, 19 November 1857, p. 2.

9 Brouwer, "Transcending the 'unacknowledged quarantine'", p. 48.

10 Linda K. Kerber, "Separate Spheres, Female Worlds, Woman's Place: The Rhetoric of Women's History", *Journal of American History*, 75 (1988), p. 18.

Even the origins of Methodism in St. Stephen illustrate this point. Having gathered the first church within the parish in 1785, Duncan McColl shared with William Black in founding New Brunswick Methodism.[11] Yet their wives were remembered as leaders in their own right: "equally preeminent", their "conversation was always spiritual and beneficial to their sisters".[12] As in the rest of the province, local Methodism became part of the regional Wesleyan "conference", and by the 1860s, two circuits of class meetings and congregations encompassed nearly all of the parish.[13] The most densely populated and socially diverse part of the province outside Saint John, the parish of St. Stephen contained both inland settlements and villages along the St. Croix River bordering Maine. Despite their close proximity, the two largest of these incorporated as towns in the 1870s.[14] By 1861, the first census to include a question on religion listed one-quarter of the parish's 5,160 inhabitants as Methodists, constituting one-third of all Protestants. Those who named Methodism as their nominal census adherence and those who were Methodist church members between 1861 and 1881 form this study's major data base.[15] Family histories and Methodist marriage records traced the origins of Methodist women.[16]

11 For the early history of Methodism in St. Stephen see T.W. Acheson, "Duncan M'Coll", *Dictionary of Canadian Biography*, vol. VI (Toronto, 1987) and "Methodism and the Problem of Methodist Identity in Nineteenth-Century New Brunswick", in Charles H.H. Scobie and John Webster Grant, eds., *The Contribution of Methodism to Atlantic Canada* (Montreal and Kingston, 1992), pp. 107-23.

12 Stephen Humbert, *The Rise and Progress of Methodism in the Province of New Brunswick* (Saint John, 1836), p. 28.

13 Since the southeast corner of the parish belonged to the St. David circuit, the 1872 assessment for the Ledge and three directories were used to separate these households: RS 148/C14, Provincial Archives of New Brunswick [PANB]; *Hutchinson's New Brunswick Directory for 1865-66* (Saint John, 1865); *Hutchinson's New Brunswick Directory for 1867-68* (Saint John, 1867); and *Lovell's Province of New Brunswick Directory for 1871* (Montreal, 1871). Although the St. Stephen and Milltown circuits initially included parts of St. James, all analysis except that of Sunday school returns refers to Methodist churches within the parish of St. Stephen itself.

14 Graeme Wynn, *Timber Colony* (Toronto, 1981), p. 150; Harold A. Davis, *An International Community on the St. Croix (1604-1930)* (1950; rpt. Orono, Me., 1974), p. 249.

15 The key sources for the quantitative analysis are the 789 full or trial church members between 1860 and 1881. 1860 is the starting date because in both circuits 1859-60 was the first year of an itinerancy. These members included most but not all of the 82 lay leaders from the same period, as well as the 99 named adult baptisms between 1835 and 1881. Local Methodist church records exist on microfilm at the Provincial Archives of New Brunswick. The largest source consists of parish census data from both 1861 and 1871: all individuals who were ever a Methodist member, adherent, lay leader, or

Although Methodists constituted the oldest and largest religious group in St. Stephen, they also reflected the parish's religious diversity. Methodists included former, current or future adherents of the Church of England and of the two major strains of local Presbyterianism. They included Free Christian or Regular Baptists, Congregationalists, Universalists, Adventists and Swedenborgians. Even the Roman Catholics, the second largest group in the parish, included a few partly Methodist families.[17] In 1871, 344, or 30 per cent, of all households within the territory of the two circuits included wholly or partly Methodist families.[18] One-fifth of these families were divided in nominal census adherence, generally because of differences between adults, or, more rarely, among children over ten or between children and adults. Of 545 "ever" Methodist adult adherents present in both 1861 and 1871, one-third were listed as Methodists in only one census.[19] But despite transience and out-migration,[20] proselytism brought Methodism larger

who underwent adult baptism; the households in which these individuals lived; all household heads; and for 1871 only, individuals over the age of seven from all religious groups. These records were linked by hand and supplemented by information on origin from Robert F. Fellows, ed. *The New Brunswick Census of 1851: Charlotte County* (Fredericton, 1975), and on location within the parish from the three directories cited earlier and from *Map of St. Stephen and Calais from an Actual Survey by O.S. Osborn*, (Philadelphia, 1856). The Records of the St. Stephen Rural Cemetery 1856 to 1881 on microfilm at PANB provided information on origin, marital status, and death dates for many Methodist members.

16 County marriage records and marriage bonds were consulted for specific individuals. For family histories see I.C. Knowlton, *Annals of Calais, Maine and St. Stephen, New Brunswick* (1875; rpt. St. Stephen); D.M.L. Dougherty, *A History of Getchell Settlement-Mayfield* (privately printed c. 1988); Charles T. Libby, *The Libby Family in America* (Portland, Me., 1882); Rebecca Nichol, *Hannahs of the St. Croix* (Hartland, N.B., 1984); William Todd, *Todds of the St. Croix Valley* (privately printed at Mount Carmel, 1943); Hanson Family History, Elmer and Alice Hanson Collection, PANB; Getchell Family History, Mrs. Marion Getchell Collection, PANB; Hill/Grimmer Family History, Phil Grimmer Scrapbook, PANB; Tobin Family History, private possession of Graeme F. Somerville, Saint John, N.B..

17 This denominational flow, which worked both for and against Methodism, occurred in other denominations: of 710 household heads in either 1861 or 1871 who were linked to both census returns, roughly one fifth had changed their adherence.

18 These 344 were those in which the head, his or her relations, or a boarding family were Methodist adherents.

19 These 545 consisted of all those who were ever Methodist adherents residing within the two circuits who were over the age of 14 in 1861 or 24 in 1871.

20 Of 1,072 Methodists listed as over the age of 14 in the 1861 census or over the age of 24 in 1871, 35 per cent were listed in only one year (this and the following percentages are not corrected for mortality). Another 32 per cent were linked to records from two

shares of the parish population: 28 per cent of 6,515 in 1871, and 30 per cent of 5,899 in 1881.[21]

Methodism in these decades offered women a variety of liturgical, theological and associational options.[22] Methodist worship involved monthly open communion, the annual renewal of the covenant service and powerful hymnody, as well as simple preaching services and weekday prayer meetings. Methodism retained both infant and adult baptism, accepted Sunday schools and recognized as church members those seeking conversion as well as those who had fully converted. To remain members, Methodists had to attend the "class meeting", a devotional and fellowship subgroup whose further purpose of moral persuasion or reproach appears to have ceased very early. Other Methodists remained only "hearers" in the congregation, some occasional, others demonstrating greater commitment through other forms of church involvement. Although more committed to the temperance movement, the ideal Methodist way of life had become less sectarian in its prohibitions against worldliness: while still influential, the rule against dancing was under siege. Yet revivalism was stronger in St. Stephen during the 1860s and 1870s than it had been since the 1830s, and the class meeting survived until 1890.

A thorough analysis of the economic context of religion in St. Stephen awaits a larger study, but a few observations can be made here. Retaining a mixture of subsistence and market-oriented agriculture, the parish moved during these decades from an economy based on ships and lumber to one based on railroads and manufacturing.[23] These changes exacerbated the financial problems of local churches, as contributions dropped in rural areas and in mill villages dominated by the uncertain and eventually depressed lumber

census years, and 33 per cent remained within the two circuits between 1851 and 1871. The proportions of men and women within these groups never differed more than five per cent.

21 *Census of the Province of New Brunswick* (Saint John, 1861); Canada, *Census of 1871*; *Census of 1881*.

22 The following summary is based on church records held at PANB and the Maritime Conference Archives-United Church of Canada [MCA], contemporary Methodist literature published or available in the Maritimes, and two weekly newspapers: the *St. Croix Courier* and the *Provincial Wesleyan*, which includes 51 obituaries of local Methodists or their relations. At least 90 families within the two circuits subscribed to it on and off between 1861 and 1881.

23 T.W. Acheson, "Denominationalism in a Loyalist County: A Social History of Charlotte County, N. B.", M.A. thesis, University of New Brunswick, 1964, pp. 168, 224; Davis, *International Community on the St. Croix*, pp. 189, 224, 249, 256.

industry. The congregation of members and hearers was the source of most contributions, which particularly in the 1860s might come in the form of goods or services. Literary evidence suggests that the social origins of Methodism varied considerably within the parish and by type of church involvement. Thus, relating church involvement to that amorphous construct "respectability" is a very speculative undertaking. In the rural settlements and the two smallest mill villages, Methodism offered the only local religious services. Although Methodism was well-established in the larger town, St. Stephen, one minister lamented the social "ban" against Methodist church involvement in Milltown. Moreover, the presence of many non-member trustees and stewards, in opposition to Wesleyan rule, suggests that church membership itself was less socially significant than other forms of denominational commitment.[24]

In the 1860s, the smallest of these congregations still met in a farmhouse. The Methodist sacralization of domestic space is evident also in the imagery used in praise of family religion. One minister happily reported of a rural revival in St. Stephen that many converts "were heads of families, who left the house of God promising they would at once erect the family altar, and from henceforth offer God the morning and evening sacrifice". Methodist leaders called men *and* women to conversion and evangelism, urging every believer to use "his or her individual influence for the salvation of our families, our congregations, and the world".[25]

Yet in St. Stephen, formal church involvement was lower than that which is sometimes assumed of 19th-century practice. The best estimates of local Methodist church attendance suggest that roughly half of all adherent families attended fairly regularly.[26] But in both census years — 1861 and 1871 — only one-fifth of Methodist adherents over the age of 14 were current members.[27] Only one-third were ever church members between 1861 and 1881.[28]

24 *Provincial Wesleyan*, 20 April 1874, p. 2.
25 *Provincial Wesleyan*, 26 December 1860, p. 2; 20 November 1872, p. 4; 5 August 1881, p. 5; see also 2 January 1861, p. 2 and 17 August 1878, p. 2.
26 Clerical estimates of the total number of families in congregations throughout the two circuits between 1869 and 1873 range from 165 to 210 families. The 1871 estimate of 170 families attending church could have included 57 per cent of households within the two circuits where at least two individuals were Methodist adherents. However, the actual proportion was probably lower, since Methodist congregations were multidenominational, particularly in the rural settlements or smaller villages. Minutes of the New Brunswick District Meeting 1869-73, MCA.
27 Of 789 members, 84 had joined by 1851, the earliest year in which records for both circuits are available. Ten members in the 1860s and 1870s were clergy wives, and 198

Moreover, membership turnover was high:[29] of 789 church members between 1860 and 1881, roughly one-third remained members for only two years and almost another third for only three to six years.[30] Much of this turnover was due to transience: of the 789, only one-fifth remained in the parish between 1851 and 1871, less than one-third for at least two census years, and another fifth for only one census year.[31] The remainder, which included some Maine residents, were never linked. Many other short-term members, however, remained in the community and simply ceased attending class meetings.[32]

Clerical writers recognized that the problem of Methodist growth was not just the transience of their flocks, but their demography: "few men" formally joined the church.[33] Although some argue that women's greater involvement in church life crosses social and geographic boundaries,[34] the pattern known as the "feminization" of church memberships is clearest in

did not have a legible age in an extant census. An analysis of the 497 whose ages at church membership could be determined showed that 15 was an important division. Only five per cent of this group of 497 joined when under the age of 15, of whom ten Sunday school students were never counted as full church members.

28 Of 699 adherents in 1861, five per cent had been members in the 1850s, 22 per cent were current members, and another seven per cent would join by 1871. Of 1,024 adherents in 1871, two per cent had been members in the 1860s, 21 per cent were current members, and 11 per cent would join by 1881. The 1861 total for "never members" in surrounding decades includes four per cent who would join in the 1870s; the parallel total in 1871 includes two per cent who had been members only in the 1850s.

29 The transience of church members is noted by Paul E. Johnson in *A Shopkeeper's Millennium: Society and Revivals in Rochester, New York, 1815-1837* (New York, 1978), pp. 158-61; and Mary P. Ryan in "A Women's Awakening: Evangelical Religion and the Families of Utica, New York, 1800-1840", in Janet Wilson James, ed., *Women in American Religion* (Philadelphia, 1980), p. 94.

30 Because of the missing early Milltown records, members active in the 1860s and 1870s were not traced before 1851. Of the 789, 32 per cent were members for only one to two years, 29 per cent for three to six years, 20 per cent for seven to twelve years, and 19 per cent for longer.

31 Although missing from the census return, a few members were established as parish residents in census years through other documents.

32 Of the 789 sometime church members, 11 per cent died while still members. Of 477 continuous members no longer on the lists by 1881, 27 per cent ceased their membership while remaining in the parish (for another 21 per cent, the reasons for their disappearance from the records could not be identified). Of 105 intermittent church members, just over half had ceased their membership for a while (again, another five per cent could not be accounted for).

33 *Provincial Wesleyan*, 22 November 1865, p. 2.

34 Hugh McLeod, *Religion and the People of Western Europe, 1789-1970* (Oxford, 1981), p. 29.

sectarian, Puritan and evangelical traditions.[35] In St. Stephen, girls and women made up only slight majorities of Methodist Sunday school students[36] or adult baptisms.[37] In contrast, women consistently predominated in the church membership. Of 789 names appearing on the two circuits' class meeting lists between 1860 and 1881, 540, or 69 per cent, were female. Annual proportions of women members between 1861 and 1881 differed little from those of the 1840s and 1850s.

The greater tendency of Methodist women to join the church is evident despite the slightly and only temporarily unbalanced sex ratios of Methodist adherents during the early 1860s. Of 699 adherents over the age of 14 living within the two circuits in 1861, 53 per cent were women. Between 1851 and 1871, 43 per cent of these women had been or would become church members, compared with only 25 per cent of all Methodist men in this age group. However, once in the church, women did not demonstrate greater staying power than men: rapid membership turnover occurred among both, and women appeared only slightly less likely to cease attending the class meetings while remaining in the circuit.[38]

35 See the essays in James, *Women in American Religion*; Richard L. Greaves, ed., *Triumph Over Silence: Women in Protestant History* (Westport, Conn., 1985); Rosemary Radford Ruether and Rosemary Skinner Keller, eds., *Women and Religion in America: The Colonial and Revolutionary Periods* (New York, 1983) and *Women and Religion in America: The Nineteenth Century* (New York, 1981). For English Methodism see Gail Malmgreen, *Religion in the Lives of English Women* (London, 1986), pp. 9-10; David Hempton, *Methodism and Politics in British Society* (London, 1984), p. 13; and John Kent, *Holding The Fort: Studies in Victorian Revivalism* (London, 1978), p. 86. See also Daniel Goodwin, "Revivalism and Denominational Polity: Yarmouth Baptists in the 1820's", in Robert S. Wilson, ed., *An Abiding Conviction: Maritime Baptists and their World* (Hantsport, N.S., 1988), p. 15.

36 "Statistics" from Sunday schools totalled by circuit can be found in unpublished Minutes, New Brunswick District Meeting, (1826-55), Saint John District Meeting (1856-73), Saint Stephen District Meeting (1874-81), and the published Minutes of the New Brunswick and Prince Edward Island Conference from 1876 to 1881, MCA. The latter indicate that between one-fifth and one-quarter of yearly enrolments were "adult" and roughly half "intermediate". Despite the tremendous flux in numbers — 98 to 323 students, and 17 to 46 teachers by the 1860s — girls and women consistently made up roughly 55 per cent of both groups between 1833 and 1869, when breakdowns by sex ceased. This contrasts with findings for urban New England Sunday schools in Ann Boylan, "Evangelical Womanhood in the Nineteenth Century", *Feminist Studies*, 4, 3 (1978), p. 66.

37 Women made up only 55 per cent of the 99 named adult baptisms between 1835 and 1883, but were a larger proportion of those baptized after 1854.

38 Although comprising 69 per cent of the membership, women constituted 63 per cent

Women played a significant but ambivalent role within Methodism.[39] Although a few businessmen were major donors, a female "circle" or "society" of members and adherents acted as the regular fundraisers for each chapel in St. Stephen.[40] As class-meeting and prayer-meeting leaders, women were accorded greater ecclesiastical status within Wesleyan Methodism than within any other major denomination in the Maritimes. Yet Wesleyans retained the exclusion of women from ordination and administration that sectarian Methodists had overcome elsewhere. Because the ministry was itinerant, male lay leaders could exercise long-term administrative control, and they gained greater access to larger church bodies with the unification of Canadian Methodism between 1855 and 1884. But although class leaders were theoretically members of the circuits' Official Boards, and seven of the 17 class leaders between 1861 and 1881 were women, the only recorded board meeting they ever attended was one held in 1874 to discuss Methodist union.

With its own inherent tensions, the Methodist version of "evangelical womanhood" both echoed and challenged the ideology of separate spheres.[41] The history of the Wesleyan Ladies' Academy, with its alternating and debated emphasis on both the "ornamental" and "academic" branches of learning, reflected these tensions as well as the wider debate over the evangelical way of life.[42] Very few St. Stephen women attended the academy, but those who did included the daughter of local Methodism's wealthiest member, a merchant's daughter and two daughters of a minister, whose family had remained in the parish after his death.[43] All four daughters of William Smith had converted in St. Stephen at an 1861 revival. That same spring, during

of 155 known ex-members still resident in the circuit.

39 Gwendolyn Davies, "'In the Garden of Christ': Methodist Literary Women in Nineteenth-Century Maritime Canada", in Scobie and Grant, *Contribution of Methodism to Atlantic Canada*, pp. 206-7.

40 *Provincial Wesleyan*, 21 February 1852, p. 2; 16 August 1855, p. 2; 15 May 1856, p. 2; *St. Croix Courier*, 4 August 1868, p. 2. Unfortunately, these early groups left no records such as those used by Marilyn Fardig Whitely in "'Doing Just About What They Please': Ladies' Aids in Ontario Methodism", *Ontario History*, 82, 4 (December 1990), pp. 289-304.

41 Rosemary Gagan, *A Sensitive Independence: Canadian Methodist Women Missionaries in Canada and the Orient, 1881-1925* (Montreal and Kingston, 1992), p. 13; for evangelicalism in general see Boylan, "Evangelical Womanhood", p. 62; and Davidoff and Hall, *Family Fortunes*, p. 117.

42 John G. Reid, "The Education of Women at Mount Allison, 1854-1914", *Acadiensis*, XII, 2 (Spring 1983), pp. 3-33.

43 Wesleyan Academy, *Catalogue*, 1857; Ladies' Academy, *Catalogues*, 1859, 1877-79; Mount Allison Wesleyan College and Academy, *Catalogues*, 1864-77.

which the onset of the American Civil War had provoked much controversy in the parish,[44] the oldest sister, Celia Smith, published an abolitionist poem in the *Provincial Wesleyan*, and Harriet Smith followed in September with an implicitly pro-Northern poem, warning that political interests must always be subordinate to the "cross".[45]

These poems and another urging readers to comfort the "poor" or the "distressed" and to "chase the gloom of night" from "haunts of sin" more closely reflect the ideal of "evangelical womanhood" than the "ornamental" branch of Mount Allison's curriculum.[46] Addressing a reportedly assenting St. Stephen audience in 1854, a Methodist minister exalted domesticity but anticipated the activism of maternal feminism. Arguing that women's influence as "daughters and as sisters, and then as wives and as mothers" was "incalculable", Robert Cooney went on to ask:

Who are those who move the great springs of every benevolent institution formed for the relief of the wretched and miserablewho visits the schools, the hospital, the hovel, and the prisonWho protect [sic] every weakness and alleviate every suffering from the cry of the infant . . . to the decrepitude of old age? The answer [is] woman.[47]

Two contrasting views of women's sphere convey the tensions within "evangelical womanhood". Citing both "heroic zeal" and "Christian meekness" as female virtues, one minister wrote in 1872 that "the world" would not be "evangelized without female help". But for him that help was narrowly defined and subordinate. In contrast, the editor of the *Provincial Wesleyan* claimed in 1877 that John Wesley had "placed woman in her proper sphere in the Church, recognizing her perfect equality with the other sex . . . according to her the rights of office as a Leader".[48]

The delayed response to the "feminization" of lay religion was a socially constructed male counterpart to "evangelical womanhood". Efforts to bring more men into St. Stephen's Methodist churches were part of this promotion of "muscular Christianity" in trans-Atlantic Protestantism.[49] The higher pro-

44 Davis, *International Community on the St. Croix*, pp. 191-2; W.S. MacNutt, *New Brunswick: A History 1784-1867* (Toronto, 1963), p. 400.

45 This family profile draws on the data base cited earlier, and the *Provincial Wesleyan*, 1 May 1861, p. 1; 4 September 1861, p. 1; 10 September 1862, p. 2.

46 *Provincial Wesleyan*, 9 November 1864, p. 1.

47 *Provincial Wesleyan*, 26 January 1854, p. 2.

48 *Provincial Wesleyan*, 11 September 1872, p. 4; 10 November 1877, p. 4.

portions of male converts during revival years noted by some quantitative studies of the Awakenings were not consistently parallelled in St. Stephen.[50] Instead, the number of male members varied more according to economic context.[51] Despite the expectation of financial support from male as well as female members, there were higher proportions of male members in the more economically distressed mill villages. The lower proportions of male members in the more commercial town of St. Stephen support the clerical lament over "business men who aid the Church after the fashion of Noah's workmen, and transformation of like them, do not enter".[52] With the movement away from a mainly agrarian and artisanal economy, commercial time discipline became a greater obstacle to revivals and evening activities. Local Methodist leaders joined in the short-lived Young Men's Institute and the related unsuccessful early closing movement.[53]

Clergy concentrated their efforts on young men because of their other demographic concern that "so few young people" joined the church.[54] Although Methodism had always been institutionally concerned with the young, the culmination of "Christian nurture" in church membership became a key ideological plank in late-19th-century evangelical youth work, which drew on contemporary psychological interest in adolescent conversion.[55] In a sense, "Christian nurture" embodied the ideal expectation that

49 David I. McLeod, *Building Character in the American Boy: The Boy Scouts, Y.M.C.A., and Their Forerunners, 1870-1920* (Madison, Wisc., 1983), pp. 22-3, 42-5; *St. Croix Courier*, 28 July 1870, p. 2; 22 June 1874, p. 2; 23 November 1871, p. 2; 4 January 1872, p. 2; 11 February 1875, p. 2.

50 Richard D. Shiels, "The Feminization of American Congregationalism, 1730-1835", *American Quarterly*, 33 (1981), p. 57; Stephen R. Grossbart, "Seeking the Divine Favour: Conversion and Church Admission in Eastern Connecticut, 1711-1832", *William and Mary Quarterly*, 3rd Series, XLVIII (1989), p. 706, 735.

51 Because of their narrow social settings, current studies of women and revivalism in an economic context have been more successful at explaining local communities or changes in print culture than in offering widely applicable theories of revivalism. See Cott, *Bonds of Womanhood*; Johnson, *Shopkeeper's Millennium*; and Ryan, *Cradle of the Middle Class*, cited earlier. See also Deborah Valenze, *Prophetic Sons and Daughters: Female Preaching and Popular Religion in Industrial England* (Princeton, 1985); and Carroll Smith-Rosenberg, "The Cross and the Pedestal: Women, Anti-Ritualism, and the Emergence of the American Bourgeoisie", in Smith-Rosenberg, *Disorderly Conduct: Visions of Gender in Victorian America* (Oxford, 1985), pp. 129-64.

52 *Provincial Wesleyan*, 29 July 1881, p. 4.

53 *St. Croix Courier*, 14 December 1876, p. 2; 19 July 1867, p. 2; 16 May 1872, p. 2.

54 *Provincial Wesleyan*, 28 July 1881, p. 5; see also the series on "young men" and "young people" published in October and November 1878.

55 See Joseph Kett, *Rites of Passage: Adolescence in America 1790 to the Present* (New

church membership could be a socially constructed and timed rite of passage for men and women, rather than an adult crisis whose timing was providential or psychologically idiosyncratic. But analysing church membership as a demographic event in the lives of men and women contrasts the socially constructed ideal of "Christian nurture" with the self-constructed behaviour of lay Methodists.

Although subsequently abandoned by psychologists, the theory of conversion as a rite of passage was borrowed by historians discovering the presence of women and youth in the Great Awakenings. From revival accounts, many concluded that an existing trend toward female or youthful conversions accelerated in the early 1800s.[56] A preliminary study of early English Methodism suggested that conversions occurred most often before the age of 21.[57] Yet most quantitative studies have found that church membership remained an adult affair, with average ages at first church membership as high as the 30s, though usually lower during revivals.[58] Since these studies also show a wide range in age at membership, however, high standard deviations make the use of averages inappropriate.[59] Furthermore, determining whether the age structure of new members was any different from that of the population at large or the constituency of a particular church is impossible for British, American or early Maritime communities, which lacked a household by household enumeration of adherence.

York, 1977), chs. 3 and 6; and Neil Semple, "'The Nurture and Admonition of the Lord': Nineteenth Century Canadian Methodism's Response to 'Childhood'", *Histoire sociale/Social History*, 14 (1981), pp. 157-75.

56 Kett, *Rites of Passage*, pp. 64-5; Hillel Schwarz, "Adolescence and Revivals in Ante-Bellum Boston", *Journal of Religious History*, (1979), pp. 144-58; Nancy F. Cott, "Young Women in the Second Great Awakening", *Feminist Studies* 3 (1975), p. 16; George Rawlyk, *Ravished by the Spirit: Religious Revivals, Baptists, and Henry Alline* (Kingston and Montreal, 1984), pp. 121-3.

57 Gail Malmgreen, "Domestic Discords: Women and the Family in East Cheshire Methodism, 1750-1830", in Jim Obelkevich, Lyndal Roper and Raph Samuel, eds., *Disciplines of Faith: Studies in Religion, Politics, and Patriarchy* (London, 1987), p. 59.

58 Two studies of English Methodism use obituaries: James S. Obelkevich, *Religion and Rural Society: South Lindsey 1825-1875* (Oxford, 1976), pp. 241-2; and Julia Stewart Werner, *The Primitive Methodist Experience: Its Background and Early History* (Madison, 1984), p. 155. Studies of New England Congregationalism are summarized in Grossbart, "Seeking the Divine Favour", pp. 705-6, 712-13; see also Goodwin, "Revivalism and Denominational Polity", pp. 16-18.

59 Age at membership during the Awakenings ranged within a single revival year or church, and over birth cohorts, regions or time periods.

In St. Stephen's Methodist churches, a wide range in age at church membership persisted long after the Second Awakening. Since many who joined in the late 1860s were listed only in the 1861 census, pooling all individuals over the age of 14 in 1871 ever listed as a Methodist in either year enlarged the churches' constituency over the two decades to 1,507 adherents.[60] In the following analyses, age 24 — after which an increasing majority of women in 1871 were married — is the upper boundary of youth,[61] while age 55 — the most common beginning of family dissolution in 19th-century America — is the lower boundary for old age.[62] The results show that 43 per cent of those aged 55 or over in 1871, and 42 per cent of those aged 40 to 54, were church members sometime between 1861 and 1881. Only 26 per cent of adherents aged 25 to 39, and 16 per cent of those aged 15 to 24, were church members in these years. This pattern of older new members can be confirmed by closer analysis of 386 known residents of St. Stephen before they joined the church.[63]

Like the Puritans, most Methodists who joined the church did so after marriage, "when it came time to think of the spiritual welfare of children and when women in particular confronted the fear of dying in childbirth".[64] Of 565 new members (since the earliest complete records in 1851) with a known marital status,[65] only 38 per cent were single when they joined the church. Single adherents were generally less likely to join the church. Within each age group of the 696 adherents over 24 years of age enumerated in 1871, between

60 Since membership is considered as a proportion of the age group, the inflation of the oldest age group and the absence of the new adherents in 1881 does not affect the conclusions.

61 Michael B. Katz, Michael J. Doucet and Mark J. Stern show similar results in *The Social Organization of Early Industrial Capitalism* (Cambridge, Mass., 1982), pp. 258-9.

62 Howard Chudacoff and Tamara K. Hareven, "Family Transitions into Old Age", in Hareven, ed., *Transitions: The Family and Life Course in Historical Perspective* (New York, 1978), p. 219.

63 Of these 386 previous residents, 70 per cent of those who joined when aged 55 or over, 75 per cent of those who joined when aged 40 to 54, and 54 per cent of those who joined when aged 25 to 39 could have joined earlier.

64 Gerald F. Moran, "'The Hidden Ones': Women and Religion in Puritan New England", in James, *Triumph Over Silence*, p. 136.

65 Although the best information on marital status is from the 1871 census and for household status the 1861 census, it was also possible to deduce this information for most Methodists from church marriage or membership records and family histories. Of 789 members, only 137 had no clear marital status.

one-fifth and one-quarter of the single adherents were church members bet-
ween 1861 and 1881, compared with 46 per cent of married adherents aged 25
to 54, and 58 per cent of married adherents aged 55 or over.

Yet a gendered analysis indicates remarkably different patterns for
women and men. Of those whose ages were known, almost half of all women
compared with only 29 per cent of all men joined when they were under 25
(see Table One).

TABLE ONE
All New Members: Age at Joining

AGE	MEN			WOMEN			TOTAL	%
	No.	% Men	% Age Group	No.	% Women	% Age Group		
9 - 14	3	2	12	23	7	88	26	5
15 - 24	45	27	25	134	41	75	179	36
25 - 39	58	35	38	95	28	62	153	31
40 - 54	37	22	41	53	16	59	90	18
55 +	24	14	49	25	8	51	49	10
TOTAL	167			330			497	

Sources: St. Stephen and Milltown membership records (1851-81) and manuscript census returns for the parish of St. Stephen (1861 and 1871),

In other words, a significant number of women did not wait until marriage to
join the church. Of Methodist adherents over the age of 14 listed in the 1871
census, one-third of the 182 single women, compared with only one-tenth of
the 246 single men, were ever church members between 1861 and 1881. The
comparable proportions of married adherents were closer, but still contrast-
ing: 53 per cent of the women and 40 per cent of the men.[66]

Young or single Methodists were not the only demographic groups with-
in which male and female church involvement varied. Like their counterparts

66 These patterns are further confirmed by analysis of marital status in 1861 and house-
hold status in both census years, and are similar to those found in other studies. See,
for example, Gerald F. Moran and Maris A. Vinovskis, "The Puritan Family and Reli-
gion: A Critical Appraisal", *William and Mary Quarterly*, 3rd Series, XXXIX (1982),
pp. 45-8; Grossbart, "Seeking the Divine Favour", p. 706; Goodwin, "Revivalism and
Denominational Polity", pp. 16-18; and Lynne Marks, "Gender, Class and Family
Dimensions of Religious and Leisure Involvement in Late Nineteenth Century Small
Town Ontario", Paper presented to the Canadian Historical Association meeting,
May 1992, pp. 13-15.

in other communities, Methodist widows in St. Stephen were more likely to remain widowed and were generally older women; roughly half were household heads, and most of the remainder lived with other family members.[67] In 1871, 16 per cent of Methodist women over age 24 were widowed, and 57 per cent of these 56 women were church members sometime between 1861 and 1881. The widow of independent means was often an important figure in early English Methodism because of the financial support she could offer the church. Irish immigrant Margaret Magwood played such a role in the St. Stephen circuit when she bequeathed all her property to the regional Methodist conference. Magwood was listed without relations, servants or boarders in both the 1851 and 1861 census returns, and although remaining a Methodist church member to her death, she identified herself in 1861 as an Anglican.[68]

Widows such as Magwood were a common though not over-represented group within the Methodist membership, but widowers were rare. Only two of the 16 Methodist widowers in 1871 were ever church members; moreover, only one other man appears to have joined the church while widowed. In short, for St. Stephen's Methodist women, church membership might be part of any stage of life — from youth to widowhood — but for most male church members, it was part of married life.

A former St. Stephen minister attributed the strength of Methodism in Saint John to the fact that most of the church consisted of "*united heads of families; and of entire families*".[69] In contrast with this evangelical ideal of family religion, patterns of denominational affiliation within St. Stephen families also show how church involvement was self-constructed. In size and structure, St. Stephen households resembled those of other North American communities. In 1861 the average household size was 5.6, while in 1871 it was 5.4; in both years, 80 per cent of parish households were headed by married couples and 13 per cent by women. Although most households thus consisted of nuclear families with children, one-fifth of the 1,128 households within the two circuits in 1871 contained either in-laws or boarders: generally, a sole adult was the extra resident. Methodist households resembled the community pattern, except in having slightly higher proportions of in-laws or boarders. One can only tentatively relate the likelihood of a Methodist

67 Chudacoff and Hareven, "Family Transitions into Old Age", in Hareven, *Transitions*, pp. 224-5.
68 Malmgreen, "Domestic Discords", pp. 56, 58; Charlotte County Probate Records, 1851, vol. D, PANB; Minutes, Saint John District Meeting, 1862.
69 Robert Cooney, *Autobiography of a Wesleyan Methodist Missionary* (Montreal, 1856), p. 150.

woman in St. Stephen becoming a church member to the extent of her responsibilities in larger families, for church membership was also an escape from domestic drudgery. Mothers without small children were slightly more likely to be recent or current church members:[70] 45 per cent of 76 Methodist mothers in 1871 with children over three were members between 1869 and 1873, compared with 35 per cent of 79 mothers with younger children.[71]

Because of the denominational fluidity of St. Stephen, a number of families were divided in religious adherence, and most such divisions involved couples. Within the two circuits in 1871, 14 per cent of 944 married couples reported different adherences. Couples with children were almost equally divided between those whose children took the mother's adherence and those whose children took the father's, but in four families the children took a third adherence. For some couples, differences may have had little effect on family life. But for "Maryanne", a Presbyterian married to a Baptist, religious differences were important and affected courtship and marriage. Her letter was copied from a Maritime Presbyterian paper by a Methodist lamenting losses due to out-marriage:

> Before marriage we talked the matter over and couldn't agree . . . like hundreds of others we 'agreed to disagree'Such agreements never bring that oneness of mind and heart that married Christians are entitled toMy husband won't go with me to church for fear he will see someone sprinkled, and I am shut out of his church occasionally . . . by close communion . . . so I prefer not to go there at all. We can't talk of religion without . . . controversy, so religion is almost a forbidden subject.[72]

Maryanne considered herself more tolerant than her husband, but she resisted pressure to subordinate her own beliefs: "Some argue that it is the woman's place to yield as far as possible all points of difference and be a

70 The numbers of children listed after Methodist adherent mothers closely followed the general pattern for St. Stephen mothers within the two circuits in 1871: for 257 mothers aged 25-34, 164 aged 35-44, and 49 aged 45-54, the average numbers of children under 18 listed after them were respectively 3.1, 3.5 and 1.5.

71 Estimating other domestic responsibilities is impossible without information about household productivity. Only four per cent of Methodist households in 1871 kept servants, and there were no differences between the sex ratios of village and rural church memberships.

72 *Provincial Wesleyan*, 8 September 1877, p. 6.

member of the same church as her husband". However, she could not join his without conceding that her baptism had been invalid, which she refused to do. Revealing another social expectation — that a devout wife might influence a non-religious husband — she concluded that marrying a "kind-hearted non-professor, of good moral character" was wiser than marrying a member of a different church, as there would be a greater chance of "his being converted" than for a couple to "yield enough of their differences to enable them to walk hand in hand in the Christian life".[73]

Although most Methodist families were united in adherence and perhaps spared Maryanne's troubles, far fewer were united in church membership. In 1871, only 58 per cent of the 344 adherent families contained sometime church members between 1861 and 1881, and only 135, or 39 per cent, had current members. Of the latter, 54 per cent had only one current member and another 35 per cent had only two. Yet Methodist growth depended on the recruitment of family members from both immediate and larger kin groups, even though it never reached all individuals in these groups. Most changes in nominal religious adherence between 1861 and 1871 were made by entire households. Within the two circuits, 315 Methodist children and adults appeared in both census returns with different adherences. Of these sometime Methodists, 63 per cent changed along with two or more members of their 1861 household, and a further 17 per cent with one other member. Of the remainder, most were still acting in relation to others, some taking on the affiliation of their new spouses or the affiliation of the households in which they lived.

Membership growth depended even more on the recruitment of family members. Of the 772 Methodist members not belonging to ministers' families, close to half were associated by family, household or surname to at least three other members, and most of the remainder were so associated with one or two members. Only 160, or one-fifth, appear to have been their families' sole representatives.[74] A more precise way of showing how families recruited new members is to look at those who joined the church within the same year, usually during revivals, at special services for new members. Of the 612 church members in family groupings, 552 were new members since 1851; of these new members, 348, or almost two-thirds, joined in the same year as an-

73 *Provincial Wesleyan*, 8 September 1877, p. 6.
74 369 were associated with at least three other members, 243 with one or two. These results may not be unique to Methodism, for it is possible other social groups could be similarly organized, particularly in rural settlements.

other relation. In most cases, that relation was a spouse, child, parent or sibling.

However, patterns of kinship among church members show that for many women joining the church was an individual rather than a familial decision. Although Methodist members generally followed or preceded a family relation, the minority of apparently unrelated members included very few men. Roughly one-tenth of male members appeared without relations, compared with one-quarter of women members, and higher proportions of male new members joined the same year as another relation. Of the 188 identifiable kin groups within the church membership in the 1860s and 1870s, women and married couples constituted the majority of earliest members. Similarly, only one-half of married female members were joined by or had joined their husbands, whereas 86 per cent of married male members joined with, followed or — more rarely — preceded their wives.

These patterns were not unique to St. Stephen or to Methodism.[75] In early-19th-century revivals in Utica, New York, many converts "professed their faith in the company of relatives". Moreover, men showed "a disproportionate tendency to enter the church accompanied, or preceded, by females".[76] The apparent ability of many Methodist women to lead their families into the church should not be exaggerated, however, for there were exceptions. In one family of Methodist adherents in St. Stephen in 1861, the mother had been a member from at least 1851 until her death in 1879, and her daughter would also join the church. Yet the father reported in 1871 that he had no religion.

Both the strength and the weakness of denominational ties and female influence within Methodist families are exemplified in the history of the Robinsons, the Irish immigrant family with which this paper began. Ann Jane Robinson was born in 1793 in Malabrack where "great pains were taken, especially by her mother, to train her up . . . 'in the nurture and admonition of the Holy Ghost'".[77] She joined the church after her marriage and emigrated to New Brunswick in 1832. She and her husband would be followed in local church records by most of their children and grandchildren. The Robinson men and their male in-laws were all farmers and painters, the

75 Moran and Vinovskis, "Puritan Family and Religion", pp. 37-8; Grossbart, "Seeking the Divine Favour", pp. 733-5, 739.

76 Ryan, *Cradle of the Middle Class*, pp. 80-1; Johnson, *Shopkeeper's Millennium*, pp. 98-9, 108.

77 *Provincial Wesleyan*, 24 February 1853, p. 2.

younger generation moving to the villages. Ann Jane Robinson was excep-
tional among St. Stephen women. She led a male and female class meeting
from 1841 until her death in 1853, when she was succeeded by her son Wil-
liam. Both Ann Jane and her daughter-in-law Sarah believed they had
experienced entire sanctification. It was Ann Jane's attainment of this state of
grace embodying perfect love of God and neighbour that led her to leader-
ship; for her daughter-in-law, sanctification was a spiritual preparation for
death. The marriages of Ann Jane's children and grandchildren brought con-
verts from other denominations. However, her other son never joined the
church. He married a Presbyterian; by 1871 he was a Universalist and his
wife a Congregationalist.[78]

Former Methodists such as these, Methodist adherents who never joined
the church, and those who chose to join long after youth or marriage show
how many lay men and women resisted church membership as a normative
and socially timed behaviour. Yet women were clearly more attracted to
Methodism, even as they demonstrated their greater independence in timing
the decision to join the church. In the absence of sources on the inner moti-
vation of most Methodist women, explaining this attraction is a necessarily
tentative undertaking. Religious obituaries were often stereotyped, didactic
and generally more concerned with the preparation for and moment of death
than with conversion itself. Nevertheless, these evangelical versions of the
older ritual of "holy dying" are a reminder of the fundamental psychological
appeal of religion to men and women in the face of suffering and death. The
only other St. Stephen Methodist to claim entire sanctification was a widow,
Eliza Keith, who died in 1866 at the age of 43 after two years of constant pain
as a result of cancer: but for the "grace [of God] . . . said she, 'under my inde-
scribable sufferings I should sink into despair, but He is present with me, and
I can rejoice in his salvation'".[79] Mary Boyd had been "impressed with the
necessity of a change of heart and life, while attending the sickbed and
funeral of a near and much esteemed neighbour". After she herself fell ill, she

> talked much of Jesus and his love, and frequently spoke of her own
> death without hesitation or fearWhen asked by her mother, if
> Christ was precious now? She replied 'O yes, I feel him lifting up my
> head for as the body perishes the inner man is strengthened.' And

78 This family profile draws on the data base and obituaries cited earlier, the Charlotte
 County Marriage Records and the Milltown 1841 assessment, RS 148/C14, PANB.
79 *Provincial Wesleyan*, 28 February 1866, p. 2.

when questioned as to her family interests . . . she replied 'nothing to say, only live to Christ'.

Although the role of her mother fits the model of "evangelical womanhood", Mary Boyd's response and the final exchange reflect the priority of an idealized family religion transcending gender. For other Methodist parents, religious engagement may have been a response to infant mortality: millman Amos Priest and his wife Louisa joined the church after the deaths of their four youngest children.[80]

But anticipating cross-cultural theories of gender and religion, Puritan writers argued that it was the fear and experience of suffering and death in childbirth and child-raising that made women more religious.[81] Some historians suggest that women's sexual biology made them more aware of the fragility of life, more prone to introspection and sensitive to the supernatural or transcendent.[82] Although scholars disagree about whether women are innately more relational or affective than men, women have been more accustomed to the nurturing, co-operative and irenic roles associated with the ideal religious life. To return to the image of "separate spheres" as a social construct, women have been more excluded from political and cultural life, the natural ideational and associational rival to religion.

But since women in St. Stephen had many denominational choices, the most compelling explanations of their attraction to Methodism lie within the denomination itself. Methodism had an obvious appeal to women as mothers through its abandonment of the possibility of infant damnation and its greater stress on "Christian nurture". Moreover, the Methodist version of "evangelical womanhood" had its own appeal. As this paper has shown, Methodism offered women the role of church member both apart from or within the family. Furthermore, Methodism expanded women's sphere to in-

80 *Provincial Wesleyan*, 15 December 1869, p. 1. The profile of the Priest family is drawn from the data base described earlier and the Records of the St. Stephen Rural Cemetery.

81 Laurel Thatcher Ulrich, "'Vertuous Women Found': New England Ministerial Literature 1668-1735", in *Women in American Religion*, pp. 86-7; Cott, *The Bonds of Womanhood*, pp. 146-7.

82 Rosemary Ball, "'A Perfect Farmer's Wife': Women in Nineteenth Century Rural Ontario", *Canada: A Historical Magazine* (December 1975), p. 15; Margaret Conrad, "'Recording Angels': The Private Chronicles of Women from the Maritime Provinces of Canada, 1780-1950", in Susan Mann Trofimenkoff and Alison Prentice, eds., *The Neglected Majority: Essays in Canadian Women's History, Volume 2* (Toronto, 1985), p. 46; Valenze, *Prophetic Sons and Daughters*, p. 39.

clude leadership, and it offered women a unique place for community and voice, both sheltered and public.

When the editor of the *Provincial Wesleyan* during the late 1870s wrote that sacerdotalism and the professionalization of the ministry had crowded women out, he anticipated the judgement of historians. Probably responding to a previous article promoting a more limited "woman's mission", he wrote that "woman's position in the Church, is a form of bondage, which has come down to us through the cruel dark ages". Attacking the use of selective and misinterpreted Scripture against women, he advocated the re-establishment of women preachers.[83] Although no local women were preachers during the 1860s and 1870s, three English women preached in St. Stephen in the latter decade. In contrast with the preachers of early Methodism, these women were part of a second wave of non-denominational and primarily middle-class evangelists. Miss J.L. Armstrong, who had published *A Plea for Modern Prophetesses* and followed Catherine Booth in London, actually preached in the church at Sunday service in the town of St. Stephen.[84] "Misses Logan and Baird" toured New Brunswick for several months before their meetings in St. Stephen, held with the Methodists twice a day for over a week with reportedly "overflowing" audiences.[85]

Women who led class meetings of both sexes in the rural areas functioned as leaders of prayer meetings as well as spiritual advisers. Nancy Murchie, the wife of a wealthy farmer, was the granddaughter of McColl's first convert and a class leader after 1872. In the town of St. Stephen, Irish dressmaker and proprietor Eliza Creighton was a class leader and a "prominent worker" at prayer meetings. Although ministers' wives had led this town's classes in the 1860s, Creighton and three other women led adult classes in the 1870s: Lydia Veazy, the circuit steward's wife; Phebe Tobin, a widow from an old and active Methodist family in Halifax; and newcomer Isabella Harrison, married to a bricklayer. In addition, two young single women led a girls' class meeting in the mid-1870s.[86]

83 *Provincial Wesleyan*, 10 November 1877, p. 4; 8 December 1877, p. 5; 1 June 1878, p. 4; Nancy Hardesty, Lucille Sider Dayton and Donald W. Dayton, "Women in the Holiness Movement: Feminism in the Evangelical Tradition", in Ruether and Mclaughlin, *Women of Spirit*, p. 249; Valenze, *Prophetic Sons and Daughters*, pp. 277-9.

84 *St. Croix Courier*, 28 January 1875, p. 2; 4 February 1875, p. 2; Olive Anderson, "Women Preachers in Mid-Victorian Britain: Some Reflexions on Feminism, Popular Religion and Social Change", *Historical Journal* (1969), p. 472.

85 *Semi-Weekly Patriot* (Charlottetown), 12 October 1878, p. 4; *Globe* (Saint John), 15 November 1878, p. 2; *New Brunswick Reporter and Fredericton Advertiser*, 22 January 1879, p. 3; *St. Croix Courier*, 12 February 1879, p. 2; 19 February 1879, p. 2.

Methodism may also have attracted women because it located the church in the home, where women had the most economic and psychological power.[87] In the early 1860s, meetings and even Sunday service were still held in private homes at Union Mills and the Mohannas Settlement, but the shortage of lay leaders in proportion to members — general throughout Methodism — and the absorption of these tiny communities by their larger neighbours soon ended this practice. In the villages, there was always at least one all-female class, usually led by the minister, his wife or a female leader. One of two ongoing class meetings in St. Stephen was mixed until 1866, when it became solely male; though no reason was recorded, this change may have been aimed at gathering more male members. Although one farmer was a former class leader, in all but one year between 1861 and 1881 the only lay class leaders in the St. Stephen circuit were women. In contrast, those in Milltown were always men. This consideration, even more than the different economic context of the two circuits, may explain the higher proportions of men in Milltown.

Revival accounts and the "spiritual histories" found in obituaries of local Methodists suggest that they sought and sometimes achieved what has been described as a "community of feeling" in the church, class meeting or at the deathbed.[88] The complexity of the reality — in which the ideal was undoubtedly dimmed by divisions of personality or social class as well as gender — is conveyed by the differing appellations of church members within the records: from only initials or last names to familiarized first names or even Sister or Brother, though the latter two would disappear in the next decade. Historians have identified the powerful and affectionate sense of sisterhood among many 19th-century women.[89] Yet literary evidence and the persistent one-third of Methodist members who were male suggest that the community of feeling could be both male and female. This supports recent studies arguing that evangelical religious experience could sometimes soften gender differences, promoting affective friendships among both men and women, or the communal equivalent of family religion.[90]

86 Getchell Family History; *St. Croix Courier*, 26 September 1879, p. 5; Tobin Family History.

87 Valenze, *Prophetic Sons and Daughters*, pp. 21-2.

88 Sandra Sizer, *Gospel Hymns and Social Religion* (Philadelphia, 1978), p. 128; A. Gregory Schneider, "The Ritual of Happy Dying Among Early American Methodists, *Church History* (1987), p. 351.

89 In addition to Cott's works see Smith-Rosenberg, "The Female World of Love and Ritual: Relations Between Women in Nineteenth-Century America", in Smith-Rosenberg, *Disorderly Conduct*, pp. 53-76.

But 19th-century men had wider choices for ideological or affective community. Men could belong to quasi-religious fraternal associations such as the Orange Order or the Freemasons in St. Stephen; both contained Methodist adherents and church members, as early Methodism's prohibition against Masonic connections had before very long been overcome in the Maritimes, and in St. Stephen it had never existed.[91] Particularly when led by a woman, the class meeting offered women a unique and intimate same-sex community that was more than domestic or neighbourly. There were few associational rivals for the time and souls of Methodist women in St. Stephen until 1878, when the new Woman's Christian Temperance Union began to attract more non-member Methodist adherents than women who had joined the church.[92]

If women generally made up the majority of Methodist church members, the decline of the class meeting may have reflected not just changing Methodist piety, but also women's increasing participation in rival groups. If this is so, it demonstrates the difference between executive power and strength. Women sustained church growth, and through their contributions as church members and fundraisers gathered the food, coal, furnishings and money to support the church.[93] In comparison with lay men, they lacked only the executive power to distribute the money. But when women withdrew their strength as church members or fundraisers, the churches must surely have faltered. In other words, if the class meeting sometimes functioned as a socially and self-constructed "separate sphere" of female space and influence, women — by their associational choices — may have hastened its destruction.

Just as historians of early Methodism have debated whether it promoted or hindered radicalism, others have asked the same question of Methodism and feminism. The answer is clearly equivocal. On the one hand, Methodism defined and thus confined women to special roles, limiting their full partici-

90 Susan Juster, "'In a Different Voice': Male and Female Narratives of Religious Conversion in Post-Revolutionary America", *American Quarterly*, 41 (1989), pp. 36-7; Irene Quenzler Brown, "Death, Friendship, and Female Identity During New England's Second Great Awakening", *Journal of Family History*, (1988), pp. 367-87.

91 *St. Croix Courier*, 28 June 1867, p. 2; 1 October 1868, p. 2; 22 October 1868, p. 2; 17 December 1873, p. 2; 31 December 1874, p. 2; 14 January 1875, p. 2; Harry Edgar Lamb, *The History of St. Croix Lodge, No. 46, F.A.M. 1809-1934* (Calais, Me., 1934), pp. 9, 53.

92 Minutes, St. Stephen W.C.T.U., 29 January 1878-11 October 1881, PANB.

93 *St. Croix Courier*, 15 October 1868, p. 2; 7 October 1869, p. 3; 21 October 1869, p. 2; 15 December 1870, p. 2; 12 October 1871, p. 2; 26 December 1872, p. 2; 9 October 1873, p. 2; 12 August 1875, p. 2; 21 December 1876, p. 2; 4 December 1879, p. 2; 1 April 1880, p. 2; *Provincial Wesleyan*, 18 January 1876, p. 13.

pation in the church or the world. But on the other hand, the Methodist women who thronged to trans-Atlantic reform movements and would eventually demand ecclesiastical suffrage and ordination demonstrate how women used their religion to step outside these roles and challenge these limitations.[94]

The actual and historical voices of Methodist women exemplify this paradox as well as the ambivalence of women's sphere within Methodism. In the community of feeling, Methodist women were encouraged to speak as leaders or participants in revivals, prayer meetings or class meetings. To the writers of obituaries for the *Provincial Wesleyan*, their voices had didactic and inspirational power deserving a wider and public audience. A few St. Stephen women published poetry in their lifetime or were quoted anonymously in revival accounts, but most who gained this public audience did so only after their deaths. Yet their enduring testimonies show their conviction that through their confidence in salvation, they had overcome that last silencer of voices. As some have argued, evangelicalism accepted a narrow women's "sphere", while asserting its "unbounded potential influence".[95] Ann Jane Robinson instructed her minister on the text he was to preach from at her funeral. Even death did not close her sphere of influence.

94 Ruth Compton Brouwer, "The Canadian Methodist Church and Ecclesiastical Suffrage for Women, 1902-1914", *Canadian Methodist Historical Papers*, 2 (1977), pp. 1-27.
95 Davidoff and Hall, *Family Fortunes*, p. 176.

"SEPARATE SPHERES"
The Feminization of Public School Teaching in Nova Scotia, 1838-1880

JANET GUILDFORD

In 1838 the Nova Scotia Assembly decided that local school boards could hire women.[1] The Assembly was responding to a shortage of public school teachers and the decision was popular with both school boards and women teachers. Within 40 years women made up two-thirds of the public school work force in the province.[2] Both the recruitment of large numbers of women teachers and its consequences illustrate the ambiguities and contradictions inherent in the 19th-century, middle-class gender expectations usually referred to as the ideology of "separate spheres".[3] The feminization of public school teaching, and the gender ideology that encouraged it, had important implications for the struggle of Nova Scotia teachers to achieve professional wages and decent working conditions. Women were recruited as teachers because school administrators and politicians, persuaded that men and women belonged to separate spheres of activity, believed that women were inherently suited to the care and teaching of young children. But this widely shared gender ideology was inimical to teachers' claims to professional status, claims based on the possession of a set of acquired and scientifically based skills and knowledge. This contradiction inhibited successful collaboration between men and women within the public school work force and prolonged the struggle for higher wages and professional autonomy.

Women did not begin teaching school in Nova Scotia in 1838; rather, it was from that date that women teachers began to move from private schools to state-subsidized public schools.[4] Moreover, despite the periodic expression of fears and reservations about the feminization of public school teaching, Nova Scotians appeared to regard the development as a natural one. The femi-

1 *Statutes of Nova Scotia*, 1838, ch. 23, s. VI.

2 *Annual Report of the Common, Academic and Normal and Model Schools of Nova Scotia [Annual Report]* (1880), Table B.

3 For a discussion of the contemporary debate about separate spheres as a conceptual framework see Mary P. Ryan, *Women in Public: Between Banners and Ballots, 1825-1880* (Baltimore and London, 1989), pp. 5-8.

4 Alison Prentice, "The Feminization of Teaching in British North America and Canada, 1845-75", in Susan Mann Trofimenkoff and Alison Prentice, eds., *The Neglected Majority: Essays in Canadian Women's History, Vol. 1* (Toronto, 1977), pp. 49-69.

nization of public school teaching accompanied the creation of the reformed, state-supported elementary school systems in North America and Britain, a phenomenon that has attracted considerable attention from historians in the past few decades.[5] As David Allison, the superintendent of schools for the province, reported in 1877: "It may be desirable that we should have more male teachers, yet we are not to expect that Nova Scotia will be an exception to ... almost every country where common school instruction [is] freely brought to the people".[6]

Contemporary observers believed that women teachers were recruited because they were willing to work for low wages and because, according to the prevailing ideology of gender roles, women had a natural aptitude for working with young children. Women became teachers because they had few

5 In the United States 60 per cent of teachers were women by 1870. David B. Tyack and Myra H. Strober, "Jobs and Gender: A History of the Structuring of Education Employment by Sex", in Patricia A. Schmuck, W.W. Charters, Jr. and Richard O. Carlson, *Educational Policy and Management: Sex Differentials* (New York, 1981), pp. 131-52. Women formed the majority of the public school teaching force in Quebec and Ontario by 1871. Marta Danylewycz, Beth Light and Alison Prentice, "The Evolution of the Sexual Division of Labour in Teaching: Nineteenth Century Ontario and Quebec Case Study", *Histoire sociale/Social History*, XVI, 31 (mai-May 1983), pp. 81-110. In England women formed 75 per cent of the work force by 1914. Frances Widdowson, *Going Up Into the Next Class: Women and Elementary Teacher Training 1840-1914* (London, 1983), Foreword. In Scotland 70 per cent of teachers were women by 1911. T.C. Smout, *A Century of the Scottish People, 1830-1850* (New Haven and London, 1986), p. 220. See also Helen Corr, "The Sexual Division of Labour in the Scottish Teaching Profession, 1872-1914", in Walter M. Humes and Hamish M. Patterson, eds., *Scottish Culture and Scottish Education, 1800-1980* (Edinburgh, 1983). For a thorough recent overview of the literature on women teachers see Alison Prentice and Marjorie R. Theobald, "The Historiography of Women Teachers: A Retrospect", in Alison Prentice and Marjorie R. Theobald, eds., *Women who Taught: Perspectives on the History of Women and Teaching* (Toronto, 1991), pp. 3-36. The editors have also included an extensive bibliography. See also Wendy E. Bryans, "'Virtuous Women and Half the Price': The Feminization of the Teaching Force and Early Women Teacher Organizations in Ontario", M.A. thesis, University of Toronto, 1974. For the British experience see Barry Bergen, "Only a Schoolmaster: Gender, Class and the Effort to Professionalize Elementary Teaching England, 1870-1910", *History of Education Quarterly*, 21, 1 (1982), pp. 1-21; Dina M. Copelman, "'A New Comradeship between Men and Women': Family, Marriage and London's Women Teachers, 1870-1914", in Jane Lewis, ed., *Labour and Love: Women's Experience of Home and Family, 1850-1940* (Oxford, 1986), pp. 175-94; Widdowson, *Going Up*. The American experience is addressed in Tyack and Strober, "Jobs and Gender"; Redding S. Sugg, Jr., *Motherteacher: The Feminization of American Education* (Charlottesville, Virginia, 1978); Madeleine R. Grumet, *Bitter Milk: Women and Teaching* (Amherst, 1988).
6 *Journals of the House of Assembly of Nova Scotia [JHA]* (1877), App. 5, Annual Report, xviii.

opportunities for other paid employment and because they, too, believed that they had a natural aptitude for the job.[7]

Between 1838 and the passage of the Nova Scotia Free School Act in 1864, which eliminated tuition and introduced greater centralized supervision of public schooling in the province, the change proceeded slowly. In 1851 just under 20 per cent of Nova Scotia public school teachers were women; in 1861 women formed a third of the public school work force.[8] Feminization was much more rapid in the decade following the 1864 Free School Act. In less than five years women constituted nearly half of all teachers both winter and summer.[9] In 1870 the provincial superintendent of schools reported that:

> The rapid increase of female teachers, as compared with those of the other sex, is worthy of note. While the former increased 81% in 5 years, the number of male teachers increased only 51%. The proportion of female teachers is greater in summer, 53% of those employed in the summer, 41% employed in winter being female teachers.[10]

By the end of the 1870s two-thirds of the province's teachers were women (see Table One).

The relationship between school reform and feminization is obviously an important one. To understand it we must consider both the function of the reformed public school systems and the mid-19th-century ideological concept of separate spheres for men and women. Nineteenth-century advocates of public school reform promised many benefits, but time and again they returned to a single theme: universal free public schooling would provide moral training for the young and produce a generation of hard-working, law-abiding citizens.[11] The inculcation of these social and political values was generally more important to the aims of school reformers than the provision of either religious or intellectual education.[12] Reformed public school sys-

7 See, for example, Prentice, "The Feminization of Teaching"; Tyack and Strober, "Jobs and Gender", Widdowson, *Going Up*. For a somewhat expanded discussion of the recruitment of women into public school teaching in the last half of the 19th and early 20th-centuries in the United States see Geraldine Joncich Clifford, "'Daughters into Teachers': Educational and Demographic Influences on the Transformation of Teaching into 'Women's Work' in America", in Prentice and Theobald, *Women who Taught*, pp. 115-35.

8 Prentice, "The Feminization of Teaching".

9 Prentice, "The Feminization of Teaching".

10 *Annual Report*, (1870), p. xxi.

11 See, for example, Alison Prentice, *The School Promoters* (Toronto, 1977); and Sugg, *Motherteacher*.

12 Sugg, *Motherteacher*; Grumet, *Bitter Milk*.

tems, therefore, required a large work force capable of teaching the values and attitudes deemed appropriate by the school reformers, as well as a smaller number of administrators and teachers with strong academic background for the senior (and especially the male) students. The recruitment of women as public school teachers seemed natural to 19th-century legislators, school administrators and parents who were imbued with the separate spheres ideology.[13]

Reformed public school systems occupied an ambiguous place in the mid-19th-century social landscape. They created institutions in which some of the work of the private sphere — the training of children — was performed in a public arena under the jurisdiction of the state. They attest to the difficulty of applying the middle-class ideal of a division of labour along sexual lines, an ideal that confined male activity to the public world of economics and politics and female activity to the private world of the family and reproduction. While it seemed natural that women, suited by nature to the moral training of children, should be hired as public school teachers, public schools were more than extensions of the domestic sphere. They were also arenas for both collaboration and competition between men and women. The boundaries between the private and the public spheres were not always clearly defined, and were under constant revision. This overlapping of the private and public spheres had important ramifications in the teachers' struggle to gain recognition for their work.

Historians have continued to debate the relative importance of ideology and economics in the recruitment of women to public school teaching.[14] It can be argued, however, that the two were in fact intimately related and mutually reinforcing. Women were paid low wages because they were performing the work of the private sphere, work usually performed outside the formal economy. Women were recruited as teachers because they were believed to have a special aptitude for the job. Concepts of gender were thus central to the 19th-century division of labour. When we remember that the mid-19th century was also the period when professional police forces were first recruited in many parts of British North America it becomes clear that

13 For a discussion of this idea see Nancy F. Cott, *The Bonds of Womanhood: "Woman's Sphere" in New England, 1780-1835* (London, 1977). More recently a debate has arisen about the usefulness of the idea of separate spheres as an analytical approach. See for example, Linda Kerber, "Separate Spheres, Female Worlds, Women's Place: The Rhetoric of Women's History", *Journal of American History*, 75 (June, 1988), pp. 9-39; Alice Kessler-Harris, "Gender Ideology in Historical Reconstruction: A Case Study from the 1930s", *Gender and History*, 1, 1 (Spring, 1989), pp. 31-49; and Ryan, *Women in Public*.

14 See, for example, Bryans, "Virtuous Women".

sex and notions of gender played an enormous role in decision making. It was never suggested that women, because they were willing to work for low wages, would make an ideal police force. Reverend Robert Sedgewick, speaking to the Halifax Young Men's Christian Association in 1856, expressed his derision of such an idea when he asked the rhetorical question "What can be more unfeminine than a woman thief-catcher?"[15] While women were certainly attractive employees because of their willingness to work for low wages, ideology played a very large part in their recruitment to public school teaching. The conjunction of public school reform and the idea of separate spheres for men and women was central to the change. As Geraldine Joncich Clifford has argued, the movement of elements of the work of social reproduction from the household to the public school played an important role in turning "daughters into teachers".[16]

The ideology of separate spheres had wide acceptance in mid-19th-century Nova Scotia. Reform politician George Young, for example, writing in 1842, described women as "queens of the household" and urged the education of women for motherhood.[17] In 1846 the anonymous author of an essay on the "Improvement of Female Education" argued that women were "admirably adapted to the sacred charge of watching the young".[18] Nova Scotians were also well aware of international debates on the role of women. In the early 1850s two Halifax newspapers, both of them published by women, regularly carried items about separate spheres and the mid-19th-century debates about women's proper sphere and women's rights.[19] Reverend Robert Sedgewick tackled these debates directly in his 1856 address to the Halifax Young Men's Christian Association in which he claimed unequivocal support for rigidly distinctive roles and natures for men and women.[20]

The attitudes of Nova Scotia politicians, school administrators and teachers were imbued with the ideology of separate spheres for men and women. Nova Scotians accepted the idea that women were the queens and

15 Robert Sedgewick, "The Proper Sphere and Influence of Woman in Christian Society", in Ramsay Cook and Wendy Mitchinson, eds., *The Proper Sphere: Woman's Place in Canadian Society* (Toronto, 1976), p. 15.

16 Clifford, "Daughters into Teachers".

17 George R. Young, *On Colonial Literature, Science and Education; written with a view of improving the Literary Educational and Public Institutions of British North America*, v. 1 (Halifax, 1842), p. 126.

18 Anon. "Improvement of Female Education", *Essays on the Future Destiny of Nova Scotia* (Halifax, 1846).

19 See, for example, *Mayflower*, 1, 1 (May 1851), pp. 6-7; *Provincial Magazine*, March 1852, p. 86.

20 Sedgewick, "Women's Sphere".

moral rulers of the home, but very few advocated the full equality of the sexes. The question of women's equality did, however, emerge several times within the Sons of Temperance. In 1856 the "full and unequivocal member-ship of the female sex" was proposed at the provincial annual meeting, but it was rejected.[21] The issue resurfaced in a letter to the order's journal in 1868, when "A friend of the order" asked "Has not God made man and woman equal?" The editor disagreed. He recommended that women should retain their status as "visitors".[22] The public participation of women, even in worthy causes, remained troublesome. In 1862, when Mrs. Nina Smith ap-peared alone on the platform of the Temperance Hall to solicit aid for the poor, she addressed a slim and critical audience. One listener did admit that while he was "utterly opposed to the theory of female oratory", Mrs. Smith had performed so well that it "made his heart bleed" and he moved a vote of thanks to "the lady who had so unselfishly braved the prejudices of society to relieve the destitute".[23]

Public school reform and the acceptance of the separate spheres ideology in Nova Scotia help us to understand the general trend toward the feminiza-tion of the public school work force, but when we average relative numbers of men and women teaching in the province as a whole we miss some import-ant local differences. There were significant variations in the timing and extent of feminization. The city of Halifax was among the first school dis-tricts in which the majority of teachers were women. The predominance of women in urban teaching forces has been widely noted by other historians. Urban areas were the first to develop bureaucratic school systems with large numbers of female teachers in the younger classes of graded schools and a smaller number of men in supervisory positions.[24] As Table One demon-strates, Halifax followed the pattern of other urban areas. Very soon after the implementation of the Free School acts of 1864-7, Halifax had a predomi-nantly female work force supervised by a corps of male principals and administrators.[25]

The situation in rural areas must be examined more closely, and with careful attention to local conditions. The retention of male teachers in the eastern counties is particularly significant. All four Cape Breton counties still had more men than women teaching in public schools in 1879. In Antigonish

21 *Abstainer*, 15 November 1856.
22 *Abstainer*, 25 November 1868.
23 *Acadian Recorder*, 22 February 1862.
24 Danylewycz, Light and Prentice, "Evolution", pp. 82-3.
25 *Annual Report*, (1870), Report of the Board of School Commissioners for the City of Halifax for 1870, pp. 9ff.

TABLE ONE
Female Teachers as a Percentage of All Teachers (average winter-summer)

School District	1851	185	1861	1869	1871	1877	1879
Annapolis							38
Antigonish				25			40
Cape Breton				24			27
Colchester				60			77
Cumberland				63			80
Digby				50			59
Guysborough				49			70
Halifax Co.				62			81
Halifax City	36	55	52	58	65		81
Hants				59			65
Inverness				13			26
Kings				41			60
Lunenburg				52			76
Pictou		27		45			59
Queens				52			73
Richmond				42			47
Shelburne		64		51			75
Victoria				19			40
Yarmouth				48			69
Nova Scotia	20	39	30	45	47	61	66

Sources: Prentice, "The Feminization of Teaching", p. 57; Annual Report (1859), p. 157; Annual Report (1877); Annual Report (1879). Until 1864 School Districts and Counties did not conform. Halifax City remained one school district for statistical purposes throughout the period.

County 60 per cent of the teachers were male. The only exception to this pattern was Pictou County, where women constituted 59 per cent of the teachers, still below the provincial average of 66 per cent women. Although other factors may have played a part in this trend, the influence of Scottish educational traditions, including that of the male teacher, is a useful point of departure. Traditional sexual divisions of labour played an important role in the timing of the feminization of public school teaching. Danylewycz, Prentice and Light have argued that the tradition of female teaching orders in Quebec hastened the acceptance of women teachers in the province.[26] While John Reid, in his study of Scottish influences on higher education in the Maritimes, reminds us of the need for careful attention to the transmutation of Scottish traditions, it can safely be argued that the Scottish parish school system did not foster the acceptance of women teachers.[27]

26 Danylewycz, Light and Prentice, "Evolution", p. 94.
27 John G. Reid, "Beyond the Democratic Intellect: The Scottish Example and University Reform in Canada's Maritime Provinces, 1870-1933", in Paul Axelrod and John G. Reid, eds., *Youth, University and Canadian Society: Essays in the Social History of Higher Education* (Montreal, 1989), pp. 275-300. See also R.D. Anderson, *Education and Opportunity in Victorian Scotland: Schools and Universities* (Oxford, 1983).

The Scottish immigrants to northeastern Nova Scotia brought with them the tradition of the parish school system, established in the 17th century. This system had two characteristics that would preclude women teachers. One was the religious duties performed by many parish schoolteachers. The parish teacher usually doubled as the session clerk and often led the reading of the psalms at Sunday services, public tasks that could not be performed by a female teacher.[28] The second was the role of the parish school in preparing its students for further intellectual training at the burgh schools, or county academies, and at university. Unlike the situation in either North America or England and Wales, provision was made for some students to progress from the parish elementary schools through to the burgh secondary schools and then to university. It is significant that the feminization of the Scottish public school teaching force did not really begin until after the passage of the British 1872 School Act. This act, by providing funding only for primary schools and not for secondary schooling, changed the orientation of the Scottish school system and eliminated the link between primary education and the universities.[29] The persistence of male teachers in counties with high proportions of Scottish immigrants and their descendants owes some debt to the legacy of the parish school system.

Further research is needed to reach firm conclusions on the matter of recruiting women teachers, and other factors must be weighed. Prentice and Theobald, in their recent review of the historiography of women teachers, emphasize the complexity and local variation in the recruitment of women teachers to public school teaching.[30] At this point any conclusions about the reasons for the regional variations within Nova Scotia in the rate of feminization are premature, but the rich literature in the field suggests a number of interpretative approaches. Strober and Tyack, in their study of American teachers, argue that it was only in the areas that rejected other educational reforms that large numbers of male teachers remained in the public school system.[31] This interpretation flies in the face of the conventional Scottish reputation for a love of learning, and further research on the public schools of Cape Breton would be needed to test it. However, the willingness of Pic-

28 Bruce Lenman, *Integration, Enlightenment and Industrialization: Scotland 1746-1832* (Toronto, 1981) p. 12.
29 Helen Corr, "The Sexual Division of Labour in the Scottish Teaching Profession, 1872-1914", in Walter M. Humes and Hamish M. Paterson, eds., *Scottish Culture and Scottish Education, 1800-1980*, (Edinburgh, 1983); Smout, *Scottish People*, pp. 221-2; Anand C. Chitnis, *The Scottish Enlightenment: A Social History*, (London, 1976), p. 127.
30 Prentice and Theobald, "The Historiography of Women Teachers".
31 Tyack and Strober, "Jobs and Gender", p. 137.

tou County school boards to hire women in the 1870s is interesting, as that county maintained a reputation for the quality of its schools.

A further line of inquiry presented by Danylewycz, Light and Prentice must also be explored. They argue that the presence of other more lucrative opportunities for paid work for men was an important variable in their participation in public school teaching.[32] This factor may have been of considerable importance in mid-19th century Cape Breton. It is interesting to note, however, that counties on the south shore of the province, especially Queens and Shelburne counties, which also experienced poor economic conditions in the 19th century, were much more likely to hire women. By 1879 three-quarters of the teachers in both counties were women (see Table One). Variations in attitudes toward female teachers among Protestant denominations may have played a role in these counties. Baptists and Methodists, in contrast to Presbyterians, sometimes had less rigid views of women's role in education.[33] A number of questions about the local contours of feminization in Nova Scotia remain unanswered.

Attitudes to the general process of feminization in the province varied considerably throughout the period. Politicians appeared to have very little difficulty accepting the idea of women teachers in the public schools of Nova Scotia. The idea of free schools supported by local property assessment was a controversial issue from the late 1830s to the mid-1860s, and denominational education remained contentious throughout the period.[34] The subject of women teachers paled in comparison to these thornier subjects. In 1837 the Education Committee of the Nova Scotia Assembly prepared a package of school reforms. Among the recommendations was a somewhat grudging acceptance of women teachers. The committee recommended that "Female Teachers, who are often the most valuable that can be obtained" should be entitled to a share of the provincial education grants.[35] Both the Assembly and the Legislative Council accepted the recommendation without debate. It was agreed "that where a female Teacher can be more advantageously employed than a male teacher", the local school board could hire a woman.[36]

32 Danylewycz, Light and Prentice, "Evolution".

33 I would like to thank one of the anonymous *Acadiensis* readers for raising this important point.

34 For a discussion of education debates in Nova Scotia see Janet Guildford, "Public School Reform and the Halifax Middle Class, 1850-1870", Ph.D. thesis, Dalhousie University, 1990. The Nova Scotia government passed free school legislation in 1864. *Statutes of Nova Scotia*, 1864, ch. 58.

35 *JHA* (1837-8), App. 72, p. 161.

36 *Statutes of Nova Scotia*, 1838, ch. 23, s. VI.

The change was totally ignored in the local press. The *Novascotian* published three letters in early March supporting the Assembly's other school reforms. A letter writer from Musquodoboit apparently did not expect to see large numbers of women enter the occupation. The writer hoped for other reforms that would "raise the character of this class of men, by increasing their means; and making their profession an object of ambition to men of talents and acquirement".[37] The lack of interest in the question of women teachers was strikingly apparent in the one statistical survey of the Nova Scotia school system in the 1840s. In 1842 the report of the short-lived Nova Scotia Central Board of Education presented a multitude of tables, but it did not provide an analysis of male and female teachers. While the language of the report assumed that teachers were male, it is impossible to determine whether or not the members of the board strongly preferred male teachers in the common schools.[38]

Considerably more light was thrown on attitudes to women teachers during the 1850 session of the Legislature. In the course of the general debate on public schooling, female teachers and the education of women were discussed a number of times. Practical approval of female teachers was expressed in the form of a grant to the Amherst Female Seminary, which trained female teachers.[39] While members on both sides of the House expressed general approval for educating girls and hiring women as teachers, apprehension and ambivalence also emerged, and the discussion of women teachers was always couched in the language of separate spheres.[40] Reform leader Joseph Howe hoped that local school boards would be unrestricted in hiring women teachers, but he believed that any Nova Scotia woman would rather be married to a yeoman than "head the best school in the country".[41] The member for Hants County "highly eulogized the character and acquirements of the female teachers" in his riding, claiming that there was a "kindliness in female teachers which was of utmost value to children". His attitude, however, revealed inconsistencies. Despite his apparent approval for women as teachers he argued, without explaining why, that school boards should not hire only female teachers if men applied.[42] The politicians' attitudes toward women were perhaps best revealed by their humour. During one debate a member earned "roars of laughter" when he commented about women, "I love them,

37 *Novascotian*, 1 March 1838.
38 *First Annual Report of the Nova Scotia Central Board of Education* (Nova Scotia, 1842).
39 *JHA* (1851), App. 51, Report of the Education Committee, p. 185.
40 *Novascotian*, 6 May 1850.
41 *Novascotian*, 6 May 1850.
42 *Novascotian*, 6 May 1850.

sir, as I would love my mother, and I could stand here and plead all night for them".[43] On another day Conservative leader J.W. Johnston evoked a good response when he reminded his fellow members that it was dangerous to introduce the subject of ladies into the debate because "they have already thrown us off our track".[44] Talking about women in the Assembly elicited laughter because women were not part of the public sphere of politics, but belonged in the private sphere of the household.

Education administrators, on the other hand, never made jokes. They were an earnest breed, dedicated to fighting ignorance and vice wherever they found it. Unlike the situation in Upper Canada where one man dominated the educational affairs of the province for 40 years, Nova Scotia had six different senior education administrators in the 30 years between 1850 and 1880.[45] To varying degrees all the Nova Scotia superintendents of education expressed qualified support for hiring women teachers, and all did so in terms of the special abilities of women in caring for young children. Certainly the superintendents of education in Nova Scotia discussed the situation in ideological terms. All, with the possible exception of J.W. Dawson, had some misgivings about the feminization of public school teaching, and all endorsed a strict division of male and female labour within the school system.

Nova Scotia's first school superintendent, J.W. Dawson (1850-3), a young Pictou County geologist and bookseller, actively promoted the recruitment of female teachers.[46] His own formal education had begun in a "Dame School", a small private school for young children run by a woman.[47] In 1850, after a trip to Massachusetts, he reported very favourably on the number and ability of women teachers in the state.[48] As a patriotic Nova Scotian Dawson saw a further advantage in training his countrywomen as teachers. He believed that it would stem the out-migration of Nova Scotia women.[49]

About 20 per cent of Nova Scotia teachers were women during Dawson's brief regime as superintendent, but he noted that they were usually hired

43 *Novascotian*, 6 May 1850.

44 *Novascotian*, 2 February 1850.

45 Alison Prentice, *The School Promoters* (Toronto, 1977).

46 J. William Dawson, *Fifty Years of Work in Canada: Scientific and Educational* (London, 1901).

47 Dawson, *Fifty Years*. For a discussion of dame schools see E. Jennifer Monaghan, "Noted and Unnoted School Dames: Women as Reading Teachers in Colonial New England", Conference paper for the 11th Session of the International Standing Conference for the History of Education, Oslo, Norway, 1989.

48 *JHA* (1851), Annual Report.

49 Out-migration from the province was female-led. See Patricia Thornton, "The Problem of Out-Migration from Atlantic Canada, 1871-1921: A New Look", *Acadiensis*, XV, 1 (Autumn 1985), pp. 3-34.

only for the summer term, and replaced by men, who during the summer may have been drawn into agricultural or other work. He felt this practice was "injurious" to the state of education, and advocated the retention of good teachers, whether male or female, during the whole year.[50] Dawson was impressed with the quality of some of the women teachers he found at work in Nova Scotia. He singled out the women teachers of Barrington, in Shelburne County on the province's south shore, for special praise. They were "especially deserving of credit for their knowledge of the branches required in their schools and of improved methods of teaching".[51] Dawson's superintendency was a brief one; he resigned from the position after just two years. For the next two years educational affairs in the province were overseen by two regional inspectors. Hugh Munro, the inspector for eastern Nova Scotia, made no comment at all on women teachers; no doubt he encountered very few. Charles D. Randall, responsible for western Nova Scotia, was a strong supporter of female teachers and argued that it was not sex that mattered in a teacher, but qualifications. This kind of comment must always be regarded with suspicion. The sex of the teacher obviously did matter to Randall because he noted that women were "natural guardians of the young".[52]

Alexander Forrester (1854-64), a Scottish-trained minister and zealous educational reformer, was Nova Scotia's second superintendent of public schools.[53] His attitude toward female teachers was considerably more ambivalent than either Dawson's or Randall's, and his support was dependent on the conventions of a rigid delineation of separate spheres for men and women. He spelled out his approach in the teachers' textbook he published in 1867. He noted that "both by the law of nature and revelation" there was a "position of subordination and of dependence assigned to women", and thus there ought to be "situations in educational establishments better adapted to the one sex than the other".[54] In other words, women were acceptable as teachers of young children, but men should retain their jobs as the teachers of older children and as supervisors.

In 1864 Forrester, a long-time Liberal partisan, was demoted by the Conservative government and replaced by Theodore Harding Rand (1864-70), an Annapolis Valley Baptist who had been a teacher at the Normal School in

50 *JHA* (1851), App. 53, Annual Report; *JHA* (1852), App. 11, Annual Report, pp. 72-3.
51 *JHA* (1852), App. 11, Annual Report, p. 67.
52 *JHA* (1854), App. 73, Report of the Education Committee, p. 374.
53 Judith Fingard, "Alexander Forrester", *Dictionary of Canadian Biography*, Vol. IX (Toronto, 1976), pp. 270-2.
54 *The Teachers' Text Book* (Halifax, 1867), pp. 565-6 cited in Prentice, "The Feminization of Teaching", p. 61.

Truro.[55] Rand, too, endorsed the idea of separate roles for male and female teachers. Addressing the Provincial Education Association in 1870 he tried to reassure the male teachers who wanted to "throw a shield around male teachers, lest their lady associates drive them all out of the province".[56] Rand did not believe that male and female teachers were in competition for the same jobs. While men lacked "maternal sympathies so requisite for the conduct of the lower grades . . . [w]e must retain a certain proportion of the masculine element" for more advanced students.[57]

Rand was fired as superintendent of schools in February 1870 because he bucked the Council of Public Instruction (CPI) during a separate school dispute in Cape Breton.[58] He was replaced by Rev. A.S. Hunt (1870-7), a successful Baptist minister who lacked any experience with the public school system of the province. Forrester and Rand had demonstrated that professional educators were independent and obstructive, and the CPI chose Hunt because its members felt he would support their political policies and smooth over the separate school question, which he did until his death in 1877.[59] But Hunt's lack of experience with the public school system left him unprepared for the extent of feminization in the early 1870s. He also had to contend with the fact that some people complained about the increasing numbers of women teachers, while others "had a very decided preference" for them.[60]

Hunt's own attitude to women teachers was complex. While initially he deplored the feminization of the public school work force, he gradually changed his opinion. Although there were echoes of the separate spheres ideology in his thinking, he was not entirely confident of the natural ability of women to exercise a good influence on children, and his approval for women teachers was closely tied to their educational attainments. Hunt's thinking on the question is most interesting because it contains elements of both older ideas about the depravity of women and newer ideas about the need for specialized training in the making of an effective school system.

In his first report Hunt commented that the "evil" of large numbers of female teachers was "operating unfavourably upon the public welfare".[61] And

55 Margaret Conrad, "Theodore Harding Rand", *Dictionary of Canadian Biography*, Vol. XII (Toronto, 1990), pp. 879-84.

56 *Journal of Education*, 29 (February 1870), p. 450.

57 *Journal of Education*, 29 (February 1870), p. 450.

58 Conrad, "Theodore Harding Rand".

59 For obituaries of Hunt see *Christian Messenger*, 31 October 1877; *Acadian Recorder*, 24 October 1877. It is probably a comment on Hunt's lack of professional credentials that no biographical work has been published on his career. For a brief discussion of his appointment see Conrad, "Theodore Harding Rand".

60 *Annual Report* (1876), pp. ix-x.

he may have been one of the few Canadians to take satisfaction in the depression of the 1870s, because it dried up new work opportunities for male teachers and kept them in the school system.[62] These denunciations reflect only one facet of Hunt's complex attitudes toward women. Although he was imbued with the separate spheres ideology, Hunt was not persuaded of the value of women's natural aptitude for mothering or teaching, and he was apprehensive about the effect of "ignorant" women on the development of children. He advocated the introduction of more rigorous training for girls in the public school system and hoped that women teachers would also receive better training.[63] He explained his thinking to the provincial Education Association in 1872:

> Our common schools are open alike to the sexes, and I am of the opinion that our colleges and academies also ought to be, and in a few years, I think will be, open to females . . . [T]he most highly cultivated intellect is requisite to train a child in his early years. It is most unsafe for the moral and intellectual, as well as for the physiological welfare of a young child, to trust it to the keeping of ignorant and uncultivated persons. Here is at once a reason why mothers should have the best education that the country can afford, for mothers must have charge, some of them exclusive charge, of the earlier years of their children — an ignorant woman in such a position is a sad object to contemplate.[64]

With longer experience in the public school system of Nova Scotia Hunt did moderate his position on women teachers. He felt that the complaints about feminization would dissipate as the level of training among women teachers improved.[65] By the time David Allison, a classical scholar and the president of Mount Allison College, assumed the superintendency in 1877 feminization was a fait accompli and no longer the source of much discussion.[66]

61 "Our Public Schools", *Journal of Education*, 37 (June 1871), p. 573.
62 *Annual Report* (1876), pp. ix-x.
63 "Our Public Schools", *Journal of Education*, 37 (June 1871), p. 573; Superintendent's Address to the Education Association of Nova Scotia, *Journal of Education*, 44 (August 1872), p. 50.
64 Superintendent's Address to the Education Association of Nova Scotia, *Journal of Education*, 44 (August 1872), p. 50.
65 *Annual Report* (1876), pp. ix-x.
66 "David Allison", in Henry James Morgan, ed. *The Canadian Men and Women of the Time: A Handbook of Canadian Biography* (Toronto, 1898), p. 18. For Allison's initial impressions of feminization see *JHA* (1877), App. 5, Annual Report, p. xviii.

Feminization and the separate spheres ideology that promoted it had important ramifications for teachers' efforts to improve their wages, working conditions and political power. By 1870 Nova Scotia school administrators were speaking confidently and optimistically about the "dignity of the teacher's profession". An editorial in the provincial *Journal of Education* claimed that

Teaching is no longer an ignoble pursuit, nor a field for scholastic ambition, but a profession engaging the public confidence, demanding great talents and industry, and securing great and satisfactory rewards.[67]

These claims must have read like wishful thinking to the teachers of Nova Scotia. The struggle to achieve professional status was long and difficult, and teachers had made little progress by 1870. There has been debate among historians about whether "professionalization" is the most accurate description of teachers' efforts to improve their situation, but the term has been adopted for this study because it was used by contemporary education administrators and teachers in their struggle for improved wages, working conditions and status.[68] References to teaching as a profession began to appear in the Nova Scotia press as early as the 1830s and continued to be used throughout the period.[69] Alexander Forrester, for example, asked in a pamphlet promoting the Normal School, "Would it . . . not prove of incalculable service to the cause of education to have the business of teaching exalted to the rank and dignity of one of the learned professions?"[70] In 1870 the *Journal of Education* used the teachers' claims to professional status as the basis for higher wages for teachers.[71] The professionalization model is helpful in understanding the position of teachers if we adopt Barry Bergen's approach to the question. He argues that professionalization must be examined as "the process of constituting and controlling a market for special services, expertise or knowledge".[72]

67 *Journal of Education*, 32 (August 1870), p. 498.
68 For a discussion of recent approaches to the history of teachers efforts to improve their situation see Wayne J. Urban, "New Directions in the Historical Study of Teacher Unionism", *Historical Studies in Education/Revue d'histoire de l'education*, 2, 1 (Spring/printemps 1990), pp. 1-15. Also useful is Jennifer Ozga and Martin Lawn, *Teachers, Professionalization and Class* (London, 1981).
69 See, for example, *Novascotian*, 1 March 1838; *Provincial Magazine*, 2, 2 (February 1853), p. 52.
70 *Register and Circular with Brief History and Condition of the Normal School of Nova Scotia 1862* (Halifax, 1862), p. 12.
71 *Journal of Education*, 30 (April 1870).

A second useful point can also be drawn from the literature on the professionalization of teaching. Ozga and Lawn point out that claims for professionalization played an ambiguous role in the teachers' efforts to improve their conditions. The state could and did use professionalism to control teachers, by encouraging them to tie their aspirations very closely to the level of service they provided to the community, thereby discouraging unseemly demands for personal gain. However, teachers also used their claim to professional status in order to assert their right to higher wages and greater control of the conditions of their work, to which they felt entitled by virtue of their specialized knowledge and skills.[73]

There can be little doubt that Nova Scotia teachers, like their counterparts in other places, failed in their early bids for professional status. While wages did improve for a few men in senior positions, most male teachers continued to earn a wage comparable to that of labourers, and women were paid on a scale very similar to the wage rates of domestic servants.[74] Even the most senior male education officers in the province were powerless to assert their claims to professional control against the interference of elected political officials. The demotion or firing of three well-qualified senior officials in the decade following the passage of the Free School Act in 1864 made this point very clear. Alexander Forrester was demoted to principal of the Normal School in 1864 by the Conservative Nova Scotia government because of his long-time support for the opposition Liberals.[75] At the same time the provincial government stripped the Normal School of its right to confer teaching licences on its graduates and instituted a new licensing examination system. In 1867 F.W. George, an experienced educator, was fired as inspector of schools for Cumberland and replaced with a political appointee.[76] And in 1870 superintendent T.H. Rand was fired for opposing the government's separate school policy.[77] By 1880 Nova Scotia teachers did not control access to the profession, wages or the conditions of their work.

72 Barry H. Bergen, "Only a Schoolmaster: Gender, Class, and the Effort to Professionalize Elementary Teaching in England, 1870-1910", *History of Education Quarterly*, 22, 1 (1982), p. 8.

73 Ozga and Lawn, *Teachers, Professionalization and Class*.

74 *Halifax Daily Reporter and Times*, 12 January 1874; Ian McKay, "The Working Class of Metropolitan Halifax, 1850-1889", Honours Essay, Dalhousie University, 1975.

75 Fingard, "Alexander Forrester".

76 F.W. George to Lt.-Gov. Sir Hastings Doyle, 7 September 1869 Provincial Secretary's Correspondence, RG 7, vol. 69, Public Archives of Nova Scotia [PANS].

77 T.H. Rand to the Provincial Secretary, 5 February 1870, Provincial Secretary's Correspondence, RG 7, vol. 69, PANS; *JHA* (1870) App. 22, Arichat Schools.

The teachers did try a variety of strategies to improve their lot, and their efforts illustrate both the strengths and weaknesses of professionalization as a political tool. Sometimes the actions were short-lived, as was the case when 22 teachers petitioned the Halifax School Board for higher wages in 1855.[78] Others attempted to improve their skills by attending government-sponsored Teachers' Institutes.[79] A teacher who attended an institute at Truro in 1852 reported:

> I have returned with a feeling of delight . . . one source of regret alone
> I feel regarding it, and that is that we continued together for so short
> a time . . . I feel happier in my work, because many of the plans I have
> tried in doubt have been tried by others, and that with success.[80]

Teachers' Institutes could also be adapted to serve more autonomous professional goals. In 1870 nine teachers from the town of Pictou conducted their own Teachers' Institute, holding semi-monthly meetings and operating a library "of the best works on Education and practical teaching".[81]

Teachers began to create sustained autonomous organizations in the early 1860s. The Halifax and Dartmouth Teachers' Association was formed in 1862 by 17 men and five women to elevate the status of teachers.[82]A few months later 14 teachers, ten men and four women, established a province-wide organization. At first the group called itself the United Teachers' Association of Nova Scotia, but six months later the name was changed to the Provincial Education Association (PEA). The change in name suggests a shift in the political orientation of the organization from the elevation of the status of the teacher to the improvement of educational services within Nova Scotia.[83] While these two goals were always associated by the teachers' organizations they were not identical, and the contradictions expose the ambiguity of professionalism.

Between 1862 and 1880 the PEA functioned as a combination lobby group and scientific society for the teachers of Nova Scotia. Its membership, open to teachers of both sexes, was dominated by senior male teachers, many of them teachers and principals of academies rather than elementary schools, and county inspectors. With the one exception of Amelia Archibald, a Hali-

78 *Presbyterian Witness*, 22 December 1855.
79 *JHA* (1851), Annual Report.
80 *JHA* (1852) Annual Report, App. 11, p. 60.
81 *Annual Report* (1870), Inspector's Report, Pictou County, p. 54.
82 *Constitution of Halifax Dartmouth Teachers Association* (Halifax, 1862).
83 Minutes of the Provincial Education Association [PEA], 16 May 1862, 25 September 1862, PEA Minute Book, RG 14, vol. 69, PANS.

fax teacher who served as a member of the Management Committee of the association in 1873, the executive was entirely male.[84] The PEA was moribund between 1876 and 1879, and in 1880 it was superseded by the Educational Association of Nova Scotia. The change represented a loss of autonomy by the teachers. The new Educational Association was established under the auspices of the Council of Public Instruction, and the membership included all provincial education officials and everyone associated with provincial colleges as well as teachers. The format of the first convention resembled a teachers' institute rather than the scientific society form used by the PEA.[85]

The records of the PEA are, unfortunately, sparse, but there is no evidence that the association regarded the feminization of public school teaching as a professional or political issue. Although it was open to all teachers in the province, the PEA attracted only a handful of women, and it can be assumed that these women were dedicated professionals. For the most part they were treated by their male colleagues with a protective paternalism appropriate to the conventions of the separate spheres ideology. The association recognized the salary differentials between men and women by collecting lower membership dues from women teachers, and in 1869 it voted to sell Alexander Forrester's *Teacher's Text Book* to "Lady Members" for one dollar instead of two.[86]

Male members also protected women from having to expose themselves to censure by speaking on a public platform. On the few occasions when women teachers prepared papers for meetings the papers were read by men and the writer remained anonymous. In July 1871, for example, Halifax school principal C.W. Major read a "paper by a lady teacher entitled 'Miscellaneous Observations of the Studies of Girls'", and in 1873 F.W. George, principal of the New Glasgow Academy, also read a paper from an anonymous "lady teacher".[87] The pattern was interrupted in 1874 when Dartmouth teacher Maria Angwin stood on the public platform to read her own paper, ironically entitled "The Old is Better".[88] Angwin, later the first women licensed to practise medicine in Nova Scotia, was obviously out of step with her colleagues, and the next year another male teacher read a paper "handed in by a lady".[89]

84 See PEA Minutes, 1862-80 and Petitions, RG 5, Series P, vol. 77, no. 86, 20 February 1864 and vol. 77, no. 165, 11 February 1868, PANS.
85 *Report of the First Annual Convention of the Education Association of Nova Scotia* (1880), PEA Minute Book.
86 *Journal of Education*, 25 (June 1869), p. 396; PEA Minutes, December 1873.
87 PEA Minutes, 20 July 1871 and December 1873.
88 PEA Minutes, December 1874.
89 PEA Minutes, December 1875; Lois Kernaghan, "'Someone Wants the Doctor': Maria

Although women were clustered at the low end of the occupation and paid considerably less than men at each licence level, the participation of even a few in the PEA demonstrates that some women were ambitious to improve their standing.[90] In the early 1850s women teachers attended Teachers' Institutes sponsored by the Nova Scotia superintendent of schools, J.W. Dawson.[91] In 1858 Forrester published an essay by a young woman pupil at the Normal School in the *Journal of Education and Agriculture* on teachers' need for special knowledge about the nature of child development.[92] From the time it opened in 1854 the provincial Normal School at Truro always had a large proportion of female students. It was not until 1869 that female teachers were eligible to take the examination for first-class licences. In October 1869 a 16-year-old Normal School student was the first woman to gain a first-class licence.[93] However, the highest licence granted in the province was the academic licence, not the first class. Therefore women were still ineligible for teaching in provincial secondary schools. The two medal winners at the Normal School in 1877 were both women, and the four students with highest marks in the licensing examinations in 1881 were women.[94]

A few women were active in professional activities beyond the PEA and the Normal School, and some won recognition for their efforts. In 1870 Miss H.M. Norris of Cape Canso won a ten-dollar prize from the Provincial Education Association for the best educational tract, "Five Days a Week, or the Importance of Regular Attendance at School".[95]Letitia Wilson, who taught the school in Doctors Cove, Shelburne County, attained both respect and financial reward. In 1870 the trustees of her school found her services so

Angwin, M.D., (1849-1898)", *Nova Scotia Historical Society Collections,* Vol. 43, (1991), pp. 33-48.

90 *JHA* (1869), Annual Report, App. 7, Table 1.

Winter Term	Acad.	1st class	2nd class	3rd class	Total
Male	13	231	260	290	794
Female	0	232	182	90	504

The salary differentials for 1869 were: Male 1st class: $397; Female 1st class: $256; Male 2nd class $253; Female 2nd class: $181; Male 3rd class: $186; Female 3rd class: $150. RG 14, vol.30, #471, 1869, PANS.

91 Of 68 teachers attending a Teachers Institute at Truro in November 1851, 24 were female. *Journal of Education,* 3 (January 1852); Five female teachers (Susan Best, Annie Kidson, Esther Gould, Mary E. Troop, C.A. Troop) also attended an Institute at Truro in April 1851. Forty men also attended. *Novascotian,* 28 April 1851.

92 *Journal of Education and Agriculture,* 1, 3 (September 1858), pp. 36-8.

93 *Journal of Education,* 27 (October 1869), p. 413.

94 *JHA* (1877), App. 5, Annual Report, p. xviii; *Annual Report* (1881), App. A.

95 *Journal of Education,* 29 (February 1870), pp. 446-7.

profitable "both educationally and financially" that they increased her salary sufficient to make her the highest paid teacher in her class in the county.[96]

Such success was unusual, and the PEA did not provide a forum for women's professional ambitions. In the early 1870s two women took their grievances to a wider audience. Both these women were unhappy about the lack of financial remuneration they received as well as their lack of status. The language they employ is as significant as their arguments. They argued their cases explicitly in terms of women's special aptitude for teaching the young, and called on the chivalry of their colleagues and employers rather than demanding recognition of their professional skills. Both women wrote anonymously. Apparently even complaints couched in socially acceptable terms were likely to be met with resistance and criticism.

The first was written to the provincial *Journal of Education* in 1871. The author developed her argument systematically:

> Have the friends of right, and the keen discrimination of providential arrangements, considered these conclusions? What place does the woman occupy in the family? Who does not know that in the most important institution in the world, *Home*, woman's mind is the governing power? Who does not know that all minds receive the first training, the first direction, the first noble, generous pulsation of future ambition, under the moulding and elevating authority of the female? Take from our homes this female training; take from society, generally, this element, and what are our homes or what our country? There is a part of the great system of instruction in which woman towers immensely above man. The teacher's office is specially suited to women — who are natural educators.[97]

She went on:

> When it is stated that, for the same labour, females receive less pay, though that labour may be as well, if not better, performed, we are compelled to feel that an aspersion is cast upon our sex, from which our past history and present influence ought to save us, and if it has any meaning at all, is a sad commentary upon the chivalry and gallantry of our countrymen.[98]

96 *Annual Report* (1870), p. 41.
97 "Female Teaching", *Journal of Education*, 36 (April 1871), p. 559.
98 "Female Teaching", *Journal of Education*, 36 (April 1871), p. 559.

The second anonymous woman teacher brought her complaints to a Halifax newspaper in 1874. Her tone was more urgent than that of the letter writer three years earlier, but her argument, that male gallantry ought not to permit the underpayment of women teachers, was similar:

> Now, Mr. Editor, when we take into account the time, trouble and expense given in order to obtain a first-class license, and the loss of dignity entailed in interviewing the Commissioners, one by one, and in appealing to every feeling known to humanity (save that of qualification for the office), it will be granted that the salary given is not glaringly liberalThe only remedy for this evil is increase in salary It is pitiable to reflect that the only city officials so treated are *women*, whom one would suppose the chivalrous instinct of a *gentleman* would lead him to protect, not oppress.[99]

The deeply held gender attitudes of both male and female teachers crippled their ability to address their situation directly and to negotiate collectively with the state. Reformed public schools provided moral training for children, work associated with the unpaid reproductive labour of the private sphere. But that work was performed in the public sphere for wages. The separate spheres ideology could not fully accommodate the novel institutional setting of the public school which did not fit neatly into it. This uneasy fit made it very difficult for male and female teachers to negotiate collectively to improve their working conditions. The gender ideology had special meaning for teachers of both sexes. And it is important to remember that, whatever reassurances were attempted by school administrators such as T.H. Rand, men and women were in competition for jobs. Rand himself pointed to this competition indirectly in the *Journal of Education* in 1870 in an item on selecting teachers. He complained that when it came to hiring, many local school boards made inappropriate choices, and nearly all those poor choices were women teachers. He said that very few "real Teachers" applied for teaching jobs. Most were "estimable young ladies without money" who were hired because the local school trustees believed that money raised in town should help the poor, or they were untrained school girls hired because they were local or because their fathers were influential in the locality.[100]

Superintendent Hunt also tried to reassure male teachers that they need not compete with women for jobs. In 1871 he argued that women teachers

99 *Halifax Daily Reporter and Times,* 12 January 1874.
100 *Journal of Education,* 30 (April 1870).

simply could not compete with men "in inculcating what we may call the severer studies so necessary to fit young men for the hard, practical duties of life".[101] He believed that it was a false economy for school trustees to take advantage of the supply of cheap female teachers.[102] The report of the inspector for Pictou County in 1870 refers very explicitly to the competition:

> Though painful to acknowledge, it is a humiliating fact that too many sections are influenced in their selection of teachers more by dollars and cents than by the merits of candidates. Many young men, holding first-class licenses, experienced difficulty in obtaining situations, because they objected to labour for the paltry salaries offered. Trustees also complain of the scarcity of teachers. The fault and the remedy rest with themselves.[103]

J.B. Calkin, the principal of the Normal School, offered the most modern solution to the competition. In 1874 he argued that teaching salaries should be based on qualifications, not sex.[104] It is eloquent testimony to the durability of the separate spheres ideology that his was virtually a lone voice. The editor of a Halifax newspaper expressed a much commoner attitude in a tirade against equal rights for women when he stated that "a sensible and practical woman can always get her rights".[105]

In reality the separate spheres ideology prescribed the expectations and attitudes of Nova Scotia women teachers in ways that made it difficult for them to bargain effectively in the public sphere. Women teachers, as the two writers quoted above attest, believed that they had a natural aptitude for teaching. A natural aptitude does not constitute a learned skill, or in Bergen's words, "special service, expertise or knowledge".[106] Expertise and skill are political constructs; that is, the recognition of skill depends on the success of its possessor in persuading society of its value, not on the degree of difficulty or length of time involved in acquiring it. Women have historically been less successful than men in that process because the skills of women have been defined as belonging to the private sphere, outside the economic values that permeate the public sphere. One measure of this difficulty is found in the descriptions of male and female teachers in mid-19th-century Nova Scotia.

101 *Journal of Education*, 37 (June 1871), p. 573.
102 *Journal of Education*, 37 (June 1871), p. 574.
103 *Annual Report* (1870), Inspector's Report, Pictou County.
104 *Annual Report* (1875), Report of the Provincial Normal School, App. B, p. 95.
105 *Presbyterian Witness*, 21 August 1869.
106 Bergen, "Only a Schoolmaster", p. 8.

Male teachers were recognized for their "careful training and ability".[107] Female teachers, on the other hand, were admired for their "affectionate solicitude" and "unimpeachable fidelity".[108] Women were praised for their innate characteristics, while men were valued for their acquired or learned skill.

Because women were performing work that they were divinely called to, and rested their claims for status on God and nature, they lacked a language in which to advance their claims in the public sphere. This is evident in the women teachers' appeals for chivalry, language that carried more weight in the private sphere than in the public. It is very significant that both of these women used the language of chivalry and natural ability rather than that of human rights and acquired skill.

The full extent of these disadvantages can be understood when we take a longer view of the impact of the separate spheres ideology on the life cycle of women. This ideology proposed that marriage and motherhood were the routes to economic security and social influence. More research is needed to determine just how long women remained in the public school work force, but we do know that women teachers in Nova Scotia were not encouraged to remain in their positions after marriage.[109] The inspector for Cumberland County was the only provincial education official to broach the subject of married teachers directly. He wrote:

> Married ladies are necessarily unable to give steady attendance to school duties, the higher law of maternity compelling them often to be at home. The law of nature seems to be that ladies should, on entering the married state, devote themselves to domestic and social cares, and not to public duties. The family is the school in which the married lady should teach.[110]

107 Minutes of the Commissioners, 12 June 1850, Records of the Board of Commissioners of Schools for the City of Halifax, RG 14, no. 29, PANS.

108 Minutes of the Commissioners, 12 June 1850, Records of the Board of Commissioners of Schools for the City of Halifax, RG 14, no. 29, PANS.

109 The experience of Nova Scotia teachers differed from that of their counterparts in London and in France where married teachers were encouraged to remain in the work force. See Copelman, "A New Comradeship", and Leslie Page Moch, "Government Policy and Women's Experience: The Case of Teachers in France", *Feminist Studies*, 13, 2 (Summer 1988), pp. 301-24. Jean Barman has argued that in British Columbia women teachers often had careers at least as long as their male counterparts: Jean Barman, "Birds of Passage or Early Professionals? Teachers in Late Nineteenth-century British Columbia", *Historical Studies in Education*, 2, 1 (Spring 1990), pp. 17-36.

110 *Annual Report* (1876), Inspector's Report, Cumberland County, p. 30.

The inspector from Pictou County simply assumed that women moved out of the work force at marriage, and coyly reported that "Cupid's intrigues have carried off *seven* of our female teachers".[111]

The forced retirement of women teachers at marriage again reminds us that public school teaching was conducted in the public sphere. It is oversimplifying a complex process to argue that public school rooms became an extension of the private sphere. The public school system was created by male politicians, administered and supervised by male education officers, and its senior teaching positions were retained for male teachers. The men within the public school system were insistent in their claim to specialized knowledge and their position as professionals. Bureaucratization created career ladders for male teachers, with a few lucrative and socially prestigious positions within their sight, if not their grasp. Yet, unlike medical doctors, who were successful in masculinizing their occupation as part of the process of professionalization, male teachers had to wage their struggle in a field that by 1880 was dominated by women. Pictou County school inspector Daniel McDonald, an active member of the Provincial Education Association, identified professionalization quite explicitly with men. In his report for 1870 he lamented that the number of "professional men is small" and stressed the importance of educating the public "to provide salaries adequate to the comfortable maintenance of a family, and to render the schools permanent institutions before young men can be expected to devote their lives to teaching".[112]

While the competition of women in the field may have generated bitter resentment among many men, the separate spheres ideology to which they were committed demanded that they treat their female colleagues with paternalism and chivalry. The strong representation of Scottish-trained academy teachers in the Provincial Education Association in the 1860s and 1870s intensified the dichotomy between elements of the public and private spheres in public education, making it more difficult to negotiate the boundaries within the profession and to present common cause. These men had to press their claims to professional control of a feminized and degraded institution with politicians for whom feminization and the associated low costs were acceptable and even desirable. For male teachers, as for female teachers, the acceptance of a rigid distinction between the public and private spheres inhibited successful collaboration and thus professionalization.

Gender analysis must be applied broadly to the question of public education in mid-19th-century Nova Scotia. Public school reform in the mid-1860s

111 *Annual Report* (1877), Inspector's Report, Pictou County, p. 34.
112 *Annual Report* (1870), p. 53.

created a demand for a large work force that was capable of providing moral training for young children. The separate spheres ideology accorded women a special role in the nurture of young children, and women quickly became numerically predominant in that work force. They were not hired because of their special training or skills but because they had what were believed to be natural characteristics that they shared with all women. The separate spheres ideology that promoted the recruitment of women teachers thus proved highly problematic to both men and women working within the reformed public schools. Nineteenth-century Nova Scotia teachers were unable to persuade politicians and taxpayers that they controlled the market on a special skill.

THE CEREMONIAL SPACE OF WOMEN
Public Processions in Victorian Saint John and Halifax

BONNIE HUSKINS

Parades provided more than entertainment for spectators in the 19th-century city. Urban participants used the varied form and content of public processions to communicate "ideas about social relations".[1] Included in this performative commentary on social relations was the prescriptive 19th-century gender ideology of "separate spheres" which relegated women to the private domestic sphere. Advocates of separate spheres warned that any women who took on "performative roles" outside the home risked gaining a reputation as "women of the streets".[2] It was asserted that female participation in an unregulated public place meant social mixing and might lead unprotected women into sexual immorality.[3] In reality, the parameters of 19th-century female experience were not so rigidly demarcated. As this paper illustrates, women continually negotiated the boundaries of their public "ceremonial space" through participation in 19th-century parades and processions.[4] As Susan Davis puts it, "Such public enactments . . . have been part of the very *building* and *challenging* of social relations".[5] The ability of the ceremonial to build and challenge social relations (including gender ideology) suggests that separate spheres ideology was both mutable and dynamic. The varied participation of women in public processions also illustrates the complex and sometimes contradictory nature of separate spheres ideology. The more frequent inclusion of women in public processions in the late Victorian period shows that the boundaries of separate spheres were changing. The parameters of propriety shifted, so that by the late 19th century, the public participation of women was acceptable as long as it met certain criteria. Female participants had to be accompanied by a protective

1 Susan G. Davis, *Parades and Power: Street Theatre in Nineteenth-Century Philadelphia* (Philadelphia, 1986), pp. 3, 4.

2 Davis, *Parades and Power*, p. 47; Mary Ryan, *Women in Public: Between Banners and Ballots, 1825-1880* (Baltimore, 1990), p. 4.

3 Leonore Davidoff, *The Best Circles: Society Etiquette and the Season* (London, 1973), pp. 81-2.

4 The concept of "ceremonial space" is borrowed from Mary Ryan, "The American Parade: Representations of the Nineteenth-Century Social Order", in Lynn Hunt, ed., *The New Cultural History* (Berkeley, 1987), pp. 131-53.

5 Davis, *Parades and Power*, p. 5. Emphasis added.

male escort, and their performative repertoire was limited to the representation of icons and symbolic imagery. On the one hand, then, this gender ideology limited the range of performative roles open to women; on the other hand, it defined a few very respectable and visible roles for a minority of female participants.[6]

Saint John and Halifax provide the context for this study of women's participation in public processions. Saint John and Halifax were both commercial entrepôts in the Victorian period. Halifax relied on the salt fish trade, particularly with the West Indies, and a general import trade. Saint John merchants extracted and processed timber from a large wooded hinterland along the St. John River and engaged competitively in an international timber trade and shipbuilding industry. The cities had quite different ceremonial traditions. As the capital city of Nova Scotia, Halifax enjoyed a good deal of pomp and circumstance. Halifax also retained a large British garrison until 1906, after the British army had withdrawn from the other Canadian bases, including Saint John. Halifax's status as a soldiertown and sailortown ensured a tradition of military parades and undoubtedly discouraged any alternative traditions.

Saint John, on the other hand, lost its status as capital city to Fredericton. In reaction, Saint John boosters focused on the city's industrial identity as the "Liverpool of British North America". One Haligonian noted in comparing Halifax with Saint John, "Both cities engage largely in commerce, but in our city it holds a secondary place, in the other it is everything".[7] Saint John also became the headquarters of the "low Church" Anglicans, Methodists, Presbyterians and the new Roman Catholic see in 1845. This anti-establishment ethos contributed to the rise of a burlesque tradition of processions in Saint John. Sex, class and race were all subject to performative comment, notably the burlesques offered by the Calithumpians and Polymorphians, theatrical societies created especially for participation in parades and processions.[8] The

6 This paper is adapted from my "Public Celebrations in Victorian Saint John and Halifax", Ph.D. thesis, Dalhousie University, 1991. The dissertation and paper have not been easy undertakings, particularly because of the paucity and bias of the sources. Most of the evidence on female participation in public celebrations is taken from newspaper descriptions and published programmes. Because these are largely official sources, it has been necessary to read between the lines and use the available sources very creatively. Any errors in interpretation are mine.

7 As quoted in C.M. Wallace, "Saint John Boosters and the Railroads in the Mid-Nineteenth Century", *Acadiensis*, VI, 1 (Autumn 1976), p. 73.

8 The term "Calithumpian" is a dialect word from the west of England referring to Jacobins, radical reformers and "disturbers of order at Parliament". Davis, *Parades and Power*, p. 98. The origin of the term "Polymorphian" may be an adaptation of the word "polymorphism", defined by *Funk and Wagnall's New Standard Dictionary of*

active ceremonial role of Saint John's working and lower middle classes may be related to the active and powerful role these groups played in the city's public affairs. Saint John's dock workers, for example, obtained considerable bargaining power and public prominence as a result of the seasonal pressures of the timber market.[9] The early establishment of the Saint John Common Council in 1785 provided the "middling strata" of that city with a longer legacy of participation in public life than the Haligonians, who did not form a corporation until 1841.[10]

In any case, both ceremonial traditions featured men as the leading organizers and performers. Separate spheres ideology confined most women to nurturing and supportive roles, such as spectators and behind-the-scenes helpers. It must be acknowledged, however, that if separate spheres ideology had truly been a rigid societal blueprint, women would *not have appeared at all* in these ceremonial traditions; they would have remained in the private domestic sphere. On the contrary, women could be found en masse in the streets during parades and many other communal gatherings in 19th-century Saint John and Halifax. Women's role as spectator must not be dismissed as merely neutral or passive. As anthropologist John MacAloon has noted, spectacles demand "action, change, and exchange", not only on the part of the "human actors on centre stage", but from the audience as well.[11] Similarly, historian Susan Davis has argued that "the domain in which public performance takes place must be viewed as structured and contested terrain, rather than as a neutral field or empty frame for social action".[12] Women engaged in a wide variety of activities on the sidelines. While certain respectable female spectators segregated themselves from the vulgarity of the masses by occupying elevated platforms, sitting in special cordoned off areas, or watching the festivities from the privacy of buildings and carriages, many women lined the procession routes, cheering and waving their handkerchiefs and parasols, and some even tagged along behind the entries. Prior to the visit of the Prince of Wales to Halifax in 1860, a male commentator spoke of the dif-

the English Language as "the property of having or presenting many forms", or a derivation of the word "polymorpha", a whirling beetle which dances on pond surfaces. E.M. Slader, "From the Victorian Era to the Space Age", *New Brunswick Historical Society Collections*, 21 (1973), p. 10, Saint John Regional Library.

9 Ian McKay, "The Working Class of Metropolitan Halifax, 1850-1884", Honours essay, Dalhousie University, 1975, pp. 174-5.

10 For a discussion of the common council see T.W. Acheson, *Saint John: The Making of a Colonial Urban Community* (Toronto, 1985).

11 John J. MacAloon, *Rite, Drama, Festival, Spectacle: Rehearsals Toward a Theory of Cultural Performance* (Philadelphia, 1984), p. 244.

12 Davis, *Parades and Power*, p. 13.

ficulties involved in trying to control the crowds along the procession route: "In the present state of *feminine curiosity and fashion* it would be unwise to attempt [crowd control]".[13] In other words, crowd control was difficult because of the aggressive behaviour of women, who pushed themselves forward with their obstructive hoops and crinolines. So the word "spectator" is perhaps a misnomer for these female celebrators — they can be more accurately described as "indirect participants".

Female relatives and "sweethearts" also frequently functioned as a "silent working army" behind the scenes.[14] These female "stage hands" sewed costumes and decorations for the floats and made or procured banners for the various organizations. A newspaper correspondent commented that the "superior taste" of the firemen's turnout on Halifax's natal day in 1862 proved that the "fingers of the wives and sweethearts" were "not idle".[15] After the Loyalist centennial in 1883, the Saint John fire brigade and Portland firemen published a card of thanks to the women for their assistance in trimming the engines.[16] The "lady friends" of the Polymorphians also formed committees and sewing circles to make costumes and decorations for the processions.[17] While this role is admittedly nurturing and submissive, and a creation of separate spheres ideology, it nonetheless provided women with an important organizational function during public ceremonials.

Public performance, however, tended to be dominated by male players in the early to mid-19th century. The exclusion of women from performative roles is an important cultural statement. As Susan Davis has pointed out, all forms of communicative culture are "products of selectivity in transmission" and "depend on omission as much as inclusion".[18] Men often presented female imagery in their processions because women represented images of purity and patriotism, and were popular subjects for depiction. The pervasiveness of separate spheres ideology, however, made public performance socially unacceptable for respectable women. Thus, if the men wanted to de-

13 "G." in the *Morning Sun* (Halifax), 16 July 1860. Emphasis added.

14 Mary Ryan, *Cradle of the Middle Class: The Family in Oneida County, New York, 1790-1865* (Cambridge, 1981), p. 110. Women worked as a "silent working army" during American processions. Davis, *Parades and Power*, p. 194; Ryan, *Women in Public*, p. 43. For a discussion of the Dorcas meeting and the "endless round of stitching and serving" endured by Victorian women see F.K. Prochaska, *Women and Philanthropy in 19th Century England* (Oxford, 1980), p. 11.

15 "Phoenix" in the *Acadian Recorder* (Halifax), 23 June 1862.

16 *Daily Sun* (Saint John), 21 May 1883.

17 *Daily Sun*, 11, 22 May 1883, 3, 17 June 1887; *Daily Telegraph* (Saint John), 15, 19 May 1883; *Globe* (Saint John), 16 May 1883.

18 Davis, *Parades and Power*, p. 17.

pict feminine imagery in their demonstrations, they used props, played the roles themselves or used young boys. The firefighters' torchlight procession during the Prince of Wales' marriage celebration in Halifax in 1863 used props to depict feminine imagery, in the form of two unidentified oil port-raits of women (perhaps female mascots or patrons) in front of and behind the reel of Engine Company No. 2.[19] The tailors' entry in the trades proces-sion held in Saint John to mark the turning of the sod of the European and North American railway in 1853 used two boys in flesh-coloured costumes to depict Adam and Eve.[20]

Among the most popular societies to portray female roles were the Poly-morphians and the Calithumpians. While little is known about the Calithum-pians, the more visible Polymorphians established various neighbourhood branches with officers and membership rolls.[21] An analysis of the social profiles of a sample of Polymorphians (56 members from the Haymarket Square branch and 28 from the Portland club) reveal that they were all young white males, and most were native-born, Protestant and from the skilled trades or the lower echelons of the white-collar sector.[22]

19 *Morning Sun*, 15 April 1863.
20 *New Brunswick Courier* (Saint John), 19 September 1853.
21 The Polymorphians began with a club in the vicinity of Haymarket Square. A branch was then set up in Portland during Queen Victoria's golden jubilee in 1887. *Daily Sun*, 30 March, 5 April 1887. This was followed by a third in the South End and a fourth in Carleton (called the Algerine Club) during the diamond jubilee in 1897. *Daily Sun*, 19 June 1897. The term "Polymorphian" had been used earlier by a short-lived fraternal organization in Saint John in the 1850s, but its connection with the burlesque group is unknown. The fraternal organization sponsored a regatta in 1855 and a ball in 1857. *New Brunswick Courier*, 22 September 1855, 14 February 1857; Invitation to ball given by Proteus Camp No. 1, Polymorphian Tribe, 1857. Invitations, folder 5, N.B. Museum. I am indebted to Mrs. Sandra Thorne for the latter reference. William F. Bunting, a collector of customs and a clerk of the Board of Assessors in Saint John, was chief of the Proteus Camp of Polymorphians, a society which had "no resem-blance to the polymorphians of the present day [1897], but was a secret [fraternal] organization". Obituaries at the conclusion of the Bunting Diaries, N.B. Museum. Polymorphian branches have also been found in Moncton and Windsor, Nova Scotia. During the golden jubilee in 1887, the Moncton Polymorphians marched in Saint John's procession, while the Saint Johners participated in the Polymorphians' domi-nion day procession in Moncton. *Daily Sun*, 27 May, 22, 28 June 1887.
22 This is only a partial analysis of the membership rolls of both branches (there are a total of 251 Haymarket Square members and 77 in the Portland Club). In the current sample, I have included only those members I have been able to verify in two sources — the city directory and at least one census, or in both the 1881 and 1891 censuses. Further analysis is ongoing. For the source of the membership lists see *Souvenir of the Queen's Jubilee: An Account of the Celebration of the City of Saint John, N.B., in Honour of the Jubilee Year of the Reign of Her Most Gracious Majesty Queen Victoria*

The Calithumpians and Polymorphians drew on music hall culture and folk traditions to *parody* women. Inversion and parody have a very long history. According to Roger Caillois, "simulation" or mimicry is one of the universal characteristics of human play.[23] Play-acting and masking can be traced back to early European mummings and charivaris. Mumming refers to the tradition of masking (and initially house-visiting) which occurred during calendrical festivals, primarily Christmas.[24] The charivari was essentially a "comic costumed street procession"[25] which expressed disapproval of sexual behaviour or social pretention or voiced political protest.[26] The burlesque demonstrations of the Calithumpians and Polymorphians were essentially organized and institutionalized adaptations of these masking and mocking traditions. Calithumpians and Polymorphians usually confined their performances to the celebration of notable events. According to one source, a Saint John resident named Bob Wilkins organized the "Polymorphian Club" for the purpose of "entertainment, particularly the taking part in the numerous parades and celebrations of the day".[27]

The Calithumpians and Polymorphians were deeply conservative in their burlesque. They strove to protect the social order by parodying those groups which strayed from the typical Polymorphian profile: the main targets were usually women and other ethnic/racial groups. According to Susan Davis, who commented on similar revellers in 19th-century Philadelphia,

> As much as these neighbourhood bands of young male peers created sensations of solidarity for themselves by dressing up, drinking, and visiting, they also defined who belonged in their groups and who did not. By creating hilarity through the delineation of deviant characteristics (blackface, *women's dress*), young men laughingly drew their social circle tighter.[28]

(Saint John, 1887), Saint John Regional Library; *Daily Sun*, 28 June 1887.

23 Roger Caillois, *Man, Play and Games*, M. Barash, trans. (New York, 1961), p. 12.

24 Herbert Halpert and George M. Story, eds., *Christmas Mumming in Newfoundland. Essays in Anthropology, Folklore and History* (Toronto, 1969); Davis, *Parades and Power*, pp. 103-9.

25 Davis, *Parades and Power*, p. 96.

26 Allan Greer, "From folklore to revolution: Charivaris and the Lower Canadian rebellion of 1837", *Social History*, XV, 1 (January 1990), pp. 25-44; Bryan D. Palmer, "Discordant Music: Charivaris and Whitecapping in Nineteenth-Century North America", *Labour/Le Travailleur*, 3 (1978), pp. 5-62.

27 Slader, "From the Victorian Era to the Space Age", p. 10.

28 Davis, *Parades and Power*, p. 110. Emphasis added.

The tableaux of the Calithumpians and Polymorphians resonated with separate spheres ideology. The players primarily parodied women who transcended the boundaries of separate spheres, because they represented the clearest threat to the burlesquers' collective sense of male identity. "Who'll wear the breeches", a tableau held during the Queen Victoria's birthday procession in 1882, mocked "hen-pecked" husbands and their strong-willed wives, who wore the "breeches" in the family. Polymorphians also parodied women who surpassed their "proper sphere" by entering the cash economy. A float entitled "Colored Voters" featured an inscription which read "Brooms Must Be Protected", an allusion to the women of Loch Lomond (an African-New Brunswick settlement near Saint John) who made brooms and sold them in the city market to help support their families.[29]

This ridicule of the Loch Lomond broom-makers illustrates how the fusion of gender, race and class could intensify the parody. The Loch Lomond broom makers were evidently not respected as "ladies"; this was not merely because of their race, but also their participation in trade, which was a function of the structured inequalities of their class position.[30] The Polymorphians' 1882 procession featured an entry called "Loch Lomond Mashers", which ridiculed women of colour in their "poke bonnets". The Polymorphians' tableau entitled "Goin' to de Ball", featured in Queen Victoria's birthday procession in 1881, mocked black dialect, but also parodied the efforts of the women of colour to become "real ladies" by donning the trappings of respectable Victorian dress.[31] This scornful sarcasm is very similar to Mary Jane Lawson's descriptive denigration of the African-Nova Scotian women who dressed in Victorian paraphernalia for the summer baptisms in Preston.[32] As Suzanne Morton notes: "The fact that the symbols of femininity and middle-class women were subject to mockery when associated with African-Nova

29 For marching order see Figure 2. Suzanne Morton notes that few legal wage-earning opportunities existed for African-Nova Scotian women in Halifax County in the late 19th century, so many of them also produced and sold various goods in the marketplace. "Separate Spheres in a Separate World: African-Nova Scotian Women in late Nineteenth-Century Halifax County", in this volume.

30 For further elaboration of the implications of the fusion of gender, race and class, see Morton, "Separate Spheres in a Separate World"; see also Judith Fingard, *The Dark Side of Life in Victorian Halifax* (Porter's Lake, N.S., 1989).

31 For marching order see Figure 1. The parody of African-American dialect also occurred in burlesque parades in 19th-century Philadelphia. Davis, *Parades and Power*, p. 106.

32 Mrs. William Lawson, *History of the Townships of Dartmouth, Preston, and Lawrencetown, Halifax County, Nova Scotia* (Halifax, 1893), pp. 188, 190

Scotia women [and also African-New Brunswick women] immediately attunes us to the links between racism and sex".[33]

The Calithumpians' procession during Saint John's Loyalist centennial in 1883 portrayed woman as "freak", in the form of an outrageous two-headed giantess driven by a monkey. The Polymorphians' procession during the same celebration also retained elements of gender inversion. Although the float depicting a pioneer cabin was said to be staffed by five females and four males, the names of those involved indicate that they were all played by young men. Another tableau of a bridal party featured men in the roles of bride and bridesmaid.[34] These depictions of women were not as sardonic as the Calithumpians' portrayal of the giantess, or the earlier Polymorphian processions. This softening of the burlesque may indicate a class difference between the two organizations, as young men of the middling strata came to dominate the Polymorphian organization and attempted to infuse the displays with a modicum of respectability. One way in which the Polymorphians attempted to make their processions more respectable was by regulating the propriety of the displays. The president of the Polymorphians, Charles Nevins, an upwardly mobile clerk, subjected every member's costume and float to the approval of the club during Queen Victoria's golden jubilee in 1887.[35] The Haymarket Square branch took their regulatory role seriously and expelled Solomon Green and James Driscoll from the procession for wearing unauthorized costumes "most offensive to public decency".[36] Another possible reason for down-playing sardonic female imagery was the increased participation of female relatives and friends in late-19th-century Polymorphian processions. The Polymorphians could not very well ridicule "the female sex" under the very noses of their wives and daughters.[37]

The images women portrayed in late-19th-century processions did not reflect the "the diverse experiences, multifarious roles, and distinct interests

33 Morton, "Separate Spheres in a Separate World".

34 See Figure 3. For names see the *Daily Sun*, 15, 19 May 1883.

35 *Daily Sun*, 10 June 1887.

36 *Daily Sun*, 28 June 1887.

37 An analysis of the names of some of the female participants in the Polymorphian processions indicates that they were related to male members of the organization. For example, Edith Chesley, who appeared in the tableau called the "Queen's Drawing Room", sponsored by the Portland club in 1887, was the sister of member Purdy Chesley. Annie and Janie Belyea, who appeared on the float entitled "Canada" in 1887, were daughters of Haymarket Square member David Belyea. Christine and Isabella, the daughters of Polymorphian Roderick Ross, appeared on the entries "Canada" and "Fairyland" respectively. Martha and Sadie Jackson, the daughters of George Jackson, also participated on the "Canada" float. For names, see *Souvenir of the Queen's Jubilee*; *Daily Sun*, 28 June 1887; Saint John Census, 1881 and 1891.

of their sex".[38] Direct female participation could take the form of either symbolic or descriptive representation.[39] Women primarily appeared in symbolic roles — that is, they did not appear as themselves, but as feminine personages far removed from their own actual experiences. During Saint John's centennial in 1883, women-friends of the Polymorphians played the roles of Queen Elizabeth's court, and during the jubilees, of Queen Victoria and her royal entourage. Women also took part in the Calithumpians' 1883 re-enactment of the landing of the Loyalists.[40]

Women also portrayed female icons. For example, Saint John's No. 2 fire company used a real woman to depict "Britannia" in their Loyalist centennial torchlight parade.[41] The Polymorphians also employed real women to portray "Britannia", "The maid of Erin" and "Miss Canada" in the jubilee processions.[42] Despite direct female participation, the Polymorphians still defined women as "outsiders" by relegating them to symbolic depictions. Why were women confined to mainly symbolic and often nationalistic and patriotic representations? Women's "qualities" made them "perfect vehicles for representing the remote notions of national unity and local harmony".[43] As non-voters, women symbolized the ideal of a society free of partisan conflict, and as non-combatants (domestic and maternal beings), they stood above class conflict and the problems of the nation.[44]

Descriptive representation, or women playing themselves, was less common in the 19th century, but it was not unknown. Women's participation in temperance marches was tolerated by many advocates of separate spheres ideology because involvement in this cause was considered an extension of women's maternal domestic role, in that they were concerned about the reformation of personal behaviour, which would have an important impact on the quality of family life. Women found acceptance as members of the Old Halifax Temperance Society, which processed during the Halifax Centenary in 1849, and the Halifax Catholic and Total Abstinence Society, which appeared in the 1860 procession marking the visit of the Prince of Wales to Halifax and the Halifax Confederation procession in 1867. Although the Sons of Temperance, an American fraternal organization which invaded the Maritimes in the late 1840s, refused to give "'full and unequivocal member-

38 Ryan, *Women in Public*, p. 55.
39 Ryan, "The American Parade", pp. 149-50.
40 See Figures 3-5.
41 *Daily Sun*, 17, 19, 23 May 1883.
42 See Figures 4 and 5.
43 Ryan, "The American Parade", pp. 149-50.
44 Ryan, "The American Parade", pp. 150-1.

ship to the female sex"',[45] temperance marches still featured women from the auxiliary societies. The Sons of Temperance marched during the Halifax Centenary in 1849 and the visit of the Prince of Wales to Halifax and Saint John in 1860.[46]

When women strayed beyond this maternal role, they risked generating more opposition from separate spheres supporters. One Halifax editor did not appreciate the participation of women in the trades procession held in Halifax to celebrate the Canadian union in 1867. The Virginia Tobacco Company's entry in the procession featured factory women at work making tobacco and cigars,[47] appropriate in an industry which would become one of the major employers of women in Halifax.[48] The other female marchers were probably relatives, members of female auxiliaries,[49] or, as the anti-Confederation papers contended, extra bodies added to stack the procession.[50] Regardless of their status, the *Novascotian*, a local anti-Confederation paper, did not approve of their inclusion in the Confederation procession: "Women too there were among the trades, who, it is not libel to say, were not well posted in the details of the Union scheme, and who were far better fitted to judge the beauties of the gaudy print than those of the action of our legislators".[51] Not only were the female marchers "uninformed", but non-voters as well — a combination which did not qualify them to participate in the procession as representatives of the polity. The women in the trades procession had obviously stepped beyond the acceptable male-defined boundaries for

45 Janet Guildford, "'Separate Spheres' and the Feminization of Public School Teaching in Nova Scotia, 1838-1880", in this volume.
46 For the full order of march for these processions see Huskins, "Public Celebrations in Victorian Saint John and Halifax", pp. 182, 183, 203-4. In Saint John, women also served as members of the "Saint John Total Abstinence Society". They composed 40 per cent of the organization before 1835, less than 25 per cent after that date, and edged up to 30 per cent in 1840. Acheson, *Saint John*, p. 144. Women also formed their own "Ladies' Total Abstinence Society for the City and County of Saint John", which submitted a temperance petition to the legislature in 1847. Gail G. Campbell, "Disfranchised but not Quiescent: Women Petitioners in New Brunswick in the Mid-19th Century", in this volume. Women also appeared in temperance marches in 19th-century Philadelphia: Davis, *Parades and Power*, p. 149.
47 *Novascotian*, 2 July 1867; *Morning Chronicle* (Halifax), 2 July 1867. Philadelphia's trades processions also featured female factory workers. Davis, *Parades and Power*, p. 119.
48 McKay, "The Working Class of Metropolitan Halifax", p. 168.
49 For a discussion of the woman's auxiliary see Mary Ann Clawson, *Constructing Brotherhood: Gender, Class, and Fraternalism* (Princeton, 1989), pp. 178-210.
50 *Morning Chronicle*, 2 July 1867; *Novascotian*, 8 July 1867.
51 *Novascotian*, 8 July 1867. Gentlemen generally avoided politics in the company of "ladies". Prochaska, *Women and Philanthropy*, p. 14.

female participation in the public sphere. As Mary Ryan has noted, it was the man's role to "speak for and act upon the community as a whole". A reciprocal power did not "accrue to women by virtue of their stature in the private realm".[52]

This editorial must, however, be balanced against the lack of any further comment on the inclusion of women in the procession. Many men evidently had no reservations about the involvement of working-class women in public ceremonials. This lack of concern may be another example of the elasticity of the boundaries of separate spheres; alternatively, it may be a function of the class affiliation of the women involved. Many middle-class observers may not have seen the public participation of working-class women as worthy of comment or concern, since they did not fall within the purview of middle-class respectability. If, however, a middle-class woman had appeared in a procession in a role other than a symbolic or maternal one, the commentary would probably have been more scathing. Here we address the interplay of class and separate spheres, another indication of the complexity of 19th-century gender ideology.

Women in 19th-century Saint John and Halifax did not unconsciously conform to the rigid 19th-century dichotomization between private/female and public/male. Rather, through participation in public processions, they negotiated a ceremonial space for themselves in the public sphere, alongside their male counterparts. Separate spheres ideology did, however, define and limit female representation and participation in public ceremonials. In the early to mid-19th century, men portrayed and parodied female roles and imagery. The late Victorian period witnessed increased female involvement, albeit confined to a limited repertoire of roles. Thus, separate spheres ideology showed itself to be both constraining and flexible, in that it limited the range of female representation and participation, yet also accommodated the idea of female performance in the public sphere.

52 Ryan, *Women in Public*, p. 8.

Figure 1:
POLYMORPHIAN PROCESSION
QUEEN'S BIRTHDAY, 1881

Major-General Gorman
Baird's Mammoth Minstrel Band
Grand Marshal Armstrong and suite
Barnum-like oddities
Chinese mandarins, negroes, jockeys, etc . . .
"Who'll wear the breeches"
"Then comes the tug of war"
"Eliza Taylor's Quilting Party"
"The Irish Jaunting Car"
"Goin' to de ball"
"Loch Lomond"
"Triumph Laundry Soap"
"'Hum' Fife and Drum Band"
monkey, old man in one horse shay
artillery corps
negroes, Indians, jockeys

Source: *Daily Evening News*, 24 May 1881.

Figure 2:
POLYMORPHIAN PROCESSION
QUEEN'S BIRTHDAY, 1882

Grand Marshal Gorman
70 different figures
62nd Fusiliers Band
Bagtown Bell Ringers
"Colored Voters"
"Venor on a high horse"
"Oscar Wilde's Barber Shop"
"Dodds vs Foster"
Steam calliope
Cage of wild animals
"Loch Lomond Mashers"
Many other representations . . .

Source: *Daily Telegraph*, 25 May 1882.

Figure 3:
POLYMORPHIAN PROCESSION
LOYALIST CENTENNIAL, 1883

Police guard
President of the Polymorphians
62nd Fusiliers Band
Grand Marshal Armstrong
70 mounted men in armour
Artillery Co., 1783
Queen Elizabeth's court, on the coach "Tally Ho"
Col. McQuarrie, mounted
Pioneers of 104th Regiment
Bandmaster
Band of 104th
104th Regiment on foot
Surgeons of Regiment
Harding St. fife and drum band
Sloop "King George"
"Log Cabin"
"Irish Jaunting Car"
Royal Fife and Drum band
"Bridal Party of ye olden time"
"Emigrant train"
Calithumpian Club banner
Mechanics' Band
"Old Time Carriage"
Characters of all kinds on horseback
Indians on horseback
2-headed Giantess, driven by a monkey
Artillery Band

Source: *Daily Sun*, 28 June 1887.

Figure 4:
POLYMORPHIAN PROCESSION
QUEEN VICTORIA'S GOLDEN JUBILEE, 1887 *

Mounted police
Sergt. Weatherhead, Fred. Jenkins, Harry Kilpatrick, and
 John Weatherhead

Chief of Police Marshal and Detective John Ring
Police Sergt. Watson and John Colwell
Mounted Armoured Lancers
"Britannia"
NBBGA Band
"The Blind Half Hundred Band"
"The Blind Half Hundred Regiment"
Platoon of Police
City Cornet Band
Fairville fife and drum Band
Barouche — President Johnston and Officers of the Portland Club
"Five Decades of Queen Victoria's Reign" — Portland Club
"Queen's Family" — Portland Club
Barouche — Mayor and Aldermen of Moncton
Moncton Cornet Band
"Mikado" — Moncton Club
"Canada"
"Zulu Band"
"Zulus"
"Fairyland"
"Japanese Pagoda"
Miniature Haymarket Square and Bandstand
"Noah's Ark"
Chief "Darktown Fire Brigade" in a cart
"Darktown House"
"Darktown Fire Brigade"
"Darktown Hose Reel Co."
"Darktown Hook and Ladder Cart"

* Unless otherwise noted, entries in 1887 and 1897 processions on behalf of Haymarket Square Club.
Source: *Daily Sun*, 28 June 1887.

Figure 5:
POLYMORPHIAN PROCESSION
DIAMOND JUBILEE, 1897

Grand Marshal Wm. A. Quinton
"Jameson Raiders" — South End Club
City Cornet Band
"Armoured Knights"

"Victoria"
"Britannia"
"The Scottish Highlanders"
"Robin Hood"
"Robin Hood's Merry Men"
"Ireland"
"Irish Guards"
"Fairyland"
Citizens Band of Sussex
"Tower of London"
"Beef Eaters"
Kingsville Band
"John Bull"
"Men of Warsmen"
62nd Fusiliers Fife and Drum Band
"Zulus"
Temple of Honour Band
"Royal Guard of 1837" — North End Club*
Richard Rawlings, Marshal
"Coronation Scene, 1837" — North End Club
"Royal Guard of 1837, mounted" — North End Club
"'Hearts of Oak', HMS Nile"—North End Club
"Her Majesty, 1897"
"Royal Guards of 1897" — North End Club
Carleton Cornet Band
"Algerine Contingent" — Carleton Club
"A Band of 75 Crusaders, mounted" — Carleton Club
"Pirate craft 'Algerine'" — Carleton Club

*Portland Club
Source: *Daily Sun*, 23 June 1897.

"NOT TO BE RANKED AS WOMEN"
Female Industrial Workers in Turn-of-the-Century Halifax

SHARON MYERS

"We are not going to work!" That said, nine women removed their aprons, dug their filleting knives into their wooden work tables and walked out of the Christie Fish Company. It was the early spring of 1910 in Dartmouth, Nova Scotia, and the women, who had arrived from Scotland the previous October, announced a variety of grievances concerning wages and working conditions. They took care not to portray their action as a strike or walkout, arguing only that they wanted "to be treated 'human' ". The Christie women used the rhetoric of the public sphere to present their grievances, but they appealed for help to the Society for the Prevention of Cruelty (SPC), an organization which investigated domestic issues, rather than to a local labour organization.[1]

The solutions the women were offered reflected the domestic orientation of the SPC. Although the women issued no complaint about their living arrangements, two of the three settlement terms addressed the private world of the home: the supply of fuel and the provision of a housemother.[2] The ap-

1 See Judith Fingard, "The Prevention of Cruelty, Marriage Breakdown and the Rights of Wives in Nova Scotia, 1880-1900", in this volume. The author acknowledges with thanks the comments of David Frank on the earliest version of this paper and those of the readers of this volume on successive versions. The author wishes to express particular gratitude to Janet Guildford and Suzanne Morton for their incisive comments and gentle guidance. She accepts, nonetheless, all responsibility for any errors and shortcomings.

2 *Daily Echo*, 30 April 1910, p. 2; 2 May 1910, p. 7; *Herald* (Halifax), 3 May 1910, p. 3. A search of the records of the Society for the Prevention of Cruelty has revealed no statement or notation regarding the fishworker dispute. Society for the Prevention of Cruelty [SPC], Men, Women and Children Cases, MG 20, vol. 515, no. 3, Public Archives of Nova Scotia [PANS]; and SPC, Minute Book, 1907-25, MG 20, vol. 517, no. 2, PANS. Note that in the autumn of 1899 male weavers at the Nova Scotia Cotton Manufacturing Company struck. There is no indication that women were activists in that strike. It does appear, however, that some of the men strikers pulled other family members from the factory when they struck. Some men returned to the mill mid-strike and took their families back to work with them. The extent to which women encouraged, agreed or even participated in those moves is not known. The strike can be followed in the *Acadian Recorder*, 2 November 1899, p. 2; 7 November 1899, p. 3; 20 November 1899, p. 3; 24 November 1899, p. 3; and 19 December 1899, p. 3. These young women appear to be the only group of women in the Halifax area to assert

pointment of a housemother was made because she would provide the young women with moral guidance, supervision and an example of domesticity, not because the workers had requested one.

Domestic solutions to problems experienced in the public work force alert us to the tensions and complications which shaped the experience of the female industrial labour force in late-19th-century Halifax. The contradiction between middle-class gender role ideals and the intractable demands of industrial capitalism placed female industrial workers in the impossible position of negotiating the territory between prescription and reality. The gender role ideals associated with the notion of separate spheres filtered into many social institutions including the factory, and the women who engaged in paid work in the public sphere walked an unsettled terrain.[3] This paper explores the situation of a significant number of mostly young, single women who found waged employment in manufacturing in Halifax after 1880. Although these women found ways to resist their exploitation, they had difficulty improving their wages, status and working conditions. The challenges they faced is the theme of this paper. Women's economic vulnerability, workplace fragmentation and rapid turnover, opposition from male employers and mixed messages of support from middle-class reformers — all these factors limited the ability of working-class women to advance their cause.

Gender-role ideology shaped the relations between bosses and their female labour force, and it structured the labour force itself, leaving women in a particularly vulnerable economic position. That vulnerability was, in part, the source of high levels of fragmentation and turnover in the female labour force — a process which limited women's ability to create the leadership needed to propel them into the world of organized labour. It is ironic that their most effective means of protest — quitting — served to undermine the development of formal labour activism. Employers enhanced the economic power that industrial capitalism afforded them by embracing the power of-

themselves so strongly and conspicuously in the era before the First World War. Historians who have attempted to locate and count strikes have noted no official strikes or walk-outs by women in Halifax in this period. See Douglas Cruikshank and Gregory Kealey, "Canadian Strike Statistics, 1891-1950", *Labour/Le Travail*, 20 (Fall 1987), pp. 85-146; and especially Ian McKay, "Strikes in the Maritimes, 1901-1914", *Acadiensis*, XIII, 1 (Autumn 1983), pp. 3-46 (for a brief discussion of the fish "lassie" action see p. 24). For a discussion of the SPC[A] in a slightly earlier period see Judith Fingard, *The Dark Side of Life in Victorian Halifax* (Porter's Lake, N.S., 1989); see also Fingard, "The Prevention of Cruelty".

3 See Margaret McCallum, "Separate Spheres: the Organization of Work in a Confectionery Factory: Ganong Bros., St. Stephen, New Brunswick", *Labour/Le Travail*, 24 (Fall 1989).

fered by the prevalent gender ideology, which legitimized the segregation and economic devaluation of women. As well, middle-class Halifax feminists could not always be relied on to join the cause of their working-class sisters. Messages of support were decidedly mixed and rarely resulted in concrete gains for women workers.

Despite the challenges they faced, women who worked in manufacturing were able to develop some means of protest, and these, too, were shaped by gender ideology.[4] The tension between socially prescribed ideals and the real roles industrial women occupied shaped the ways in which they expressed and negotiated their power as workers and as women.[5] This argument has, perhaps, been applied best by Leslie Tentler in her examination of working-class women in the United States. Tentler argues that dominant social ideology accompanied by a negative experience of work confirmed for women their desire to marry and turn to reproductive labour, which evinced some level of social approval, even respect.[6]

Piecing together the script of Halifax's female industrial workers presents a challenge. Business records for firms employing large numbers of women are non-existent for this period. The verbatim testimony offered by industrial workers to the Royal Commission on the Relations of Capital and Labour (1889) is disappointing as only ten female operatives, all of them from the cotton factory, presented evidence in Halifax.[7] Although women's work was habitually under-enumerated, a complete search of the 1891 manuscript census records for Halifax has proved a rich source of information about the demography of Halifax's industrial women and their relationship to the family economy. However, there is no distinction between full-time and part-time work among those who listed occupations, and it has been impossible to separate those who worked in factories from those who performed industrial work within the home, such as dressmaking.[8]

4 For the fuller version of this paper see Sharon Myers, "'I Can Manage My Own Business Affairs': Female Industrial Workers in Halifax At the Turn of the Twentieth Century", M.A. thesis, Saint Mary's University, Halifax, 1989.

5 On the importance of differentiating prescription from practice in the writing of women's history see Ruth Pierson and Alison Prentice, "Feminism and the Writing and Teaching of History", *Atlantis*, 7 (Spring 1982), p. 42.

6 Leslie Woodcock Tentler, *Wage-Earning Women: Industrial and Family Life in the United States, 1900-1930* (New York, 1982).

7 On the value of gleaning information from the limited number of female testimonies to the Commission see Susan Mann Trofimenkoff, "One Hundred and Two Muffled Voices", *Atlantis*, 3 (Autumn 1977), pp. 67-82.

8 On the inherent dangers of using censuses to study female labourers see Richard Wall, "Work, Welfare and the Family: An Illustration of the Adaptive Family Economy", in Lloyd Bonfield *et al.*, eds., *The World We Have Gained: Histories of Population and*

The spread of modern industry was slow to reach Halifax. As late as the 1870s, mechanization had struck only some of the tobacco, furniture, baking and shoemaking shops.[9] Artisanal workshops co-existed with small factories, leaving Halifax with one hand holding the pre-industrial age, the other grasping for the industrial future.[10] Stimulated by the protective tariffs of the National Policy, employment and production in Maritime manufacturing doubled between 1870 and 1890.[11] In 1885 government investigators announced that there had been "a marked advance in industrial pursuits and in material progress generally" as well as "a vast increase in the number and variety of machines and labor-saving appliances in factories and workshops".[12] The advance of industrialization — which demanded large, inexpensive labour pools — and the increasing importance of the family wage economy provided some women with the opportunity to participate, if only temporarily, in work in the public sphere.

Factories rose in north-end fields cut by the Intercolonial Railway and market and military roads. The massive, nine-story Halifax Sugar Refinery grew at the foot of Young Street, nestled between the harbour shore and the Intercolonial tracks. Up the steep Young Street hill and onto its level plane, pocketed at the intersection of Young Street, Kempt Road and Robie Street, rose the Nova Scotia Cotton Company, which eventually employed the greatest number of the city's women under a single roof.[13] Southeastward towards

Social Structure (New York, 1986), p. 294. See also Edward Higgs, "Women, Occupations and Work in the Nineteenth Century Census", *History Workshop*, 23 (Spring 1987), pp. 59-80 where he states, "it is necessary to treat the occupational information in the manuscript census enumerators' book with caution, and that the historian's use of the published census reports should be even more circumspect".

9 *Halifax City Directory, 1871-1872* (Halifax, 1872), p. 36.

10 Ian McKay, "The Working Class of Metropolitan Halifax, 1850-1889", Honours essay, Dalhousie University, 1975, p. 24; see also Henry Veltmeyer and John Chamard, *The Structure of Manufacturing in Halifax: Gorsebrook Institute Working Paper No. 3-48* (Halifax, 1984).

11 S.A. Saunders, *The Economic History of the Maritime Provinces* (Fredericton, 1984), p. 83. On the economic growth of the Maritimes in this period see, among others, T.W. Acheson, "The Maritimes and Empire Canada", in David Bercuson, ed., *Canada and the Burden of Unity* (Toronto, 1980), pp. 87-115, and "The National Policy and the Industrialization of the Maritimes, 1880-1910", *Acadiensis*, I, 2 (Spring 1972), pp. 3-28; David Alexander, "Economic Growth in the Atlantic Region, 1880-1940", *Acadiensis*, VIII, 1 (Autumn 1978), pp. 47-76; L.D. McCann, "Staples and the New Industrialism in the Growth of Post-Confederation Halifax", *Acadiensis*, VIII, 2 (Spring 1979), pp. 47-79, and "Metropolitanism and Branch Business in the Maritimes, 1881-1931", *Acadiensis*, XIII, 1 (Autumn 1983), pp. 112-25.

12 Canada, *Sessional Papers, 1885*, no. 37.

13 See Paul Erickson, *Halifax's North End: An Anthropologist Looks at the City* (Hants-

Halifax's more traditional business district, women worked at the Clayton and Sons and the Doull and Miller clothiers, at the Nova Scotia and the Mayflower tobacco companies, and at Moir's confection factory and other firms which hired smaller numbers of the city's women. Many other women worked in their homes, combining the stitching of pieces for clothiers with their routine domestic work, their incomes sometimes further supplemented by taking in boarders or day-children. The 2,558 women and men employed in industry in Halifax in 1871 swelled to 4,021 in 1891. Two decades later, 378 manufactories in Halifax employed over 5,500 people. By 1891, 194 city factories employed 1,257 women.[14] Obviously, by the 1890s the direct involvement of women in the wage-labour work force was not rare, and the broader participation rate of Nova Scotia women is even more significant given the number that pursued wage opportunities in the United States.[15]

Like most industrial women, those of Halifax were concentrated in certain industries: cotton and woollen manufacturing, boot and shoe making, tobacco processing and, most especially, the sweated garment trades.[16] This concentration meant that any Halifax factory likely to hire women did so in great numbers. At Clayton and Sons clothiers, for instance, women outnumbered men by an eight to one ratio. Gender ideals shaped the recruitment of

port, N.S., 1986), especially pp. 47-49; and Phyllis Blakeley, *Glimpses of Halifax: 1867-1900* (Halifax, 1949).

14 In 1881, 193 of the 351 establishments employed women. In 1891, 189 of the 348 establishments employed women. In 1891, 13.2 per cent of Nova Scotia women over the age of ten were employed in wage work, two points above the national average. Only 10.6 per cent were employed in 1901, reflecting a turn-of-the-century decline in the number of industrial establishments, but in 1911, 13.17 per cent of the province's women worked for wages (a percentage point below the national average). Between 1891 and 1911 the male to female ratio in the general Nova Scotia work force was roughly 6 men per 1 woman, though for 1901 the ratio was closer to 7 to 1. Canada, *Census of 1901*, vol. III, tab. XX, p. 327; *Census of 1911*, vol. III, tab. IX, pp. 230-1; *Census of 1911*, vol. VI, tabs. VI and VII, pp. xvi and xvii. On the exclusion of small establishments from the 1901 census and the irregularities of census reporting see Kris Inwood and John Chamard, "Regional Industrial Growth During the 1890s: The Case of the Missing Artisans", *Acadiensis*, XVI, 1 (Autumn 1986), pp. 101-17.

15 Margaret Conrad, *Recording Angels: The Private Chronicles of Women From the Maritime Provinces of Canada, 1750-1950* (Ottawa, 1982), p. 14; see also Betsy Beattie, "'Going Up to Lynn': Single, Maritime-Born Women in Lynn, Massachusetts, 1879-1930", *Acadiensis*, XXII, 1 (Autumn 1992), pp. 65-86.

16 Data compiled from a complete collection of cotton workers in Halifax in the nominal census manuscripts for 1891 and a complete collection of all female industrial workers, as defined by the industrial schedule of the census, in Halifax (including female cotton workers) from the nominal census; see also Joy Parr, "Women at Work", in W.J.C. Cherwinski and Gregory S. Kealey, eds., *Lectures in Canadian Labour and Working-Class History* (St. John's, 1985), p. 80.

the new female labour force as work that had been performed in the household was transferred to the factory. Sixty-five per cent of the roughly 1,257 women and girls the census recorded as labouring in the Halifax manufacturing sector in 1891 worked in dressmaking, millinery, tailoring or garment making.[17]

Following patterns of women's wage-employment elsewhere, in 1891 the majority of Halifax's industrial women were young and unmarried.[18] In the tailoring and garment-making sector, 41 per cent of the women were under 20 and 68 per cent were under 25 years of age. The cotton industry showed a similar concentration of young women. Three-quarters of the women in the factory were aged 20 or under and fully 94 per cent of the women were under 25 years of age. Dressmakers, who were likely to work in their homes, tended to be older and nearly half of them were over 25. By working at home many of these women may have been able to combine familial labour with necessary access to a wage.[19] Pieceworking at home allowed women more control over their labour, and it eliminated the need for childcare for working mothers. It also may have facilitated the sharing of work with other family members, thus generating further income opportunities.[20] The vast majority of Halifax's industrial women, however, were unmarried. In 1891, 93 per cent of women recorded in industrial occupations in the manuscript census were single women, among whom eight per cent were widowed.

The concentration of young, single women engaged in factory work tells us that the decision to seek paid employment outside the household was strongly influenced by the women's life cycles and by prevailing gender

17 Canada, *Census of 1891*, vol. III, tab. I.
18 Census Manuscripts [microfilm], Halifax, 1891. The youth of the female work force also applies to semi-urban areas in Nova Scotia. See D.A. Muise, "The Industrial Context of Inequality: Female Participation in Nova Scotia's Paid Labour Force, 1871-1921", *Acadiensis*, XX, 2 (Spring 1991), pp. 3-31.
19 Census Manuscripts, Halifax, 1891.
20 See D. Suzanne Cross, "The Neglected Majority: The Changing Role of Women in Nineteenth-Century Montreal", in Susan Mann Trofimenkoff and Alison Prentice, eds., *The Neglected Majority: Essays in Canadian Women's History* (Toronto, 1977), p. 73; and Bettina Bradbury, "Women and Wage Labour in a Period of Transition: Montreal 1861-1881", in David Bercuson, ed., *Canadian Labour History: Selected Readings* (Toronto, 1987), pp. 31-2 for home-sewing and 33-7 for married women and in-home work. For the advantages of working at home see Elizabeth Roberts, "Women's Strategies, 1890-1940", in Jane Lewis, ed., *Labour and Love: Women's Experience of Home and Family, 1850-1940* (Oxford, 1986), p. 232. For a brief discussion of factory women's use of the Jost Mission in Halifax as a source of child care see Christina Simmons, "'Helping the Poorer Sisters': The Women of the Jost Mission, Halifax, 1905-1945", in Veronica Strong-Boag and Anita Clair Fellman, eds., *Rethinking Canada: The Promise of Women's History* (Toronto, 1986), pp. 157-77.

ideals. John Sutherland, foreman at the Mayflower Tobacco factory, told the 1889 Royal Commission on the Relations of Capital and Labour that "girls" worked at his factory until they married.[21] Indeed, the family role of the majority of female industrial workers, namely daughters, and their concentration in the mature stages of the family life cycle illustrate clearly the nature of the work force. For the vast majority of women, involvement in the wage labour force was a stage of transition between childhood and marriage.[22] Most young women appear to have accepted the idea that they would leave the paid work force at marriage to take on full-time, unpaid domestic labour.

It was only under the most severe economic conditions that a married woman with children chose to work outside the home. A cotton worker told the 1889 Labour Commission that wives went to work only when their husbands were ill.[23] Less than 10 per cent of female workers were heads of households, and the majority of them were widows and abandoned wives. The removal of the male wage-earner caused intense financial difficulty for a young family and required strategies such as the wife's return to her family of origin or affixing lodgers and extended family members to the household to secure income. But in some cases, particularly when the children were too young to work, a mother entered or returned to the factory to support her children, though even then the family bordered on utter destitution.

While the paid work of mothers and daughters whose families lived in Halifax was of vital economic consequence, the young, unmarried woman who moved to the city to labour in its factories may have experienced even more severe economic vulnerability. Those without relatives in the city often boarded with other families. Earning on average only $3.50 a week in industrial wages, they often paid $3 a week or $4 to $6 each fortnight in boarding costs.[24] Many young women who came to the city must have either brought relatively substantial savings or continued to depend on their rural families

21 Canada, *Royal Commission on the Relations of Capital and Labour-Nova Scotia Evidence* [hereafter *RCRCL*] (Ottawa, 1889), p. 73. Gee identifies the average female age of marriage in Nova Scotia at 26 in 1871 and 1891. Ellen Thomas Gee, "Marriage in Nineteenth-Century Canada", *Canadian Review of Sociology and Anthropology*, 19 (1982), p. 320.

22 This pattern of young, unmarried women working is in keeping with the experiences of most of Canada's working women during this period. For an overview see Joan Sangster, "Canadian Working Women", in Cherwinski and Kealey, *Lectures in Canadian Labour and Working-Class History*, pp. 59-78, but pp. 59-63 regarding the demography of the female work force. On the importance of contextualizing working women within their families see Bettina Bradbury, "Women's History and Working-Class History", *Labour/Le Travail*, 19 (Spring 1987), p. 24.

23 *RCRCL* (1889), p. 72.

24 *RCRCL* (1889), p. 41.

for financial support for some time after their arrival in the city in order to get through the unpaid training period many employers demanded. At the cotton factory women trained for five or six weeks before they received wages. Clayton's expected women to endure a three-month, unwaged training period.[25] Given that the contribution of women's wages most often was necessary to the economic survival of the family or her own subsistence, a dependable and regular income was vital, but the certitude of wages was a precarious thing in the female industrial worker's world of fines, piecework and layoffs.

For most women workers the most important feature of the factory was the employer's attempt to organize, control and subjugate the workplace through regulations.[26] Fines were pervasive in early industries and undermined the income stability of working women. They were instituted not simply to reimburse management for an unmarketable product, but also to serve as an incentive for discipline, order and careful attention to work. At the cotton factory, fines were instituted for misconduct, damage, talking among workers, lateness (which was any time after 6:25 a.m.) and poor work. The weaver was charged when, through no fault of her own, oil dropped from the loom onto a piece of cloth. There were no direct fines at Taylor's Boots and Shoes, but Taylor acknowledged that if the hand's work was in any way damaged, she was forced to pay for the piece. At the Mayflower Tobacco factory on Cornwallis Street hands were not fined, but they were fired if they breached the good graces of their boss.[27]

Despite such constraints, women tested the effectiveness of these rules. While informal in character, especially in contrast to the Christie walkout, their actions are a testimony to women's resistance and attempts to influence their world of work. The fact that cotton factory officials imposed fines for breakage, misconduct, playing and throwing items suggests that workers had broken machinery and enjoyed some sort of workplace revelry that was disruptive. Some workers challenged the rules regularly and got away with it. A young carder reported that she was late for work every day and had never been fined.[28] In merely arriving late, one might argue, she had directly and successfully challenged the rule structure of the factory.

25 *RCRCL* (1889), pp. 2, 5, 201, 202, 203, 208. Of the many young women who moved to Halifax to work in the city's factories, it is clear that they were usually migrating from rural areas and towns within the province. By 1891, over 83 per cent of the women were Nova Scotia born. Interestingly, only 49 per cent of their fathers and 61 per cent of their mothers were native Nova Scotians. Nominal returns for Halifax, Census Manuscripts, 1891.
26 See James Rinehart, *The Tyranny of Work* (Don Mills, 1975), p. 32.
27 *RCRCL* (1889), pp. 17, 20, 22, 74, 77, 80, 203, 204.

Employers could also reduce women's wages in other ways, such as by keeping pieceworkers waiting for materials. A reeler at the cotton factory told Royal Commissioners that her wages ranged from $4.28 for a busy week to $2.32 when she was made to wait for work. Management decided when women would be assigned to piecework and often changed the women's wage scale by putting them on piece rate some days and on wage work others. As a result, few women counted on a steady, uniform wage.[29] It seems women might also have controlled their work speed to some extent. A factory official reported that his hands turned out work more quickly when they were paid by the piece than when they were paid wages. Guaranteed a set wage, women presumably decreased their production momentum, a response which can easily be read as an attempt by women workers to control the labour process.[30]

Temporary and seasonal shutdowns further undermined women's income stability. The Mayflower Tobacco Company, for instance, averaged only nine months of operation a year. In the summer of 1890 the Nova Scotia Cotton Manufacturing Company worked a three-day week, and in the summer of 1901 the factory completely shut down for nine weeks.[31] Yet the female industrial labour force of Halifax was capable of affecting, if only in limited ways, the production of the factory. Every summer, workers at the cotton factory and at Doull and Miller turned from their work to spontaneous summer picnics. Though the firms provided workers with one annual company picnic, employees held their own picnics and attended at least a dozen picnics of other firms. Women were also known to "fake a faint" to be allowed part of a day off. Outworkers used their family members to aid them in their piecework and, occasionally, women would disobey a direct order: when the spinning department of the cotton factory were asked to work late one evening, they refused.[32]

The demography of the factory work space may have provided women with a less direct but nonetheless effective means of shaping their experience

28 *RCRCL* (1889), p. 207.
29 *RCRCL* (1889), pp. 204, also 201, 203, 206.
30 *RCRCL* (1889), p. 81.
31 *Morning Chronicle* (Halifax), 4 July 1890, p. 3; *Novascotian*, 16 August 1901, p. 7; and *RCRCL* (1889), p. 20. On the regularity of seasonal cotton factory shutdown see Peter DeLottinville, "Trouble Comes to the Hives of Industry: The Cotton Industry Comes to Milltown, New Brunswick, 1879-1892", *Communications historiques/Historical Papers* (1980), p. 107.
32 *RCRCL* (1889), pp. 7, 21, 23, 204; The information on "faking faints" was provided through an interview: Elizabeth M., oral history interview, conducted by Sharon Myers, Halifax, 1988.

in modern industry. Tamara Hareven suggests that "it is necessary to look not only at the ways in which industrial work affected family organization and work roles but also at the way the family affected conditions in the factory". The pattern of kin clustering in specific factories and departments which Hareven located for the northeastern United States also applied to Halifax industries.[33] It was especially true in the Nova Scotia Cotton Manufacturing Company where, following an industry tradition, family members clustered and worked together. The majority of workers at the cotton factory were recruited from among the families of employees already working there. Slightly more than 30 per cent of all female workers lived in households where other members also worked in the same factory. Twenty-nine per cent of all industrial women shared their occupational task with all their family members in their industry, and an additional 2.3 per cent of all the women shared the same task with at least some of their family members who worked in the same industry. Because more than 40 per cent of the cotton industry women were employed at the same task as a family member, many worked in the same room as at least one of their kin.[34] This pattern suggests that in some instances women were able to influence the hiring practices of the factory. In addition, an older sister or other family member may have eased new recruits through the potentially troublesome enculturation into factory life by assisting in skills training and also by sharing the informal rules of life on the shop floor. Thomas Dublin has argued that the geographical proximity and task sharing of industrial women aided the teaching of factory lingo, the conveyance of appropriate behaviour (as defined by the workers), and the transmission of gossip, which eased the new worker's move to factory life.[35]

While the proximity of family members afforded some industrial women a sense of commonality or unity, it is important not to overestimate a sense of "united sisterhood" among working-class women. Despite their similar economic and demographic backgrounds and similar working conditions,

33 Census Manuscripts, Halifax, 1891. Tamara Hareven found family and ethnic ties were the "undisputed" factors in hiring at the Amoskeag mill; see Tamara Hareven, *Family Time and Industrial Time: The Relationship Between the Family and Work in a New England Industrial Community* (Cambridge, 1982), pp. 4, 43. See also Thomas Dublin, *Women at Work: The Transformation of Work and Community in Lowell, Massachusetts, 1826-1860* (New York, 1979), pp. 35-38, 43-44; William Reddy, "Family and Factory: French Linen Weavers in Belle Epoque", *Journal of Social History*, 8, 2 (Winter 1974-75), p. 104; Daniel Walkowitz, *Worker, City, Company Town* (Chicago, 1978), p. 61. This phenomenon was decidedly less frequent in the Yarmouth cotton mill. Muise, "The Industrial Context of Inequality", p. 22, note 37.

34 Based on data collected from the Census Manuscripts, Halifax, 1891.

35 See Dublin, *Women at Work*, pp. 47-9, 60.

the sense of shared experience among the factory women of Halifax was limited. Dispersed throughout the neighbourhoods of the city, separated by factory, divided by workroom, isolated by rules restricting them from talking to each other, female factory workers in Halifax were often disassociated from their toiling sisters. The ability of factory women to become acquainted with each other was further undermined by high employee turnover rates. When asked if his hands had worked for a long time at his factory, Superintendent Bonn of the Mayflower Tobacco Company replied, "We are constantly changing".[36]

Among the resources women employed to carve out better work lives for themselves, leaving one factory for another, or quitting, was markedly more popular than collective action. The personal history of Elizabeth M., a dipper at Moir's chocolate factory, illustrates the frustration of many working-class women. Elizabeth's father, a police officer, died a hero in his attempt to rescue a family from their burning home. The economic crisis created by his death was only partially alleviated by Elizabeth's three older sisters who went to work at Moir's. When old enough to work, Elizabeth left school with some regret to take up the job her sister had secured for her at the chocolate factory. She apprenticed at Moir's for the requisite two years. When her apprenticeship finished, Elizabeth thought herself quite a skilled dipper — skilled enough, in fact, to be assigned to piecework where her speed would assure her better pay. She was, however, put on wage work. Elizabeth wrote to the management and requested to be put on pieces. They returned her letter saying that only they would decide when she was ready for piecework. Offended, Elizabeth quit and worked as a clerk at various shops throughout the city. Eight years later, she returned to Moir's where she worked a five-day week instead of the six days shops required.[37]

While high rates of job turnover produced discontinuity and individualism in the women's work force, the isolation of homeworkers was especially profound. On 3 April 1888, W.J. Clayton of the clothing factory Clayton and Sons of Halifax testified before the Royal Commission on Labour and Capital that although he had 300 employees in his books, only about 100 actually worked in the factory. The others, he told the commissioners, worked occasionally for his factory on home work, and often worked for other clothing factories in the city, too. W.H. Gibson of the clothing firm Doull and Miller

36 *RCRCL* (1889), p. 20; In her interview, Elizabeth M. reported high rates of job turnover. Elizabeth M., oral history interview.

37 Elizabeth M., oral history interview; see also Wayne Roberts, *Honest Womanhood: Feminism, Femininity and Class Consciousness Among Toronto Working Women, 1893-1914* (Toronto, 1976), p. 53.

reported his company's use of homeworkers. Only 55 of 125 employees worked in the building; the rest worked on piecework at home. Gibson remarked further that some of the outworkers used members of their family to assist in the work — part of a hidden economy of female workers which the census fails to identify.[38]

If women were fragmented amongst themselves, they were even more distinctly isolated from the male workers of their factories. The introduction of masses of women into public sphere labour created concern among their male co-workers. Based on the testimony of male workers to the Labour Commission, Susan Mann Trofimenkoff claims that "these men also knew that women's work was different from theirs. Now the existence of factories implied — although did not always ensure — that women's work could be the same as men's, might even be better and usually was cheaper".[39] While the implication may have been that men and women shared the same work, there was, in fact, a fairly strict division of labour in the Halifax industrial landscape. Women seated at long tables in the Moir's factory hand dipped creams, fudges and nuts in chocolate. The men at Moir's brought the unfinished products to the women and removed the finished ones from them.[40] At the Nova Scotia Cotton Manufacturing Company women spun, wound and slashed. The men ran the picker machines and worked as mechanics, overseers and supervisors. Although both men and women wove, the men ran more looms, assuring them both more pay and more status. In the clothing industry, men attained journeyman tailor status, whereas women laboured on as unaccredited tailoresses. The leather of the boot and shoe industry was cut by men and stitched by women.[41] "The field of work for women", wrote one contemporary, "is necessarily a restricted one".[42]

The male employer's perception of female industrial workers is revealed in several ways, but the most conspicuous evidence of their attitude is found in the labour division of men and women and in the discrepancy of wage payments between the sexes. Indeed, those divisions and discrepancies were both products and tools of separate spheres ideology. Employers found that the ideology justified their ghettoization of female workers. That division

38 *RCRCL* (1889), pp. 1, 7.
39 Mann Trofimenkoff, "One Hundred and Two Muffled Voices", p. 76. Steven Maynard has suggested that the changing gender map of the workspace created a "crisis in masculinity" among Canadian working men. Steven Maynard, "Rough Work and Rugged Men: The Social Construction of Masculinity in Working-Class History", *Labour/Le Travail*, 23 (Spring 1989), p. 160.
40 Elizabeth M., oral history interview.
41 This information is drawn from the *RCRCL* (1889).
42 *Blind of Our Provinces — 1895*, MG 100, vol. 248, no. 18, PANS.

and difference also helps us to understand the relationship between the female industrial worker and her male co-workers.[43] The average weekly pay for a male employee at the cotton factory was $7.50. In contrast, the average weekly pay for a female operative was $3.90, while children earned $1.25 for their work. Women weavers could potentially make the same as male weavers — around $10 a week for six looms, but more often women worked only four looms. Apart from the weaving room, however, women seldom performed the same tasks as men. Women were concentrated in the low-paying spinning room and in the winding and slashing department where wages ranged from $2.25 to $6 a week. They were totally excluded from the jobs which were labelled highly skilled and paid higher wages. No woman was allowed to break into the ranks of the prestigious loom fixers. The powerful and prestigious Spinning Master, Master Carder, and Superintendent of Winding, Weaving and Warping were men employed at between $15 and $16 a week.[44]

Publisher Andrew McKinlay's testimony to the Royal Commission helps us to understand the gendered construction of skill. McKinlay employed 20 young women at his company, all of whom worked at ruling books or sewing their bindings. Despite the fact that women had a monopoly on those skills at his shop, implying some level of expertise if only by virtue of their gender monopoly, the notion that women could be skilled apparently escaped McKinlay. When asked by a Royal Commissioner if he had any folders whom he considered experts, McKinlay replied that he had only "girls" working that trade. "I mean girls", continued the commissioner, to which

43 On the role of institutionalized sexual division of labour as a determinant of wage discrimination see, among others, Mercedes Steedman, who argues that the work assigned to women in the clothing industry was assigned in keeping with the larger social position of women, namely, those women were rendered peripheral and assigned home-work. Mercedes Steedman, "Skill and Gender in the Canadian Clothing Industry", in Craig Heron and Robert Storey, eds., *On the Job: Confronting the Labour Process in Canada* (Kingston and Montreal, 1986), pp. 156-60. While division of labour based on gender was universal and the attachment of the label "skilled" was applied almost exclusively to the work men did, Jacques Ferland has found that the division of labour on the basis of gender was less significant in the cotton industry than in the boot and shoe industry. Jacques Ferland, "'In Search of the Unbound Prometheia': A Comparative View of Women's Activism in Two Quebec Industries", *Labour/Le Travail*, 24 (Fall 1989), p. 23. Heron and Storey remind us that "skill" is a socially constructed and historically negotiated phenomenon. Craig Heron and Robert Storey, "On the Job in Canada", in *On the Job*, p. 29. The historical and environmental mutability of the concept of skill is demonstrated clearly in Joy Parr, *The Gender of Breadwinners: Women, Men and Change in Two Industrial Towns, 1880-1950* (Toronto, 1990).
44 *RCRCL* (1889), pp. 21, 24, 74, 76, 79; and Census Manuscripts, Halifax, 1891.

McKinlay replied, "We cannot call them experts".[45] The same patronizing attitude was also evident in the testimony of Henry Bonn, superintendent of the Mayflower Tobacco Company. Bonn reported that the firm employed 21 men and 50 girls and women. The men averaged $6 a week, while the women, assigned to piecework, averaged $3 to $5 a week and were employed in different tasks. The commissioners wondered if women could improve their wages at the company:

Q. Is it the rule that the women who earn day's wages get upwards afterwards?

A. No; I hardly ever take them from that position and put them in the way of promotion, because they do not wish it; the [sic] prefer day's work. I have to get new hands when I want to increase the other work.[46]

The process of cleaving work roles with the axe of gender and then stripping the value of women's work by paying less for it was present throughout Halifax industry.[47] Women were concentrated not only in certain industries, but also in distinct jobs within those industries, for which they received less pay than their male co-workers. Industrial employers used the concept of separate spheres to determine work roles along gender lines and to justify paying women less. The ghettoization of women by factory managers reflects not only a sense that women's work was different than men's, but also that women could be seen as inferior industrial workers. The economic devaluation of women's work supported the continuing ascription of status and power to men. As men watched over the work of women, transformed women's pieces into valuable finished products and laboured in the statused trades, their patriarchal hegemony was reaffirmed by the structure and culture of the

45 *RCRCL* (1889), p. 217.

46 *RCRCL* (1889), pp. 19, 73.

47 At Taylor's Boots and Shoes, the 100 men earned, on average, $6 to $10 a week while the 40 women were paid between $2 and $6. The young women of 15 or 16 years of age earned $2 each week for pasting. No women were involved in cutting the leather, for which they could have earned $7 to $9. Of the 55 employees who actually worked inside the clothing factory of W.H. Gibson, the 11 male journeymen tailors earned $9 a week in comparison to the $3 average weekly earnings of the tailoresses, who were assigned to piecework. The 45 women who worked at home earned the same as their sisters in the factory, though they may have rented their sewing machines which would have diminished their income. At the clothing factory of Clayton and Sons, male tailors averaged $5 to $12 in the course of a week. Women who worked by the week took only $1.50 to $6 home to their families, while women on piecework earned, as a maximum limit, $4.50. Drawn from the *RCRCL* (1889).

factory. Though industrial women participated in the public sphere of work, they did not participate in a male world of work, and the potentially liberating experience of waged work in the public sphere was thwarted.

The economic oppression of low wages and their economic ties to the family unit obstructed women's vision of their collective interests. The female work force was fractured amongst itself and drained of indigenous leadership by high turnover rates; untrained in the traditions of radical labour activism, these women found little support from male colleagues who could share that history. Attempts to encourage collective action were crushed under the thumbs of managers and factory officials. At Moir's, the unfounded rumour that a woman was involved in creating a union resulted in her dismissal and might also have resulted in her blacklisting in the Halifax area.[48] Robert Taylor stated that if his workers struck he would replace them and let them "come back with their fingers in their mouths wanting work again".[49] When spinners at the Halifax cotton factory refused to work past 6:00 p.m., the manager threatened to replace them with operatives from England.[50] These warnings resonated in the ears of factory women. The importance of the female industrial worker's contribution to the family wage economy or her own support discouraged radical assertions of autonomy, and the threat of dismissal and/or blacklisting threatened her very subsistence. But industrial women were clearly capable of affecting their work life. Sometimes their actions were covert and restrained, though nonetheless effective. At other times, as with the Christie fishworkers, their acts of resistance were very overt, appealing to the public for the redress of grievances.

Because of their visibility in the public world of paid work, female factory workers became a focus of middle-class debates about the role of women. The tension at the centre of the debate was between middle-class gender ideals and the public economic roles demanded of working-class women by their position in the family economy. Some commentators were unequivocally opposed to women's participation in the work force:

But what is the cause for this great army of woman workers? . . . Authorities differ; they all agree, however, that neither the condition

48 Elizabeth M., oral history interview.
49 *RCRCL* (1889), p. 16.
50 *RCRCL* (1889), p. 204. The non-unionization of women was something of a North American norm. Alice Kessler-Harris has found that from 1900 to 1920 only 1 in 15 American industrial women were unionized whereas 1 in 5 men were union members. Alice Kessler-Harris, *Women Have Always Worked: A Historical Overview* (New York, 1981), p. 91.

of our womankind nor our national ideals, nor the indifference of our men, nor actual conditions of poverty make it necessary.[51]

Others struggled to reconcile some women's need to work for wages with their ideas about women's appropriate domestic role. There seemed to be both an uneasy acceptance of the fact that some women were driven to work outside the home by financial necessity and a persistent unease about the social consequences of women's work in the public sphere. In 1902 a Halifax *Herald* columnist wrote:

> It is not a thorough absurdity to foresee a possible day when 'man, proud man, the noblest work of God', . . . will be driven clear out of business and left at home while his beloved struggles 'on change'. I confess to a very old-fashioned idea of what is women's sphere . . . [but] it is still a fact that there are many unmarried and some married women upon whom rest obligations which they must either meet or starve.[52]

Yet in other corners, working women found abundant support. Maria Angwin, the first woman licensed to practise medicine in Nova Scotia, was an unabashed feminist and proponent of women's right to work.[53] She was active in the Woman's Christian Temperance Union from its inception and a vigorous crusader for temperance and physical purity. In 1895 she addressed the "superfluous woman" debate, staunchly defending women's right to work in a variety of occupations: "At every turn she is met with the severely solemn reminder, 'you must not do this, it is man's work', or the tenderly sneering reminder you are not able to do this, it is man's work".[54] She explicitly addressed the fears of many critics of women workers when she argued: "So persistently is this class ignored by the advocate of 'women's proper sphere', we are forced to the conclusion that female wage earners are not to be ranked as women".[55]

Angwin directly pointed to the ambiguity in the position of those who articulated the doctrine of separate spheres and charged them with blatantly

51 *Herald* (Halifax), 1 February 1908, p. 6.
52 *Herald*, 5 November 1902, p. 4.
53 See Lois Kernaghan, "'Someone Wants the Doctor': Maria L. Angwin, M.D. (1849-1898)", *Nova Scotia Historical Society Collections*, vol. 43 (1991), pp. 33-48.
54 Maria Angwin, "The Case of the Superfluous Woman", *Herald*, 10 August 1895, MG 100, vol. 298, no. 17a, PANS.
55 Maria Angwin, "The Case of the Superfluous Woman", *Herald*, 10 August 1895, MG 100, vol. 298, no. 17a, PANS.

failing to come to grips with the issue of working women. Wage-earning women participated daily in the public sphere and challenged social notions of women's proper role. And, as Angwin suggested, the work they did was perceived as "man's work". But few bourgeois critics attempted to order women back to the home. To have done so would have been hypocritical; middle-class women, in their new role as social commentators and advocates, had themselves breached the barriers of the domestic sphere. Even many who would have preferred that women could remain within the private sphere accepted that many women workers were in desperate financial need.

Some middle-class reformers, accepting women's participation in the paid work force as inevitable, advanced proposals which they believed would improve the conditions of working women's lives. They advocated better enforcement of the laws governing factory work, technical education for women and programmes to guard the moral virtue of young women workers. The Halifax Local Council of Women, an umbrella organization for over 20 women's groups at its height of popularity and a local chapter of the National Council of Women, promoted all three.

Although the local chapters of the National Council were free to set local agendas and create policy, in the 1890s the Halifax Council showed little interest in the working conditions of women.[56] It did, however, respond to initiatives from the National Council. In the summer of 1895 the Local Council prepared a report on working hours for women and children at the request of the national organization. The report determined that women at the cotton factory worked from 6:30 a.m. to 6:30 p.m. and that women who worked in other industrial establishments had a shorter workday.[57] The issue apparently died until 1899, when the National Council requested information on the Factory Act and on factory inspection.[58] This time Halifax Council passed a resolution calling on the Nova Scotia legislature to regulate the hours of work of women and children and to appoint a woman to inspect factories.[59] After the turn of the century, the Local Council became some-

56 For a study of the Council in Halifax just beyond the time period of this study see Rebecca Veinott, "The Call to Mother: The Halifax Local Council of Women, 1910-1921", Honours essay, Dalhousie University, 1985.

57 Halifax Local Council of Women [HLCW], Minute Book, July 1895; 31 October 1895, MG 20, vol. 535, no. 1, PANS.

58 HLCW, Minute Book, 17 February 1899; 24 March 1899, MG 20, vol. 535, no. 2, PANS.

59 HLCW, Minute Book, 24 March 1899, MG 20, vol. 535, no. 2, PANS. Note also that in the spring of 1897 the Council had called for a national act limiting the work week to 54 hours. *Herald*, 28 May 1897, p. 6. A Factory Act was passed in Nova Scotia in 1901 which limited the hours of work for women and children and forbade the invol-

what more concerned about industrial women of their own volition, not sim-
ply at the urging of the national body. In the winter of 1906, Bessie Egan, of
the Society for the Prevention of Cruelty, reported on the laws related to
women and children to the Local Council. No girl under 16 and no boy
under 14 was to be employed longer than 72 hours a week. The report was
referred back to the committee to "further enquire into laws concerning
working women and to note any flagrant abeyance of these laws, with a view
to our asking, from the Provincial government for the appointment of a
woman factory inspector". Almost a year later the committee reported that
the provincial government had failed to appoint the female inspector called
for under the Factory Act. In the spring of 1907, Reverend Foster Almon
urged the Local Council to pressure the government to appoint inspectors. A
month later the Children's Aid Society joined the campaign.[60]

The Local Council of Women was also among those who called for the
establishment of industrial training for women.[61] At the prompting of May
Sexton, a graduate of the Massachussetts Institute of Technology whose hus-
band, F.H. Sexton, was the provincial director of technical education, the
council called for the establishment of a training school for women. May
Sexton argued that the training would allow women stuck in dreary and un-
rewarding work an opportunity for advancement. The council found support
from the Halifax *Mail Star*:

> Each year large numbers of girls are obliged to leave the public
> schools at the ages between 13 and 17 and go to work. Many of them
> are compelled to aid in the support of the family, and all untrained as
> they are, the girls have to take employment as they can find it — in
> factories and shops, at very small wages. They have no trade, no re-
> source, and no chance to learn a trade, as boys have.[62]

vement of children and women in tasks which were likely to cause permanent injury.
Nova Scotia, *Statutes of Nova Scotia*, Factory Act, sec. 9, p. 1420, and sec. 11.

60 HLCW, Minute Book, 12 February 1906; 20 November 1906; 8 April 1907; 13 May
1907, MG 20, vol. 535, no. 3, PANS.

61 HLCW, "History of the Halifax Local Council of Women", MG 20, vol. 1054, no. 1,
p. 18. The Constitution of the Halifax Local Council of Women reads: "Believing that
the more intimate knowledge of one another's work will result in larger mutual sym-
pathy, and a greater unity of thought, and, therefore, in a more effective action, certain
Associations of women have determined to organize a Council of Women". Article II
states that "the council shall serve as a medium of communication and a means of pro-
moting any work of common interest". HLCW, *Constitution of the Halifax Council
of Women*, MG 20, vol. 538, no. 1.

62 *Mail Star*, 28 November 1908 in HLCW, Scrapbook, 1908-1917, MG 20, vol. 204,
PANS.

This campaign met with failure when the provincial government refused to provide new technical training programmes for women.[63]

The Local Council of Women was also concerned about protecting the moral virtue of young working women. Michael Smith has noted a shift among Nova Scotia's reformers from critical feminist reform toward a more maternal social purity movement. "Fit" and "moral" women, guardians of an idealized private sphere, could raise a generation of fit and moral children. While the crusade for vested domesticity provided the reformers with a focus for ensuring stability in a world in flux, it also, remarks Elizabeth Fox-Genovese, "severely hampered their view of themselves, of their proper social roles and of their goals".[64] As Mariana Valverde has shown, and as the research of Michael Smith confirms for Halifax, women's sexuality was increasingly the target of "moral" campaigns.[65]

In an article entitled "Danger of the Street", a reformer expressed concern about young women loitering on Barrington and Gottingen streets:

> Their conduct is of the kind that leads away from healthy, wholesome self-respect to careless, easy familiarity, from modesty to brazenness. Who has not noted the careless gesture, the pert remark, and the silly giggle of the 'pick-up?' Then there is the walk, the inviting dark doorway, and the 'date' to be kept on a subsequent nightThe whole effect upon them is insidious and degrading She will lose the essential qualities of womanliness that command every man's respect. In some cases, the girl will go down and out, and the end will be ruin, sorrow and misery.[66]

63 Ernest R. Forbes, "Battles in Another War; Edith Archibald and the Halifax Feminist Movement", *Challenging the Regional Stereotype: Essays on the 20th Century Maritimes* (Fredericton, 1989), p. 76; and Simmons, "Helping the Poorer Sisters", p. 164; see also Janet Guildford, "Coping with De-industrialization: The Nova Scotia Department of Technical Education, 1907-1930", *Acadiensis*, XVI, 2 (Spring 1987), pp. 69-84.

64 Elizabeth Fox-Genovese, "Placing Women's History in History", *New Left Review*, 133 (May/June, 1982), p. 13.

65 Michael Smith, "Female Reformers in Victorian Nova Scotia: Architects of a New Womanhood", M.A. thesis, Saint Mary's University, 1986; Mariana Valverde, *The Age of Light, Soap, and Water: Moral Reform in English Canada, 1885-1925* (Toronto, 1991). See also Angus McLaren, *Our Own Master Race: Eugenics in Canada, 1885-1945* (Toronto, 1990).

66 "Danger of the Street: Where Lieth Responsibility?" MG 100, vol. 248, no. 21, PANS. Emphasis is in the original. Christine Stansell writes: "Street life was antagonistic to ardently held beliefs about childhood, womanhood and ultimately, the nature of civilized urban society. The middle-class of which the reformers were a part was only

The notion that young working women were poised on the brink of sexual danger, especially by engaging in the public life of the street, recurs throughout the minutes of the Halifax Local Council of Women. In 1896, the organization argued that the age of legal consent should be raised to 21. "The council thinks that the procuration of any girl or woman for immoral purposes", read the minutes,

> should be punished as a *crime*, not as a misdemeanour and that there should be no age limit in the case of seduction. It is the opinion of this Council that protection should be extended to *all* women in dependent positions, such as shop girls, domestic servants, etc., and not limited as in the present to women in factories, mills and workshops.[67]

In 1899 the age of consent was raised to 18.[68] It was not surprising that the council soon after turned its attention toward the development of a municipal curfew bill. In a letter to the editor of the *Daily Echo*, Eliza Ritchie, an executive member of the council, called for the implementation of a curfew in an effort to "give to the children living in the poorer parts of the City and to the young people working at the factories, etc., a counter attraction to the streets".[69]

The reforms advocated by middle-class men and women were sometimes met by a defensive, suspicious and rigorous assertion of individual, working-class autonomy, and working-class voices were raised against the interference of the middle classes in their lives. Such interference could also lead working-class women to criticize those of their own class whose actions might call their integrity as workers into question. In November 1912, the Halifax press swelled with controversy about women's wages. A series of letters argued that wages should be increased or women would turn to prostitution for survival, illustrating once again the feeling that the sexual purity of working-class women was at risk. "In plain words", wrote one concerned citizen, "these respectable working girls are on the point of starvation". Writers called for

emerging, an economically ill-defined group, neither rich nor poor, just beginning in the antebellum years to assert a distinct cultural identity. Central to its self-conception was the ideology of domesticity, a set of sharp ideas and pronounced opinions about the nature of a moral family life". Christine Stansell, "Women, Children and the Uses of the Streets: Class and Gender Conflict in New York City, 1850-1860", in Linda K. Kerber and Jane DeHart Mathews, eds., *Women's America: Refocussing the Past* (New York, 1987), pp. 132-3.

67 HLCW, Minute Book, 20 February 1896, MG 20, vol. 535, no. 1, PANS.
68 HLCW, Minute Book (1894), 29 May 1899, MG 20, vol. 535, no. 1, PANS.
69 *Daily Echo*, 11 January 1908, in HLCW, Scrapbook, MG 20, vol. 204, PANS.

increased funding to the Young Women's Christian Association (YWCA) so its services could match those of the Young Men's Christian Association, especially so it could provide a soup kitchen. In response, a young woman who earned $5 a week at Moir's wrote, "If a girl earns $3.00 a week, it's almost certain it's because she isn't worth moreI don't want any charitable person to take an interest in me. I can manage my own business affairs".[70] Her comments were telling. They reflected a rigorous sense of working-class autonomy, resisting the meddling — or perhaps more accurately, the appraising — impulse of bourgeois social commentators. Her response also conveyed a sense of individualism in the attempt to distance herself from others of her class and gender whom she perceived to be inferior workers.[71] But an attempt to assert her sense of respectability is the underlying theme of her comments.

This Moir worker and the Christie fishworkers were not the only women to plead their cases through public mechanisms, and the Society for the Prevention of Cruelty received a number of requests for help. Fanny, Elizabeth and Emma J. Mercier, recently arrived from Newfoundland, appealed to the SPC on at least two occasions. On the first, they were seeking remedy for a work situation and on the second they sought advice on a family matter. In November 1892 they complained to the SPC when they were fired. They argued that they had not heard the whistle summoning them back to work after a steam failure had closed the cotton factory. Further, they argued, they had not been paid as promised and were now left without any means of support. The SPC referred the problem to the mayor, who promised to make inquiries.[72] On the second occasion the Mercier women appealed to police officer D.A. Gillis, who reported the matter to the SPC. Fifteen-year-old Elizabeth wanted to marry a private in the Leicestershire Regiment. The older

70 See the *Herald*, 27 November 1912, p. 162; 4 December 1912, p. 9. The comments of the citizen were not purely philanthropic. Still displaying a sense of Victorian suspicion of working women, she wrote: "perhaps it is their own fault. Perhaps they spend their earnings in 'feathers and folderalls', and so have to herd togetherCould they be clean or decent under such circumstances?" It is also interesting to note that factory management were among those asking for the provision of food services. See also Nova Scotia, *Journal of the House of Assembly*, 1920, Appendix 33, "Report of Commission on Hours of Labor, Wages, Working Conditions of Women Employed in Industrial Occupations".

71 The sense of autonomy and individualism among working-class women was not unique to this woman. In her study of working women at Ganong's in St. Stephen, New Brunswick, Margaret McCallum found that women refused to take lunch together even when supplied with a common lunch room. McCallum, "Separate Spheres", p. 75.

72 SPC, Case Book, p. 65, 2 November 1892, MG 20, vol. 513, no. 1, PANS; and *Acadian Recorder*, 4 November 1892, p. 3.

sister did not want her to marry without the consent of their parents. This matter was referred to Mr. Barnstead, the issuer of marriage licences.[73]

Maude Redford of Creighton Street, an employee at the cotton factory, also appealed to the SPC for advice. Her parents had only three rooms and a kitchen. Maude shared those rooms with her parents, four siblings and four borders. She had moved next door to board with her neighbour but her mother came after her, forcing her to move back home. Unfortunately, we know nothing of Maude's fate.[74] The Christie workers, the Mercier's and Redford actively sought redress for problems in their public and private lives through the use of public or quasi-public agencies, in particular the SPC.

The ideological construct of separate spheres permeated the experience of women in the factory, the family and the larger society. Industrial women found themselves in an especially peculiar predicament because the factory was perceived as a part of the public sphere. While other workers, such as teachers and nurses, had powerful rhetorical bases upon which to claim their "natural" suitability for their work, factory women were doing what was perceived as more rugged, masculinized work.[75] The masculinity of that work was defined by its geographic position, namely the factory, despite the fact that the sectors of manufacturing in which women worked, such as food and clothing, produced goods traditionally associated with home-based work — work which was historically undervalued and underappreciated. The rhetorical tools available to female teachers, who claimed that they were performing "natural" women's work of nurturing, guiding and instructing young children, were less available to industrial women. They could claim long-held custom and practice in performing their types of work, but this lacked the emotional potency available to other women workers. A mature rhetoric which legitimized and envalued the manufacturing work of women would await the crisis of the First World War. For this earlier generation of female industrial workers, the grounds for justifying their entrance into the public sphere of labour were largely economic and the language of the formal economy was a traditionally male dialect. Their struggle, therefore, was to search out a suitable definition of womanhood which also reflected their class.

Working-class women clearly did not live in "a separate sphere or domain of existence" but within "a position within social existence generally".[76] Their world of work was very public. So too was their recourse to the SPC

73 SPC, Case Book, p. 93, 30 December 1892, MG 20, vol. 513, no. 1, PANS.

74 SPC, Case Book, p. 5, MG 20, vol. 513, no. 1, PANS.

75 See Janet Guildford, "'Separate Spheres': The Feminization of Public School Teaching in Nova Scotia, 1838-1880", in this volume.

76 Joan Kelly, "The Doubled Vision of Feminist Theory", in Women, History and Theory (Chicago, 1984), p. 57.

and the police for solutions to both domestic and work problems, as well as their letters to the press. The involvement of young factory women in the street life of Halifax was a blatantly public activity. But the prescription of separate spheres exercised a limiting influence on their lives. It limited women's opportunities for paid work and justified the low wages they received for their labour. The ideology may also have limited their formal organization as workers, leaving industrial women in a weaker position to assert their rights as labourers. Further, the notion that women's place was within the home as a wife and mother may have affirmed for these women the sense that factory life was temporary. The promise of relief from the difficult conditions of the workplace through a return to unpaid domestic work may have served to undercut further the building of formal labour organizations.

The treatment of the Christie women demonstrates the limits that separate spheres ideology imposed on working women. They based their arguments for fair treatment on an appeal for "human", inclusive treatment, but they turned for help to the SPC, which recommended unsolicited remedies in the private sphere and reminded the Christie women that their primary location was the home. It is interesting that the Christie women turned to the SPC. If the SPC occupied ground between the public and private worlds,[77] what might we conclude about the industrial women's belief that their interests were best served by an agency which served as an intermediary between the two spheres? What might their appeal for help tell us about women's new roles in the industrial labour force and about their shifting roles as women?

Industrial women and middle-class commentators in Halifax were grappling with a changing notion of women's appropriate role, one in conflict with dominant social ideology. In the face of such disjuncture there was the potential to create new understandings of "appropriate" gender role behaviour, a malleable identity "elaborated on the hard wiring of the x and y chromosomes".[78] Increasingly the meaning of working-class womanhood included the notion that young women would labour for a period of time in the industrial work force of the city. But central to the understanding of that new role was the general perception, and prescription, that the out-of-home work of women would be a temporary thing, a stage of transition in the passage to the role of wife and mother.

77 Fingard, "The Prevention of Cruelty".
78 I borrow this phrase from the introduction of the "Gender Histories and Heresies" issue of *Radical History Review*, 52 (Winter 1992), p. 1.

SEPARATE SPHERES IN A SEPARATE WORLD
African-Nova Scotian Women in Late-19th-Century Halifax County

SUZANNE MORTON

As a visible minority in a dominantly Euro-American environment, African-Nova Scotian women in the last quarter of the 19th century were conspicuous both as women and as racially different. In photographs, sketches and literary writings we can catch glimpses of black women at the Halifax city market. Court records and newspaper accounts expose "colored" women among the city's numerous prostitutes. The public nature of these particular activities distorts the diversity of the female African-Nova Scotian experience, and their high visibility to contemporaries is contrasted to their invisibility in the way that the past has been presented.[1]

The obvious public presence of African-Nova Scotian women around Halifax county and in the city streets also conflicts with predominant images of women in the 19th century. The Euro-American middle-class obsession with categorization placed women in the home and men in the workplace. This division of space, referred to as the idea of separate spheres, was supported by a host of gender-related characteristics. To some extent, this framework reflected the division of labour in society, but the ideology and values associated with it extended beyond task performance. Of course, men and women did not actually live in separate spaces, but it is impossible to

1 I have consciously chosen to use African-Nova Scotian in this text to emphasize the historic presence of people who shared some form of African descent in Nova Scotia. I use African — in the same way that other groups of "hyphenated Canadians" are identified — with the understanding that the Nova Scotia Black community did not originate in a single geographic location in Africa and that their historic identity was further shaped by the United States or the Caribbean. In the context of this study the contemporary term to describe African-Nova Scotians was colored. This essay is not Afro-centric in its outlook as it investigates the effect of a dominant Euro-Nova Scotian cultural ideology on this community and generally overlooks what may have been more important issues for the Black community such as economic survival, racism, and the impact of family separation with high levels of outmigration. As the author I should acknowledge that I am not of this community but have undertaken this research as part of my continuing interest in historical social relations in the province. I gratefully acknowledge the assistance of a SSHRC post-doctoral fellowship and the comments of Judith Fingard, the Toronto Gender History Group and my former colleagues at Queen's University.

deny some kind of division between public and private existed. Men and women shared both a domestic and public life, and the idea of separate spheres was less about the physical reality than about the way that society was thought to be ordered.

African-Nova Scotian women lived in a bicultural world with two distinct historical communities shaping their identities. Evidence of the tenacity of the culture of the African diaspora was suggested by women's central participation in trade, their flamboyant taste in dress, and their skills in the art of herbal healing.[2] While folklorist Arthur Huff Fauset concluded during Nova Scotia fieldwork in the 1930s that the "pressure of western culture" had led to the loss of traditional stories, he also noted the retention of special religious customs and dialect.[3] In 19th-century Halifax County, some African-Nova Scotian women continued African traditions through activities such as making baskets, carrying them on their heads and drawing upon an extensive oral tradition of pharmacopoeia.[4] Women managed to combine the culture of the African diaspora, which included economic independence and relative sexual autonomy, with aspects of the Euro-American gender conventions such as the ideology of separate spheres.[5]

2 Evelyn Brooks Higginbotham, "Beyond the Sound of Silence: Afro-American Women in History", *Gender and History*, 1, 1 (Spring 1989), p. 56; William D. Piersen, *Black Yankees: The Development of an Afro-American Subculture in Eighteenth-Century New England* (Amherst, MA, 1988), pp. 101-2, 84, 103.

3 Arthur Huff Fauset, *Folklore from Nova Scotia* [*Memoirs of the American Folklore Society*, Vol. XXIV (New York, 1931)], p. viii.

4 Peter H. Wood, "'It was a Negro Taught Them': A New Look at African Labor in Early South Carolina", *Journal of Asian and African Studies*, IX, 3&4 (July and April 1974), pp. 160-79. Many of the Black Loyalists came from South Carolina.: James W. St. G. Walker, *The Black Loyalists: The Search for a Promised Land in Nova Scotia and Sierra Leone, 1783-1870* (London, 1976), p. 5.

5 Linda Kerber, "Separate Spheres, Female Worlds, Woman's Place: The Rhetoric of Women's History", *Journal of American History*, 75, 1 (June 1988), p. 26. One of the most interesting ways to examine the gender conventions of the first-wave of African-Nova Scotian immigrants, the Loyalists, is to look at those who left for Sierra Leone in the 1790s. Africanists have noted that these Nova Scotian women differed greatly from Africans who lacked any experience in North America and from their fellow settlers, the Maroons. In particular, Nova Scotian women were noted for their economic autonomy and their relative sexual independence. Almost all first generation Nova Scotian women in Freetown possessed an occupation and nearly one-third of the households were headed by women. By the mid-19th century, there was at least the appearance of economic dependence among Nova Scotian women in Sierra Leone that paralleled their female kin who remained in Nova Scotia. See E. Frances White, *Sierra Leone's Settler Women Traders* (Ann Arbor, 1987); Christopher Fyfe, *A History of Sierra Leone* (Oxford, 1962), pp. 143, 101, 102.

American research has suggested that while African-Americans maintained transatlantic traditions, they were strongly influenced by 19th-century Euro-American bourgeois gender conventions. Historians such as Jacqueline Jones, Evelyn Brooks Higginbotham, James Horton and Sharon Harley have argued that separate spheres ideology offered self-respect and protection to a group of women particularly vulnerable to economic exploitation and sexual harassment and assault in the public sphere. Elevating domestic culture made a great deal of sense in a hostile world. Women's low status as wage-earners encouraged them to adopt as their central identity their domestic and family roles as wives, mothers and sisters.[6] The conceptual framework of separate spheres offers insight into the experience of African-Nova Scotian women by demonstrating both the constraint and the empowerment it offered. Separate spheres ideology did not reflect the physical or material reality of their lives, nor was it the only ideology shaping their identity. Racism and sexism, however, meant that separate spheres ideology afforded women both limitations and protection. Halifax County was selected as the focus for this study because of the large concentration of African-Nova Scotians both in the city and in surrounding rural communities such as Preston, Hammonds Plains and Beech Hill, also known as Beechville.

Blacks came to Nova Scotia with European settlement as slaves, both as Loyalists and Loyalist property after 1783, as refugees during the War of 1812, and throughout the 19th century as West Indian immigrants connected by the North Atlantic economy. Many households in Halifax County originally settled on poor agricultural land around Preston and Hammonds Plains and found that subsistence farming was possible only when household production was supplemented with the day-labour wages available in the city. Rural communities continued to be important, but households and individuals attracted by wage-labour moved into the city of Halifax, concentrating themselves in the working-class Ward Five along Creighton, Maynard and Gottingen Streets or the peri-urban Ward Six community known as Africville. Urban migration rarely solved economic problems and many African-Nova Scotian men and women were among the thousands of Maritimers who left the region for better opportunities in the Boston states or Central Canada. Sources make numbers difficult to determine and the census was highly unreliable; however, in 1881 there were 1,039 Nova Scotians of Afri-

6 Higginbotham, "Beyond the Sound", pp. 56, 59; James Oliver Horton, "Freedom's Yoke: Gender Conventions Among Antebellum Free Blacks", *Feminist Studies*, 12, 1 (Spring 1986), p. 58; Sharon Harley, "For the Good of Family and Race: Gender, Work and Domestic Roles in the Black Community, 1880-1930", *Signs*, 15, 2 (Winter 1990), pp. 337, 347.

can descent listed as living in the city and another 1,485 in the county and Dartmouth, for 2,524 people in the county's total population of 67,981.[7]

TABLE ONE
African-Nova Scotian Population
Halifax County, 1871 and 1881

	Total Population 1871	1881	African-Nova-Scotian Population 1871	1881	Per cent of Total Population 1871	1881	African-Nova-Scotian Women Over Age 12 1871	1881
Ward One	6634	7998	44	36	0.7	0.5	26	20
Ward Two	3320	3598	100	24	3.0	0.7	46	17
Ward Three	3277	2801	149	77	4.5	2.7	64	32
Ward Four	2331	1942	115	91	4.9	4.7	51	46
Ward Five	10046	13545	414	691	4.1	5.1	188	322
Ward Six	3974	6170	71	120	1.8	1.9	24	44
Total Halifax	29582	36054	893	1039			399	481
Beech Hill	407	438	66	61	16.2	13.9	23	26
Hammonds Plains	740	785	319	355	43.1	45.2	102	118
Dartmouth	4358	5673	172	252	3.9	4.4	58	81
Windsor Road	850	965	102	112	12.0	11.6	34	39
Truro Road	998	903	93	98	9.3	0.9	26	36
Preston	715	794	516	594	72.2	74.8	186	218
Other	19313	22369	27	13	0.1	>0.1	5	7
Total	56963	67981	2188	2524	3.8	3.7	833	1006

Source: Canada, *Census of 1871*, Vol. 1, Table III, "Origins of People", pp. 326-8; Canada, *Census — 1881*, Vol. 1, Table III, "Origin of the People", p. 212, and Census manuscripts [microfilm], 1871 and 1881, "Nominal Return of the Living".

Research on African-Nova Scotians in the 19th century is generally hampered by the paucity of reliable sources. Descriptions by Nova Scotians of European descent are marked by racism and by a disregard that extended to government records such as the decimal census. African-Nova Scotians were seriously under-enumerated in the census and their entries marked by a high degree of inaccuracy. For example, an examination of black women buried in the Halifax Camp Hill cemetery between 1871 and 1873 and between 1879 and 1890 revealed that less than half the of 86 women interred could be matched with either the 1871 or 1881 census.[8] Sources authored by the black

7 Canada, *Census of 1871*, Vol. 1, *Census —1881*, Vol. 1, In 1871 the population of the city was 29,582 and the county 37,008. This included 893 African-Nova Scotians in the city and 1,295 in the county and Dartmouth. By 1881 the city was more populous than the largely rural county, with the city listing 36,054 inhabitants and the county and Dartmouth only 31,863. The total population (city and county) increased by only 1,327 inhabitants, which included an increase of 336 African-Nova Scotians. Urbanization may have affected black Nova Scotians differently as the rural/urban percentage remained virtually unchanged.

community are rare and generally restricted to church conventions and petitions.[9]

The prominence of Peter McKerrow as historian and secretary of the African Baptist Association and family member of the household that most frequently appeared in legal sources may also distort any insights. It is impossible to separate McKerrow's personal values of respectability and appropriate behaviour from more widely-held attitudes. The absence of diaries, letters or even records of women's organizations means that we can know something about the material conditions of women's lives, but not their self-perceptions and attitudes. On the rare opportunities when we can see them, we are able only to observe their actions, never fully understand their motivations.[10]

8 PANS, Micro: Halifax, Cemeteries, Camp Hill (reel 10). Unfortunately, the 1891 census did not record race. The extent to which African-Nova Scotians were responsible for misinformation in the census is problematic. Enumerators were instructed that "Origin is to be scrupulously entered, as given by the person questioned": Canada, Census of 1881 Manual, p. 30. Judith Fingard has noted that black community leaders Peter McKerrow and his brother-in-law William B. Thomas were not recorded as African in the 1881 census. On the other hand, in this same household, other entries appeared twice. Inez and Rachel Thomas were listed both at their mother's home in Preston (120-128) and in Ward 2 (145-255) of the city living with their brother's and sister's families. I suspect other cases of duplication among young women engaged in domestic service listed at both the family's and employer's residence. Judith Fingard, "Race and Respectability in Victorian Halifax", *The Journal of Imperial and Commonwealth History*, 20, 2 (May 1992), p. 179.

9 Frank Stanley Boyd, ed., Peter E. McKerrow, *Brief History of the Colored Baptists of NS, 1783-1895* ([1895] Halifax, 1976). The opinions of Peter McKerrow are disproportionately prominent as he was also secretary of the African Baptist Church and the major defendant in the only civil court case I uncovered involving African-Nova Scotian women. As the son-in-law of Rev. James Thomas, Peter McKerrow was closely connected to one of the few African-Nova Scotian families who dominate recorded historical sources.

10 The paucity of sources has recently become further complicated by an appalling act of vandalism at the Public Archives of Nova Scotia. During the summer of 1990 someone stole the index cards relating to African-Nova Scotians and women. This act of vandalism placed another obstacle in the way of research on African-Nova Scotians' past. Yet so much needs to be done. This study introduces the experience of African-Nova Scotian women and reveals the need to follow up with research on residual African traditions, family structure, urban-rural movement, out-migration and female church organizations in the early 20th century. As Judith Fingard has demonstrated with court records, school records, cemetery records and detailed newspaper work promise more insight into African-Nova Scotian history. Understanding the way that race worked together with class and gender in shaping experience will not only offer knowledge of the African-Nova Scotian past, but will also lead to a better understanding of all Nova Scotian society.

While Nova Scotia was a racist society in the 19th century, the circumstances were very different from those in the United States. Slavery, although important, was never widely practised. Furthermore, unlike the urban free blacks of the north, more than half the African-Nova Scotian population lived in rural areas where they were property owners, albeit of often very poor land. Wage-labour, therefore, was not as vital to community survival as it was often mixed with subsistence agriculture or household-based manufacturing. Nor was the labour of African-Nova Scotian women in any particular demand. High levels of outmigration across Nova Scotian society suggest a surplus of local labour. In the case of African-Nova Scotian women, this meant that they competed for positions in domestic service with urban and rural women of Euro-American descent.

With this difficulty in documentation, and the racial bias of most historians, research so far has produced relatively little insight into the 19th-century African-Nova Scotia community and, with the important exceptions of work by Judith Fingard and Sylvia Hamilton, even less specifically on women.[11] Assumptions made about the historical experiences of women have been a mix of current cultural stereotypes and imported models from American history. For example, in a published 1985 lecture James W. St. G. Walker pointed

11 Fannie Allison *et al., Traditional Lifetime Stories: A Collection of Black Memories,* Vol. 2 (Westphal, N.S., 1990); Belle Barnes *et al., Traditional Lifetime Stories: A Collection of Black Memories* Vol. I (Westphal, N.S., 1987); Donald H. Clairmont and Dennis William Magill, *Africville: The Life and Death of a Canadian Black Community* (Toronto, 1974); Judith Fingard, *The Dark Side of Victorian Halifax* (Lawrencetown, 1989); Fingard, "Race and Respectability"; Sylvia Hamilton, "Our Mothers Grand and Great: Black Women of Nova Scotia", *Canadian Woman Studies/Les Cahiers de la Femme canadienne,* 4, 2 (Winter 1982), pp. 33-7; "A Glimpse of Edith Clayton", *Fireweed* 18 (Winter/Spring 1984), pp. 18-20; and Marie Hamilton, "Mothers and Daughters: A Delicate Partnership", *Fireweed,* 18 (Winter/Spring 1984), pp. 64-8; Bonnie Huskins, "Race and the Victorian City: Blacks and Indians During Celebrations in Saint John and Halifax, 1838-1887", Paper presented to the Canadian Historical Association, Victoria, B.C., 1990; Frances Henry, *Forgotten Canadians: The Blacks of Nova Scotia* (Don Mills, 1973); J.A. Mannette, "Stark Remnant of Blackpast: Thinking of Gender, Ethnicity and Class in 1780s Nova Scotia", *Alternative Routes,* 7 (1984); Bridglal Pachai, *Blacks of the Maritimes* (Tantallon, N.S., 1987); *Beneath the Clouds of the Promised Land: The Survival of Nova Scotia's Blacks, Vol. 1: 1600-1800* (Halifax, 1987); *Beneath the Clouds of the Promised Land: The Survival of Nova Scotia's Blacks, Vol. 2: 1800-1989* (Halifax, 1990); Calvin W. Ruck, *The Black Battalion, 1916-1920: Canada's Best Kept Military Secret* (Hantsport, N.S., 1987); Carolyn Thomas, "The Black Church and the Black Women", in Bridglal Pachai, ed., *Canadian Black Studies* (Halifax, 1979), pp. 234-38; James W. St. G. Walker, *The Black Identity in Nova Scotia: Community and Institutions in Historical Perspective* (Westphal, 1985), Robin Winks, *Blacks in Canada* (New Haven, Conn., 1971).

to the common stereotype that the local community had been dominated by women, who were often responsible for "family discipline, household management and even the breadwinning".[12] In an interesting construction of race and gender identity, Walker claimed that there were "more female" jobs available for black women than "black" jobs for the black man.[13] The differentiation between "black" — read male — and "female" immediately alerts us to the acceptance of a preconceived norm in which women were not supposed to be directly involved in breadwinning. This view of the past had also been reflected in the research conducted by Frances Henry in 1969 when she made the remarkable claim that dated women's paid labour outside the home as "a fairly recent phenomenon in the community".[14] Henry believed that the transformation from a subsistence to a consumer economy forced women out of the home and into the labour market to supplement the low wages available to African-Nova Scotian men. Like Walker's implicit categorization of "black" jobs and "female" jobs, Henry presumed the existence of a time when subsistence production could support a household without the need for supplemental wages or perhaps even the public economic activities of women. In this view wage-earning women outside the home were an exception to the normal gendered division of labour. Henry's identification of a well-defined sexual division of labour in which "it was generally felt the woman's place was in the home" may have been more recent than she had imagined.

The inconsistency between prevalent expectations and lived experience was further complicated by the fact that the experience of African-Nova Scotian women in late-19th-century Halifax County was by no means homogeneous. Divisions existed based on class, rural or urban residency, religion, ethnicity and more abstract criteria such as the value placed on respectability. Different waves of immigration may have carried with them distinct gender conventions. While these divisions were real, the racist nature of this society meant that these internal divisions were not perceived by the dominant Euro-American culture. The puritanical women who silently stare at us through studio photographs differed greatly from the lively market women in their multi-layered petticoats and pipes. But as late as the 1920s, a white woman in Halifax looking for help with her laundry felt free to stop any African-Nova Scotian woman on the street and request "where she could get a good girl".[15]

12 Walker, *Black Identity*, p. 2.
13 Walker, *Black Identity*, p. 11.
14 Henry, *Forgotten Canadians*, p. 57. She was evidently referring to married women.
15 *The Worker* (Toronto), 15 November 1924.

The example of being approached on the street not only illustrates the racist assumptions of this white woman but also her assumptions about class. Most African-Nova Scotian households in Halifax and in the county were working class and as a result many black women shared aspects of the lives, and sometimes their actual residence with, white working-class women. But racism in fact reinforced class and, unlike their white counterparts, African-Nova Scotian women had virtually no legal wage-earning opportunities outside domestic service, taking in laundry, or sewing. Regardless of status in the community, property holdings or occupation of the husband, married women and widows charred, and young women were servants. Certainly there must have been a considerable variety of conditions under these labels. Unpredictable and irregular general day-work differed from regular weekly clients. Young women who lived in service in other African-Nova Scotian households may have had a dissimilar experience than their sisters and cousins who worked for white families. Indeed, one African-Nova Scotian household in Ward 5 kept a servant in 1881, even though their own daughter worked as a servant elsewhere. It is nearly impossible to understand class solely in terms of occupation as the few occupations reported offer no insight into hierarchy or power within the community. Evelyn Brooks Higginbotham has noted that racism and limited occupations among African-Americans "skewed income and occupational levels so drastically" that social scientists have measured adherence to bourgeois conventions, including gender relations, "as additional criteria for discerning blacks who maintained or aspired to middle-class status from those who practised alternative lifestyles".[16] Racism and sexism and the resulting limited employment opportunities open to African-Nova Scotia women obscured the level of real difference within the community.

Paid work usually related to a woman's life course. Young women before marriage and widows without access to a male wage were the women most likely to work. Waged-work outside the home for married women may have been more common within the black community, but this was not necessarily reflected in the census. As the census undoubtedly missed many black women, it also missed many women's occupations, particularly when a man's occupation was provided. Relatively few married women were listed in the 1871 and 1881 censuses as engaging in paid labour; but these included schoolteacher Caroline Byers, dressmakers Mary Howell and Elizabeth Brown, and three shopkeepers, Isabel Dixon, Margaret Gleen and Catherine Gideon — whose husbands were employed in migratory occupations as seamen or ship stewards. The virtual absence of female farmers in the 1871

16 Higginbotham, "Beyond the Sound", p. 58.

census conceals much agricultural work, but specifically the source of agri-cultural production in the many rural female-headed households. Married women who undertook occasional or casual day labour as charwomen were also severely under-represented in the 1871 census, which listed only eight women. This number increased to 53 in 1881 (see Table Two). The under-representation of this form of casual employment was significant. Was casual day-labour for black women so common that no mention of it was thought necessary? Many other occupations were also missed in the census. Both Mary Ann Reid Gigi and Sarah Anderson of Hammonds Plains had no occu-pation listed in the census yet both worked regularly as midwives.[17]

Other medical and pharmaceutical skills widely held by women also went unacknowledged. Louisa Bailey's 1891 occupation as a herbalist would have been impossible to discern without independent consultation from city directories.[18] Not surprisingly, illegal occupations such as brothel keeping, prostitution and bootlegging were absent, but these illicit occupations formed only a small part of the informal or hidden economy operating in the city and county. Residents of Halifax would have regularly seen African-Nova Scotian women at work in the informal economy, visible in public view at the Halifax market in the city's downtown. It was the perception of census enumerators that obscured the important public but informal roles women played in the economy, whether this be as vendors, boarding house oper-ators, charwomen or midwives.

The under-representation of African-Nova Scotian women's public work was characteristic of all working-class women. While African-Nova Scotian women and working-class women of European descent shared the lowest-paid jobs, employment for black women may have been particularly difficult to acquire and vulnerable to loss. In the limited strata of "female" jobs, Afri-can-Nova Scotians did not work in factories, and only in shops if they were family operations. The number of rural and urban Euro-American women available for domestic work meant that black women were not in specific de-mand as servants. Analysis of the placements of African-Nova Scotian women in Halifax households reveals that although Ward One had nearly four times the number of domestic servants as any other ward, only 11 were of African descent. Conversely, Ward Five, where households were least like-

17 Pachai, *Beneath the Clouds*, Vol. II, p. 104; Viola Parsons, *My Grandmother's Days* (Hantsport, 1988), p. 18.
18 Allison *et al.*, *Traditional Lifetime Stories*, Vol. II, p. 73; Parsons, *My Grandmother's Days*, p. 15.

ly to include domestic servants and had the highest ratio of domestic servants to the general population, named 53 female black servants.[19]

TABLE TWO
African-Nova Scotian Female Occupations
in Halifax County, 1871 and 1881

Occupations	Halifax		Dartmouth and Rural		Total	
	1871	1881	1871	1881	1871	1881
Servant	55	80	9	45	64	125
Butler		2				2
Cook		5				5
Housekeeper		1	4	1	4	2
Pastry Cook		1				1
Charwoman	5	57	1		6	57
General Work	2				2	
Housecleaner	1				1	
Washing	27	5	4		31	5
Dressmaker	2	10	2		4	10
Basketmaker				1		1
Grocer	2				2	
Confectioner	1	1			1	1
Shopkeeper		4				4
School Teacher	1	1	2		3	1
Private Tutor	1				1	
Clerk		1		2		3
Farmer			1	12	1	12
Collector		1				1
Hairdresser		1				1
Illegible		1				1
Total	97	171	23	61	120	232

Source: Canada, Census manuscripts [microfilm], 1871 and 1881, "Nominal Return of the Living".

African-Nova Scotians may have had difficulty acquiring positions as servants as they were disproportionately absent from the city's best residential area and over-represented in the worst area. If acquiring a position as a servant was difficult, other occupations were more blatantly blocked. Even the pretence of upward mobility was not available. Racial discrimination meant that young black women were prohibited from being trained as nurses or entering the Provincial Normal School at Truro to prepare for a teaching career.[20] Although prohibited from professional qualifications, as early as

19 In 1891 Ward One listed 812 domestic servants out of a total population of 8550. Ward Five with a population of 14,347 named 188. Canada, Census, 1891, manuscript. Claudette Lacelle notes that in 1871, 28 per cent of households in Ward 1 had servants compared to 10.1 per cent and 14.4 per cent in the two sections of Ward 5: *Urban Domestic Servants in 19th-Century Canada* (Ottawa, 1987), p. 81.
20 The first African-Nova Scotian to graduate from the Truro school was Madeline Francis Symonds in 1928. Nurse training and placement in hospitals was not available until

1874 a number of local black women undertook teaching under the provision of a special permissive licence.[21]

The need for teachers in the black rural communities was constant. Few young women who had the option of residency in the city chose to return to the more difficult rural life. Good students were encouraged to get their licences but this did not affect the supply of available black teachers nor were they necessarily successful in obtaining positions in desirable schools. In 1891 the superintendent noted the case of a young black woman at the Halifax County Academy who, upon finishing her Grade C exam, was eligible for a permissive licence, but "I could not, however, persuade her to go to the country and teach, as her prospects were much better in the city".[22] Selina Williams of Fall River was an exception. As a young black teacher with a permissive license who taught day school successively at North Preston and Beech Hill, in addition to her duties as a Sunday School teacher. Her unusual decision to stay in the county made her the object of Peter McKerrow's praise in his church history and in the convention minutes.[23] McKerrow concluded that "If a dozen or more of the young women in various sections of the country where these schools are organized would contemplate the good they would be doing for the race in years to come they would wake up, even now, to a sense of duty".[24] In this interesting assessment, McKerrow clearly placed the responsibility of education and "race improvement" on women, while at the same time implying the absence of this sense of duty among local young women. McKerrow's assumption that women were responsible for

1946. Pachai, *Beneath the Clouds*, Vol. II, p. 190; Donald H. Clairmont, Dennis W. Magill, *Nova Scotian Blacks: An Historical and Structural Overview* (Halifax, 1970), p. 35.

21 *Morning Chronicle*, 3 December 1874. Miss Ann Joseph taught at the Colored School in Dartmouth.

22 Nova Scotia, *Nova Scotia, House of Assembly Journal and Proceedings*, 1891, Appendix 5, Education, p. 52. Judith Fingard notes that Laura Howell taught in the Dartmouth school in 1891 and the Maynard Street School from 1896 to 1899. Martha Jones who finished her studies in 1884-5 was unable to find a position in the city. Fingard, "Race and Respectability", p. 188, fn. 81. Maria Wood, of Beech Hill and Mary Bauld of Hammonds Plains are listed as school misses in 1871 and Esther Butler was listed in 1871 and 1881.

23 Nova Scotia, House of Assembly Journal and Proceedings, 1889, Appendix 5, Education; McKerrow, *Brief History of Colored Baptists*, p. 45; Pearleen Oliver, "From Generation to Generation; Bi- Centennial of the African Baptist Church in Nova Scotia", PANS.

24 Minutes of the 47th African Baptist Association of Nova Scotia Convention, 1900, Acadia University Archives [AUA].

public education and community service drew upon the tenets of separate spheres ideology.

Education of daughters was taken seriously by many parents with at least one young woman sent to Boston when the racist policies of the Halifax school board prohibited access to education beyond grade seven.[25] But the desire for female literacy was not restricted to young girls. Forty-year-old laundress Eliza Johnston attended the Maynard Street school in the 1880s as a full-time student, achieving 100 per cent in several subjects for her efforts.[26] Rural women also cared about reading and writing. Selina Williams recalled in 1956 that when the North Preston school opened in 1897, mothers and fathers accompanied their children to class until the school inspector, concerned about overcrowding, agreed to provide lighting for an adult night school conducted three nights a week.[27]

Literacy or advanced education, however, did nothing to alter the basic fact that there were few careers open to young black women in Halifax. Many young women joined their brothers, husbands and parents or even set off by themselves to New England or Central Canada. That these women sent back to Halifax barrels of used clothes from employers suggests that even women who left the limited local opportunities still found themselves in the restricted field of domestic service.[28]

Domestic service was the most important occupation for African-Nova Scotian women as noted in the census occupational listings. It was confirmed in the racist attitudes of Anglo-Celtic middle-class women such as Mary Jane Lawson, who conceded of her black Preston neighbours that "many of the women make good domestic servants".[29] Paid domestic labour in a private household is full of contradictions. Domestic work is perhaps the ultimate form of women's work, but not when it is performed in someone else's home, and not when it is undertaken as part of a wage relationship. Women performing domestic work outside their own homes undertook work that was

25 Fingard, "Race and Respectability," p. 182.
26 Halifax School Registers, Lockman Street School, Maynard Street School, RG 14, R 1, PANS.
27 Although the county paid for lightening oil, Selina Williams taught for free. Edna Staebler, "Would You Change the Lives of These People?" *Maclean's*, 12 May 1956, p. 60.
28 Parsons, *My Grandmother's Days*, p. 27. Between 1870 and 1900 more than 90 per cent of employed African-Canadian women in Boston were classified as working in menial occupations: Elizabeth Hafkin Pleck, *Black Migration and Poverty: Boston, 1865-1900* (New York, 1979), p. 104.
29 Mrs. William Lawson, *History of the Townships of Dartmouth, Preston and Lawrencetown, Halifax County, Nova Scotia* (Halifax, 1893), p. 192.

simultaneously public and private, productive and reproductive.[30] The wide-spread nature of this work was reflected in the censuses, which listed 64 African-Nova Scotian women as servants in 1871 and 125 in 1881. A similar increase was recorded in the number of women listed as charwomen, who increased from six to 57. These dramatic increases were likely the result of slightly improved record-keeping rather than any specific change in the labour market. The only occupation for African-Nova Scotian women where numbers declined from 1871 to 1881 was work as laundresses; the 31 women in this group in 1871 declined to only five women ten years later. Mary Ann Brown Thomas, widow of James Bates Thomas, may have attempted to counterattack the advent of commercial laundries that affected casual employment opportunities in this area, listing herself in the 1880-81 city directory as the proprietor of Prince Wales Laundry, operating from her home. Such commercial attempts were rare and service occupations were typically private with some specialization as cooks, housekeepers and housecleaners. Specialization did not necessarily mean permanent residence with the employer. Halifax women may have preferred day labour where they did not live permanently in someone else's home and were not at the beck and call of the employer 24 hours a day. To achieve this independence and the possibility of a private life, one Hammonds Plains woman walked the eight miles into Bedford to do domestic work.[31]

Private work in someone else's home contrasted with the obviously public work black women undertook in their participation at the city market. Market activity combined domestic skills, market gardening, resourcefulness and imagination to ensure that the necessary supply of cash continued to come into the household. Surviving photographs and the classic 1872 sketch by W.O. Carlisle, "Negresses Selling Mayflowers on the Market Place", corroborate the literary evidence. Women from the county gathered wild fruits, according to one witness, from every conceivable kind of berry and flowers according to the season. In the early spring mayflowers and mosses appeared. These were followed by bouquets of ferns and little birchbark boxes. In the late fall and as Christmas approached, wreaths, evergreen swags and branches joined dyed grasses, "carefully pressed and waxed" autumn leaves, and sumach berries.[32] Throughout the year, women also sold an assortment of herbs

30 Dionne Brand, "Black Women and Work: The Impact of Racially Constructed Gender Roles on the Sexual Division of Labour, Part Two", *Fireweed*, 26 (Winter/Spring 1988), p. 87.

31 Parsons, *My Grandmother's Days*, p. 21; Harley, "For the Good of Family", p. 347. Harley noted that day work permitted domestic and family life.

32 Lawson, *History of the Townships of Dartmouth, Preston and Lawrencetown*, p. 188-9; *Novascotian* (Halifax), 17 October 1885; Margaret Marshall Saunders, *The House of*

and "roots of miraculous properties", all kinds of market vegetables and "Brooms, baskets, tubs, clothes-props, peasticks, hop and bean poles, rustic seats and flower boxes". Some vendors also sold the famous baskets,[33] and one Preston woman in the 1891 census reflected this important trade when she identified herself as a basketmaker. Preparing these goods for market meant a tremendous amount of work that combined reproductive and pro-ductive labour and the efforts of most members of the household. Various goods had to be made, grown or painstakingly gathered, and then arranged and transported into the city. In such a complex group of household activities the boundary between public productive and private reproductive work is impossible to isolate.

While separate spheres ideology limited the economic opportunities avail-able to African-Nova Scotian women, it did not offer reciprocal financial protection. Low pay and irregular work meant that African-Nova Scotian women were dependent on access to a male wage, even if it was lower and more irregular than that available to other working-class men. Economic cir-cumstances also meant that women were not protected from the workplace. Rural women lived and worked on their farms. The time women spent fashioning splitwood baskets or arranging bouquets to be sold at the city market was not distinct from other household duties such as childcare or tending the garden. Likewise, urban women engaged in domestic service or employed in family business experienced no spatial differentiation between the location of work and home.

This lack of spatial differentiation was evident even among the McKer-row-Thomas family, one of the most prominent African-Nova Scotian families in the city and county. Sometime in the 1840s the Welshman James Thomas married Hannah Saunders, an African-Nova Scotian living in Pres-ton. Thomas eventually became leader of the African Baptist Church of Nova Scotia and fathered with Hannah at least seven children. Religious leadership, business success and marriages of the children linked the Thomas family to the most respectable black families of Halifax. Among the connec-tions of this family was the marriage of daughter Mary Eliza to Antigua-born Peter McKerrow in 1863. McKerrow was a leading member of the Morning Glory Lodge of Good Templars, the Ancient and Accepted Masons Union

Armour (Philadelphia, 1897), pp. 287-8. Saunders noted that African-Nova Scotian women were not the only women to sell their goods of at the market as she also men-tions the presence of Acadian women from the Eastern Shore.

33 Joleen Gordon, *Edith Clayton's Market Basket, A Heritage of Splitwood Basketry in Nova Scotia*, photographs by Ronald Merrick and diagrams by George Halverson (Halifax, 1977).

Lodge No. 18, trustee of Cornwallis Street African Baptist Church and secretary to the Nova Scotia African Baptist Association.[34]

In 1892 the Supreme Court of Nova Scotia heard an appeal case regarding property from the estate of Rev. James Thomas that had been lost through foreclosure and then secretly purchased by his son-in-law and estate executor Peter McKerrow. McKerrow claimed his acquisition of the property was without the knowledge of his wife or three sisters-in-law and that he was uncertain as to when they eventually discovered the transaction as he had "never discussed the matter with any of them".[35] Furthermore, McKerrow claimed his wife Mary had co-executed this mortgage without becoming familiar with the contents of the papers she was signing. Since one aspect of this case was the right of the female heirs to a monthly annuity from the property, it is conceivable that they feigned ignorance to strengthen their case to entitlement of monies owing. That none of these female heirs, including his wife, knew of McKerrow's financial dealings would have been quite remarkable. Three of the heirs, Rachel Thomas, Inez Thomas and Mary McKerrow were living in the same residence as McKerrow. Working as clerks in the business at the time of the transaction, they probably possessed some knowledge of the firm's operation. On the other hand, their financial ignorance was possible and if the ideology of separate spheres, which protected women from the marketplace, was present in any African-Nova Scotian households, it was likely to be found here. The desire for respectability and possible upward mobility partially rested on appropriate gender roles, including the adoption of separate spheres ideology even when material and class circumstances did not allow for an actual separation of workplace and residence. Certainly there was not physical protection from the workplace. Three of Rev. James Thomas's daughters resided at some point at the same address as the family's hat and fur business; in addition, Thomas's son William and his second wife Laura not only lived beside the Sackville Street family business, but Laura had a separate listing in the city and provincial directory to advertise her business as a dressmaker and milliner.

The notion of protecting women from the economic world was also not present in the estate of John Robinson Thomas, Rev. James Thomas's oldest

34 Fingard, "Race and Respectability", pp. 174-6.

35 Daniel McN. Parker, Wm J. Lewis, Wm. F. Parker Executors of last will and test of Martin P. Black, plaintiffs and Wm. B. Thomas, Peter E. McKerrow, Thomas G.D. Scotland, Jas. T. McKerrow, Wm. B. Thomas Peter E. McKerrow executors of last will and testament James Thomas and Moses Vineberg, Bernard Kortosk, Jacob G. Ascher (Kortosk and Co.) and Rachel C. Sockume, Mary E. McKerrow, Inez E. Thomas, Elizabeth Ann Johnston, defendants, 'A' Appeals — Supreme Court of Nova Scotia, Volume 9, 1891-92: # 3360, RG 39, PANS.

son and Peter McKerrow's brother-in-law. Upon John Thomas's death in 1876 he had two insurance policies of $2,000 and $1,000 that should have provided some security for his widow and three children under the age of nine. Of this amount, however, his wife Eliza, received only $500, while $1,500 was to be invested and divided among the three children when they reached the age of majority. A further $1,000 was given to his father along with his share in the family business. Long-term support for the widow or for the children until they qualified for their inheritance did not appear to be a primary concern of John Thomas. As a result, in the 1881 census widow Eliza Bailey Thomas was listed as a charwoman; the children were living with neighbours and their maternal step-grandmother, not the Thomas family who received the generous proportion of their father's estate.[36] The extent to which this estate was unusual, where financial protection for an aging parent took priority over providing for a young family, is unknown as so few wills were recorded. It may have been that John Thomas believed that his widow was in a better position to support herself than his aging father and mother.

The public survival skills expected of Eliza Bailey Thomas conflict with assumptions of the female character and expose the limitations of exactly which women were to be included within "women's sphere". Dionne Brand has noted that African-Americans were rarely perceived by the dominant culture as "ladies" and that the term lady had "predictable race and class connotations". White ladies were protected by the private sphere of motherhood and genteel domesticity, made possible by material circumstances that were beyond the resources of most black women.[37] The types of waged employment available to African-Nova Scotians were tasks that women traditionally performed, but they were with rare exception suitable work for "ladies".[38] Black women were expected to be engaged in hard physical labour such as scrubbing, thereby confirming their unladylike reputation; yet, at the same time, those who restricted their labour to the private domestic sphere and expected their husbands to act as breadwinners could be perceived as lazy.[39] In

36 Nova Scotia Probate Court, John Robinson Thomas, #2299, 1876. Eliza Thomas appears to have inherited property on Creighton Street from her father after his death in 1886. RG 35-102, 'A', #8 1890 Street Ward Five Valuation Book, PANS.

37 Brand, "Black Women and Work: Part Two", p. 91. See Phyllis Marynick Palmer, "White Women/Black Women: The Dualism of Female Identity and Experience in the United States", *Feminist Studies*, 9, 1 (Spring 1983), p. 153; Jacqueline Jones, *Labor of Love, Labor of Sorrow: Black Women, Work and the Family from Slavery to the Present* (New York, 1985).

38 Brand, "Black Women and Work: Part Two", p. 91.

39 bell hooks, *Ain't I a woman: Black Women and Feminism* (Boston, 1981), p. 78.

creating the image of the unladylike woman, race reinforced and worked together with class so that the bonds of womanhood were narrow.

Nova Scotian women of European descent were careful to distance and differentiate themselves from black women with racist characterizations and descriptions of their unladylike behaviour. In Margaret Marshall Saunders' depictions of black women in her journal entries and novels, she emphasized their unrestrained and therefore unladylike manners such as laughing loudly or swearing, and even alleged masculine characteristics such as smoking pipes or walking with a basket balanced on their heads.[40] Mary Jane Lawson's offensive comparison of the Preston women at market to monkeys is well-known — "chattering and like them enjoying the warmth and pleasantness of summer". Less familiar is the scorn she heaps on African-Nova Scotian women for playing at being real ladies in the festive atmosphere surrounding summer baptisms. Lawson sarcastically noted that "Before such events, there is a great demand for articles of dress: parasols, hoop-skirts, sash ribbons, veils, and fans, are all apparently necessary adjuncts of the ceremony". The fact that the symbols of femininity and middle-class womanhood were subject to mockery when associated with African-Nova Scotia women immediately attunes us to the links between racism and sex. In the late 19th century black women in Halifax County were equally vulnerable to ridicule by their association with masculine paraphernalia such as pipes or the most feminine accessories of dress.[41]

The press also delighted in providing examples of "unladylike" behaviour among African-Nova Scotian women, such as that of the woman in 1874 found guilty of beating her husband with a potato masher.[42] The events that precipitated this reaction were irrelevant as ridicule and her unfeminine reaction became central in portraying a woman who actively defended herself. An unorganized wedding ceremony that nearly resulted in the bridesmaid and groomsman mistakenly marrying was another opportunity to exaggerate the differences between white and black women. In the confusion a white woman stepped up "who like all her sex and color, knew the ceremony well" and stopped the proceedings before the wrong couple wed. The point of this story under the sarcastic byline of "Almost Fatal Mistake"

40 Saunders, *The House of Armour*, pp. 287-8. Margaret Conrad, Toni Laidlaw, and Donna Smyth, eds., *No Place Like Home: Diaries and Letters of Nova Scotia Women* (Halifax, 1988), "Margaret Marshall Saunders".

41 Lawson, *History of the Townships*, pp. 188, 190. The important connection between finery, or dressing above one's class and the fallen woman is the subject of Mariana Valverde, "The Love of Finery: Fashion and the Fallen Woman in Nineteenth-Century Social Discourse", *Victorian Studies,* 32, 2 (Winter 1989), pp. 169-88.

42 *Morning Chronicle*, 22 September 1874.

was that black women were not even familiar with the most important female ritual of the wedding.[43]

In the same way, racial stereotypes about black sexuality and the economic realities of African-Nova Scotian women could reinforce each other in the minds of the white middle-class. That African-Nova Scotian women composed a disproportionate number of the city's prostitutes is hardly surprising in light of the absence of alternative occupations. While this figure may be inflated by the special attention directed at black prostitutes, the result of their visibility as a racial minority, it nonetheless underlines the lack of legal options available.[44] The association between prostitution and African-Nova Scotians may have influenced white middle-class attitudes. Judith Fingard has hypothesized that the lack of female reform agitation around this "social problem" in part may be the result of its association with the African-Nova Scotian community.[45] If this damning racism was true, it suggests the extreme extent to which white women distanced themselves from their African-Nova Scotian sisters. White women wanted to make certain that not all women were included in their sphere.

As a result of this racial malignancy and meagre economic options, it was not surprising that elements of separate spheres ideology were adopted by the black community. The ideology offered advantages beyond accommodation to the dominant culture. Sharon Harley in her work on African-American women has noted that a strictly defined sexual division of labour could be instrumental in supporting claims to middle class status, or to what Judith Fingard might describe perhaps more appropriately as respectability. In addition to status, adherence to clearly defined gender roles could also protect single and married African-American women from racist charges of "immorality" used to undermine this femininity.[46] This interpretation appeared to be supported by the analysis of Carrie Best, born in 1903 in New Glasgow, who described her mother as "a meticulous homemaker and cook" whose duties extended beyond her home as she worked for at least one other family. But working outside the home in no way seemed to interfere with the importance she placed on her role as a wife and mother. As Best observed of her mother: "Although kind, loving and generous she was none the less a disciplinarian guarding the sanctity of the home and family safety like a lioness with her cubs. Black womanhood was held in low esteem during the early

43 *Morning Chronicle*, 22 January 1874.
44 B. Jane Price, "'Raised in Rockhead. Died in the Poor House'; Female Petty Criminals in Halifax, 1864-1890", in Philip Girard and Jim Phillips, eds., *Essays in the History of Canadian Law, Vol. III, Nova Scotia* (Toronto, 1990), pp. 200-31.
45 Fingard, *The Dark Side of Life in Victorian Halifax*, p. 97.
46 Harley, "For the Good of Family", p. 347.

part of the twentieth century and only the home afforded the protection needed to ensure security from outside influences".[47] Best's description of her mother reveals the distinctive way that separate spheres ideology was interpreted by African-Nova Scotian women as it mixed the idea of protection offered by the private sphere with power and strength. Here was not a metaphor that projected the domestic sphere as a haven for delicate and helpless women but rather as the lair of the proud and strong lioness and her cubs.

TABLE THREE
African-Nova Scotian Household Structure
in Halifax County, 1871 and 1881

	Female-headed households with children under 12		Households with children under 12 in which a married male and female are listed		Households with children under 12 with a surname different than household head or when born after woman 50	
	1871	1881	1871	1881	1871	1881
Ward One	0	0	0	0	0	0
Ward Two	0	0	12	0	0	0
Ward Three	6	2	11	6	1	0
Ward Four	3	2	7	10	1	0
Ward Five	13	14	38	56	6	14
Ward Six	1	0	7	17	1	0
Beech Hill	2	1	8	6	3	0
Hammonds Plains	5	4	36	37	17	15
Dartmouth	2	6	22	26	5	3
Windsor Road	2	1	7	8	3	7
Truro Road	3	3	7	11	1	4
Preston	10	12	51	65	7	33
Other	1	0	2	1	0	0

Source: Canada, Census manuscripts, 1871 and 1881 [microfilm], "Nominal Return of the Living".

Almost all that was happening within peoples' residences remains concealed. Although no topic in North American history has produced more debate than the discussion of the African-American family, family structure among 19th-century African-Nova Scotians is unexplored. The general debate has been largely characterized by the label of the matriarchal family, offering the false impression that women had more power than was the actual case. Matriarchy has been used as a relative term to contrast the gender relations around power in the middle-class Euro-American family. African-Nova Scotian women probably had more power within the household than their white middle-class counterparts. But as Suzanne Lebsock has cogently argued, "given this standard, women need not be the equals of men, much less men's superiors, in order to qualify as matriarchs".[48] The label of ma-

47 Carrie M. Best, *That Lonesome Road* (New Glasgow, 1977), p. 43.
48 Suzanne Lebsock, *The Free Women of Petersburg: Status and Culture in a Southern*

triarch given the black family actually offers much insight into the structure
of white middle-class households. Given the American literature one would
also expect to find numerous female-headed households. While there is some
evidence in the frustrated notes of the census enumerator of alternative
household structures, notably common-law relationships, the census data
does not appear to suggest an unusually high degree of female-headed house-
holds, even in this transient port city (see Table Three).[49] In Halifax it also
does not appear that women deliberately chose not to marry. Prominent wi-
dows with property who remarried included Hannah Saunders Thomas,
Louisa Brown Bailey and Eliza Bailey Thomas.[50] What seems to be most dis-
tinct about the structure of African-Nova Scotian households, both urban
and rural, was the number of children with different surnames than the
household head, or the number of third generation children residing in the
household. This fluid household structure cautions us against imposing a
preconceived definition of the private family. The public/private divide may
have had different boundaries as extended family and neighbours' children
were frequently incorporated into what one might have considered to be the
most closed and personal relationship.

Like their Euro-American counterparts, at times African-Nova Scotian
women were purposely kept out of the public, particularly the political,
sphere. A 1864 petition from "the coloured population of Hammonds
Plains" was submitted by 40 men and on behalf of "14 Widows and some
other helpless Females with Families".[51] Similarly, women did not sign the
petitions criticizing racially-segregated schools, although they did attend and
speak at meetings on the topic.[52] To what extent this exclusion and emphasis
on women reflected political power in the black community is unknown, but
it seems plausible that, at least partially, women were excluded in the hope of
benefiting from relief grants or better school through conforming to the ob-
vious patterns in the dominant culture.[53] On the other hand, while all female

Town, 1784-1860 (New York, 1985), p. 88.

49 "Their marriages are in many instances more connexion for a short season". Census
 manuscript, Halifax, 1871, Ward 5 F-2, p. 60 [microfilm reel C10552].

50 Lebsock, Free Women of Petersburg, p. 52. For Hannah Thomas Colley, see May 1881,
 p. 85, Marriage Records, Halifax County, PANS. For Louisa Brown Bailey, see
 McKerrow, Brief History, Marriage List, 9 January 1877 and 152 Creighton St., 2 Ger-
 rish Lane, 1890 Street Ward 5, Valuation Book, RG 35 A5, PANS. For Eliza Bailey
 Thomas Ewing, see Fingard, "Race and Respectability", p. 178 and 190 Creighton St.,
 1890 Street Ward 5, Valuation Book, RG 35, A5, PANS.

51 Terrence Punch, "Petition of the Coloured Population of Hammonds Plains", The
 Nova Scotia Genealogist, V, I (1987), p. 40. Original is in RG "p" Vol. 88, doc. 8
 (microfilm), PANS.

52 Fingard, "Race and Respectability", p. 173; Morning Chronicle, 17 June 1892.

organizations were slow to develop within the African-Nova Scotian com-
munity, masculine institutional social life from the 1870s on was varied and
included the Morning Glory Lodge of the Good Templars, the African-Nova
Scotian Lodge of the Freemasons and the African Choral and Literary Asso-
ciation.[54] These African-Nova Scotian fraternal organizations parallelled
similar associations in the Protestant and Catholic Euro-American com-
munity. In the most formal aspects of public life, there was very little space
for women, regardless of race.

This contradiction between formal and informal roles was nowhere more
apparent than in the African-Nova Scotian churches. Separate spheres ideo-
logy, which emphasized the special spiritual nature of women, could easily
justify leadership positions within the church. Yet this leadership was pri-
marily informal. In his history of the African Baptist Association, Peter
McKerrow lists more women than men in church membership and praises
their contribution as "the women . . . in most of the churches, take the lead".
McKerrow, however, could not allow these words of praise to stand on their
own, and women's public position in the Nova Scotia churches was justified
by biblical precedent: "Good women are like the precious stones. Our sa-
viour found no fault with the woman who went into the city and told all
thing that ever she did. Dorcas made clothes for the poor of her community.
Priscilla, with her husband, took Apollos and instructed him more perfectly
in the way of God".[55] Thus women had a historic role in the church, but the
models presented were not the dynamic, independent and powerful women
of the Old Testament, but the more feminine servants and teachers of the
New Testament.

Like the seamstress and the teacher, the church provided women the oppor-
tunity for acceptable public roles such as Sunday School teachers, organists
and singers.[56] Women, however, were perhaps less acceptable in church poli-
tics as participants in the internal split that divided the African Baptist
Association throughout the 1870s. Rev. James Thomas noted women's invol-
vement in this split in his 1871 circular letter that read: "The Church at

53 Women of European descent in the Maritimes were active petitioners: see Gail Camp-
 bell, "Disfranchised but not Quiescent: Women Petitioners in New Brunswick in the
 Mid-19th Century", in this volume. Judith Fingard notes that in 1873 African-Nova
 Scotian mothers from Zion School petitioned the school commissioners to introduce
 sex-segregated classes: Fingard, "Race and Respectability", *p. 181.*

54 *Morning Chronicle,* 4 February 1874; Frederick Cozzens, *Acadia: or a month with the
 Blue Noses* (New York, 1877), p. 33; *Acadian Recorder,* 19 June 1879.

55 McKerrow, *Brief History of the Colored Baptists,* p. 55.

56 Minutes of the 27th African Baptist Association of Nova Scotia Convention, 1880 at
 Halifax, AUA.

Halifax stands true to her first organ and rules, with the exception of one male and 2 or 3 female: let us pray for them". Thomas then went on to note that "A number of the brethren and sisters in Preston sent a letter to the Association, stating that they were in a divided state".[57] Women were thus active in church politics even though they were generally excluded by formal structures of church government and religious leadership.[58] Minutes from various meetings of the British Methodist Episcopal Church in Nova Scotia make no specific mention of women except in a motion of appreciation to the hosting clergyman "and lady" and as the subject in a charge of seduction against an Amherst clergyman.[59] Similarly, the African Baptist Association of Nova Scotia met for 37 years before its first female delegate attended the 1891 convention.[60] The following year three women were among the delegates, including Louisa Bailey and sisters Cooper and Fletcher.

The position of women within the local Baptist church had a dramatic boost in 1903 with the arrival of Rev. B.B.B. Johnson at the Cornwallis Street Church. Johnson himself was probably not unlike other American clergy who had brief sojourn in Nova Scotia, except for one unique asset — his wife was ordained. The presence of Mrs. M.E. Johnson, temporarily at least, changed the face of public worship at the 1903 convention at East Preston. Mrs. Johnson led the convention in two prayers and joined in a temperance sermon.[61] In 1904 she perhaps unintentionally violated Nova Scotia law when she married Edward Wilson and Sophia Smith at Preston.[62] With this exception, Mrs. Rev. Johnson appears to have spent much more time with the children in Sunday School than publicly preaching the gospel.[63]

57 Minutes of the 18th African Baptist Association of Nova Scotia Convention, 1871 at Hammonds Plains, AUA.
58 Like Euro-American women in Nova Scotia, African-Nova Scotian women in the 1790s had been important lay preachers and religious leaders. James W. St. G. Walker, *The Black Loyalists*; George Rawlyk, *Ravished by the Spirit: Religious Revivals, Baptists and Henry Alline* (Montreal-Kingston, 1984), p. 82.
59 *Minutes of the Three Annual Conferences of the British Methodist Episcopal Church, Nova Scotia - At Liverpool July 18th to 22nd, 1884.* (Chatham, Ontario 1884), p 41, Arnett Papers, Wilberforce University, Wilberforce, Ohio, pp. 58, 101; Nova Scotia District: 31 July 1868; 2 June 1877; 18-26 May 1878; 15-19 May 1879; 7-10 May 1880; 8-11 July 1881; 18-22 July 1884.
60 Pachai, *Beneath the Clouds*, Vol. II, p. 78; Pearleen Oliver, *Brief History of the Colored Baptists of Nova Scotia, 1782-1953* (Halifax, 1953).
61 Minutes of the 50th African Baptist Association of Nova Scotia Convention, 1903 at East Preston, AUA.
62 Register, Halifax County 1904, p. 99, No. 301, PANS. The Nova Scotia Marriage Act stated that weddings could be conducted only by men: *Revised Statutes of Nova Scotia,1900*, Vol. 2, Ch. 111, Sn. 3, p. 220.

Mrs. Johnson was not the only woman to publicly speak to the African Baptist assembly. Lay leadership was frequently female and included the Nova Scotia-born Louisa Bailey. Bailey's church interests were originally directed in the area of foreign missions but later shifted to local mission fields and temperance. By the late 1880s, Louisa Bailey was twice widowed and had connections to important families in the Baptist Church.[64] She was relatively financially secure, owning property on Creighton Street and Gerrish Lane and working successively as a dressmaker, variety and second-hand shopkeeper, and finally as a herbalist from a store-front on Gottingen Street.[65] At the 1885 Baptist convention, Bailey was among the three women who addressed the meeting on temperance. According to McKerrow she "spoke admirable on the question at issue, showing the great influence that women have either for good or evil". Again, the influence of the separate spheres ideology, that women had a special role in promoting morality, was obvious in McKerrow's conclusion that "If Christian women would nobly stand up against the drink traffic wherever they go, they will be using an influence the greatness of which eternity alone will reveal, and a just recompense will be their reward".[66] In 1892 Bailey, one of the first female delegates to attend any convention, again "spoke with much force" on the important issue of temperance.[67] Her addresses to the various Baptist conventions thereafter were regular as she continued her involvement in temperance, home mission and local church operations.[68] Although there was no formal organization for home mission work, Louisa Bailey together with Charlotte Grosse of Beech Hill "gave verbal statements of work performed by them at Beech Hill and adjoining settlements". The work of Bailey and Grosse was recognized in the church's mission report and by the Africville congregation who also were touched by their hard work.[69] Whether Louisa Bailey herself upheld the ide-

63 Minutes of the 50th African Baptist Association of Nova Scotia Convention, 1903 at East Preston, p. 18, AUA

64 Louisa Brown Bailey was widow of Rev Alexander Bailey - a supporter of Rev James Thomas in the religious rivalry that split the African Baptist Church and trusted friend of James Thomas as witness to his will. In addition Bailey was step-mother of John Robinson Thomas' wife, cared for two of the Thomas grandchildren and shared her house in 1871 with one of Thomas' future sons-in-law, William Johnston.

65 RG 35-102 A #5 1890 Street Ward 5 Valuation Book, PANS; *Halifax City Directory*, 1881, 1885, 1896.

66 Minutes of the 32nd African Baptist Association of Nova Scotia Convention, 1885 at Cornwallis, AUA.

67 Minutes of the 39th African Baptist Association of Nova Scotia Convention, 1892 at Dartmouth Lake Church, p. 6, AUA.

68 Minutes of the 42nd African Baptist Association of Nova Scotia Convention, 1895, AUA.

ology of separate spheres and a limited public role for women is difficult to determine. Certainly her private life was full. After her husband's death Bailey had the responsibility for her successive businesses, an aging mother and two step-grandchildren. Similarly, her colleague in home missions, Charlotte Grosse, was able to combine active leadership outside the house with the responsibility for seven children who in the 1881 census were between the ages of less than a year and 13.[70] As for white working-class women who joined the Salvation Army, religious work provided a legitimate justification for moving beyond the domestic sphere,[71] and we must surmise that both Bailey and Grosse crossed boundaries that defined the proper place for women. At the same time, Louisa Bailey at least appears to have been cautious and aware of the potential conflict in her public leadership. At the 1907 convention, as a woman who was probably approaching her seventies, "She told how much can be done in a quiet way to advance God's Kingdom upon earth by sisters as well as brothers".[72] If Louisa Bailey actually used the phrase "quiet way" to convey the idea that the public actions of women were not completely acceptable, and this description was not the opinion of the convention secretary, the delicate balance between public and private roles for women was acknowledged.

The presence of remarkable women in "quiet" but vital leadership positions may explain why women's groups within the church were slow to develop. As early as 1883, Peter McKerrow began his campaign for the establishment of female home missionary societies in every congregation as "their labors are generally more successful than the males".[73] No action followed this call and again in 1903 an equally unsuccessful motion was presented by the "Reverend Sister Johnson". Thereafter, nothing formal was established

69 Minutes of the 50th African Baptist Association of Nova Scotia Convention, 1903, at East Preston, pp. 15, 20, AUA. The spellings Grosse and Grouse are both used.

70 It appears that a a poem by Louisa Bailey about her mother was included in McKerrow's history of the African Baptist Church. The poem is signed only L.A. Bailey. Bailey married for a third time sometime between 1907 and her death in 1911. *Herald*, 30 December 1911, *Acadian Recorder*, 30 December 1911. In Allison *et al.*, *Traditional Lifetime Stories*, Vol. II, Deacon Reginald Hamilton noted the importance of his grandmother Charlotte Grouse, p. 50.

71 Lynne Marks, "Working-Class Femininity and the Salvation Army: Hallelujah Lasses in English Canada, 1882-1892", in Veronica Strong-Boag and Anita Clair Fellman, eds., *Rethinking Canada: The Promise of Women's History* (Toronto, 1991), p. 198.

72 Minutes of the 54th African Baptist Association of Nova Scotia Convention, 1907, p. 4, AUA.

73 Minutes of the 30th African Baptist Association of Nova Scotia Convention, 1883 at Weymouth, AUA.

for ten years until the creation of the Women's Missionary Society in 1913 and the Ladies' Auxiliary in 1917.[74] Quasi-women's groups had emerged in the 1890s, such as the Pastor Aid Society at the Cornwallis Street Church with Louisa Bailey as president and Mary Eliza McKerrow as vice-president. This was not a formal women's group, for although most of the executive appears to have been women, the important position of secretary was held by Peter McKerrow himself.[75] The appearance of largely women's groups with perhaps a token man was also characteristic of white women's organizations in the city.[76] Female church organization developed very late among the African-Nova Scotian women, largely because women were not fulfilling an auxiliary role but were at the centre of financial and spiritual leadership. While women such as Louisa Bailey and Charlotte Grosse stand out, less prominent women also played a crucial role. Access to paid employment meant that to a limited extent women were also able, if they so chose, to financially support their church. This financial contribution by women was impressive in the 1903 list of church members who had paid their annual tax. At the Cornwallis Street Church, 11 couples were listed, along with nine men and 16 single women. This pattern of extraordinary support from single women was repeated in the rural areas such as Beech Hill where two single men are listed beside nine women.[77]

The churches acted as both a space for women to provide financial and spiritual leadership and a buttress for those in the community who upheld a belief in separate spheres. The church also provided a haven where public behaviour was almost safe from ridicule.[78] The acceptable way for women to be strong and have an identity outside the home was spiritually. Therefore when Hammonds Plains native Caroline David died in 1903 she was described as a

74 Oliver, *A Brief History of Colored Baptists*. In 1915 a similar organization called the Daughters of Zion was in operation at the Halifax Methodist Church. *Halifax Herald*, 1 March 1915.

75 Minutes of the 39th African Baptist Association of Nova Scotia Convention, 1892 at Halifax, p. 10, AUA.

76 E.R. Forbes, "Battles in Another War: Edith Archibald and the Halifax Feminist Movement", *Challenging the Regional Stereotype: Essays on the 20th Century Maritimes* (Fredericton, 1989), p. 81.

77 Harley, "For the Good of Family", p. 348: Minutes of the 50th African Baptist Association of Nova Scotia Convention, 1903 at East Preston, p. 12, AUA.

78 African-Nova Scotian men were also vulnerable to ridicule. Rev. James Thomas in his 1877 circular letter commented on visitors to the convention "the strangers who had flocked from the city, and neighbouring districts; . . . some to worship others to mock and criticize": Minutes of the 24th African Baptist Association of Nova Scotia Convention, 1877, Hammonds Plains, AUA.

"kind mother, a loving wife and a true child of God".[79] Similarly, Viola Parsons remembered stories of her great- grandmother Sarah Anderson, probably born in the 1830s. Parsons was told that her great-grandfather "was an easy going man, but [great-grand] Ma was strong, courageous and a hard worker. She didn't have any fear because she was filled with the Holy Spirit".[80] This hard worker was widowed with ten children in 1871 and operated one of the most productive farms in Hammonds Plains. African-Nova Scotian women, who were often the object of ridicule had few occasions to be presented with dignity in the white press. Yet a description of a large baptism at Africville in 1874 conceded that "the white robes of the lady converts presented quite a pleasing appearance".[81] In a specific religious moment, even the racist press could briefly see African-Nova Scotian women as ladies.

The ideological construction of separate spheres had meaning to African-Nova Scotian women, but it could not be taken at face value. The ideal of separate spheres, with its emphasis on supposedly broad-based unique characteristics, was based on the experience of middle-class Euro-American women. When these women categorized and classified black women, the veneer of sisterhood did not stand up, and separate spheres became a tool of racism to exclude women who were different. Euro-American men and women who professed a belief in separate spheres worked to ensure that gender was not to be the only primary division within society. Common links that existed between black and white working-class women and all women tied to rural subsistence production were not recognized. Separation of productive and reproductive work in most rural subsistence households was a fiction, and the segregation of work and home was equally unlikely in the city. The public lives of African-Nova Scotian women were marked by an informality and a corresponding vulnerability, which occurred in the context of a lively informal economy and lay leadership positions in the church. Gender ideology that placed women in the home offered protection and dignity within their own community, even if it could not secure recognition from the white middle class. While the ideology of separate spheres could be usefully adopted to respond to the particular needs of African-Nova Scotian women it also made them susceptible to a powerful combination of racism and sexism.

79 Minutes of the 50th African Baptist Association of Nova Scotia Convention, 1903 at East Preston, AUA.
80 Parsons, *My Grandmother's Days*, p. 18.
81 *Morning Chronicle,* 1 June 1874.

THE PREVENTION OF CRUELTY, MARRIAGE BREAKDOWN AND THE RIGHTS OF WIVES IN NOVA SCOTIA, 1880-1900

JUDITH FINGARD

Domestic violence has attracted considerable historical interest recently as a result of contemporary concern over wife and child abuse, the gender bias of the legal system and the tendency of governments to undervalue rescue shelters for women and their children. In keeping with present day horrors, court records and daily newspapers of the Victorian period revealed sensational cases of battered wives and neglected children. Moreover, male brutality seems to have produced the same public outrage in the late 19th as in the late 20th century. While we still do not know what the connection was between heightened awareness of family conflict and its frequency, patriarchal aggression was certainly perceived to be related to the impact of industrialization on power relations within marriage. At the same time, the evidence that male drinking habits contributed to men's violent behaviour reinforced middle-class reformist interest in temperance as a social policy. Since female activists were in the vanguard of the temperance crusade, the plight of long-suffering wives and children also became a concern of the women's rights movement.[1]

1 Judith A. Allen, *Sex & Secrets: Crimes involving Australian Women since 1880* (Oxford, 1990), ch. II; Linda Gordon, *Heroes of Their Own Lives: The Politics and History of Family Violence, Boston 1880-1960* (New York, 1988), and "A Right Not to be Beaten: The Agency of Battered Women, 1880-1960", in Dorothy O. Helly and Susan M. Reverby, eds., *Gendered Domains: Rethinking Public and Private in Women's History: Essays from the 7th Berkshire Conference on the History of Women* (Ithaca, 1992), pp. 228-43; Kathryn Harvey, "To Love, Honour and Obey: Wife-Battering in Working-Class Montreal, 1869-79", *Urban History Review/Revue d'histoire urbaine*, XIX, 2 (October 1990), pp. 128-40; Elizabeth Pleck, "Feminist Responses to 'Crimes against Women', 1868-1896", *Signs: Journal of Women in Culture and Society*, 8, 3 (Spring 1983), pp. 451-70, and *Domestic Tyranny: The Making of Social Policy against Family Violence from Colonial Times to the Present* (New York, 1987), ch. 3; Ellen Ross, "'Fierce Questions and Taunts': Married Life in Working-Class London, 1870-1914", *Feminist Studies*, 8, 3 (Fall 1982), pp. 575-602; Nancy Tomes, "A 'Torrent of Abuse': Crimes of Violence between Working-Class Men and Women in London, 1840-1875", *Journal of Social History*, II, 3 (Spring 1978), pp. 328-45. A useful review of the literature on the contemporary problems is Wini Breines and Linda Gordon, "The New Scholarship on Family Violence", *Signs: Journal of Women in Culture and Society*, 8, 3

The new visibility of domestic violence in the 19th century can be attributed, at least in part, to the advocates of the anti-cruelty movement who added human beings to their agenda once their right to protect animals had been established. As a result of the re-orientation of the movement, abused women were provided with opportunities to seek assistance and to assert their rights. Without the resort by women to anti-cruelty societies many of their trials and tribulations would probably have gone unnoticed since their earlier options had been either to suffer in silence in the privacy of the home or to take the great risk of charging the culprit in the public forum of the court. Such organizations as the Society for the Protection of Women and Children from Aggravated Assaults (London, 1857), the Massachusetts Society for the Prevention of Cruelty to Children (Boston, 1878), the Society for the Protection of Women and Children (Montreal, 1881) and the Protective Agency for Women and Children (Chicago, 1885) identified domestic violence as a common characteristic of Victorian marriages and frequently responded to instances of wife abuse. Violence, which had long been regarded as a private affair, now had its public opponents.[2]

Nova Scotians, especially residents of Halifax, were also caught up in the activities of the anti-cruelty movement as a result of the establishment in 1876 of the Nova Scotia Society for the Prevention of Cruelty (SPC), an animal protection society which extended its attention to humans in 1880. Since the specifics of time and place are important in establishing both the distinct and common features of social initiatives, the Nova Scotia society provides a useful case study. The prime function of the SPC between 1880 and 1900 was the provision of marriage counselling and legal aid for estranged couples and harassed spouses, usually at the instigation of the wife. Violence was certainly commonly reported but the victims often chose to downplay it in favour of a more materialist approach to their unhappy marriages. Their agency was more noticeable than the society's intervention. In most cases the problems faced by women and girls took them personally to the SPC. In the case-book

(Spring 1983), pp. 490-531.

2 On the London society, see George K. Behlmer, *Child Abuse and Moral Reform in England, 1870-1908* (Stanford, 1982), p. 59, and Margaret May, "'Violence in the Family': An Historical Perspective", in J.P. Martin, ed., *Violence and the Family* (Chichester, 1978), pp. 145-6. On the Boston society, see Gordon, *Heroes of Their Own Lives*. The minutes of the Montreal Society for the Protection of Women and Children can be consulted at the National Archives of Canada. On the Chicago society see Elizabeth Pleck, *Domestic Tyranny*, ch. 5. On the historical as well as contemporary connection between cultural feminism and animal protection, see Josephine Donovan, "Animal Rights and Feminist Theory", *Signs: Journal of Women in Culture and Society*, 15, 2 (Winter 1990), pp. 350-75.

for 1897, for example, only 30 per cent of the cases relating to females were initiated by third parties; in 1900, with three agents active in Halifax instead of one, and an increasing number across the province, the percentage of outside interveners in female cases had risen to 42.5, still a distinct minority.[3] This was not unique to Nova Scotia. Linda Gordon has found that 60 per cent of the complaints of known origin made to the turn-of-the-century Massachusetts Society for the Prevention of Cruelty to Children came from family members, the great majority women and children. North American judges, police and welfare agents were not therefore setting the wives' agenda, as A.J. Hammerton claims they were doing in Britain.[4]

Unlike many of the complaints which came to the attention of the societies in the large industrial cities, those in Nova Scotia were as likely to come from women whose husbands were soldiers or sailors as they were from those married to craftsmen or factory workers. Although evidence of the stress involved in the transition from handicraft production to mechanization is reflected in the frequency of cases involving husbands who were bakers,[5] and shoemakers,[6] just as prominent in the complaints of women was the husband's absence from home on military service, at sea, or in migrant labour. Furthermore, reputedly abusive or neglectful husbands included not only members of the working class but also representatives of management,

3 Most of the research for this paper is based on evidence in the papers of the Nova Scotia Society for the Prevention of Cruelty (SPC) deposited in the Public Archives of Nova Scotia. Since the records are incomplete, even for the 20 years featured in this paper, systematic analysis of the characteristics of the cases is impossible. I have used 1897 (MG 20, vol. 514) and 1900 (MG 20, vol. 515, nos. 1 and 2) as focal years for some limited analysis. John Naylor was the Halifax agent between the formation of the society as an animal protection society in 1876 and his resignation in 1899, hence my interest in comparing two years under different regimes. Case material for the early 20th century is spotty and encompasses only September 1908-August 1911. The runs of daily journals and case books, useful for trying to capture the "voices" of the female clients include the years 1884-85, 1887-89, 1892-1901, with incomplete material for 1889, 1898, 1899, 1901. On Naylor, see Fingard, *The Dark Side of Life in Victorian Halifax* (Halifax, 1989), ch. 8.

4 Linda Gordon, "Feminism and Social Control: The Case of Child Abuse and Neglect", in J. Mitchell and A. Oakley, eds., *What is Feminism?* (Oxford, 1986), p. 80; A. James Hammerton, "The Targets of 'Rough Music': Respectability and Domestic Violence in Victorian England", *Gender & History*, 3, 1 (Spring 1991), p. 39.

5 SPC, MG 20, vol. 516, no. 5, entry for 10 December 1884; no. 6, entry for 13 July 1885; no. 7, entry for 26 October 1887; no. 9, entry for 21 March 1889; MG 20, vol. 513, entries for 15 June 1892, 30 January 1893, 10 April 1895.

6 SPC, MG 20, vol. 516, no. 5, entries for 22 April, 13 May, 28 June 1884; no. 6, entry for 20 June 1885; no. 8, entry for 28 January 1888; no. 9, entries for 19 February, 6 August 1889; MG 20, vol. 513, entries for 23 March 1892, 4 January 189[3].

the law and the church,[7] as well as the most respectable members of the black "elite".[8] The society shunned most cases involving middle-class women not because of the widely held view that violence was a proletarian vice but because it confined its mission to helpless individuals who were invariably identified as poor and therefore unable to seek redress through other means.

Despite the interest of Halifax women in temperance, feminism played a minor and indirect role in shaping the SPC's activities. The ubiquitous ladies' auxiliary was formed which helped to finance the society's work but it was an on-again, off-again operation.[9] With a small middle-class population, the city's resources were stretched across a host of causes in imitation of a larger urban setting. By the 1880s temperance, prostitute rescue and prevention, and child welfare had captured the attention of the activist wives and daughters of merchants and professionals. Moreover, since the SPC was ably managed for most of its first quarter-century, it did not display the same need for the scarce human resources that other causes did. Indeed it could be argued that John Naylor, the agent, and his male supporters pre-empted women's initiative in this area. They relied on women — both lay and religious — to care for rescued or relinquished children in the existing institutions but even then the initiative flowed from the SPC to the managers of the homes and orphanages, not in the reverse direction. Timing may also have contributed to the relative female neglect of domestic disharmony. The SPC made its debut over a decade before such feminists as Edith Archibald and Eliza Ritchie arrived on the scene. By the time the society engaged the services of a woman for the first time in 1900, Bessie Egan's participation in women's organizational life in Halifax provided her with sympathetic but still relatively passive supporters.[10]

7 SPC, MG 20, vol. 516, no. 5, entries for 31 March, 18 September, 23 October 1884; no. 8, entry for 21 August 1888; MG 20, vol. 514, entry for 5 August 1896; MG 20, vol. 516, no. 3, Naylor to Smith, 1 April 1889.

8 SPC, MG 20, vol. 516, no. 7, entries for 30, 31 December 1887, 3 January 1888; MG 20, vol. 513, entry for 21 March 1894; Judith Fingard, "Race and Respectability in Victorian Halifax", *Journal of Imperial and Commonwealth History*, 20, 2 (May 1992), p. 187.

9 SPC, extracts from *Evening Mail*, 19 March 1881, and *Citizen*, 28 April 1881, MG 20, vol. 519, no. 1; Naylor to Wetmore, 5 March 1885, MG 20, vol. 516, no. 3, Naylor to Fairbanks, 16 January 1889, MG 20, vol. 516, no. 3, and Naylor to Mackintosh, 3 September 1891, MG 20, vol. 516, no. 4.

10 SPC, Minutes, 10 August 1900, 5 May 1904, MG 20, vol. 517, no. 1. See Ernest R. Forbes, "Battles in Another War: Edith Archibald and the Halifax Feminist Movement", in his *Challenging the Regional Stereotype: Essays on the 20th Century Maritimes* (Fredericton, 1989), pp. 67-89.

The explanation for the continued fastidiousness of Halifax's matrons is not a lack of interest in the anti-cruelty movement *per se*. Indeed they displayed a great interest in the animal protection work of the SPC. They were keen to teach humane sentiments to school children through the establishment of bands of mercy, an ambience which produced an animal rights novelist in Margaret Marshall Saunders. Their failure to extend their concern to abused wives lies partly in their milieu. In a small, still relatively close-knit community where progressive ideas caught on slowly, intervention in matrimonial matters was too radical a step for the wives and daughters of the respectable middle class. As Margaret Hunt has recently argued, the privatization of middle-class family violence rendered it "unspeakable" and condemned its witnesses to silence. That silence prevailed among female activists in Halifax.[11]

If the role of middle-class women in the SPC was problematic, that of the female clients was not. By virtue of their assertiveness, they emerged as the champions of women's rights. These women, often middle-aged or older, with long experience of family crisis, sought state sanction through the aegis of the Society for the Prevention of Cruelty for the reprimand of their husbands or the dissolution of their marriages. Elizabeth Walsh was 62 years old in 1885 when she reported her husband for failing to contribute to her support for 20 years.[12] In 1887 Emma Carvery had been married for 21 years and had ten children when she reported her husband Alexander to the SPC for turning them out of the house.[13] Mary Ann Brokenshire, mother of six, had been married 29 years when her husband Joseph assaulted her by kicking her in the chest.[14] Similarly, Jane Fisher had been married to Alexander for 23 years and had seven children when he started to beat her.[15] After 24 years of marriage, Jane DeWolfe, bruised and lame through battering by her husband, finally decided that "she cannot put up with it any longer."[16] When a third party did report the case, it was often the mother and occasionally the mother-in-law or the daughter of the woman at risk, a type of cross-generational female solidarity far more prevalent than cross-class contact.[17]

11 Margaret Hunt, "Wife Beating, Domesticity and Women's Independence in Eighteenth-Century London", *Gender & History*, 4, 1 (Spring 1992), pp. 10-33.
12 SPC, MG 20, vol. 516, no. 6, entry for 20 January 1885.
13 SPC, MG 20, vol. 516, no. 7, entry for 27 October 1887.
14 SPC, MG 20, vol. 516, no. 8, entry for 6 January 1888.
15 SPC, MG 20, vol. 516, no. 8, entry for 26 May 1888.
16 SPC, MG 20, vol. 513, entry for 6 December 1894.
17 SPC, MG 20, vol. 516, no. 9, entries for 30 April, 9 May 1889; MG 20, vol. 513, entries for 17 October, 23 November 1892, 9 January, 13 February 1893, 18 October 1894, 12 July 1895.

While the defining characteristics of the anti-cruelty movement in Nova Scotia might have had some distinctive features, the identity, problems and perceptions of endangered women were not unique. The strategies they adopted when trapped in unsatisfactory marriages resembled those found elsewhere. These included not only women's active agency on their own behalf but also wives' reluctance to prosecute their husbands and their overwhelming desire for separation and maintenance agreements. In order to explore the dimensions of women's resistance and resilience as revealed in the SPC records this discussion will focus on the nature of the marital problems which were reported to the society, the ways women interpreted male misbehaviour, the remedies sought by wife-complainants, and the limitations of the law. Since the SPC records were confidential — only rarely did the press get hold of and report the identity of SPC clients — they provide candid accounts. They are tantalizingly brief and often incomplete but the matter-of-fact and often apparently verbatim language employed by the agent suggests that the stories may have been typical rather than exceptional. They describe the marital problems of Catholics and Protestants, blacks and whites, new Canadians and the native born.

Most problems which married women encountered and reported to the SPC fell into one of two categories. One was lack of financial support from the husband for the wife and children. Nineteen of the 68 cases involving females, primarily mothers, recorded in the Society's records in 1897 were for non-support. In 1900, 34 of the 119 female-centred cases fell into this category. In each of these two years the non-support cases constituted the single largest category of female cases. Although physical mistreatment frequently accompanied non-support complaints, women seem to have put up with black eyes and bruises as long as they received their share of the husband's wages. It was not brutality which precipitated family crisis. In the case of Emma Smith, it was a lack of support which caused the violence: husband John, who had been shunning work in favour of drinking and card playing, struck her "because she spoke to him about his wages".[18] When women claimed that they had been mistreated by their husbands for years, it was more than a sudden burst of confidence that occasioned their complaints. Janet Isner, a butcher's wife, reported in 1891, after her husband "had struck her on the head with the rung of a chair and kicked her", that he had been

18 SPC, MG 20, vol. 514, entry for 28 October 1896. Ellen Ross agrees it was not violence but "threats of murder, physical attacks on children (very rare according to all observers), refusal to provide income, and sexual insult": "'Fierce Questions and Taunts'", p. 593.

mistreating her for eight of their ten years of marriage.[19] In 1892 when Jane Pollard, wife of a blacksmith, displayed two of the worst black eyes the SPC agent had ever seen, she stressed that her husband had been "brutally illtreating her for years".[20] The concentration of much of the domestic violence on Saturdays confirms the fundamental struggle over the husband's pay packet as the cause for complaints.[21]

In many cases of insufficient support, the wife was accustomed to supplementing the husband's earnings through the sale of her own labour. When such women complained, they usually cited such factors as the husband's unwillingness to work, his inability to work because of a severe drinking habit or his desertion of the family. The 1888 annual report of the SPC summarizes, probably with some embellishment, the problem of one working woman who had to clean houses all day in order to meet her lazy husband's demands for money: "His custom was . . . to go out and do some small job whereby he would get 25 cents, with which he would buy a flask of whiskey, and get a volume of light literature from the Circulating Library and then go home, lie down on the bed, read the book and drink the whiskey until he fell asleep. By the time his wife came home from work he was ready for another flask". He would not even look after his child while his wife worked. She had to employ a neighbour.[22] In February 1889, the SPC agent fortuitously witnessed the expulsion of a young mother and her very sick baby from their home by the husband, an erstwhile baker who had been on a four-month drunken binge. The family was supported by the wife, who dealt in secondhand clothes.[23] Cassie Fultz, wife of Thomas, an unemployed machinist, went out to work to support her drunken husband and her three infant children.[24] Despite the fact that the problem of Mrs. Wristen's abusive and unemployed husband was traced to drinking, she tried to help out with the support of their eight children by making and selling beer. When his unemployment took him to Quebec in search of work in a tobacco factory, she fell behind with her rent and was removed against her will to the poorhouse. In

19 SPC, MG 20, vol. 513, entry for 14 September 1891.

20 SPC, MG 20, vol. 513, entry for 3 September 1892; see also entries for 8 March, 15 April, 5 December 1892.

21 For example: SPC, MG 20, vol. 516, no. 6, entries for 19 May, 21 July 1885; no. 9, entry for 12 February 1889; MG 20, vol. 513, entries for 20 February, 6 March, 19 December 1893; MG 20, vol. 514, entries for 3 August, 21 September 1896. See Ross, "'Fierce Questions and Taunts'", p. 582.

22 NSSPC, *Eleventh Annual Report* (1888), p. 19; see also, SPC, MG 20, vol. 514, entry for 16 September 1897; MG 20, vol. 515, no. 2, entry for 13 August 1900.

23 SPC, MG 20, vol. 516, no.9, entry for 2 February 1889.

24 SPC, MG 20, vol. 514, entry for 17 November 1897.

these adverse circumstances the cooperation of her older children provided her with the flexibility needed to regain the family's independence. While she joined the candy department of Moir's factory, her 15-year-old eldest son got a job in a cigar factory and her eldest daughter of 14 was given the responsibility of keeping house and caring for the younger siblings, including a baby.[25] In 1884, the SPC used the international anti-cruelty network to track down Captain Jonathan R. Anderson in New York. He had abandoned his wife and five children three years earlier and sent them only $50 in total to provide for their maintenance. The wife wore herself out with sewing at home in order to support her family and sought the assistance of the SPC only after her illness and attendant poverty brought them to the brink of starvation.[26]

The catalyst which made many a working woman take measures to end the abusive relationship was not so much violence as the husband's interference with her hard-earned wages, usually after he had squandered his own. Richard Fisher, unemployed and described as an habitual drunkard, lived on what his wife made at washing and dressmaking in the winter of 1892 until he dared to strike her and knock her down.[27] Whether they washed, sewed or cleaned, assisted at births or kept shop, wives would not countenance interference from n'er-do-well husbands with their desperate attempts to feed, clothe and house themselves and their children. Bridget McLellan, for example, deeply resented being compelled to give her drunken husband, Stewart, part of the money she earned by washing when it was needed to feed and clothe her children as well as pay the rent.[28] Martha Duggan, a successful midwife, was also subjected to financial harassment by her drunken and misogynous husband James.[29]

The second circumstance which sent women to the anti-cruelty agent was fear. After Sophia Gooley received a black eye as a result of a blow from her husband Patrick's fist, she was afraid to continue to live with him.[30] Apprehensive of the rumoured return of her cruel husband from military service in Quebec, Mary Nauffts went to the SPC for protection.[31] A fortnight's physical abuse by John McAvoy after his release from Dorchester Penitentiary convinced his fearful wife that it was time to have him arrested.[32]

25 SPC, MG 20, vol. 514, entries for 10 July, 28 October 1896.
26 SPC, MG 20, vol. 516, no. 1, copies of Naylor's letters 5, 26 December 1884, pp. 416, 417-18.
27 SPC, MG 20, vol. 513, entry for 11 April 1892.
28 SPC, MG 20, vol. 513, entry for 27 May 1892.
29 SPC, MG 20, vol. 514, entry for 9 August 1897.
30 SPC, MG 20, vol. 513, entry for 27 January 1892
31 SPC, MG 20, vol. 513, entry for 30 January 1893.
32 SPC, MG 20, vol. 513, entry for 23 February 1895.

Although intimidation was a common weapon in the husband's arsenal, women could not afford to take chances when husbands threatened to take their lives.[33] Jemima Isadore Arnold found that being married to the son of a Church of England clergyman was no guarantee of domestic felicity. In 1895, a week after her marriage to Charles Arnold, a Halifax county fisherman, the abuse began and, within two months, he threatened to kill her with a table knife.[34] Eliza Grant, a Preston matron, suffered mortification as well as fear. Her husband John terrified her by brandishing a knife, attacked her on the road where he tried to choke her, threatened to buy a pistol and shoot her, and finally intercepted her on the way to church in order to tear off her clothes and expose her "bear [sic] breasts to a number of young men".[35]

Pregnant women felt particularly vulnerable and were not willing to risk the fate of their unborn children once the threats began.[36] Other women feared the contract of venereal disease from dissolute husbands.[37] Still others feared homelessness: they had ample cause. Every bit as frequent as reports of beatings were instances of wives being thrown out or locked out of their dwellings, or the husband threatening to perpetrate this outrage.[38] Indeed the supreme pinnacle of male dominance appears to have been mastery of the hearth. Casting out the wife was a political statement in that it transferred a private affair to the street and gave the man the satisfaction of causing the woman's public humiliation.

To define the problems as either non-support or fear is not to deny other sources of anxiety and conflict. Basic incompatibility — interpreted as quick or violent temper or mutual aggravation — was recognized by complainants and society alike.[39] Not surprisingly, this problem tended to arise soon after marriage either among young couples or, more frequently, in second marriages wherein expectations had already been established by an earlier relationship.[40] Incompatibility could also turn on the tension caused by other family

33 See, for example, SPC, MG 20, vol. 513, entries for 20 August 1891, 14 March 1893, 13 December 1894, 21 October, 14 December 1895; MG 20, vol. 514, entry for 3 October 1896; MG 20, vol. 515, no. 2, entry for 14 September 1900.

34 SPC, MG 20, vol. 513, entry for 14 October 1895.

35 SPC, MG 20, vol. 513, entry for 25 July 1894.

36 SPC, MG 20, vol. 513, entry for 19 July, 4 November 1895.

37 SPC, MG 20, vol. 513, entries for 19, 26 January 1893.

38 See, for example, SPC, MG 20, vol. 513, entries for 16 January, 11 February, 12 December 1893, 23 February, 7 March, 1 June 1894; MG 20, vol. 514, entry for 22 August 1896; MG 20, vol. 515, no. 2, entry for 22 October 1900.

39 SPC, MG 20, vol. 516, no. 8, entry for 23 February 1888; MG 20, vol. 513, entries for 27 February 1892, 24 March 1893; MG 20, vol. 514, entry for 18 August 1896.

40 SPC, MG 20, vol. 513, entries for 2, 20 November 1893, 25 February 1895.

members. In second marriages step-children aggravated conjugal difficulties.[41] In other families in-laws caused disharmony.[42]

In making complaints, women undoubtedly learned to convey information that would carry the greatest weight with the SPC. But it was not just a case of telling the agent what he wanted to hear. Women's fundamental objections to elements of male culture and masculinity also helped to shape the deepening cleavage between working-class wives and husbands over appropriate behaviour. The difference of approach was particularly evident in matters of drinking habits, the circumstances surrounding physical separation, and the use of colloquial speech.

While we still do not know if men abused women because they drank or if they drank in order to abuse, drunkenness was prominent in most complaints about beating and neglect. When Kate Moore reported that her blacksmith-husband Frank had kicked her in the side and beaten her with his fist on the head, she claimed that he had "no reason for doing so, but that he was in liquor".[43] Husbands were reported to be good men when sober but brutes when they overindulged. Because many drank in order to get drunk, the deliberate dulling of the senses in order to commit an outrage on the wife seems plausible. The occasional abuse which was unrelated to intoxication reinforces the need to suggest other explanations than alcohol-related "helplessness" for male aggression, such as patriarchal pride.[44]

Men not only needed to demonstrate their dominance; they also used their power to drive their wives away. If an unsatisfactory wife could be intimidated out of the shared home, the marriage ceased to have a physical focus and the man could go his own way. Men who found marriage termination through their own desertion to be inconvenient were able to achieve the same objective by deliberately driving their wives to the limits of endurance. After James DeWolfe accused his wife of infidelity and told her to get out, she asked the SPC if she could leave him, a course which admirably suited his

41 SPC, MG 20, vol. 513, entry for 7 March 1894; MG 20, vol. 514, entry for 30 June 1896.

42 SPC, MG 20, vol. 516, no. 9, entry for 25 March 1889; MG 20, vol. 513, entries for 18, 22 August 1892; MG 20, vol. 514, entry for 13 February 1897.

43 SPC, MG 20, vol. 514, entry for 5 August 1896.

44 SPC, MG 20, vol. 513, entry for 23 March 1892; *Acadian Recorder*, 27 August 1889; on men excusing themselves on account of drunkenness, see Pat Ayers and Jan Lambertz, "Marriage Relations, Money, and Domestic Violence in Working-Class Liverpool, 1919-39", in Jane Lewis, ed., *Labour & Love: Women's Experience of Home and Family, 1850-1940* (Oxford, 1986), p. 209; on drunkenness as a convenient, conservative explanation see Ellen DuBois and Linda Gordon, "Seeking Ecstasy on the Battlefield: Danger and Pleasure in Nineteenth-Century Feminist Sexual Thought", *Feminist Studies*, 9, 1 (Spring 1983), p. 11.

plans.[45] When a woman went home to her parents or moved into her own lodgings, a man was free to pursue his other options.

On the other hand, many of the known complaints between husband and wife related to couples who no longer cohabited. In these circumstances, women looked to the SPC to force their husbands to provide support after they had removed themselves from the dangers of the husband's home. Bridget Lavers sought support from her husband for their 12-year-old son only after seven years of separation.[46] Mary Andrews lived on Bloomfield Street and her husband on Gottingen when she reported him for neglecting her and their five children.[47] Maggie McDonald went into service after she left her drunken and jealous husband and sought assistance to force him to support their child. She justified her request not on the ground of his duties as a father but by a comparison of her $8.00 a month pay with his $1.25 a day.[48] Lena Howell left her husband because of "his bad ways", taking three of their six children. Two years later he returned the other three to their mother and reduced the maintenance allowance.[49] Kate McIntyre, a shopkeeper, wanted support from her estranged husband for their 13-year-old son. His compliance was conditional on her return home, something she was unwilling to do.[50]

Separate abodes did not, however, protect wives against spousal abuse. Charles Petersen broke into his wife's house in 1893 and stole seven dollars of her hard-earned money which she had been saving to pay the rent.[51] Mary Ryan lived on the same street as her husband, who came by and subjected her to beatings, name-calling and threats.[52] Similarly, Johannah Duffield's husband, who did not live with his wife and seven children and contributed nothing towards their support, visited periodically to disturb, abuse and beat them.[53]

45 SPC, MG 20, vol. 514, entry for 11 November 1896.

46 SPC, MG 20, vol. 513, entry for 7 March 1893.

47 SPC, MG 20, vol. 513, entry for 26 August 1895.

48 SPC, MG 20, vol. 514, entry for 7 May 1896.

49 SPC, MG 20, vol. 514, entry for 3 December 1896.

50 SPC, MG 20, vol. 514, entry for 22 July 1897. Gordon stresses the irony of imposing such a condition. *Heroes of Their Own Lives*, p. 101.

51 SPC, MG 20, vol. 513, entry for 24 January 1893.

52 SPC, MG 20, vol. 513, entry for 14 December 1894.

53 SPC, MG 20, vol. 513, entry for 7 October 1895; see also MG 20, vol. 514, entry for 5 November 1896. Judith Allen, who does not appear to use any anti-cruelty papers for her Australian study, is therefore somewhat wide of the mark in her general claim that "no source of evidence recorded the extent to which violent husbands pursued and harassed estranged wives": *Sex & Scandals*, p. 49.

Of course men also deserted. In Victorian Halifax it was an occupational hazard for the wives of men engaged in soldiering, sailoring and tramping in search of work. British soldiers left the country and their families to take up new postings. Merchant seamen failed to make provision for the payment of a portion of their wages to their wives before the start of a voyage, thereby leaving their women stranded. Men left their wives and children in rural areas and went to Halifax in search of work or, by the turn of the century, Halifax men were attracted to new areas of employment such as the industrial boom town of Sydney.

The structure of the employment market in each case gave the SPC opportunities for assisting the wives. Soldiers who had been transferred out of Nova Scotia could be fairly easily traced as long as they remained in the army. John Thomas Hutton, gunner in the Royal Artillery, spent three years married to Emma in Halifax before accompanying his captain to St. Lucia for a few months in 1896 and then to England. Subsequently, the abandoned Emma Hutton was unable to secure a reply to her letter to the captain but through correspondence SPC agent Naylor tracked him down in Sheerness, Kent and discovered that Gunner Hutton had concealed his marriage from his captain. In these circumstances the captain suggested a financial solution: Mrs. Hutton could secure a court order in Halifax for a regular deduction from her husband's pay.[54]

Commercial seafaring was arguably even more detrimental to the interests of wives than was military service. Seamen were more difficult to trace, maintenance arrangements were elusive and mortality at sea was a constant threat to the welfare of the family on shore. The SPC corresponded with local shipowners in attempts to secure support for abandoned seafaring families who were left without any regular allotment.[55] While the neglect of family by some seafaring men was undoubtedly accidental, the occupation was also one which provided maximum licence for avoiding marital responsibilities. When Margaret Walsh complained in 1895 that her husband William, a seaman on

54 SPC, MG 20, vol. 514, entry for 24 November 1896. Even in cases where the husband had secured his discharge and settled into civilian life in the old country, the SPC occasionally succeeded in making contact through local magistrates in the hope that exposure, pressure and shame might produce a degree of improvement in the life of the wife left destitute in Nova Scotia. See the case of Blanche Neil, SPC, MG 20, vol. 514, entry for 4 February 1897.

55 SPC, MG 20, vol. 513, entry for 13 December 1893; MG 20, vol. 513, entry for 28 January 1892. On seafarers and family support in Britain, see Valerie Burton, "The Myth of Bachelor Jack: Masculinity, Patriarchy and Seafaring Labour", in Colin Howell and Richard J. Twomey, eds., *Jack Tar in History: Essays in the History of Maritime Life and Labour* (Fredericton, 1991), pp. 179-98.

the SS *St. Pierre,* had left port six weeks earlier without making any provision for the family's support from his monthly wages, she had to admit that he had been avoiding his financial responsibilities throughout their three-year residence in Halifax.[56] Similarly, in 1900 Joseph Fairclough's wife reported that her husband was on the point of leaving port without arranging an advance of wages for her.[57]

Although the merchant service did not provide the same ready opportunity as the army did for tracing absconding husbands, the SPC used its connections with its counterparts in other cities to find neglectful husbands. In 1895 the society contacted the SPC in Saint John on behalf of Fanny McDonald and her six children who had received only $18 during a three-year absence of their seafaring man. The secretary of the SPC in Halifax's rival city located Archibald McDonald who promised to send money for the family's support.[58]

Until the turn of the century, Halifax drew regional workers to its labour market, but the rise of Sydney produced a migration of Halifax men to try their luck in the new steel town. Frequently they left their wives and children behind, often intending to return, but in the meantime creating an increased case-load for the SPC. With the mayor of Sydney as the president of the local branch of the SPC in 1900, the Halifax society had a direct line into the town — which it used, on the complaint of wives, to locate several errant husbands who had abandoned their families on the mainland. [59]

While complaints about alcohol-related misbehaviour and desertion by husbands remained constant over the period, increasing attention to vulgar language occurred in the last years of the century.[60] During this period working-class wives came to the conclusion that profane colloquialisms were not appropriate. Perhaps their children brought notions of "proper" middle-class language home from school. Much of the emphasis on cleaning up the husband's language coincided with the early period of compulsory education

56 SPC, MG 20, vol. 513, entry for 13 November 1895.

57 SPC, MG 20, vol. 515, no. 2, entry for 10 July 1900.

58 SPC, MG 20, vol. 513, entry for 2 September 1895.

59 SPC, MG 20, vol. 515, no. 2, entries for 1, 13, 23 August, 5, 28 September, 3 October and 16 November 1900. Another Halifax man, A. Dauphinee, went off to Sydney leaving a wife and seven children without support. When he returned several weeks later, the prosecution against him was dropped on his agreement to remit $5 a week for their support. Within four months, however, the wife and the six youngest children had to be provided for in the poorhouse in the absence of adequate support. See SPC, MG 20, vol. 515, no. 2, entries for 16 November, 27 December 1900, 15 April 1901.

60 SPC, MG 20, vol. 513, entries for 5 August 1892, 9 February 1893, 26 December 1894; MG 20, vol. 514, entry for 30 October 1896.

which was phased in after 1888. Education and improvement of both language and behaviour were essential ingredients in the emergent notions of respectability. Children needed appropriate models at home as well as in school. When women complained about their husbands' filthy or blasphemous language, they often did so as a way of protecting the innocence of their children. One of Ruth Marks' numerous complaints against her husband Henry was that he set "an evil example to his children by the obscene language he uses".[61]

Conflict over other aspects of child-rearing also led to blows. A woman incurred her husband's graphic disapproval if she sought to protect her children against his mistreatment. In the case of the Barrett family, where the husband denied his wife's allegations of beatings, it transpired that a strong difference of opinion existed over the conduct of their 16-year-old daughter. James Barrett, a truckman, objected to Annie permitting their daughter to go out at night with "young fellows above her in social position".[62] When Emma Carvery, her face badly cut, accused her husband Alexander of beating her, he claimed that the trouble arose over the issue of who should chastise the children. She responded that it was not the chastising that bothered her but chastising administered when Alexander was drunk.[63] When Emma McGrath reported her husband Timothy for abuse, she claimed that the beating occurred because she had tried to protect her three-year-old crippled son against her husband's wrath.[64] Women sometimes resorted to physical separation in order to shield their children from their fathers. Elizabeth Burns had her two sons of seven and ten admitted to the Protestant Orphanage as boarders because they were neglected by their father. [65] In 1901, one year after she first complained of neglect, the wife of Daniel Bowers rescued her two children from the mistreatment of their father by removing them from Halifax to her home in Pictou with the blessing of the SPC. The society knew that custody law, which had always protected the father's rights to possession of his children, now favoured the mother in such circumstances.[66]

61 SPC, MG 20, vol. 515, no. 1, entry for 19 February 1900; also MG 20, vol. 514, entry for 8 July, 10, 11 August 1897.
62 SPC, MG 20, vol. 516, no. 8, entry for 9 July 1888.
63 *Acadian Recorder*, 19 June 1889.
64 SPC, MG 20, vol. 514, entry for 29 March 1897.
65 SPC, MG 20, vol. 515, no. 2, entries for 2 May, 9 July 1900. See also the case of Victoria Middleton, SPC, MG 20, vol. 514, entries for 12 October 1896, 21 July 1897.
66 SPC, MG 20, vol. 515, no. 2, entries for 12 May 1900, 22 April 1901. For the attitude of the divorce court, see Rebecca Veinott, "Child Custody and Divorce: A Nova Scotia Study, 1866-1910", in Philip Girard and Jim Phillips, eds., *Essays in the History of*

Given the nature of SPC prudery, sexual explanations for marriage breakdown were not often recorded. Mrs. Cosy complained that her husband was not properly made in the private parts, Mrs. Richard Smith claimed that her husband wanted her to "go" with other men as a way of supporting him, Mrs. Linnahan told "a bad story about her husband and his daughter", and Rose Doyle reported that her husband Augustine not only "goes with other women" but was also "diseased".[67] A number of wives were offended when their husbands spent their time or their wages on other women.[68] The case-books commonly report the wife's claim to be "ill-used". Although it may have been a synonym for physical mistreatment, this term was often cited in conjunction with references to abuse or beating. In some cases it might therefore have been the agent's euphemism for marital rape.

Whatever their particular complaint, women did not seek help from the SPC without knowing what they wanted. Few wives were anxious to prosecute their husbands, especially if their aim was to secure support from them. For every court case, six or more cases were resolved out of court. In the years 1897 and 1900, for example, 28 of the 187 cases relating to women and girls resulted in prosecutions. In only a tiny minority of the prosecutions were imprisonment or fines imposed. Even the infrequent court cases were likely to be a culmination of a long, unpublicized struggle by the woman for the recognition of her rights.

Wife-complainants tended to pursue three possible solutions, often consecutively. The first was to convince the husband of an error on his part and make him apologize and promise to do better. A cautionary letter from the SPC, followed by an interview, was the usual method of achieving this. In some cases both husband and wife appeared together and the agent tried to reconcile their differences. The purpose of this preliminary intervention was to give the husband a good fright as well as another chance. Mrs. Henn, whose husband Maurice had a "bad" reputation as a neglectful, drunken profligate, went so far as to allow the SPC agent to take out a warrant against him in 1889 in order "to give him a fright".[69] When Maggie Nickerson's charge of beating and ill use in 1897 resulted in the arraignment of her drunken husband John, his discharge occurred only after a sound magisterial

Canadian Law, Volume III: Nova Scotia (Toronto, 1990), pp. 273-302.

67 SPC, MG 20, vol. 514, entry for 11 August 1897; vol. 516, no. 5, entry for 15 September 1884; vol. 516, no. 8, entry for 20 March 1888; vol. 516, no. 9, entry for 12 March 1889.

68 SPC, MG 20, vol. 516, no. 8, entry for 31 January 1888; MG 20, vol. 513, entry for 4 May 1892; MG 20, vol. 514, entries for 29 March, 21 July 1897; *Acadian Recorder*, 3 July 1889; Ross, "Fierce Questions and Taunts", p. 593.

69 SPC, MG 20, vol. 516, no. 9, entry for 4 February 1889.

lecture, filled with good advice.[70] The society was quite willing to comply with the wife's agenda by putting the fear of the Lord into the cruel and heartless husband.

A second solution was to take out a warrant for assault, threats or neglect with the help of the SPC agent. Once the husband was arrested, attempts were made to reach an agreement without imposing a fine or jail sentence. In part this approach was dictated by the wives' reluctance to proceed to prosecution. In fact they frequently undermined the society's intervention by refusing to testify. The two most common alternative measures were to induce the husband to take the pledge in cases where the offence was alcohol-related, and, in cases of violence or harassment, to bind the husband over to keep the peace for 12 months through the payment of one or two securities.[71] Samuel Giles committed all the sins of a bad husband, short of battery. He would not support his family, drank continually and threatened his wife's life. He was considered by the magistrate to be a suitable candidate to enter into peace bonds.[72] Impecunious husbands, however, could seldom afford to pay for the securities and ended up in jail.[73] Occasionally a harried wife actually preferred the incarceration of her husband. After enduring her husband's three-month drunken binge, Susan McDermott told the SPC she wanted him arrested and sent to jail to sober up.[74]

Pledges and peace bonds were often holding operations which provided only temporary relief. Then prosecution, with an eye to punishment, became the solution. James Ronan, a military pensioner with a wife and 11 children, was bound over to keep the peace in May 1893. By October he was again beating his wife. Clearly her options were to put up with his mistreatment or take him to court.[75] Conviction, however, raised other problems. Wives of incarcerated men feared privation. As with securities for keeping the peace, defendants could seldom afford to pay the fines, and the alternative, imprisonment, created hardship for the family. The case of the Connors family illustrates this dilemma. In September 1900 Jane Connors complained that her husband Edward would not support her. When confronted with a letter from the SPC to this effect, Connors agreed to give his wife and children $2.00 per week. When he failed to make the first payment, he was arrested but avoided prosecution by signing an agreement to make over $2.50 a week

70 SPC, MG 20, vol. 514, entry for 6 January 1897.
71 SPC, MG 20, vol. 514, entries for 9 June, 11 December 1896.
72 SPC, MG 20, vol. 515, no. 2, entry for 14 September 1900.
73 *Acadian Recorder*, 27 August, 11 September 1889.
74 SPC, MG 20, vol. 514, entry for 29 October 1896.
75 SPC, MG 20, vol. 513, entry for 3 October 1893.

to his wife. Two weeks later Mrs. Connors again reported neglect and non-support, at which point the SPC had Connors prosecuted under the vagrancy section of the Criminal Code (1892): "being able to work and thereby being able to maintain his family wilfully refuses or neglects to do so". He received the severest penalty then available: six months in the county jail at hard labour. This sentence did nothing to solve the family's economic problems, and within a fortnight Mrs. Connors had to apply to the society for charitable assistance.[76] Imprisonment also increased the chances that an angry husband, on release, would seek revenge by resorting to even more abusive behaviour.

By far the most popular solution in this period was a formal deed of separation, preferably containing maintenance provisions. The separation was the poor woman's divorce and she invested a great deal of faith in it, at least until it failed her. She used it to establish her independence, to protect herself from the interference of her erstwhile mate, and to secure the possession of her children and her property. Almost without exception separations were arranged at the wife's instigation, though the SPC certainly advised both parties to opt for a separation when no other solution seemed possible.[77] It was the preferred panacea for the full range of marital difficulties: beatings, drunkenness, forcible expulsions, threats, desertion, non-support.[78] Where there were children at home, the wife's attitude towards a separation often turned on their fate. When Margaret White reported her husband Arthur, a fireman at the hospital, for drunkenness, abuse and turning her out of the house, her main concern about a possible separation was her right to her 14-month-old child.[79] The SPC records are filled with references to separation arrangements for couples with and without children. Changes in women's rights relating to property, contracts and child custody undoubtedly encouraged the resort to separations in the last two decades of the century.[80] Unfortunately, the signed documents were not retained among the deeds and their precise contents are therefore unknown. Once executed the deeds of separation were relegated to the private sphere.

76 SPC, MG 20, vol. 515, no. 2, entries for 11 September, 4, 13 October 1900; Magistrate's Court: RG 42, Series D, vol. 38, entries for 19 September, 3, 4 October 1900; *Evening Mail*, 4 October 1900; Gordon, *Heroes of Their Own Lives*, p. 101.

77 SPC, MG 20, vol. 516, no. 3, Naylor to Baker, 29 June 1886. On the general features of legal separations see James G. Snell, *In the Shadow of the Law: Divorce in Canada 1900-1939* (Toronto, 1991), p. 167; as the solution preferred by abused wives, see Gordon, *Heroes of Their Own Lives*, p. 274.

78 SPC, MG 20, vol. 514, entries for 28 September, 27 October 1896, 11 October 1897.

79 SPC, MG 20, vol. 514, entry for 27 October 1896.

80 Philip Girard and Rebecca Veinott, "Married Women's Property Law in Nova Scotia, 1850-1910", in this volume.

Nothing illustrates the continued vulnerability of married women in this period more than the failure of the separations they so desperately sought and optimistically secured. Three cases in the winter of 1893 illustrate the problematic nature of separation agreements. Mrs. O'Malley, legally separated from Thomas, was still subjected to continual annoyance, "thereby preventing her from earning a living for herself and children".[81] Despite their two signatures on a deed of separation dated December 1891, Mary Chambers could not escape her drunken, brutish husband John. He "ignored the said deed and forced himself upon his wife, who at the time was keeping a little shop and doing well". After he sold everything in sight, she had to give up the shop and by March 1893 was "living a cat and dog life".[82] Not only did Elizabeth McLeod fail to receive one cent of the $4.00 per week allowance specified in her deed of separation, but she was also eventually forced for financial reasons to allow her husband to move back into her house — after which he resumed his physical abuse.[83] In effect, then, in the absence of adequate enforcement, legally separated women were often no better off than their sisters who simply lived apart from their husbands. If a separated woman was left unmolested, chances are it had nothing to do with the unenforceable piece of paper signed by her erstwhile husband.

As the fragility of separation agreements indicates, neither wives nor their anti-cruelty supporters could rely on the legal system to support the rights of women to lives free from male tyranny and perfidy. The punishment of husbands for severe physical abuse of their wives provides the most graphic example. In cases of extreme violence, the courts meted out ludicrously short sentences to the husband and provided no assistance to the broken and rejected wife. James Howley, for example, went to jail for 90 days in 1882-83 "for beating his wife in a horrible manner while drunk".[84] According to the *Acadian Recorder*, "Her face was a mass of bruises, both eyes were swollen and black and the right side of her face cut and disfigured. Her shoulders and arms bore the marks of many cruel blows, and . . . when she appeared against him she even then took his part, saying he was all right if it were not for the drink".[85] In this case the sentencing lagged far behind the penalty demanded by community standards. One commentator, who aired his views in the press, was outraged: "This man was awarded a most ridiculously inadequate punishment for an offence which was most decidedly an attempt to murder

81 SPC, MG 20, vol. 513, entry for 9 January 1893. Ayers and Lambertz, "Marriage Relations, Money, and Domestic Violence", p. 210.
82 SPC, MG 20, vol. 513, entry for 18 March 1893.
83 SPC, MG 20, vol. 513, entry for 28 March 1893.
84 *Morning Chronicle*, 20 December 1882.
85 *Acadian Recorder*, 19 December 1882.

— a punishment which is meted out alike to drunkards and disorderly people. Surely a man who maltreats a woman to the verge of killing her should be punished with far more rigor than the hackneyed sentence of $10 or 90 days . . . Let us suppose that Howley had paid the fine . . . In all probability he would have gone home and completed the job by killing the poor woman".[86]

A prophetic statement as it transpired: Sarah Jane Howley died suddenly on 29 October 1884. The SPC was prominently represented at the inquest, after receiving a report that Howley had battered his wife to death.[87] The evidence underscored the continued misery of Mrs. Howley's life. She often slept in the attic, two floors above her family's flat, because she was afraid of her husband's reception and was sometimes barred from entry. She diligently tended her family of four children except when she was out to work as a seamstress or quietly consoling herself with a bottle. In return her husband continuously subjected her to verbal and physical abuse. She was seldom free of black eyes. On the afternoon of 29 October her nine-year-old son saw his father beat her on the back with a chair leg. Before she expired that night, James again struck her over the back with the leg of a chair after she had collapsed on her bed. The SPC secured the support of the coroner's jury for an autopsy but it confirmed what the coroner predicted: that "death resulted from paralysis of the heart, which was probably caused by the excessive use of intoxicating liquor". Despite the society's persistent complaints no charges were laid.[88]

Five years later little had changed by way of sentencing procedures when Lillian Skein of Halifax was brutally assaulted by her husband James. He used his fists and his feet. He knocked her down with a blow to the head, broke her collar bone, kicked her repeatedly in the head, and jumped on her stomach. A combination of her struggles and his savagery meant that the hair was literally torn from her head by the roots. Lillian bled profusely and suffered great pain. According to the newspapers, she nearly died. James absconded after the attack, leaving Mrs. Skein to the care of the SPC, and it was more than three weeks before he was arraigned in magistrate's court and committed for trial. Tried under a new speedy trials act in the county court, Skein was sentenced to a mere three months in jail.[89] Although longer senten-

86 *Morning Chronicle*, 22 December 1882.
87 SPC, MG 20, vol. 516, no. 5, entry for 30 October 1884.
88 The post-mortem did not include the brain. *Morning Chronicle*, 1 November 1884; *Acadian Recorder*, 30, 31 October, 1 November 1884.
89 *Acadian Recorder*, 24 August, 16, 23 September 1889; *Morning Chronicle*, 27 August, 5 October 1889; Stipendiary Magistrate: RG 42, Series D, vol. 35, entry for 30 September 1889; Prothonotary's Office, County Court Criminal Proceedings Book, 1889-1900,

ces for assault and the use of suspended sentences to force the husband's compliance with separation agreements became common in the early years of the new century, endangered wives and their defenders continued to receive little assistance from the courts.[90]

Quite apart from these limitations, the approach of the SPC itself was not without overtones of moralizing and suspicion which sometimes worked against the interests of misused wives. Because men dominated the anti-cruelty movement, husbands were likely to be believed if they denied their wives' charges or made excuses for themselves. Mariner Donald McVicar encouraged the SPC to dismiss his wife's non-support charge by claiming that she "was drunken and worthless and had just got out of Rockhead [prison]".[91] Sometimes women made complaints against their husbands only to be told, after the society had interviewed the husband, that they were "in the wrong" or had no grounds for action.[92] Moreover, the adulterous wife was beyond the pale as far as the SPC was concerned. A number of complaints made by wives relating to expulsion from their homes and loss of their property were dismissed or disregarded because the husband or his representative claimed they had been unfaithful.[93] Thus when a woman went to the SPC to claim her rights, she confirmed her credibility by providing proof of physical violence buttressed by the support of witnesses and a "good" reputation.[94]

Although its standards were not free of male bias, the Nova Scotia SPC persisted in roundly condemning domestic violence and calling for severe punishment for abusive husbands. In no circumstances did the anti-cruelty proponents believe that the torture, suffered by countless women in the privacy of their homes, could be condoned. Even a "bad" wife must be protected against cruelty. Although Mrs. Beers was "a drunken woman and practically worthless", she was encouraged in the prosecution of her husband, Joseph, because he was "very rough and cruel to her".[95]

entry for 4 October 1889.

90 See SPC, MG 20, vol. 515, no. 3, entries for 23 September 1908, 1 September 1909. The SPC continued to be the acknowledged authority in such cases: *Acadian Recorder*, 7 December 1903.

91 SPC, MG 20, vol. 515, no. 1, entry for 24 February 1900; also MG 20, vol. 515, no. 2, entry for 23 April 1900.

92 SPC, MG 20, vol. 515, no. 2, entries for 11 April, 14 May 1900, 5 February 1901.

93 SPC, MG 20, vol. 515, no. 2, entries for 7 June, 29 December 1900, 11 November 1901.

94 SPC, MG 20, vol. 515, no. 2, entry for 10 July 1900.

95 SPC, MG 20, vol. 515, no. 2, entry for 23 August 1900; see also MG 20, vol. 515, no. 1, entries for 8, 17 January 1900. Nova Scotia was the only Canadian province which allowed cruelty as a ground for divorce. James Snell, "Marital Cruelty: Women and the Nova Scotia Divorce Court, 1900-1939", *Acadiensis*, XVIII, 1 (Autumn 1988), pp. 3-32; Kimberley Smith Maynard, "Divorce in Nova Scotia, 1750-1890", in Girard and

For the significant proportion of women who brought their own complaints to the SPC, the intervention of the society in their troubled or ineffective marriages provided a middle ground between suffering in silence and publicly proclaiming their husbands' sins in court. As the popularity of the SPC with working-class women indicates, the search for compromise, reconciliation and negotiated separations, which the SPC advocated, accorded well with the goals of most wives who were themselves singularly non-violent in their approach.[96] As we search for historical evidence of women's agency in their own lives, especially their struggle as wives to establish their rights to a decent livelihood and peaceful coexistence, we must not forget the spaces between the private and the public occupied by such organizations as the Society for the Prevention of Cruelty.

Phillips, eds., *Essays in the History of Canadian Law, Volume III: Nova Scotia*, pp. 232-72.

96 For an historical account of an abused woman in Ontario who was driven to kill her husband, see Karen Dubinsky and Franca Iacovetta, "Murder, Womanly Virtue, and Motherhood: The Case of Angelina Napolitano, 1911-1922", *Canadian Historical Review*, LXXII, 4 (December 1991), pp. 505-31; for the landmark slaying in 1982 of Billy Stafford by his battered wife, the late Jane Hurshman Corkum, see Brian Vallée, *Life with Billy* (Toronto, 1986).

THE LITERARY "NEW WOMAN" AND SOCIAL ACTIVISM IN MARITIME LITERATURE, 1880-1920

GWENDOLYN DAVIES

On 15 March 1862, a young British widow and her son allegedly sat on the deck of a ship in Bangkok harbour and mourned their "homelessness, forlornness, helplessness, mortification, indignation". "Fears and misgivings crowded and stunned me", wrote Anna Harriette Leonowens eight years later in *The English Governess at the Siamese Court*: "My tears fell thick and fast, and, weary and despairing, I closed my eyes, and tried to shut out heaven and earth".[1] Having accepted an invitation from King Mongkut of Thailand "to undertake the education" of his 67 children and many wives, Anna Leonowens could little imagine on that self-dramatized night under the stars that two books based on her Siamese experience would someday bring her fame and the admiration of Oliver Wendell Holmes, Henry Wadsworth Longfellow, Ralph Waldo Emerson and Harriet Beecher Stowe; that in 1944 Margaret Landon would immortalize her in *Anna and the King of Siam*; and that actresses as varied as Gertrude Lawrence, Irene Dunne and Deborah Kerr would bring her romanticized history to stage and screen.

All of this may seem far removed from the topic of the "New Woman" and social activism in late 19th-century Maritime Canada, but amongst the many things that Anna Leonowens could not foresee on that night in Bangkok in 1862 was a career subsequent to her five years as a governess in the Siamese court — a career that not only escalated her into authorhood and modest fame but one that also took her to Halifax, Nova Scotia, from 1876 to 1897. Here, living in the midst of a lively family of Canadian and Siamese grandchildren, she proceeded to publish three more books; travelled to Russia in 1881, allegedly on assignment for the *Youth's Companion*; helped found Halifax's Pioneer Book Club and Shakespeare Society; co-founded the Victoria School of Art and Design (now the Nova Scotia College of Art and Design, where a gallery is named in her honour); spoke out for women's suf-

1 Anna Leonowens, *The English Governess at the Siamese Court* (Singapore, 1988), p. 10. For a discussion of Anna Leonowens' life, see Leslie Smith Dow, *Anna Leonowens: A Life Beyond* The King and I (Lawrencetown Beach, 1991), and Lois K. Yorke, "Ann Harriet Emma Edwards", *Dictionary of Canadian Biography*, vol. XIV (forthcoming).

frage; participated in various social causes to better the condition of women and children; and in 1894 assisted the Countess of Aberdeen in founding a branch of the Local Council of Women in Halifax.

Anna Leonowens is only one of a number of energetic and talented literary women who challenged late 19th-century social expectations in the Maritimes by channelling their organizational, platform and writing skills into causes of social activism. Dubbed leaders by some and desecrators of women's sphere by others, they were the exponents in fiction and in fact of the New Woman, whose incursions into recreational, educational and professional life, participation in the work force and growing political influence informed countless newspaper articles and legislative debates in the 1880s and 1890s. Caricatured by detractors "as a highly objectionable feminine monstrosity, that wears bloomers, smokes cigarettes, and holds unorthodox views on the marriage question", the New Woman was seen by others "as a happy combination of sage, saint, and heroine", a force "who armed with a brand new scheme for making over the universe is going to rid our modern civilization of all the great evils with which it is now infested".[2] In both capacities, she appeared in numerous Maritime poems, novels and plays in the late 19th century as a representative of the debates informing society at the time. Challenging the "separate spheres" ideology of traditionalists and liberating the Victorian literary heroine from the bonds of domesticity, the New Woman protagonist of the 1880s and early 1890s, endorsed by writers such as Amelia Fytche and Eliza Ritchie, reflected the intellectuality and independence afforded women by new opportunities in education and the professions.

As feminist activity in the Maritimes began to shift toward maternal feminism in the late 1890s, however, so too did the tone of New Woman writing.[3] Influenced by activists in the fields of child, family, industrial and educational reform, writers such as Margaret Marshall Saunders and Sophia Almon Hensley turned to fiction, poetry and essays to dramatize the New Woman's power for social change. As with the writers of the 1880s and early 1890s, their New Woman was a bellwether figure, raising issues, exploring the relationship of women to their time and winning readers to the convictions of the author. But these convictions were rarely revolutionary in tone. Instead, evolutionary change, nurtured by maternal feminism and an astute sense of the political influence of that approach in achieving reform, seems to have

2 Eliza Ritchie, "Higher Education", *Herald* (Halifax) Woman's Extra, 10 August 1895, p. 3.
3 E.R. Forbes, "Battles in Another War: Edith Archibald and the Halifax Feminist Movement", in *Challenging the Regional Stereotype* (Fredericton, 1989). See also Michael J. Smith, "Female Reformers in Victorian Nova Scotia: Architects of a New Womanhood", M.A. thesis, Saint Mary's University, 1986.

been the avenue adopted by writers such as Saunders and Hensley. In a sense, their writing — like that of their immediate predecessors — was an act of negotiation, knitting the separate sphere to the public one in an alliance that claimed social good as much as women's rights as part of their intention.

Although the question of women's sphere may have been central to the social debates of the 1880s and 1890s, the issue had been recurring in Maritime literature for at least a hundred years. As early as the 18th century, Maritime women had turned to poetry, prose and fiction to explore issues of social and gender concern. Thus, the conflict for Mary Coy Bradley of Gagetown and Saint John in the 1780s and 1790s was between the expectations of the domestic sphere and her desire to enter public life. In her published memoir she conjectures that had she been a man, then she would not have been denied freedom to preach from the pulpit or forced to remain in a loveless marriage "bound by law to yield obedience to the requirements of my husband".[4] But economic dependence and her own religious need to rationalize rebellion as diabolically inspired militated against her actually leaving either her husband or her church. As with the "Patty Pry" letters published in the *Novascotian* from 29 June to 7 September 1826 or the novels of Mary Eliza Herbert produced in the mid-19th century, it was to be the actual act of writing — of addressing the reader and of publishing in a public venue — that enabled Bradley to subvert the confines of her narrow domestic sphere and give voice to her rebellion.

As Sidonie Smith and Julia Watson have argued in *De/Colonizing the Subject*, "For the marginalized woman, autobiographical language may serve as a coinage that purchases entry into the social and discursive economy".[5] Thus, Mary Eliza Herbert's first-person cry in her unpublished manuscript novel *Lucy Cameron* may echo simultaneously the agony of self-knowledge and the vindication of self-denial for both the unhappily married and the unmarried. Herbert's Lucy lacks education and a family structure to save her from the financial necessity of marrying without love. The result is a denial of self-worth at the same time as she implicitly condemns a society that leaves no option for an impecunious woman but a marriage of convenience:

If he were only my brother, cousin, uncle, anything else but my husband, . . . but to know that I belong to him, that I have forged, with my own hands, life-long fetters, to read in every look, in every action,

4 Mary Bradley, *A Narrative of the Life and Christian Experience of Mrs. Mary Bradley* (Boston, 1849), p. 106.

5 Sidonie Smith and Julia Watson, eds., *De/Colonizing The Subject: The Politics of Gender in Women's Autobiography* (Minneapolis, 1992), p. xix.

that, he considers me his property; one whose sole aim should be to cheer, amuse, and minister to him, a "Something dearer than his dog and nobler than his horse," ah, this is bitterness indeed.[6]

Yet Herbert — herself one of the "odd"[7] or unmarried women in a Victorian society that saw marriage as the norm — never published this work which suggested that marriage could reduce women to chattel status. Nonetheless, in a romance such as *Belinda Dalton, Or Scenes in the Life of a Halifax Belle* she revealed the vulnerability of an older, unmarried woman in the hands of a sharp lawyer, and novels such as *Emily Linwood, or, The Bow of Promise* and *Woman As She Should Be, or, Agnes Wiltshire* reveal that women with educated minds and hearts can lead spiritually fulfilling lives as teachers and church workers. In this sense, Herbert's writing in the 1850s and 1860s anticipates the appreciation for independence and dignity that was to inform New Woman writing some 30 years later, although there is nothing so overtly impassioned in Herbert's published work as the passages that appear in her unpublished *Lucy Cameron*.

Nevertheless, the appearance of the intelligent heroine in Herbert's romances caught the nuance of the age, for by the 1850s women were beginning to demand more opportunities in education in the Maritimes and to break down the stereotypes associated with them. "We are tired of the shadow, and would find the substance", noted "Fausta" in the *Christian Messenger* in 1857, as she condemned girls who "converse upon nothing else than dress, concerts, balls, the last new song, the last new novel, and when these fail to interest, recourse is had to silly games, dancing, etc".[8] Instead, she and other correspondents in the region's newspapers asked male authorities to "educate your daughters intellectually"[9] by providing institutions of learning that would cultivate their minds. The Baptists and the Methodists led the way in establishing academically sound seminaries for women, as John Reid has pointed out in "The Education of Women at Mount Allison",[10] and Irene

6 Mary Eliza Herbert, *Lucy Cameron*, Ms.2.32, Folders 13-14, Dalhousie University Archives.

7 Katherine Coombs, "Wot's awl this abaat the noo woman?", *The Studio. High Art and Low Life: The Studio and the Fin de siecle* (London: Studio International Special Centenary Number, Vol. 201, No. 1022/1023, 1993), p. 66.

8 Fausta, "Correspondence", *The Christian Messenger* (1 April 1857), pp. 92-3. Quoted in James Doyle Davison, *Alice of Grand Pré* (Wolfville, 1981), p. 49.

9 Fausta, "Female Education", *The Christian Messenger* (4 March 1857), p.61. Quoted in Davison, *Alice of Grand Pré*, p. 48.

10 John Reid, "The Education of Women at Mount Allison, 1854-1914", *Acadiensis*, XII, 2 (Spring 1983), pp. 3-33.

Elder Morton of Hantsport recalled in her memoirs in 1905 and 1912 the di-
lemma of having to choose between Sackville's Methodist Mount Allison
Ladies' Academy (founded in 1854) and the Baptists' Berwick Seminary for
Young Ladies (soon to be the Grand Pre Seminary, Wolfville, founded in
January 1861). Impressed by Alice Shaw, one of the first of six young women
to leave Nova Scotia in mid-century to study at Mount Holyoke and then re-
turn to the Maritimes to establish female seminaries on the American model,
Morton was to recall of her teachers of this period that "these were superior
women among Baptists, whose education and environments in early life led
them to hope and dream and labor to see 'A college like to man's' built for
young women in their native land".[11] In 1875, Mount Allison's awarding of
the first Canadian degree to a woman seemed to fulfil the hopes articulated
by women of all denominations and backgrounds, and Acadia, Dalhousie
and the University of New Brunswick were to follow suit by conferring de-
grees on women in 1884, 1885 and 1889 respectively.

Only four years after Dalhousie had awarded its first degree to a woman,
the difficulties that educated women would encounter in breaking out of the
separate sphere were highlighted in an entertaining if somewhat reactionary
Halifax play entitled *Culture*. Published anonymously but written by physi-
cian Dr. William Tobin, the play portrays a wife — the object of her husband's
condescension — who, in an attempt to measure up to her husband's social
expectations of her, enrols surreptitiously for a bachelor of arts degree at Dal-
housie. The play successfully contrasts Bella's traditional education in
cookery, hygiene, sewing and domestic management with the demands on
her to be an informed modern companion to her husband and a source of
pride to him in public. "Such ignorance", pontificates Henry, as he ruminates
on Bella's deficiencies, "mortifies a husband and makes him dread taking his
wife into society".[12] When Bella emerges from her secret studies at Dalhousie
with an impressive knowledge of chemistry, literature and history, and ex-
poses Henry's shallowness and pomposity, the comedy seems to have made
its point. Lamentably for the taste of the modern reader, however, the play
concludes with traditionalism triumphant when Bella agrees to abandon her
B.A. in exchange for Henry's renewed devotion to her and a trip to Paris.
Nonetheless, *Culture* highlighted for the popular taste — in a way that for-
mal essays never could — the centrality of the education issue for women.
And although man and convention won at the end of the play, woman

11 Irene Elde Morton, "Grand Pré Seminary", *The Acadia Pierian* (May 1905), p. 10 and
 "History of Acadia Seminary", manuscript, 1912, Acadia University Archives. See also
 Davison, *Alice of Grand Pré*, p. 56.

12 * * * *, *Culture*! (Halifax, 1889), p. 7.

emerged from the performance looking much cleverer, much better informed and potentially much more powerful than the opposite sex. Whether Dr. Tobin intended such an impression is difficult to deduce, but the performance of the play on 26 February 1902 at a time when maternal feminism overshadowed the education issue for women may account for the tone of the Halifax *Evening Mail's* review the next day. Praising the play's references to events of a local nature and to "the laying of sewers across the Common",[13] the commentary so manages to avoid the feminist theme of Tobin's comedy that one can only assume that the reviewer found the subject too inflammatory or too unpalatable to invite response.

However, the question of female education and independence was to be treated no less problematically in *Kerchiefs To Hunt Souls*, an 1895 novel by Amelia Fytche that highlights the spunk and ginger of the New Woman while at the same time revealing her vulnerability in a world of double standards. Education opens up new worlds for Dorothy Pembroke, enabling her to run her own school in Nova Scotia and to go abroad to teach, however penuriously. But she discovers that the education of the New Woman has not changed social attitudes toward women, especially in France, where Dorothy ventures after rejecting the overtures of her dull, pragmatic Maritime beau. Verbally fencing with her titled French admirer, the Comte de Gallerand, she tries to articulate the cultural differences surrounding women's place as she sees them:

Neither you nor any other foreigner, monsieur, can understand the position of woman in England and America to-day; she has been kept so long in the background, hedged in by rules and conventionalities, that when once a break is made, she rushes in pell-mell, carrying all, both good and bad, before her, like a mighty river overflowing its banks.[14]

In a sense, Dorothy conforms to her own description of others, rushing pell-mell into errors of judgement that teach her that female reputations are still fragile things in a male-dominated world, and that a woman's professional career can be dashed in moments with one wrong association. Fytche allows her protagonist the luxury of passion and romance in France, but the author disappoints the reader's sentimental expectations of married bliss. Analysing

13 "A Double Bill", *Evening Mail* (Halifax), 27 February 1902, p.6. I wish to thank Dr. Patrick O'Neill, Mount Saint Vincent University, for drawing my attention to this review.
14 Maria Amelia Fytche, *Kerchiefs to Hunt Souls* (Sackville, 1980 [1895]), p. 160.

at the conclusion of the novel the hard lessons that she has learned, Dorothy ruminates on the passivity and paralysis into which women are lulled by their acceptance of conventional gender and economic relations. "It seems truly as if nothing but sorrow and death will open women's eyes", she notes; "we have so long been deceived, flattered, and hoodwinked that, like the slaves, we glory in our bonds".[15] In this sense, *Kerchiefs to Hunt Souls* differs little from New Woman novels by Sarah Grand and others in Britain in the 1890s. Such works "attempted to dramatise the iniquities that in turn justified the cry for emancipation", notes Katherine Coombs: "At the same time they needed to demonstrate the sheer weight of the conventions beneath which women struggled and which, as things stood, would inevitably crush them. The New Woman surprisingly could not, and did not succeed in her pursuit of happiness".[16]

Kerchiefs To Hunt Souls is a flawed novel in its pacing and melodrama, but it is a novel of pertinent social observation in its revelation of the potential social and economic exploitation of women employed as governesses, servants and shop girls. Fytche reveals these injustices through her secondary character, Alice Jeffreys, a penniless daughter of the military who effectively conveys Fytche's comments on the self-righteous moralism of charitable foundations funded by the middle class to support ordinary working women. As Carrie MacMillan has pointed out, the similarities between the Governess' Home in Fytche's novel and comparable institutions in contemporary Halifax or New York were not lost on contemporary or modern readers.[17] Social injustice demands social action, Fytche seems to be suggesting through Jeffreys, who, discouraged by poverty and patronized by Church of England charity, yearns for empowerment through political action:

> If I had enough money, I'd start tomorrow on a crusade to working-women; nothing can be done without organization. If we could only hang together we could carry the world. It's this distrust of each other that does the mischief. How can we expect the men to fight for us?[18]

Fytche's note of asperity is echoed by other educated women of the period, particularly those who found that education may have opened professional

15 Fytche, *Kerchiefs to Hunt Souls*, pp. 289-90.
16 Coombs, "Wot's awl this abaat the noo woman?", p. 70.
17 Carrie MacMillan in Fytche, *Kerchiefs to Hunt Souls*, pp. xv-xvi.
18 Fytche, *Kerchiefs to Hunt Souls*, p. 209.

doors but had not won them enhanced political influence or acceptance. "Woman may toil over the washtub to earn bread for her hungry children, and her work will pass unnoticed"; Dr. A.I. Hamilton wrote wryly in the Halifax *Herald* in 1894, "but let her study law or medicine, and from all quarters, both male and female, will come the cry that she is not in 'woman's place'". Hamilton, the first woman graduate from Dalhousie's medical school, was in a position to comment. A dedicated feminist who set up practice amongst the working class of Halifax's North End after she graduated in 1894, she experienced both the voicelessness of poor women and the opposition facing middle-class women who became politically or professionally active.[19] "The women who get paid for their work in solid cash contribute in cash", she argued: "As a woman who has earned her own living from childhood, I claim all privileges of a bread winner and demand a vote".[20] However, as E.R. Forbes and Michael J. Smith have noted, women such as Hamilton had a difficult time in the early 1890s making gains for the suffragist movement in their applications to the Nova Scotia legislature.[21] It is not surprising, therefore, that literary exponents of the vote often felt it necessary to hide their subversiveness under a shroud of reasonableness and respectability. Elizabeth Gostwyck Roberts of Fredericton was typical of this syndrome in her literary contribution to one of the Halifax *Herald's* special women's issues in 1895, muting her feminist, iconoclastic views in a dialogue loaded with signifiers of domestic bliss and male approbation:

Eleanor: Well, I must say, dear, I was shocked to hear that you were writing in favor of woman suffrage. It seems to me so — so very unwomanly, don't you know.

Katherine: Please explain yourself, Eleanor.

Eleanor: Oh! oh! — I don't know how, but you know what I mean. How could you take proper care of your house, and perform all your social duties, and take part in those dreadful politics too.

Katherine: Well, I think I spend quite as much time over "those dreadful politics" now as I will when we are allowed to vote. My husband

19 Enid Johnson MacLeod, *Petticoat Doctors. The First Forty Years of Women in Medicine at Dalhousie University* (Lawrencetown Beach, N.S., 1990), pp. 9-14.

20 A.J. [sic] Hamilton, "The Rights of Women", *Herald*, 1 August 1894, p. 2.

21 Forbes, *Challenging the Regional Stereotype*, p. 72. See also Smith, "Female Reformers in Victorian Nova Scotia", pp. 56-67, 112-56.

and I read together every evening, and really you have no idea how interesting it is. Of course, I don't want you to think that we read nothing but political news. We study sociology, and history — and John is teaching me Greek. It is such fun!

Eleanor: Fun, indeed! I'm astonished at you, letting John work like that when he is so busy all day. And you must have time for nothing but books and writing.

Katherine: My dear Eleanor, be just. Does my house look bare or un-tidy? I will take you all through it, and you shall confess you never saw a prettier little home. And does John look ill or overworked? As for my writing, I would not have mentioned it had you not brought up the subject, — but I make a very fair income by it, enough to be a great help in the housekeeping.[22]

From a literary point of view, such a piece is not only non- dramatic but also didactically obvious. However, it is perhaps defensible in its blatancy when one considers it in the international context of cartoons published by *Punch* or Britain's National League for Opposing Woman Suffrage that show suffragettes' homes as dishevelled, their children as abandoned and their husbands as starving. In Nova Scotia, efforts to pass a modified bill for the vote through the legislature in 1895 were met with derision and defeat. The *Daily Echo* commentator condescendingly talked of the "dear old girls" in the galleries who

stamped their feet and shook their canes (women's suffragists all carry canes, they will smoke next) but nothing came of the indigna-tion meeting. . . . Many a hard-working man went without his supper on Wednesday and many a child was put to bed that evening without saying its little prayer, all because the dear wife and mother wanted to see the great emancipation measure carry in the house.[23]

Clearly, writers such as Evelyn Fenwick Keirstead and Eliza Ritchie had popular opposition of this sort in mind when they published essays on edu-cation in the *Herald* on 10 August 1895, for they avoid any mention of women's political advancement and instead stress higher education for women

22 Elizabeth Gostwycke Roberts, "Two Specimens of the Busy Woman", *Herald* Woman's Extra, 1 October 1895.
23 Quoted in Smith, "Female Reformers in Victorian Nova Scotia", p. 140.

as important for physical health, religion and society. Ritchie, herself a Ph.D. who had taught at Wellesley College before returning to the Maritimes, also stressed the importance of education in preparing the New Woman for "greater wisdom in the conduct of philanthropic movements, and a more rapid progress in all that makes for the best interests of society".[24] In doing so, she was touching on one of the most important areas of empowerment for women and one area where the New Woman was perceived as being less threatening. As Theodora Penny Martin has noted of the United States in *The Sound of Our Own Voices*, many women became interested in philanthropic work through their initial involvement in study clubs. From talks on Shakespeare and Egyptian art, they gradually moved "to the arena of practical action, from education for self to education for service":

> Their efforts on behalf of public schooling — campaigns for kindergartens, smaller class size, safe playgrounds, and the inclusion of art and music in the curriculum — have been termed "heroic." Dubbed "municipal housekeepers," urban club members did much to improve sanitation and living conditions in the cities. They became leaders in the establishment of local and national conservation sites. These new club women moved quickly and efficiently from philosophy to philanthropy and rarely looked back.[25]

The process was much the same in the Maritimes where the response of many middle-class women to the socials ills generated by increasing urbanization and industrialization was to attempt to initiate reform through membership in groups as varied as the Ladies' Auxiliary of the Society for the Prevention of Cruelty to Animals (SPCA), the Woman's Christian Temperance Union or the Local Council of Women. It was reform, not charity, that these organizations emphasized, notes Karen Sanders,[26] for their members were convinced that by attacking issues such as intemperance, factory exploitation of children, inadequate schooling and poor hygiene, they could gradually temper the forces eroding the stability of the home and the community. "The woman of today who is not allied with this grand procession", noted the *Acadian* in 1893, "upon whose breast is not pinned the white ribbon of temperance, or the red ribbon of education, or the cross of the King's

24 Ritchie, "Higher Education", p. 3.
25 Theodora Penny Martin, *The Sound of Our Own Voices. Women's Study Clubs, 1860-1910* (Boston, 1987), pp. 1-4.
26 Karen M. Sanders, "Margaret Marshall Saunders: Children's Literature as an Expression of Early 20th Century Reform", M.A. thesis, Dalhousie University, 1978, pp. 78-9.

Daughters, or the badge of the Band of Mercy, or the emblem of social purity, is behind her century".[27]

Many of these women, such as Frances Elizabeth Murray of Saint John, were typical in belonging to more than one philanthropic organization. A member of the socially prominent Hazen, Botsford and Murray families of New Brunswick, Murray was a biographer and author of several historical articles on women; her sister, Ellen, assisted the work of Laura Matilda Towne in South Carolina in establishing the Penn School for freedmen during and after the Civil War. Frances Murray remained in Saint John throughout most of her life, although in 1892 she joined her sister at "Frogmore" in South Carolina for part of the year. In 1885, her interest in the humane treatment of animals and the education of children led her to become president of the Ladies' Humane Educational Auxiliary of the Saint John SPCA. Initially devoting her energies in this organization to founding Bands of Mercy amongst schoolchildren and in organizing a Christmas dinner for the newsboys of the city, she and her fellow members had become more politicized by the 1890s when they were asked to visit public institutions such as the poorhouse and the asylum, to forward to the Governor-in-Council the names of two women for an appointment to the schoolboard and, in 1894, to throw their efforts behind the establishment of a Local Council of Women with all the projects on health care and education that this implied.[28]

The Saint John reformers kept in contact with those in Halifax, where women such as Dr. Maria Angwin, Edith Archibald and Anna Leonowens drew upon their professional or literary skills to inform their platform campaigning. It is difficult to visualize the elegantly begowned heroine of Rodgers and Hammerstein's *The King And I* as an active lobbiest for the dignity of female prisoners, improved truancy laws and woman's suffrage, but Anna Leonowens stands out in the minutes of the Halifax Local Council of Women and the Victoria School of Art and Design in the 1890s for the eloquence and energy with which she pursued causes. Her books on Thailand (Siam) and India had all contained passionate defences of women's rights, and in Halifax she argued "that while women are refused the franchise they should refuse to pay taxes".[29]

Her work with teachers on appropriate reading material for school children, her observations on the humane treatment of women prisoners in the

27 "A New Womanhood", *Acadian* (Wolfville), 17 February 1893, p. 1.
28 Gwendolyn Davies, "Frances Elizabeth Murray", *Dictionary of Canadian Biography*, Vol. XIII (Toronto, 1994), pp. 748-9.
29 Phyllis R. Blakeley, "Anna of Siam in Canada", *Atlantic Advocate* (January 1964), p. 41.

Boston courts (as compared to Halifax), her criticism of the city of Halifax for allowing slum landlords to reign unsupervised over their tenements,[30] and her argument that every home in the city needed "paved streets, cheap light and car service, and if possible public baths and laundries furnished at minimum cost to the people residing in the neighbourhood"[31] — all contributed to the spirit of social activism in Halifax in the 1890s. When she left Halifax in 1897 to supervise her granddaughter's education for several years in Germany, the Halifax *Herald* lamented that "so long dominated by a superficial and frivolous 'society'", Halifax could ill afford to lose a woman of "her talents, acquirements, ripe experience gained by extensive travel", and ability to discharge "responsible duties in varied and widely different spheres". "What she has already done in Halifax", noted the paper, "will like the concentric circles on the disturbed surface of a smooth lake, continue to expand till arrested by the distant shores".[32]

Amongst the changes for which Leonowens campaigned most vociferously were those that improved the future of children, especially in the tenement areas of the city. This not only included the creation of playgrounds in crowded areas but also, as she argued in an article entitled "Rudderless Minority", the establishment of "kindergartens, training school for domestics, industrial manual, and art school For Our Rich And Poor Alike; the museum with its reading rooms and lecture halls and public libraries for the youth of all classes".[33] In this respect, she was very close to two other writers a generation younger, for Margaret Marshall Saunders and Sophia Almon Hensley, both of them well-educated and well-travelled, also began in the early 1890s to turn their lecturing, journalistic and creative skills toward articulating their vision of social change.

For both Saunders and Hensley, the approach to activism was through maternal feminism, an avenue that increasingly became the emphasis for Nova Scotia feminists after the defeat of enfranchisement efforts in the mid 1890s.[34] In Hensley's case, involvement in the Mothers' Club and the Society for the Study of Life in New York; professional activities as a journalist; and experiences as a lecturer on heredity, children in tenements and the single tax — all informed poetry and prose that increasingly defined her view of the

30 Halifax Local Council of Women, #1-13 Minute Books, 1894-1947, MG 20, vol. 535, #1, Public Archives of Nova Scotia [PANS]. For example, see 13 December 1894, 27 June 1895, 31 October 1895 and 30 November 1895.
31 A.H. Leonowens, "Rudderless Minority", *Herald* Woman's Extra, 10 August 1895, p. 3.
32 "Her Farewell To Halifax", *Herald*, 19 June 1897, p. 12.
33 Leonowens, "Rudderless Minority".
34 Forbes, *Challenging the Regional Stereotype*, p. 72.

political and social rights of women. Saunders, who was one of the first two women to sit on the Acadia University Board of Governors in 1911, had come to writing and to social causes through the Baptist manse. Her maternal feminism was given particular expression in her work for The War Sufferers Committee of New York in 1915 when she took to the platform to raise money for food and shelter for those "anguished mothers across the sea who are watching the boys they cherished as the apple of their eye being done to death by other boys of other loving mothers".[35] Her 1905 novel, *The Story of the Graveleys: A Tale for Girls*, is typical in developing a number of her other concerns. Berty Graveley (significantly given an androgynous name) is a sprightly, energetic force for reform in her community. Although she enjoys a middle-class background and social circle, she and her grandmother are compelled for financial reasons to live amongst the working-class poor of River Street. This places her in an ideal position in the novel to be Saunders' intermediary — to have legitimate access to the power structure while seeing at first hand the need for social reform. "Let the town give the poor their rights", she argues to the politicians:

> They ask no more. It's no disgrace to be born poor. But if I am a working girl in River Street, I must lodge in a worm-eaten, rat-haunted house. I must rise from an unwholesome bed, and put on badly made, uncomfortable clothing. I must eat a scanty breakfast, and go to toil in a stuffy, unventilated room. I must come home at night to my dusty, unwatered street, and then I must before I go to sleep, kneel down and thank God that I live in a Christian country — why, it's enough to make one a pagan just to think of it! I don't see why the poor don't organize. They are meeker than I would be. It makes me wild to see River Street neglected. If any street is left unwatered, it ought to be Park Drive rather than River Street, for the rich have gardens and can go to the country, while the poor must live in the street in the summer."[36]

While Saunders' personal conservatism prevented her from translating her literary sentiments into political activism, there is no doubt in passages such as Berty's that the author felt passionately about the impact of poverty

35 Marshall Saunders, "An Appeal For Funds To Aid The War Sufferers Committee of Mercy New York, June 1915", in Margaret Marshall Saunders Papers, Box 5, file 3, courtesy of the William Ready Division of Archives and Research Collections, McMaster University Library, Hamilton, Ontario.

36 Margaret Marshall Saunders, *The Story of The Graveleys* (London, 1905), p. 234.

on the lives of women and children. In presentations to professional and service groups, in her journalism and in *The Girl From Vermont, The Story of the Graveleys* and other fictions, she denounced child abuse and child exploitation in the factories. Throughout both her juvenile and adult works, characters preach kindness to animals as a measure of humanity; preventative public health care; the role of supervised playgrounds and scientific play in keeping children away from vagrancy, crime and drink; and municipal reform in improving tenement areas. The end result is to have children grow up as responsible, productive citizens, residing, if possible, in a homogeneous family unit. The out-migration of young Maritimers to more lucrative employment in Boston was something that Saunders deplored as an erosion of both a domestic infrastructure and a healthy way of life, although she failed to address the economic necessity that prompted the out-migration. Rather, she saw Boston as "a huge pulp mill into which Nova Scotia throws many of her sons and daughters". "For one Nova Scotian who gets to be a master in the States", she argues in an essay entitled "No Place Like Home", "how many are slaves! Better a Canadian cottage than an American castle in the air. Let us go there for sight seeing, but let us not go there to get into the tentacles of the Dollar Devil".[37]

In addition to adopting an advocacy role in her writing in the area of moral and social values, Saunders employed novels such as *Rose à Charlitte, The Girl from Vermont* and *The Story of the Graveleys* to articulate her views on women's personal and political responsibility. "Men have no right to say to women, 'you shall vote, or you shall not; you shall do this kind of business, or you shall not'", notes Patty in *The Girl from Vermont*: "Men have no right to dictate to women — no more than women to men".[38] In *The Story of the Graveleys*, the appealing protagonist Berty responds to a charge of "New Womanism" with, "I'll be a new woman, or an old woman, or a wild woman, or a tame woman, or any kind of a woman, except a lazy woman".[39] And when she is accosted on a lonely footpath by a tramp, her declaration that she is "a gymnasium-trained girl" who can defend herself against "a little man like you"[40] echoes all the arguments for physical education, outdoors activity, and practical fashion that took the New Woman out of an eggshell existence into the public sphere. That Saunders saw this kind of physical fitness as relevant to her vision of social integration becomes obvious in its

37 Marshall Saunders, "No Place Like Home", *Herald* Woman's Extra, 10 August 1895.
38 Marshall Saunders, *The Girl from Vermont* (Philadelphia, 1910), p. 93.
39 *Graveleys*, pp. 99-100.
40 Saunders, *Story of the Graveleys*, pp. 197-200.

repetition, particularly when she has Patty in *The Girl from Vermont* win the respect of a group of cotton factory boys by neatly defeating them in a demonstration of the martial arts.

However interesting Saunders' corrective vision was, it was always to be limited by her uncritical celebration of family life and by her need for happy endings. So although Berty denounces marriage as "slavery to some man. You don't have your way at all",[41] it seems inevitable at the end of the novel that she will marry one of the young men lurking about. However, marriage for Saunders is for the creation of families, not for emotional, spiritual or sexual compatibility. In this respect she differs markedly from her Nova Scotian contemporary, Sophia Almon Hensley, also a daughter of the church and, like Saunders, educated in Britain as well as in Canada. Hensley's early years of privilege belied the radicalism of her later stance, but this great-great-granddaughter of Rebecca Byles Almon (who in 1784 had predicted that she would soon see women occupy central positions in church and state),[42] was of all the Maritime literary feminists the one to express her convictions most openly in public print. The assistant editor in New York of *Health: A Home Magazine Devoted to Physical Culture and Hygiene* as well as a frequent lecturer in New York on child welfare causes, Hensley, in her 1899 *Arena* article "The Society For The Study of Life", claimed that "the Suffragists have hewed and hacked their way through the solid phalanx of social opprobrium and selfish or indolent opposition; and the women of to-day, standing on the rising ground of a larger liberty and a more gracious freedom than would have been deemed possible in the past, give a grateful backward glance at their battle-scarred sisters ere they turn their expectant eyes upon the towering glory of a fuller enfranchisement".[43] *Love and the Woman of Tomorrow*, published in 1913 in London, was far more explicit in its vision of women's liberated lives than was the *Arena* article. It urged respect for women who chose not to marry; the granting of the vote so that women could turn their energies to pressing social and domestic needs; social support for unmarried mothers; and acceptance of women who wanted children but did not want to marry. It argued for enlightened sex education in the schools, for both men and women, and the recognition of sexual drives in women. Hensley also criticized the role of the Church (especially her own Anglican Church) for its

41 Saunders, *Story of the Graveleys*, p. 243.

42 R. Byles to her aunt, 24 March 1784, Byles Collection, MG l, vol. 163, PANS.

43 Mrs. Almon Hensley, "The Society For The Study of Life", *Arena* (November 1899), p. 614. For further information on Hensley, see Gwendolyn Davies, "Sophia Almon Hensley", in William New, ed. *Dictionary of Literary Biography*, vol. 99 (Detroit, 1990), pp. 163-5.

blinkered vision, and she criticized society for its double standard of mor-
ality. "We are living in a man-made world", she noted near the end of *Love
and The Woman of Tomorrow*,

> where men make laws not only for men but for women, where women
> are judged by men in the law-courts, are condemned to death by juries
> of men. Because quietness, humility and helplessness on the part of
> women made it easier for men to dominate them, to play with them,
> to subjugate them sexually, men have hindered the development of
> women individually, have stood between them and the expression of
> their own powers. When one considers how women, in spite of the
> opposition of the sex that held the authority, that controlled the
> wealth, that governed the social estimate of women, have made them-
> selves heard, have invaded the professions and succeeded in them,
> have entered the arena of the business world and "made good," it
> only goes to show how tremendous is the strength, how indomitable
> is the courage, how wide and wise is the vision of the woman of to-
> day.[44]

The *Times Literary Supplement* reviewed Hensley's book somewhat
acerbically on 3 July 1913, illustrating in the process Ann Ardis' claim in
New Women, New Novel that by relegating New Woman literature to the
margin, journalists and reviewers in this period intensified the marginaliza-
tion of women and trivialized their causes.[45] Of all the Nova Scotia writers of
this era, Hensley was probably destined to take the most marginalized posi-
tions, even joining those few Canadian women writers in the First World
War who cut through the rhetoric of patriotism and instead wrote of fear and
loss:

> Your boy with iron nerves and careless smile
> Marched gaily by and dreamed of glory's goal;
> Mine had blanched cheek, straight mouth and close-gripped hands
> And prayed that somehow he might save his soul.
> I do not grudge your ribbon or your cross,
> The price of these my soldier, too, has paid;
> I hug a prouder knowledge to my heart,
> The mother of the boy who was afraid![46]

44 Almon Hensley, *Love and the Woman of To-morrow* (London, 1913), pp. 180-1.
45 Ann L. Ardis, *New Women, New Novels* (New Brunswick, N.J., 1990), p. 13.

Because of the issues that she tackled — sex, anti-heroism — Hensley never enjoyed the popularity accorded Saunders' message novels or Leonowens' exotic life studies. But in the overall measure of literature written by Maritime women out of the catalyst of the suffragist and social movements of the prewar period, Hensley's now emerge as the frankest and the most thought-provoking.

Did any of these women writers make a difference? We do not know if people saw the play *Culture* before 1902, how many copies of Fytche's *Kerchiefs to Hunt Souls* circulated in the Maritimes, or whether the Halifax that had praised Hensley's poetry ever accepted her 1913 feminist essays published in London. Although most of these women probably knew one another or about one another, they never coalesced as a literary school. Because Leonowens was so respected for the fame of her books and her role in establishing the Victoria School of Art and Design, she was listened to with deference when she spoke on the suffrage issue. Even the newspapers took note of her. They also took note of Saunders, whose status as a best-selling author of over one million copies of the children's novel *Beautiful Joe* (1894) gave her a newsworthiness and a credibility that extended into her platform pieces and her fictions on women's role in social reform. But professional travel, removal to other cities and a shift away from philanthropic work to a pattern of private writing all dissipated the mutuality of purpose and interconnectedness of this literary group, if it had ever existed at all.

At the very best, we can say that, as individuals, these writers heightened a public consciousness about the situation of women and the nature of their demands in the period before the First World War. In doing so, they contributed to women's political culture at a point in Canada when the agitation for the vote was sensitive, and they endowed that issue with a credibility, profile and popular respectability that enabled countless non-politicized people in their mass readership to consider their position — to see it as something fair or outrageous or inevitable. While Hensley's essays may have been the most forceful of these feminist exponents, the popular romances of Fytche and Saunders were probably more successful in reaching a broad circulation of contemporary readers. Fytche and Saunders were reviewed in the periodical press, and, in Saunders' case, Christmas editions and Canadian, American and British editions of her books kept her fictionalized social agitations before the public. But social agitation is dated, particularly after the vote is won or the war is over or women have gone on to take not only B.A.'s but also Ph.D.'s. Typically, all of these women writers fell into subsequent

46 Almon Hensley, "Somewhere in France", *Everybody's Magazine*, vol. 39, no. 105 (August 1918), p. 105.

obscurity once their causes had been won and interest in them had declined. Tragically, two of them — Fytche in Saint John[47] and Saunders in Toronto — died in straitened means as well as obscurity, with Saunders eking out her income in old age by lecturing and showing lantern slides. But, in the heyday of their battle to expand women's sphere, they — like Leonowens and Hensley — demonstrated what Hensley called in 1913, "the strength — the courage — the wide and wise vision — of the woman of to-day".[48]

47 Fytche, *Kerchiefs to Hunt Souls*, p. ix.
48 Hensley, *Love and the Woman of To-Morrow*, p. 181.

CONTRIBUTORS

RUSTY BITTERMANN is a graduate of the University College of Cape Breton and the University of New Brunswick. He is now a Killam Fellow at Dalhousie University.

GAIL CAMPBELL, an authority on 19th-century political and social history, teaches at the University of New Brunswick in Fredericton.

GWENDOLYN DAVIES teaches English at Acadia University in Wolfville, Nova Scotia and is the author of *Studies in Maritime Literary History, 1760-1930* (Fredericton, 1991).

JUDITH FINGARD, the author of several books on Maritime social history, is Dean of Graduate Studies at Dalhousie University.

PHILIP GIRARD, a faculty member at Dalhousie University, is currently a visiting professor at Osgoode Hall Law School in Toronto.

JANET GUILDFORD teaches history and Canadian Studies at Mount St. Vincent University and St. Mary's University, Halifax.

BONNIE HUSKINS, a graduate of Mount Allison and Dalhousie Universities, teaches history at the University College of the Fraser Valley in Abbotsford, B.C.

HANNAH LANE is pursuing her interests in religious history and women's history and working on a doctoral dissertation at the University of New Brunswick.

SUZANNE MORTON teaches history at McGill University and is completing a new book about north-end Halifax entitled *Ideal Surroundings: Gender and Domestic Life in a Working-Class Suburb in the 1920s.*

SHARON MYERS is a Ph.D. student at the University of New Brunswick, where she is preparing a study on the history of childhood in New Brunswick.

REBECCA VEINOTT, formerly of Halifax, practises law in Yellowknife, N.W.T.

1